JOHN RUSKIN: THE EARLY YEARS

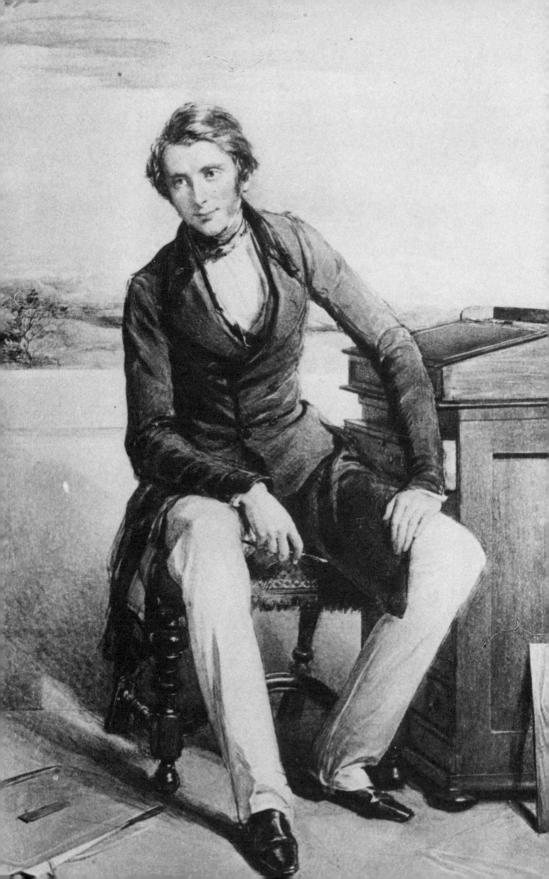

JOHN RUSKIN

THE EARLY YEARS
1819–1859

TIM HILTON

YALE UNIVERSITY PRESS
NEW HAVEN AND LONDON
1985

TO
JEANNE CLEGG

Frontispiece. *The Author of 'Modern Painters'*, reproduced from the photo-gravure of the water-colour drawing by George Richmond, R.A., 1843 (Library Edition, Volume III)

Designed by John Nicoll

Filmset by Clavier Phototypesetting, Southend-on-Sea, Essex
Printed in Great Britain at The Pitman Press, Bath

Library of Congress catalog card number 85-50177
International standard book number 0-300-03298-6

CONTENTS

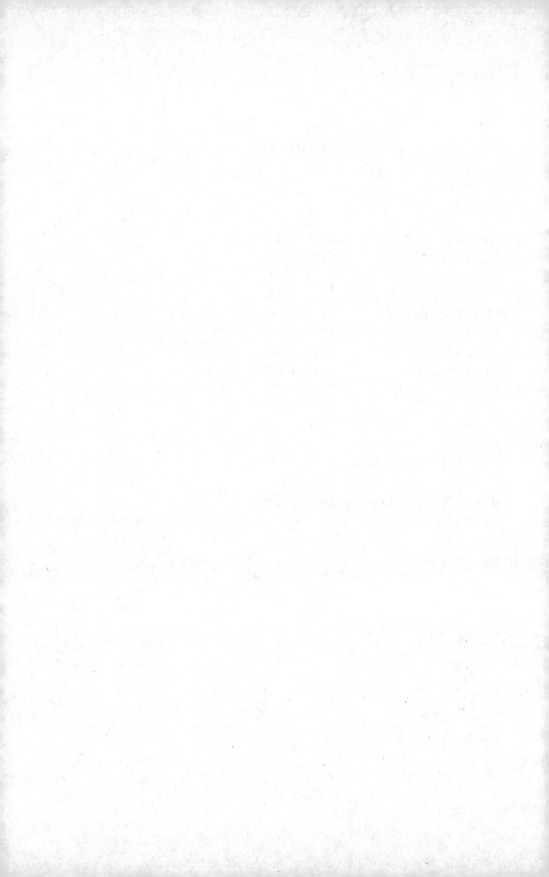

LIST OF PLATES

FOREWORD

Of great English writers, there is none so prolific as Ruskin: nor, for those who love to study him, is there any writer so valued for every sentence, every touch of the pen — right down to that individual, flickering, hurrying punctuation that, as one reads his manuscripts, seems to drive his thoughts from one page to the next. His literary production was enormous, yet nothing is redundant. In a writing career of fifty-nine years, he published some 250 titles, to which we must add his lectures, contributions to periodicals, more than thirty volumes of diary, around forty volumes of published correspondence, and dozens of thousands of letters which remain unpublished, and will not see print for many a year yet. It is not easy to come to a moderately informed view of Ruskin, and not only because of his fecundity. There are no useful modern editions of his famous early works, *Modern Painters* (1843-60) and *The Stones of Venice* (1851-3). *Unto this Last* (1860) has been given an importance it does not really possess. *Fors Clavigera* (1871-84), Ruskin's best and most extensive work, was ignored in his lifetime and has scarcely been studied from that day to this. *Præterita* (1885-9), his autobiography, is an extended rumination on his childhood rather than a statement of Ruskin's purposes in adult life; and of his mature works, what does this century really know of those gnomically-entitled volumes, so often seen in second-hand bookshops, never reprinted, *The Harbours of England, The Two Paths, Munera Pulveris, Time and Tide by Weare and Tyne, The Ethics of the Dust, The Queen of the Air, Mornings in Florence, St Mark's Rest, Love's Meinie* and *The Storm-Cloud of the Nineteenth Century*?

Ruskin's books, even *The Elements of Perspective*, are without exception personal. They were formed by the events of his life, his reading, his friendships and loves, dreams, travels and memories. No doubt this is so of many imaginative writers: but Ruskin believed his life's work to be factual and analytical. This is the first problem of understanding Ruskin's writing, and one reason for a biography. A knowledge of his life, rewarding in itself, is also the best way to approach his books. They are neither straightforward nor self-explanatory, and they have an especial unlikeness to anyone else's writing. Few of them are in an obvious sense works of literature. They rarely conform to the classic *genres* of writing. Moreover, from some point in the 1850s it is

impossible to prefer Ruskin's 'major' to his 'minor' works, and
unfinished or unfinishable books may be more rewarding than his
more crafted productions. In later years he tried to give his readers all
he thought they should know about him in order to understand his
writings. But his audience, such as it was, then became further con-
fused and sometimes alienated. This was the fate of *Fors Clavigera*,
which the present biographer believes to be Ruskin's masterpiece. *Fors*
was the monthly letter written (nominally) to instruct and inspire a
class that certainly did not read it, 'the workmen and labourers of
Great Britain'. Its six hundred thousand words, a commentary on
Ruskin's thoughts and experiences between 1870 and 1884, tell us
more about its author than does *Præterita*, his autobiography. But
much of it is obscure, however Ruskin strives to make himself under-
stood: and perhaps *Fors* was fully comprehensible only to those who
had an intimate knowledge of his life.

Præterita, whose composition began with extracts from *Fors Clavi-
gera*, did not reach the point in its narrative at which *Fors* itself was
begun; and it is not likely that the exhausted, despondent autobio-
graphy could have explained the dramas of Ruskin's life in the years
that the pamphlet was issued. I hope to have written a biography that
does so for him. *Præterita* does not tell us much about Ruskin's
maturity. Nor does it describe his position as a great Victorian. Its
bitter modesty conceals how extensive was his public career. Ruskin
was twenty-four years old when he published the first volume of
Modern Painters. He was immediately recognized as a significant didac-
tic writer. For the next forty years and more he was a force against the
basilisk of the age. His principled critique of the values of nineteenth-
century society, an opposition nobly sustained and richly elaborated,
is one of the most valuable expressions of that society. But his con-
tribution did not become clearer as he published more books, and the
nature of his writing precluded the composition of single, classic
works. Ruskin's criticism of his times might have had more impact if
it had been concentrated in ten years' work rather than forty. His
extended crusade was both familiar and ignored. To be thus, for a
writer of his temper, was to be truly solitary. Ruskin's complaints that
he was alone in the world often appear exaggerated. His books were
famous and he was a professor in the University of Oxford: what
could be more social than that? He was gregarious and people sought
his company; he had wide circles of friends; he had 'disciples'; many
people loved him; in his own way he was a family man. Yet it is true
that he stood alone and that his work was not appreciated. This was
the more so the longer he lived and wrote. *Fors Clavigera* echoes a

voice that found no response in those it most urgently addressed.

I have not found that Ruskin's purposes — let alone the emotions of his brave, unhappy life — have become much clearer as the result of twentieth-century interest. To some extent, he was the victim of the dismissive prejudices of a period. The scorn of Victorian gravity was of course one reason why he was neglected; another was the rise of the modern movement: a third was the triumph of liberal and democratic values. But the study of Ruskin's life was also impeded by the very instrument that seemed to be designed to promote it. The Library Edition of Ruskin's works was published in thirty-nine volumes between 1903 and 1912. It was, at that date, the most elaborate editorial homage accorded to any English writer, even including Shakespeare. But it appeared at the nadir of Ruskin's reputation. It is perhaps not surprising that its assumptions were not examined at that period. Unfortunately, all subsequent biographies of Ruskin have been deficient because they rely on the Library Edition's editorial apparatus and introductions. Its two editors were E. T. Cook, a Ruskinian since his schooldays, and Alexander Wedderburn, a lawyer who had been one of Ruskin's Balliol 'disciples' at the time of his road-building project in 1874, and who remained a friend ever afterwards. We will meet both Cook and Wedderburn in this book, and learn of their attitudes to Ruskin. For the moment it is enough to say that it was Cook's scholarship that formed the Library Edition; and that it was the firm hand of Joan Severn, Ruskin's cousin, that determined its biographical material.

The present biography differs from its predecessors in placing its emphasis on the later rather than the earlier years of Ruskin's life. I believe that Ruskin was a finer writer and, if I dare say so, a better man, in the years after 1860 and especially in the years after 1870. The Library Edition presents many difficulties of scholarship and interpretation to the historian of these later years. Its editors had to be reticent about a number of matters. Just as they had not wished to say much about Ruskin's marriage, they gave only the barest information about Rose La Touche, even though Ruskin's love for her was a major influence on all his writing after 1860. They could not discuss his repeated mental breakdowns, although these could hardly be ignored; and they could not examine the tortured relationship between Ruskin and Joan Severn, for to do so would have revealed the true nature of *Præterita*, a book which was controlled by Joan and was designed, therefore, to relate only those aspects of Ruskin's life that were uncontentious. These omissions are understandable. Some of them have been repaired by later scholarship. But I would add that Cook (and the

biographers who have depended on him) misrepresented Ruskin in other ways. Cook was an excellent Ruskinian, except that he was not an art historian, nor a churchman, nor an imaginative political thinker. He could not understand Ruskin's passions and he was embarrassed by his subject's religious life. He regretted Ruskin's quarrels and shied away from the implications of *Fors Clavigera*. Above all, he deliberately softened Ruskin's political views to make them conformable with his own liberalism. In this biography I have attempted to restore to Ruskin those aspects of his career and his personality.

Modern Ruskin scholarship may be said to have begun in 1929, when the late Helen Gill Viljoen, then a graduate student, visited Ruskin's old home at Brantwood. The house had long since fallen into disrepair and many of its treasures had been sold. But Viljoen discovered Ruskin's diaries, many packets of family letters and one manuscript that meant much to her, the autobiography and diary of Rose La Touche. Helen Viljoen also met W. G. Collingwood, another disciple of Ruskin who had known him since the 1870s. Collingwood had subsequently become Ruskin's secretary, and his views on the honour due to Ruskin's memory significantly differed from Wedderburn's, or Cook's, or Joan Severn's. Viljoen's discovery of original manuscript, with Collingwood's conversation, turned her away from the account of Ruskin presented in the Library Edition. She determined to study him afresh. The first fruit of her lifetime of Ruskin scholarship appeared in 1956, when she published *Ruskin's Scottish Heritage,* an account of her subject's forebears. This was announced as the first volume of a biography. My own belief is that its purpose was to analyse the inaccuracy and bias of the Library Edition: in this way it was propædeutic. Viljoen (who was never to write more than three or four fragmentary chapters of her biography) thus laid down a principle of Ruskin scholarship. She insisted that students of his work should at all times return to the manuscript sources. I have attended to this advice, and in my own researches have been guided by Helen Viljoen's friend Professor Van Akin Burd, whose exemplary editions of *The Winnington Letters* and *The Ruskin Family Letters* have been an inspiration to all modern Ruskinians. I have also benefited from the example of James S. Dearden, Curator of the Ruskin Galleries at Bembridge School. In the many months I spent with Mr Dearden reading through the Bembridge archive I learnt (as he, Professor Viljoen and Professor Burd had learnt before me) that knowledge of Ruskin has been handed down by personal help and generosity.

Helen Viljoen believed that Ruskin scholars should approach their subject as though the Library Edition did not exist. This was an

extreme position, which she perhaps held because she never worked in Oxford and did not know of the documents that had aided Cook and Wedderburn in their labours. In the Bodleian Library is an archive almost as considerable as that at Bembridge. Its main sequence is in the volumes known to Ruskinians as the 'transcripts'. These are typewritten copies of all Ruskin's correspondence which was gathered for the Library Edition but not published in it. These thousands of letters are accompanied by complete transcriptions of all Ruskin's diaries. Surprisingly, this material was not known to the editor of Ruskin's diaries, Joan Evans, with the result that her edition of these journals (1956-9), which prints less than half of the complete text, is incomplete and only randomly annotated. The full treasures of the transcripts did not begin to enter Ruskin scholarship until 1969, when Van Akin Burd published *The Winnington Letters*. I hope that this biography's use of them will repay the trust with which Alexander Wedderburn bequeathed the documents to his old university.

<p style="text-align:center">★ ★ ★ ★</p>

Such, in brief, is the history of the main stream of Ruskin scholarship, as it has appeared to me. I have of course benefited from many other scholars and Ruskinians. They are fully acknowledged in the bibliographical notes in the second volume of this biography. I must now thank Messrs George Allen and Unwin, the Ruskin Literary Trustees, for their courtesy in allowing me to publish letters and other manuscripts of John Ruskin. For permission to publish material in their possession I thank The Education Trust Ltd, The Ruskin Galleries, Bembridge School, and its Chairman, R. G. Lloyd, CBE, QC. I am grateful to the Bodleian Library and Ashmolean Museum in Oxford for allowing me to quote from documents preserved in their collections. Permission to quote from published and unpublished letters has been kindly granted by Sir Ralph Millais, Bt., the Beinecke Library at Yale University, the Master and Fellows of Trinity College, Cambridge and the Directors of the John Rylands Library, Manchester. The Syndics of the Fitzwilliam Museum, Cambridge, have given me permission to quote material in their archives. I am grateful to the Trustees of the National Library of Scotland for allowing me to quote from manuscripts in their possession and the Trustees of the Trevelyan Estate have generously given me permission to use letters now deposited in the library of the University of Newcastle upon Tyne. Permission to reproduce illustrative material has been kindly granted by: Sir Ralph Millais, Bt., the Education Trust, Ruskin Galleries,

Bembridge; The Brantwood Trust, Coniston; the Ruskin Museum, Coniston; the Ashmolean Museum, Oxford; the City of Birmingham Museum and Art Gallery; the Fitzwilliam Museum, Cambridge; the Greater London Council Photographic Collection; the Graves Gallery, Sheffield; and the National Portrait Gallery, London.

* * * *

A biographer may be allowed some personal comment in acknowledging help and inspiration. I was introduced to the study of Ruskin in the late 1950s, by a fellow cyclist who was then in retirement from his trade as a second-hand bookseller. I grieve that I have forgotten the name of this self-educated man, Clarion Club member and socialist. I no longer believe that Ruskin had any real connection with the Labour movement: but the questions I was then told to put to myself are still the right ones. What do you think about art? What do you think about the poor? I was not a successful student of Ruskin, however. I found his books puzzling and often incomprehensible. My friend did not give me much assistance. He implied that I might grow up to them. This was true: but young men are vexed by such demands on their patience.

When I was an undergraduate in the early 1960s, I was asked to understand that an interest in Ruskin was as foolish as an enthusiasm for modern art. I wish therefore to record my gratitude to the Courtauld Institute of Art, its then director, Anthony Blunt, and my friends Michael Kitson and Anita Brookner for their kind welcome and interest while I studied there as a postgraduate. Richard and Margaret Cobb helped me in many ways when I began my research. Arthur Crook, John Wain, Nuala O'Faolain, Peter Lowbridge, Anna Davin, Luke Hodgkin, Alexander Cockburn, Peter Carter and Martin and Fiona Green all encouraged me when I decided that I would one day write about Ruskin. The late Tony Godwin gave me excellent advice on writing biography, and Marghanita Laski's generosity allowed me to explore his recommendations. I have always been able to submit my writing to the wise scrutiny of David Britt, while Andrew Best of Curtis Brown has lifted many a care. I have long valued the sympathetic interest of Catherine Lampert and Elizabeth Wrightson.

Most of this book was written in Oxford. I am especially beholden to the Warden and Fellows of St Antony's College for their hospitality during the time I held an Alistair Horne Fellowship there: I am grateful for the friendly interest of Teddy Jackson, Tom Laqueur, Harry Willetts and Theodore Zeldin, Fellows of St Antony's with a wide

sympathy for the humanities. The late Frank McCarthy Willis-Bund told me much about the Irish Church in which he was raised, and I had the privilege of conversation with John Sparrow about Victorian Oxford. It has always been a pleasure to exchange views and information with Richard Ellmann. John Owen, 'Senex' of the *Oxford Times,* helped me with matters of Oxford lore and tradition. Godfrey and Peter Lienhardt asked me the sort of questions about my interests that helped me to define my views on those interests. All Oxford men are indebted to the university's librarians. My heartfelt thanks go first to Margaret Miller of the Ashmolean Museum, who enabled me to work with the museum's collection of books by and about Ruskin that were the gift of E. T. Cook: I therefore used the same editions, pamphlets, press cuttings and the like from which Cook fashioned his editorial apparatus. Jane Jakeman, now of the Ashmolean, was at that date the most helpful of all the librarians at the Bodleian — where all the librarians, I hasten to add, are efficient and sympathetic beyond the calls of duty. Fanny Stein, Ann Nimmo-Smith and Andrew and Peggoty Graham (all of Balliol families) were my friends and hosts while I lived in Oxford, and my research would not have been possible without their kindnesses to me. David Soskice, Christopher Hill, Tony Kemp-Welch, Frank and Ceci Whitford, Christopher Butler, Andrew Sugden, the late Lesley Smith, Islie Cowan, Joe Mascheck, Juliet Aykroyd, Malcolm Warner, Meriel Darby, Deborah Thompson, Raphael Samuel, Mary-Rose Beaumont, John Ryle, Peter Ferriday, W. L. Webb, Eric Hobsbawm, Sheila Rowbotham and Peter Townsend all assisted with the writing of this book, whether they knew it or not.

I was fortunate that, in Oxford in the mid-1970s, there was a group of young scholars working on various aspects of Ruskin. Since there were no older specialists in British universities they were in effect (or so it appeared to me) the avant-garde of the new Ruskin studies. Nobody hoarded their discoveries, and I feel that I must have gained more than anyone else from our discussions. Robert Hewison's thesis on *The Queen of the Air* was a pioneering piece of research: so also was Dinah Birch's dissertation on Ruskin and the Greeks. Tanya Harrod and Nicholas Shrimpton wrote doctorates that stressed Ruskin's public and literary life, while Michael Simmons's examination of *Fors Clavigera* was a truly understanding approach to Ruskin's later years. The most detailed and sensitive work on Ruskin and Italy was Jeanne Clegg's: some of it was published in her *Ruskin and Venice* (1981). She is the Ruskinian to whom I am most deeply indebted, and this biography is dedicated to her. I (and other members of this group) would wish to record our indebtedness to Van Akin Burd, both for his

scholarship and his interest in our own work. Of other Ruskinians, I extend my thanks especially to Naomi Lightman, Brian Maidment and Harold Shapiro.

The late Claude Rogers, Professor of Fine Art at the University of Reading, first invited me to examine the collections of the Guild of St George, which at that time (the mid-1960s) were stored in great confusion in the cellars beneath his department. All Ruskinians, and not least myself, are indebted to Catherine Williams for her work in cataloguing this material and for her suggestive comments on the early organization of the Guild of St George. I am also grateful to Peter Fitzgerald and Andrea Finn for inviting me to Reading, and thank the University of Reading Library for giving me access to the book and manuscript collections of the Guild of St George. I thank the Master and Directors of the Guild for a grant that assisted in the research for this book. I acknowledge the financial assistance of the Arts Council of Great Britain, and would add that the Council's Ruskin exhibitions of 1964 and 1983 both helped my work: the first, by its demonstration of the variety of Ruskin's interests, and the second (cogently devised by Dr Clegg) by showing the thematic unity of these interests, and their best expression in Ruskin's 'Guild period', the years of his Slade professorship and *Fors Clavigera*.

During my stays on the Isle of Wight I was made welcome by a number of Bembridge people. I must first of all thank Mr and Mrs Hastings and Ray and Sheila Rowsell for making holiday accommodation available to me in the winter months; and during Bembridge winters I was especially glad to have the company of John and Barbara Arthure, Rosalind Jenkinson and the late General Sir Michael West and Lady West. The best help in the writing of a long book is often of an indirect kind. To be blunt, one needs to be cheered up. My wife, Alexandra Pringle, has sustained me in all ways. So have some 'modern painters'. I owe a personal and intellectual debt to Clement Greenberg: I do not know whether it is apparent in these pages. Lastly, it is a pleasure to me to thank friends who are artists: they must have thought, over the years, that my Ruskinian interests were far removed from their own concerns. My gratitude for their support and patience goes especially to Terry Atkinson, Gillian Ayres, Michael Bennett, Anthony Caro, Barrie Cook, Barry Flanagan, John McLean, Ronnie Rees and John Walker.

* * * *

The spelling and punctuation from original manuscripts has been retained but normalized in quotation from secondary sources.

CHAPTER ONE

1785–1837

John James Ruskin, the beloved father of the subject of this book, was born in Edinburgh in 1785. He was the son of John Thomas Ruskin, whose financial misfortunes, madness and suicide were to darken the lives of both his son and the grandson he never knew. John Thomas had gone to Scotland from London, where he had been born in 1761, the son of the parish clerk of St Bartholomew the Great. As a young man he had been apprenticed to a vintner, but gave up his indentures when, after his father's death, he removed to Edinburgh. There he became a grocer: in later years he described himself as a 'merchant'.[1] Writing *Præterita* a century afterwards, Ruskin claimed that his grandfather had married suddenly and romantically. That was perhaps because his wife came from a more genteel background. Catherine Tweddale was a daughter of the manse, and her forebears had owned land. Her father was the minister of the Old Luce church at Glenluce in Galloway. Catherine was sixteen when she married. With its usual wistfulness about family legends, *Præterita* recounts that when her daughter Jessie was born in the next year, 1783, the young mother danced 'a threesome reel, with two chairs for her partners'.[2]

John Thomas's grocery business was established in only a small way when John James, Jessie's brother, was born. Their situation improved when Catherine Ruskin inherited some money in 1794. The family then moved to a house in a better part of Edinburgh, St James Square in the New Town. Little is known of John James's childhood there. But it is clear that when he entered the Royal High School in 1795 he was an intelligent and serious boy. The school's headmaster was Dr Alexander Adam, a famous figure in Edinburgh society, the author of a Latin grammar and a book on Roman antiquities. John James quickly took to the classical authors and therefore benefited from Adam's stern regime and difficult Latin exercises. He had artistic talent as well: he studied a little under the landscapist Alexander Nasmyth. His ambition in life was to be a lawyer, a common way to advancement for an able Scottish boy without a background. Had he continued at school, in the democratic and competitive Scottish education that the Royal High School typified, John James surely would have risen in his chosen profession. However, when he was sixteen John Thomas insisted that he should go to London to begin a career in trade. John James obeyed, but he never forgot his disappointment: it is

one reason why his own son's talents were so fostered. John Thomas probably had financial motives for dissuading his son from a legal career. He was expanding his business but was not doing so prudently. Acting as an agent for other merchants, he may even have speculated on his own account with remittances that were not his. At all events, we know that he did not wish to bear the cost of John James's further education, and that he wished his daughter Jessie to be settled with a practical tradesman. In 1804 he seems to have arranged that she should marry Patrick Richardson, a prosperous tanner from Perth. He was eleven years older than Jessie, and she did not marry him for love. 'Very submissive to Fates mostly unkind', was John Ruskin's view of his aunt's sad life.[3] She bore many children, lost six of them in childhood, was widowed, and died herself in 1828.

John Thomas was often away from Edinburgh. When both her children had left home Catherine Ruskin felt the need of family company. She wanted somebody to talk to, who would not be a servant but would help to run the house in New Town. Her choice fell on her niece by marriage, Margaret Cock. Margaret was the daughter of John Thomas's elder sister Mary, who had remained in the south of England when her brother had gone to Edinburgh. She had married a publican, William Cock, the landlord of the King's Head in Croydon, a small public house at the side of the market place, with two little bars and three rooms upstairs. Margaret Cock was born there in 1781. The tavern was not too large for her mother to run by herself when William Cock died. She was probably quite determined. Certainly she saw to it that her daughter got a dainty education, for a publican's daughter. Margaret attended Mrs Rice's Academy for Ladies, the best girls' school in Croydon. This might have led to a position suitable for a young lady, and the invitation from Scotland was almost such a thing. Margaret now changed her surname to Cox. In Edinburgh she probably concealed the lowliness of her background. Her modesty and carefulness became the tenets of her new life. *Præterita* describes her at this period as 'a girl of great power, with not a little pride' who 'grew more and more exemplary in her entirely conscientious career'.[4] She was by nature pious: seriously believing, that is, in the unchanging laws of her God. Her embroidery was excellent. She read a great deal in her spare time. She administered the Edinburgh household with firmness and efficiency, and was to do so for thirteen years. All her youth and young womanhood was given to this home. In these years she developed an unswerving love for her cousin, John James. In time he came to love her too. He was four years younger than Margaret, dark-eyed, romantic, a poetry lover, living by himself in London.

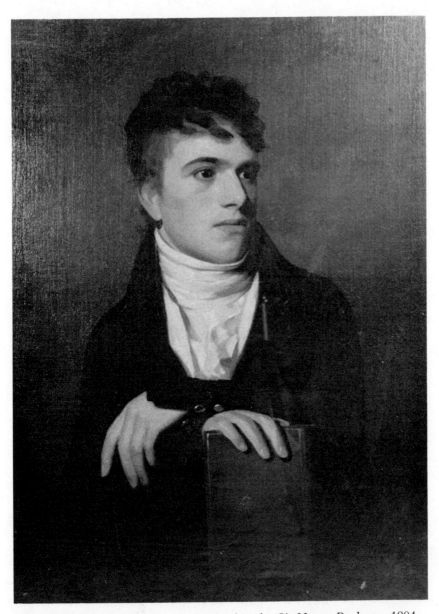

1. John James Ruskin, father of John Ruskin, by Sir Henry Raeburn, 1804.

There was also much that was exemplary in his character, as Margaret knew with pride. Although he was not often in Edinburgh, their love did not suffer on that account, except in parting. Years later, Margaret recalled 'a night of passionate grief and tears spent upon the floor of her bedroom' after he had gone back to England to return to his counting house in a wine merchant's.[5]

John James Ruskin had discovered that he had the temperament of a businessman. This was what his father lacked. John Thomas was moody and extravagant. Always hot-tempered, he sometimes fell into black rages. It is recorded — from a hostile source, to be sure — that once 'coming home from one of his rounds a day earlier than he was expected, and finding his wife having a tea party, he in a fit of anger swept off the array of china into the fireplace'.[6] No evidence suggests that he was particularly mindful of his family: many letters indicate how tolerant they were of him. He was not always able to meet his financial commitments. Worse, he was not always inclined to do so. His business floundered and then collapsed. In February of 1808 Catherine Ruskin had to write to John James in London to tell him of its failure. The younger Ruskin immediately became the strength of the family. He undertook to pay off his father's debts. It was fortunate that a large part of them was owed to a Mr Moore of London for whom John Thomas had acted in Scotland and the north of England. Moore knew John James and admired him. Proceedings for bankruptcy were avoided.

In 1809, in the midst of this family trouble, John James and Margaret became engaged to be married. The engagement was to last for eight years. They had no prospects beyond those marked by John James's determination, and limited by John Thomas's insolvency. The young people's love for each other was to grow as they themselves grew older. Initially there was not a great deal of joy in it. Theirs was not a splendid match. It was as if John James were getting married to his duties. Cousin marriages were not regarded without unease. Margaret had no money and was the daughter of an innkeeper. Since John James felt that he could not marry until he had paid off his father's debts, the affianced couple had to resign themselves to separation and long labours. John James's industry was remarkable. He went for years without a holiday. Occasional visits to the theatre and to lectures were not enough of a recreation: he worked until his health was threatened. He wrote regularly to his family and, separately, to Margaret. She supervised an enforced move from New Town to a cheaper house at Dysart, on the Fife coast near Kirkcaldy. Later the Ruskins rented Bowerswell, a house on the east bank of the Tay, not far from

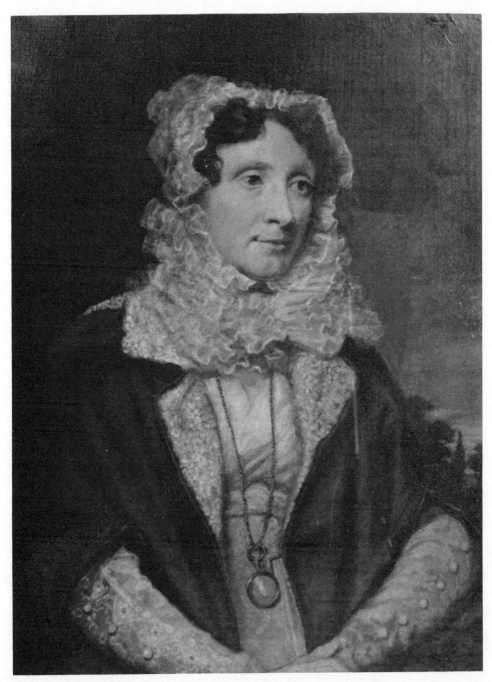

2. Margaret Ruskin, mother of John Ruskin, by James Northcote, R.A., 1825.

Patrick and Jessie Richardson in Perth. Margaret also applied herself to her own improvement. Dr Thomas Brown, later Professor of Moral Philosophy at the University of Edinburgh, was a family friend. He had been a mentor of John James's in his younger days and now was glad to advise Margaret on her reading. She taught herself Latin and even a little Hebrew. But in her loneliness she found her greatest comfort in the Bible.

In London, John James had risen to be head clerk of the wine importing firm of Gordon, Murphy and Co. By his exacting standards, it was not an efficient house. He complained to Margaret of 'their ridiculous stile which has resembled that of princes more than Merchants'.[7] He had a trusted but not powerful position and was conscious that the firm was not good enough for him. One other person thought the same. Pedro Domecq was a young Spaniard with French nationality. His family owned extensive vineyards in Spain and he was working in London to extend his knowledge of the wine business. Placed among the foreign clerks in Gordon, Murphy, 'he had not exchanged ten words in as many months' with John James when he decided to approach him with the proposition of a partnership.[8] But he had seen the thrifty young Scotsman at work, and discerned his qualities. The two men discussed the wine trade outside the office and found that they got on well. They determined to look for another partner with some capital. By happy chance they were both acquainted with Henry Telford. He was a Kentish country gentleman. His interest in life was horses. He hunted and went to every race meeting he could. But he never betted; and now he realized that he would not be risking his money by becoming a sleeping partner in Domecq's enterprise. Telford owned premises in Billiter Street, in the old City of London between Leadenhall Street and Fenchurch Street. Here the firm of Ruskin, Telford and Domecq was established. The amiable Telford gave advice when he was asked for it, sat in the office for only one month in the year, while John James was on holiday, and left matters to his younger partners.

John James had worked hard for his salary at Gordon, Murphy. He worked even harder now and in the years to come, as his intention was to build a fortune from his commission. He was helped by the boom in the wine trade after the Napoleonic wars. But his own industry, particularly in travelling, brought great rewards. He was entitled to boast, when he came to look back on the early history of the firm, that 'I went to every Town in England most in Scotland & some in Ireland, till I raised their exports of 20 Butts wine to 3000'.[9] His finances improved steadily after the foundation of the new business; prospects

were excellent: but in Scotland there were more troubles with his father. John Thomas began to object to his son's engagement to Margaret. He perhaps thought that his son could now make a better match: but it is possible that his insensitive behaviour was part of the more general misanthropy that was overtaking him. We have hints of these difficulties in a letter home from John James in 1815:

> Oh my own Mother as you have always loved me will you and my dear Father assure Margt that you have both become reconciled to our Union & be happy — or will you see her & me both fall sacrifices to this anxiety. Neither her constitution nor mine are fit for a long struggle. I have already said that if it leads to eternal Ruin I will fulfill my engagement with Margt. I hope my Dr. Father will therefore no longer cause us any uneasiness . . . Oh if you expect me to make some efforts to keep the family united — do not let her on whom my life depends sink under my Father and your displeasure. The state of our worldly matters requires that we should not oppose each other in things to add to that distress . . .[10]

John Thomas was of course in no position to prevent the marriage. His son's letter, pleading yet firm enough, shows what great strains there were on his filial piety. It also shows his forbearance. What Margaret thought is not recorded. In later years she never mentioned John Thomas.

Only a couple of months after this letter, John Thomas broke down. Reports of his melancholia now indicate that he had fallen into madness. Six hundred miles to the south, John James wrote anxiously to his mother, to enquire how much money his father had been spending and how much the neighbours knew of what had happened. He asked her to forbid drink to him and to take over the family purse. It seems that John Thomas was raving and did not recognize his surroundings. His family did not know what to do with him. John James wanted him to be at home. He could not bear the thought of his father being committed to an asylum: 'If there be any possibility of the disease subsiding or if his intervals of reason are frequent I cannot endure the thought of his being altogether among strangers . . .'.[11] It was a tenderness that other members of the Ruskin family, sixty years later, would extend to his own son. Yet it was of a necessity compassion at a distance, and it was given to Margaret to nurse the man who had opposed her marriage. John Thomas did not fully recover, and was never able to carry on business again.

Two years after this breakdown, the whole family was broken by a series of deaths. In September 1817 old Mrs Cock of the King's Head

died in Croydon. Margaret travelled south for the funeral. She had not
been there long when the news came that Catherine Ruskin had died of
apoplexy. John James went up to Edinburgh with Margaret to attend
his mother's funeral, then returned to London. He left his fiancée,
stunned by the deaths of her mother and her aunt, with a horror to
face. Ten days later John Thomas Ruskin committed suicide. Mar-
garet Cox was alone in the house with him: most accounts agree that
he cut his throat.

<p style="text-align:center">★ ★ ★ ★</p>

Three months later, as soon as was decently possible after such
bereavements, John James and Margaret were married in Perth. There
were no celebrations. Margaret had come to loathe the house at
Bowerswell, as well she might. She wanted to leave Scotland as
quickly and as quietly as possible. She never would re-enter Bowers-
well, the house in which she had known so much unhappiness, not
even when her own son was married there thirty years later. Margaret
Ruskin was not a young wife. She was thirty-seven when she wed: she
had waited long and suffered much. Nor were John James's financial
troubles now over. John Thomas left debts of £5,000 behind him,
money that would not be finally paid off for another ten years. But
John James had bought and furnished a comfortable house for his
bride. No. 54 Hunter Street, Brunswick Square, was a solid bourgeois
building. It was part of a fairly recently built terrace. Each house had
three storeys as well as an attic and a basement. There were areas in
front and small gardens behind. In this house, quite near to Gray's Inn
and the British Museum, near the open spaces in front of the Found-
ling Hospital, their only son was born on 8 February 1819.

 John Ruskin remembered little of the Hunter Street house, and
never revisited it in adult life. *Præterita* recalls the excitement of a very
small boy watching the dustmen and coalmen. One London view
stayed with him always, 'of a marvellous iron post, out of which the
water carts were filled through beautiful little trap-doors, by pipes like
boa-constrictors'.[12] He was less than five years old when the Ruskins
moved from Hunter Street to a house outside London. This move
accompanied not so much a change in status as a desire for a different
domestic life. No. 26 Herne Hill, the Ruskins's home for the next
nineteen years, was bought on a 63-year lease for £2,192. Four miles
from 'the Standard in Cornhill',[13] the old coaching station from which
distances from the capital were measured, it was a semi-detached

3. 54 Hunter Street, Brunswick Square, where John Ruskin was born in
1819. Photograph c.1950.

house of three storeys and a garret. Herne Hill is in fact part of the Norwood Hills, a ridge of the North Surrey Downs. This wooded country was watered by two streams forever dear to Ruskin, the Wandle and the Effra. From John James's new house, one of a group of four right at the top of the hill, one could see to St Paul's, to sailing boats on the Thames at Greenwich, to Harrow in the north and to Windsor Castle in the west. Below the hill were the rural villages of Walworth and Dulwich. The house itself was comfortable. Margaret Ruskin took most delight in the gardens. Ruskin recalled how she tended the lilac and laburnum at the front gate. At the back of the house she had the best pear and apple trees in the neighbourhood. The orchard was seventy yards long, a whole world to the small child who followed his mother while she planted and pruned, plucked the peaches and nectarines, and in the spring gathered almond blossoms, the first flowers after the snowdrops.

In this house Margaret Ruskin had the happiness of youth when she was forty. The long years of loneliness and waiting, the madness and the deaths, could all be forgotten. All her life Margaret was silent about those years. She had earned her happiness and there was no reason why she should dwell on the way in which she had earned it. She delighted in her child and in running her own home: she delighted in her love for her husband. The family letters from Herne Hill, written while John James was away collecting orders, seem often to be the messages of lovers twenty years younger than themselves: 'at night I go to bed saying tomorrow I shall hear from my beloved I rise in the morning rejoicing that I shall soon have your letter the rest of the day I delight myself with reading it and the thoughts of it . . .', writes Margaret to her husband.[14] Their intimate affection grew within the years of their marriage. Ten years after their wedding, twenty years after their engagement, John James is writing,

My Dear my Lovely Margaret how do you contrive to inspire me with unfading Love to light up flames of passion that neither age nor familiarity can extinguish. I see you forever as young as sweet & oh I think each year still sweeter, decked anew in some fresh Beauty, in some new graces to hold me to charm me to stir my very soul with fiercer and warmer Emotions to make me think I am come into possession of some newly discovered Treasure. Such is the power of Innocence of pure womanly love & affection as they exist and adorn the sweetest the gentlest the most feminine of her Sex. If I began to love coldly I have come to love warmly & to feel every year something added to the force of my love & my admiration . . .[15]

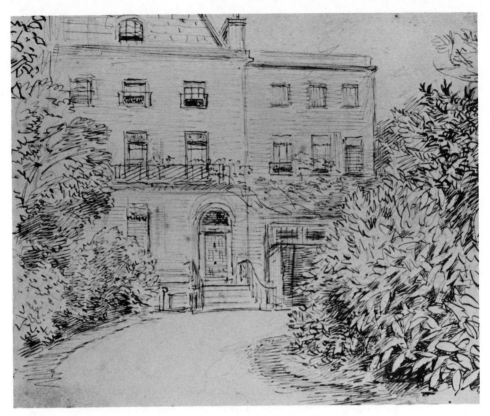

4. 27 Herne Hill, Ruskin's home in south London, 1823-42.

There are thousands of Ruskin family letters, since it was the Ruskins's habit to write every day when separated from any member of the family. John James was often away from home selling sherry, his firm's speciality, and other wines. He acted as his own salesman and as the only traveller for the firm. He would have no business with agents, but took all responsibilities on his own shoulders. This he continued long after he could have deputed work. John James had not come to the firm with capital, as Telford had with his bonds and Domecq with his Macharnudo vineyard. He contributed unwearying drive. Every night, from the commercial room of the best inn or coaching house in the town, he wrote home to his wife. This correspondence consists mainly of love letters, with talk about their son. There is little about the wine trade, and the part of the business John James must have hated: the deference to customers, the bonhomous negotiations with hoteliers and landlords, the long coach trips and the company he did not wish to keep.

John James was usually on the road for a fortnight to three weeks. Some of his itineraries can be reconstructed from the letters. In 1822, for instance, staying for one night in most places but for two or three in the cities, he went from Stamford to Newark, Leeds, Bradford, Kendal, Liverpool, Chester, Manchester, Warwick, Coventry, Leicester, Huntingdon, and thence back to London. This kind of tour did not change as the firm prospered. Fourteen years later his schedule was just as demanding. On 15 December 1836, he wrote to Margaret from Ipswich. In the next few days he was in Norwich and Yarmouth, returned to Norwich, then went on to King's Lynn. On Christmas Day he was in Lincoln — the Ruskins, being Scottish, did not celebrate Christmas — and on Boxing Day in Leeds. After that he visited Rochdale, Liverpool — staying at a hotel he detested, the Adelphi — Manchester and Birmingham. Again, the last of the sequence of letters is from Huntingdon, before reaching London and the 'head of all my possessions and heart of all my joys'.[16]

This hard-working, loving, rather proud man, stern but romantic, returned to Herne Hill from these exhausting trips, or from the long routine of the counting house, as one returns to peace, to order and love. Dinner was at half-past four, always. In summer the Ruskins took tea in the evening under the cherry tree, or in the parlour in winter, and John James would read aloud from Shakespeare, or Pope's *Iliad,* or his favourite Dr Johnson, or *Don Quixote*; classical books that were supplemented by the romantic poets of the day, in particular Byron and Scott.

A pillar of the household was Anne Strachan, young John's nurse, who had come from Bowerswell with the newly married couple and remained in their service all her life. She was a sharp-tongued, difficult person whom John Ruskin adored. Her endless disputes with Margaret Ruskin, about anything, were an accepted part of Herne Hill life, sometimes to the surprise of visitors. Perhaps she and Margaret quarrelled a little over John. Anne was a spinster; Margaret Ruskin, deeply attached to the son she had been lucky to bear at her age, spent more time with her child than was common in a similar 1820s household. Margaret would do anything for him, but she was totally unyielding in matters of right and wrong. She wrote to his father,

Were he Son to a King, more care could not be taken of him and he every day gives proof of possessing quickness memory and observation not quite common at his age with this however I fear he will be very self willed and passionate — he has twice alarmed me a good deal by getting into such a passion that I feared he would have

thrown himself into a fit this will I trust be cured by a good whipping when he can understand what it is for properly.[17]

Such disciplines were probably exaggerated in *Præterita*. Certainly Ruskin's claim in his autobiography that he lacked toys is incorrect. *Præterita*, or rather *Fors,* called the Herne Hill garden an Eden where '*all* the fruit was forbidden'.[18] This was not so. John Ruskin had toys, a rocking-horse, dogs, a pony, all the books and drawing materials he could wish for. *Præterita* is correct, however, to insist on the importance of the Bible in Ruskin's young life. Herne Hill was a paradise where Scripture was read every day. The Bible, Margaret's great solace in the years of her unhappiness, became the first principle of her son's serene childhood. Through it, he was taught to read and to remember. When John was three, his mother wrote, 'we get on very well with our reading he knows all the commandments but the second perfectly and the Lords prayer his memory astonishes me and his understanding too'.[19] This biblical teaching informs all Ruskin's later writing. The volumes themselves are familiar to the student of Ruskin. First of all was the old family Bible of the English Ruskin family, inscribed with the dates and hours of all their births, from John's great-grandfather's 'John Ruskin, Baptised Aprill 9th 1732 O.S.', to all his children and grandchildren; then the Baskett Bible of 1741 in which John James wrote his own birth and baptismal dates; and the Edinburgh Bible of 1816, which Ruskin opened when writing *Præterita* — noting then how the eighth chapter of first Kings and the thirty-second of Deuteronomy were worn dark, for they were his mother's favourite reading.[20] He learnt from this volume every morning, when his mother took out her own Bible from its silk bag with purple strings to begin the day and the day's learning.[21] Every single day of every week, from the time he began to read until he left home to go up to Oxford, Ruskin read two or three chapters a day with his mother and learnt some verses by heart. He wrote,

> She began with the first verse of Genesis, and went straight through, to the last verse of the Apocalypse; hard names, numbers, Levitical law, and all; and began again at Genesis the next day. If a name was hard, the better the exercise in pronunciation, — if a chapter was tiresome, the better lesson in patience, — if loathsome, the better lesson in faith that there was some use in its being so outspoken.[22]

In these morning sessions Ruskin also learnt by heart the Scottish paraphrases, the psalms rendered into eighteenth-century verse that

were the hymns of the Church of Scotland. He learnt to speak them resonantly and rhythmically, giving as much attention to meaning as he would when reading from Scripture. Some literature seemed also sacred to the childish Ruskin. In *Præterita*, recalling that Walter Scott's Waverley novels were 'a chief source of delight' and that he could 'no more recollect the time when I did not know them than when I did not know the Bible', Ruskin nonetheless felt it right 'with deeper gratitude to chronicle what I owe to my mother for the resolutely consistent lessons which so exercised me in the Scriptures as to have made every word of them familiar to my ear in habitual music'.[23]

Contemporary romance and the Bible could co-exist. So could assiduous attendance at church and a cheerful home life. Letter after letter speaks of the high spirits and the happiness of Ruskin's childhood. An early one came about because John was full of things to say to his father and pretended to write them on his slate. Margaret invited him to dictate what he could hardly write: only the signature is in his hand:

My Dear Papa I love you — I have got new things Waterloo Bridge — Aunt brought me it — John and Aunt helped to put it up but the pillars they did not put right upside down instead of a book bring me a whip coloured red and black which my fingers used to stick to and which I pulled off and pulled down — tomorrow is sabbath tuesday I go to Croydon on Monday I go to Chelsea papa loves me as well as Mama does and Mama loves me as well as papa does — I am going to take my boats and my ship to Croydon I'll sail them in the Pond near the Burn which the Bridge is over I will be very glad to see my cousins I was very happy when I saw Aunt come from Croydon — I love Mrs Gray and I love Mr Gray — I would like you to come home and my kiss and my love JOHN RUSKIN.[24]

This Richard Gray and his wife Mary were a Scottish couple who lived not far away in Camberwell Grove. Richard Gray was also a wine merchant. Without children of their own, the Grays enjoyed spoiling young John Ruskin. The cousins in Croydon mentioned in the letter were of another Richardson family, for Margaret's sister Bridget had married a baker of that name. They all lived over the shop in Croydon High Street. For the four boys and two girls who were the Richardson children Ruskin had 'a kind of brotherly, rather than cousinly, affection'.[25] In his early years they were much together. On at least one occasion Margaret expressed a fear that their rougher ways might be bad for John, but this does not seem to have become an issue. The Ruskins were not over-troubled by questions of social class.

Præterita gives a quite misleading picture of people living 'magnifi-cently' on Herne Hill, giving splendid receptions, attended by coach-men in wigs. His parents, Ruskin claimed, could not enter such society because of their plainness and thrift: his father would not 'join entertainments for which he could give no like return, and my mother did not like to leave her card on foot at the doors of ladies who dashed up to hers in their barouche . . .'.[26] This is nonsense: there was no such society on Herne Hill. The visitors who did come to Herne Hill were numerous, and they were more interesting. John James's diaries show that he entertained practically every night, including Sundays. His friends and social circle we shall shortly examine. For the moment we can think of the Croydon Richardsons, who might come up to borrow the pony; friends of Margaret's who would have tea and play with her precocious, talkative son; a number of Scottish people; and friends who shared John James's literary and artistic tastes and belonged to the fringes of the literary world. They were the ones who would take up John Ruskin when he was fourteen or fifteen and introduce him to the excitement of meeting literary men and writing for publication.

Ruskin did not go to school until he was fourteen, and to this extent his childhood was sheltered. But there was no want of instruction. He had his mother's lessons, his father's reading and his own curiosity. From the age of ten he had tutors. He learnt to read and write early on. He copied maps and read the standard children's authors. He began Latin, at first with Margaret and then with John James, who often corrected his exercises by letter. There was much respect for learning in this Scottish household. John James was concerned for his own self-improvement. He had been denied the opportunity for study in his youth, and he wished to make up for it in his independence. In only a few years' time, his own reading and his son's would often coincide as they discovered books together. In the early '30s (as we may discover from his accounts) John James was buying such books for family use as Lindley Murray's *English Grammar*, a Hebrew grammar and a Greek grammar (the Ruskins used Dr Adam's Latin one, kept from Royal High School days). John Burke's *General and Heraldic Dictionary of the Peerage* was bought, along with works by Tacitus, Homer, Cicero, Cæsar and Livy. There was a Homer done into French, Chateaubriand (that was rather daring), and *Anecdotes of the Court of France*. John James bought a set of Scott's novels, Dr Johnson's *Dictionary*, and his *Lives of the Poets*. He subscribed to *Blackwood's Edinburgh Magazine* and every year bought a number of annuals. Maria Edgeworth's novels were there, and Bulwer Lytton's *Last Days of Pompeii*. The radical Hazlitt (whose lectures John James might have heard) was in this library, and so was Byron.[27]

Such books were the staple of Ruskin's childhood reading. We shall hear of many others, lesser known today, such as Bernardin de Saint-Pierre's *Paul et Virginie,* which had a minor effect on his later writing. The literary atmosphere of the Herne Hill parlour was felt through all Ruskin's life, for he felt that books given to him by his parents were peculiarly authoritative. John James was determined that his son would not enter trade and Margaret mentally dedicated her child to God, and wished that he might have an ecclesiastical career. They absorbed themselves in literature because they enjoyed it. Nonetheless, the cultivation of John's evident intellect and talents was somewhat forced. John James occasionally recognized that there was absurdity in the way he encouraged his son to great things, but that did not deter him from letters such as this:

> . . . the Latin being somewhat difficult I am astonished at your understanding it so well & writing so like a Classic Author. You are blessed with a fine Capacity & even Genius & you owe it as a Duty to the author of your Being & the giver of your Talents to cultivate your powers & to use them in his Service & for the benefit of your fellow Creatures. You may be doomed to enlighten a People by your Wisdom & to adorn an age by your learning. It would be sinful in you to let the powers of your mind lie dormant through idleness or want of perseverance when they may at your maturity aid the cause of Truth and Religion & enable you to become in some ways a Benefactor of the Human Race. I am forced to smile when I figure to myself the very little Gentleman to whom I am addressing such language . . .[28]

In fact, the 'little gentleman', ten years old when he received this communication (and there were others like it), was scarcely in need of encouragement. In this same year he wrote to John James,

> I do believe that the last year of my life was the happiest: and shall I tell you why? Because I had more to do than I could do without cramming and cramming, and wishing days were longer and sheets of paper broader . . . I do think, indeed I am sure, that in common things it is having too much to do which constitutes happiness, and too little, unhappiness.[29]

This now reads as a prophetic remark. All his life Ruskin felt that time was wasted, and worse than wasted, if any day had not been used for study. At the unhappiest times of his life he worked the harder, often then returning to those subjects which had brought him joy in childhood. Foremost among these was geology. Ruskin's lifelong dedica-

tion to the analysis of the materials of the earth began at about this time. John James was fond of saying that his son had been an artist from childhood but a geologist from his infancy.[30] He encouraged and perhaps initiated John's hobby when he brought home a collection of fifty minerals bought for five shillings from a local geologist in the Lake District. 'No subsequent passion had had so much influence on my life', Ruskin wrote in *Deucalion,* his collection of geological studies.[31] These golden pieces of copper ore from Coniston and garnets from Borrowdale were the more exciting in that they came from the romantic Lakes. But, like the cheap Bristol diamonds (transparent rock-crystal found in Clifton limestone) which John James brought from that centre of the wine trade, Ruskin valued his stones first of all for their visual particularity, for the way that they needed to be closely examined, pored over. They appealed to that love of detail which was so marked a feature of his visual sense. He liked to see how small, bright things stood against a background. On a family holiday in Matlock he was struck by the New Bath Hotel and

... the glittering white broken spar, speckled with galena, by which the walks of the hotel were made bright, and in the shops of the pretty village, and in many a happy walk along its cliffs, I pursued my mineralogical studies of fluor, calcite and the ores of lead, with indescribable rapture . . .[32]

Ruskin began a mineralogical dictionary at the age of twelve. His first boyhood ambition was to become, as the famous Charles Lyell then was, the President of the Geological Society. In four or five years' time Ruskin progressed from making collections and classifications: he began to study the broader aspects of geology, its feeling for the great sweep and variety of the earth and its questioning of universal history. It led him early to intellectual life. He was attending meetings of the Geological Society, in those days a most animated institution, before he went to university.

<p style="text-align:center">★ ★ ★ ★</p>

In 1828 there was an addition to the small Ruskin family. For some time Margaret and John James had been thinking of having John's cousin Mary Richardson, of the Perth Richardsons, to come to live with them after the death of her mother Jessie. It was a sad time. Jessie had been a comfort to Margaret in her years of exile. John had loved the visits he made as a little boy to the Richardsons' house by the Tay where the river ran just outside the back door, swift and sparkling, 'an

infinite thing for a child to look into'.[33] John James wept bitterly at the thought of his sister's wasted life. But he now acted swiftly and generously to help the family. He settled one of the sons in business, gave money to the other two and brought Mary into his own home. She lived with the Ruskins until 1848 when, like John, she married. Mary was fourteen when she came to Herne Hill; from that time on John Ruskin had in effect an elder sister. They did not grow closer together as the years passed, but that was not through any lack of affection. In childhood they shared everything, from the Bible reading and drawing instruction to shared projects, expeditions and holidays. If John was the cleverer by far, Mary had four years' advantage of him. All in all, they made a contented pair. John James could not be as proud of Mary as he was of John, but he wrote to a friend, 'Mary Richardson is another treasure . . . she has an excellent understanding, & is really pious and withall possesses a Spirit & a naivete a Joyousness combined with the most perfect Innocence that makes her all we could desire.'[34] On Mary the Ruskins lavished the tuition that Perth had been unable to provide. With private tutors and at a day school in the neighbour-hood she studied music, drawing, French, geography, dancing, writ-ing, arithmetic and Italian.

A great event in the Ruskin family was the annual summer tour, wonderful holidays that opened vistas of exploration and romance. In a carriage lent them by Henry Telford, and later in one that they hired, the Ruskins toured all the parts of the British Isles that were pictur-esque or had literary associations. They went to Scotland, where they stayed at the Richardsons', in 1824, 1826 and 1827; to Wales in 1831; to the west of England in 1828; to Derbyshire in 1829, and to the Lake District in 1824, 1826 and 1830. Usually they set off after a ritual family feast, John James's birthday on 10 May, and were often touring for a matter of months rather than weeks, especially when their tours were extended to the Continent. 'I saw all of the high-roads, and most of the cross ones, of England and Wales,' Ruskin claimed.[35]

The Lake District, where he was to live after his parents' deaths, was from the first particularly dear to Ruskin. His earliest real memory was of being lifted up by his nurse Anne Strachan on Friar's Crag above Derwentwater. That was in 1824. In 1830 the Ruskins decided to make an extended stay in the Lakes. In the party were the three Ruskins, Mary Richardson and Anne. It took them five weeks to reach Kendal from Herne Hill, since they stayed in Oxford for a little while, lingered in the Midlands and made a detour to Manchester so that John James could do some business. Once among the Lakes they made excursions from the Low Wood Inn at Windermere and the Royal Oak

at Keswick. John and Mary collaborated on a journal of the tour. One entry is of especial interest. It is one of the very few times that Wordsworth is mentioned in the early years of Ruskin's life.

> We went to Rydal Chapel in preference to Ambleside as we had heard that Mr Wordsworth went to Rydal . . . We were in luck in procuring a seat very near to that of Mr Wordsworth, there being only one between it, & the one that we were in. We were rather disappointed in this gentleman's appearance especially as he seemed to be asleep the greater part of the time. He seemed about 60. This gentleman possesses a long face and a large nose with a moderate assortment of grey hairs and 2 small grey eyes . . .[36]

From this journal, in the months after the tour, the un-Wordsworthian John wrote a poem entitled *Iteriad, or Three Weeks among the Lakes.* It contains 2,310 lines in rapid rhymed couplets and is a remarkable production for a boy of eleven. It is doggerel, of course; but a doggerel that nicely recaptures the excitement of Ruskin's picturesque explorations.

It was in 1829 that the Ruskins decided to find their son a tutor. John Rowbotham, who ran a little school near the Elephant and Castle and wrote simple textbooks, came to Herne Hill twice a week to teach him mathematics. A more important teacher was the Reverend Edward Andrews. The Ruskins worshipped in his church, the Beresford Chapel, Walworth. We must now consider the Ruskins's religious background. They gave their religious (though not necessarily their political) allegiance to the Evangelical party of the day. They appreciated Evangelicalism's fervour, its insistence on the authority of the Scriptures, its stress on salvation in the atoning death of Christ, its belief in the importance of preaching and its lack of interest in liturgical worship. Since the Ruskins believed in the inspiration of Scripture they tended to be suspicious of authority within the Church. They were openly hostile to Roman Catholicism and high church practices and doctrines. To some extent, their religion was formed by their Scottishness. John James's mother, we recall, was a daughter of the manse. Her minister father and other relatives were from Galloway, where there was a strong covenanting tradition: the National Covenant of the Scottish Presbyterians of 1638 was still real to the Tweeddales. The Ruskins (and Anne Strachan) had respect for this heritage but were not bound to it. They were not rigid in religious matters, though Margaret was more conservative than was John James. Between their removal from Scotland to London and John Ruskin's matriculation at Oxford we may observe a number of shifts of

allegiance. To place their son at the centre of the Anglican establish-
ment, Christ Church, and to hope that he might become a bishop, was
hardly to adhere to the Church of Scotland. No doubt the Ruskins
changed their churches and their views in accordance with their own
elevation in the English social scale. But this is to over-simplify, and
ignores the effect of the peculiar ministers to whom they were
attached.

Some of these matters became obscure in later years. The matter of
the Ruskins's first London church is a case in point. Where did they
worship when they lived in Hunter Street? We know that John was
baptized in the Caledonian Chapel, Hatton Garden, by a bilingual
minister who preached in both Gaelic and English. Only a little
afterwards this chapel became famous and fashionable, for it was here
that Edward Irving, Carlyle's friend, arrived from Scotland in 1821
and immediately became the most celebrated preacher in London. But
the Ruskins did not attend his services.[37] *Præterita* speaks of 'The Rev.
Mr Howell', whose preaching was imitated by the infant Ruskin. This
mystified Ruskin's editors. They were unable to identify him because
Ruskin had forgotten his real name. The Reverend William Howels,
minister of the Episcopal Chapel, Long Acre (which was not very far
from Hunter Street) was a Welshman. A contemporary description of
Howels as a man 'of extraordinary inability & not a little eccentricity'
is typical of much that was said of him at the time.[38] His preaching
style was apparently ludicrous: perhaps this is why Ruskin's infant
sermon in imitation of him, 'People, be good', was 'a performance
being always called for by my mother's dearest friends'.[39] It is less
surprising that the Ruskins should have been attending a chapel within
the Church of England than that they should be sitting under a
laughing stock. Be that as it may, it is worth considering that they
preferred not to go to the Scottish revivalist sermons, with their
emphasis on conversion, that Irving was currently giving at the
Caledonian Chapel.

Edward Andrews, John Ruskin's first tutor, was an Evangelical
Congregationalist. He may also have been a fabulator. He was famous
for his ornate sermons, his energy, and his ambition.[40] He was
described, not very flatteringly, as 'a sort of Pope' among his co-
religionists. His position was apparently symbolized by his chapel in
Beresford Street. Ruskin's recollection was this:

> Dr Andrews' was the Londinian chapel in its perfect type, definable
> as accurately as a Roman basilica, — an oblong, flat-ceilinged barn,
> lighted by windows with semi-circular heads, brick-arched, filled

by small-paned glass held by iron bars, like fine threaded halves of
cobwebs; galleries propped up on iron pipes, up both sides; pews,
well shut in, each of them, by partitions of plain deal, and neatly
brass-latched deal doors, filling the barn floor, all but its two lateral
straw-matted passages; pulpit, sublimely isolated, central from
sides and clear of altar rails at end; a stout, four-legged box of
grained wainscot, high as the level of front galleries, and decorated
with a cushion of crimson velvet, padded six inches thick, with gold
tassels at the corners . . .[41]

This is accurate but satirical, and Ruskin does not mention that this
memorial to suburban Congregationalism was more expensive than
most of its type. Its cost led to Andrews's embarrassment, and nearly
his downfall. He himself had put up some of the money to pay for it,
but much more had been borrowed on a mortgage. This meant debts
which could not be paid. Andrews finally had the humiliating experi-
ence of having his church doors shut against him by the mortgagee.
He had to welcome his flock in the assembly room of a nearby public
house, the Montpelier Tavern. This disaster occurred after the Rus-
kins had left the Beresford Chapel for a more established church. But
they had known for some time that Andrews was no grave and steady
pedagogue. One of Margaret's letters reports how the minister arrived
at the house, uninvited, at eight o'clock in the morning:

He came he said to ask me about Mrs Andrews state she had another
child about three weeks ago and has continued getting weaker ever
since . . . he gave me a long acct. of her complaints in the hope I am
certain that I should say there was no chance of her living long the
Drs say there is no hope of her he also enlarged much on the torment
she had been to him for the last ten years . . . I think the Dr has
wonderful talents the way he ran on while giving John a little
insight into the Hebrews on monday . . . but he is certainly flighty
not to say more and in many respects his habits manner of conduct-
ing his secular affairs tho' with the best and kindest intentions must
to any woman with so numerous a family have caused much serious
and distressing apprehension . . .[42]

Although the elder Ruskins spoke of Andrews's 'unwise indulgence
of every caprice' they evidently did not consider him too little sedate to
be their son's tutor.[43] They thought he had brilliance in him, and liked
his popularity and energy. Crowds came to his sermons, and he
toured his parish at a run. He had advanced views about women's
education: he favoured the sort of liberal instruction that Mary was

now receiving. The children of both families were friends. One of Andrews's daughters, Emily, was to marry Coventry Patmore and become the model for *The Angel in the House*: this was the family connection through which Ruskin was first to be introduced, by Patmore, to the Pre-Raphaelite Brotherhood. Emily and John went blackberrying in the summer when the latter was first taught by Andrews. He evidently was delighted with her, his tutor, and his tutor's sermons. He wrote to John James:

> Dr Andrews delivered such a beautiful sermon yesterday I never heard him preach one like it we were putting it down as well as we can for you to look at when we come home We that is Mary and I were so delighted with the sermon that we went out on a hunt for Dr Andrews . . .[44]

The summaries of the sermons that John and Mary made are preserved in some nine notebooks. Although they were often the work of Sunday afternoons in Herne Hill, they were not imposed on the children, and Ruskin says that he was eager to 'show how well' he could record the addresses.[45]

The Ruskins's Sunday indicates that they had abandoned the strict Sabbatarianism of Scotland. They went to church only once on the sabbath and there was no family worship at home. As so often, *Præterita* is slightly contradictory and tends to exaggeration. Ruskin wrote that 'the horror of Sunday used to cast its prescient gloom as far back in the week as Friday'.[46] But elsewhere in the autobiography he was eager to point out that his mother was not like Esther's religious aunt in *Bleak House,* who 'went to church three times every Sunday, and to morning prayers on Wednesdays and Fridays, and to lectures whenever there were lectures; and . . . she never smiled'.[47] John James invited friends to supper on Sunday evenings. The reading was devotional— Bunyan's *Pilgrim's Progress* and *Holy War,* Quarles's *Emblems,* Foxe's *Book of Martyrs,* and Mrs Sherwood's *Lady of the Manor* (borrowed no doubt from Mary), 'a very awful book to me, because of the stories in it of wicked girls who had gone to balls, dying immediately after of fever' — but that was hardly exceptional in a middle-class household of the day.[48]

<p align="center">★ ★ ★ ★</p>

When John Ruskin reached the age of twelve his parents decided that he should be introduced to some more adult interests. A child of the early nineteenth century, in a house like the Ruskins's, would not

normally dine with its parents; but on special days young John would now be allowed out of the nursery — his own room at the top of the house, which was kept for him until 1889 — to sit with John James and Margaret. At these meals, John James would read aloud from 'any otherwise suspected delight', literature that was not really for children.[49] A favourite was Christopher North's *Noctes Ambrosianæ*, then appearing in *Blackwood's Magazine*. This robustly tory column, full of coarse wit and savagery, John James read 'without the least missing of the naughty words'. More important than the *Noctes* was the enthusiasm for Byron. John James was passionately fond of his poetry. It is a mark of the independence of his taste that it did not notice any religious prohibitions. In many a home like the Ruskins's, this radical and libertine would have been prohibited. But John Ruskin soon came to know most of Byron. Margaret Ruskin made no objection. *Præterita* goes so far as to associate a shocking feature of Byron's life with Margaret Ruskin's literary tastes. Ruskin is discussing La Fornarina, Byron's mistress, the illiterate wife of a baker. Margaret Ruskin, he said 'had sympathy with every passion, as well as every virtue, of true womanhood; and, in her heart of hearts, perhaps liked the real Margherita Gogni quite as well as the ideal wife of Faliero'.[50] Twenty years later, in her sixties, Margaret would be an enthusiastic reader of Elizabeth Browning's 'Aurora Leigh'. She was not a prude, and in some respects she was a liberal mother.

At this time John Ruskin was first allowed to take wine and to accompany his father to the theatre. John James, a boy actor when at school, loved any kind of dramatic spectacle. His letters often reminisce about theatrical experiences: such things as

> . . . my first play — the *Fashionable Lover* & first afterpiece the *Maid of the Oaks* — I have never seen real Oaks with the pleasure I had in the painted Oaks in that piece. Then for greater excitement we had Lewis's *Castle Spectre* for which I waited an hour before the doors opened . . . Kemble was heroic in voice & person — but a few words of Mrs Siddons Lady Macbeth & Keans Othello dwell in my memory for ever . . .[51]

Margaret Ruskin would not go to the theatre herself, but although she thought that he ought not to contribute to theatrical charities, her husband's reactions were not a matter of contention. Nor did she object to her son being introduced to such pleasures. Ruskin was ever afterwards a lover of the popular theatre.

The freedom to enjoy the romance and excitement of contemporary literature was willingly granted to Ruskin in his boyhood. John James

also indulged his son's taste in art, such as it then was. The elder Ruskin had kept up the artistic interest he once had when at school. He now, in 1831, readily agreed that John should follow Mary Richardson in taking drawing lessons. Ruskin's first instruction in art came from Charles Runciman. He was not a particularly good artist but was competent to show young people the elements of formulaic watercolour landscape. John Ruskin enjoyed these lessons and was good at them. With or without Runciman's encouragement, he soon felt the eagerness to make art as a splendid construct out of his paint box.

> I must say I was delighted when [Runciman] inquired for my colour box, and that not merely for the purpose of splashing colours over paper, but because I think that there is a power in painting, whether oil or water that drawing is not possessed of, drawing does well for near scenes, analyses of foliage, or large trees, but not for distance, or bare & wild scenery, how much superior painting would be, if I wanted to carry off Derwent Water, & Skiddaw in my pocket, or Ulles Water, & Helvellyn, or Windermere, & Low Wood, Oh if I could paint well before we went to Dover I should have such sea pieces, taken from our windows, such castles & cliffs — hanging over the ocean, And ships on those waters, in heaving commotion. There would be a night scene, with the waters in all the richness, of Prussian blue & bright green, having their mighty billows created, with Reeves best white, & the sky above, a very heaven of indigo, with the moon, & attendant stars pouring their bright rays upon the golden waters, in all the glory of Gamboge, with the moon shining out over the waters of Dover.[52]

★　　★　　★　　★

In 1832 John James's partner Henry Telford gave John a copy of Samuel Rogers's *Italy* for his thirteenth-birthday present. Rogers's poem is not now much read, but became greatly popular in its day. John James already had a copy in the house: the significance of this new book, the edition of 1830, was that it contained illustrations. They were vignette engravings after Prout, Stothard and, most of all, Turner. Rogers's first works had been published in the 1780s: his best-known poem, *The Pleasures of Memory*, is of 1792. *Italy*, whose first part was issued in 1822, its second in 1828, is in some ways a Byronic poem, though evidently the production of an older man. The 1830 edition, by virtue of its illustrations, has a place in the enlargement of the picturesque tradition that developed after the Napoleonic

wars. The picturesque mode became less provincial, less conventional. Turner's imagination and new standards of naturalism were important in this change. In literature, the picturesque tourist who visited familiar sites was replaced by a traveller in search of personal fulfilment. This image was most potent in the third and fourth cantos of Byron's *Childe Harold*. Ruskin was slightly too young in 1832 to appreciate a connection between Byron and Turner; he had never yet been to the Royal Academy, and so did not see Turner's *Childe Harold's Pilgrimage*, exhibited with a quotation from the fourth canto, when it was shown there three months after he had received Telford's present. But Turner's steel engravings in *Italy* fascinated him: and soon he would set out to find the actual sites from which the drawings had been made. Now, in the spring of 1833, he went with his father to a printseller's in the City to look at the specimen plates for Samuel Prout's *Sketches in Flanders and Germany*. John James subscribed, the book was brought to Herne Hill, the family looked at it together. It was Margaret Ruskin who suddenly suggested that their summer tour this year should follow Prout's route: why should they not go to see all these wonderful places themselves?

John James had taken them on a short trip abroad in 1825, to Paris and Brussels, with a visit to the field of Waterloo. This was to be a longer tour. Their route was from Dover to Calais, and thence to Strasbourg by following the Rhine. The detailed itinerary, the choice of hotels, payment for horses and the like along the road were made by a courier named Salvador. The Ruskins's routine was that they would breakfast early and start early, travelling forty or fifty miles a day. They would reach their destination in time for dinner at four o'clock. After dinner John and Mary would go exploring, sometimes with Anne Strachan, sometimes by themselves. They had tea at seven in the evening. John then spent two hours writing and drawing before bed. When they drove up to Schaffhausen, however, on the eve of one of the great visual experiences of Ruskin's life, this routine had been upset. They had arrived after dark, the next day went to church, and were occupied in the town until late afternoon. Ruskin wrote:

> It was drawing towards sunset, when we got up to some sort of garden promenade — west of the town, I believe; and high above the Rhine, so as to command the open country across it to the south and west. At which open country, far into blue, gazing as at one of our distances from Malvern of Worcestershire, or Dorking of Kent, — suddenly — behold — beyond!
>
> There was no thought in any of us for a moment of their being clouds. They were clear as crystal, sharp on the pure horizon sky,

and already tinged with rose by the sinking sun. Infinitely beyond all that we had ever thought or dreamed, — the seen walls of lost Eden could not have been more beautiful to us; nor more awful, round heaven, the walls of sacred Death . . . Thus, in perfect health of life and fire of heart, not wanting to be anything but the boy I was, not wanting to have anything more than I had; knowing of sorrow only just so much as to make life serious to me, not enough to slacken in the least its sinews; and with so much of science mixed with feeling as to make the sight of the Alps not only the revelation of the beauty of the Earth, but the opening of the first page of its volume, — I went down that evening from the garden-terrace at Schaffhausen with my destiny fixed in all of it that was to be sacred and useful . . .[53]

And this was so: Ruskin to the end of his days never ceased to study the Alps and to associate them with the broad principles of his teaching, even his political economy. The experience at Schaffhausen was as immediate as a revelation, and as subsequently haunting. As the family tour went on through Switzerland and to Italy, more and more of Ruskin's future work seems to be adumbrated. At the castle of Chillon, where Byron and Shelley had been before them, the Ruskins found Byron's name cut out by himself on a pillar. Salvador scratched out John's on the opposite side of the same pillar; and John James wrote in his diary that night, 'May he be the opposite of his lordship in everything but his genius and generosity.'[54] The Ruskins entered Italy by the most dramatic of passes, the Via Mala, and saw at Lake Como the very scene that Turner had illustrated in Rogers's *Italy*. They went on to Milan, then to Genoa and Turin; turned round, and entered the Alps again by the St Bernard Pass, thence driving to Vevey, Interlaken and Chamonix, the home of so much of Ruskin's mature work.

This rather odd party — how unlike the aristocratic youths who made the Grand Tour before them — travelled back to England through Paris. Here John first met the young woman to whom, soon enough, he would lose his heart. Pedro Domecq, John James's partner, was splendidly prosperous. He had inherited fine vineyards, his English business was successful, and so was his trade on the Continent. He proudly wore a royal crown over his arms, for in 1823 he had been appointed wine merchant to the king of Spain. The eldest of his five daughters, Diana, was engaged to be married to the Comte Maison, one of Napoleon's marshals. Domecq's other daughters, all much younger, were at home on holiday from their convent school. John Ruskin, at fourteen, was out of his depth. The adults were too sophisticated for him: at dinner the talk was of the recent death of

Bellini, whose *I Puritani* was then playing at the Italian Opera. His French was not as good as Mary's. He was a failure at the games the girls played: in '*la toilette de madame*' he had to impersonate parts of a woman's clothing. Dancing lessons that he had occasionally attended in Herne Hill disappeared from his mind when he was taken to the floor. The girls concluded that he was of no interest. All this was embarrassing enough. In two years' time, when he fell in love with Adèle-Clotilde, the second of the sisters, it would be torment.

★ ★ ★ ★

The Ruskins had left London in May and did not return to Herne Hill until late September. During the months they were abroad Ruskin had written constantly. He now began to write an account of the tour, illustrated by himself, in both prose and verse. Mary, previously his collaborator, was relegated to a copyist. Ruskin envisaged a finished work of 150 pieces of poetry and prose. He did not write as much as that, but his labours were prolonged. His prose, which relied on over-ornate models, was less successful than his verse.

> A low, hollow, melancholy echoing was heard issuing from the recesses of the mountains, the last sighing of the passing-away tempest, the last murmurs of the storm spirit as he yielded up his reign; it past away, and the blue rigidness of the transparent cavern of the glacier woke rosily to the departing sun.[55]

The poems are better. Often they imitate Walter Scott:

> Bosomed deep among the hills,
> Here old Rhine his current stills,
> Loitering the banks between,
> As if, enamoured of the scene,
> He had forgot his onward way,
> For a live-long summer day . . .
> — No marvel that the spell-bound Rhine,
> Like giant overcome with wine,
> Should *here* relax his angry frown,
> And, soothed to slumber, lay him down,
> Amid the vine-clad banks, that lave
> Their tresses in his placid wave.[56]

Ruskin was attempting to convert his experiences in Switzerland and Italy into the conventions established by the literature he knew. This was also the case with his art. His drawings are rather accomp-

lished. They imitate not so much Turner as steel engravings after Turner. Perhaps more important than these artistic experiments was a piece of scientific work. The tour produced his first published prose. It is entitled 'On the causes of the colour of the Rhine' and was to appear in September 1834 in *Loudon's Magazine of Natural History*.[57]

In the autumn after his first continental tour the ebullient Dr Andrews was replaced. John Ruskin started to go to school, walking down the hill to Dr Dale's small establishment in Grove Lane, Camberwell. Thomas Dale is sourly recalled in both *Fiction Fair and Foul* and *Præterita*, but these memories ignore Ruskin's debt to him. Dale had a hard mind and liked argument. While Andrews had been easy to please, Dale was a continual challenge to Ruskin. He disliked polite learning and believed in the moral force of literature. Dale was older than Andrews and further on in his career. In 1833 he was the incumbent of St Matthew's Chapel, Denmark Hill: he had been successively a curate at St Michael's, Cornhill, and St Bride's, Fleet Street, where he was to return as vicar in 1835. Dale had made a verse translation of Sophocles and had issued his own poems as well as more purely devotional books. He was a Cambridge man and was involved with the new foundation of the University of London. The wonder is that he bothered with such a school as the one in Grove Lane. Ruskin was not prepared for his reception on his first day there. He had taken Alexander Adam's Latin grammar with him

> . . . in a modest pride, expecting some encouragement and honour for the accuracy with which I could repeat, on demand, some hundred and sixty close-printed pages of it. But Mr Dale threw it back to me with a fierce bang upon his desk, saying (with accent and look of seven-times-heated scorn) 'That's a *Scotch* thing!'[58]

Ruskin attended, in the mornings only, the school run by 'my severest and chiefly antagonist master' from September 1833 to the spring of 1835, when he broke down with a severe attack of pleurisy. For the first time in his life he mixed with a number of other boys. He seems to have ignored his schoolfellows, or at any rate to have stood apart from them.[59]

> Finding me in all respects what boys could only look upon as an innocent, they treated me as I supposed they would have treated a girl; they neither thrashed nor chaffed me, — finding, indeed, from the first that chaff had no effect on me. Generally I did not understand it, nor in the least mind it if I did, the fountain of pure conceit in my own heart sustaining me serenely against all deprecation.[60]

However, some boys at Dale's school remained friends for years. There was Edward Matson, son of a Woolwich colonel who took them to see army exercises; Edmund Oldfield, interested in Gothic architecture, of which Ruskin knew nothing; and Henry Dart, a clever and literary young man whom Ruskin was to meet again at Oxford. His closest boyhood friend, however, was not at Dale's but at Shrewsbury. Richard Fall was the son of a Herne Hill neighbour. In the holidays he often spent the mornings in John's room at the top of the house, now known as his study rather than his nursery. In the afternoons the two boys would go out with their dogs, animals for which Ruskin had great fondness, now and thereafter. Richard was practical and good-humoured, some kind of capitalist in later life. He seems to have had a robust attitude to Ruskin's poetry. He 'laughed me inexorably out of writing bad English for rhyme's sake, or demonstrable nonsense either in prose or rhyme.'[61]

However, Ruskin's feelings that he had a poetic vocation was encouraged by many around him. John James carried his son's poetry with him as he went about his business. Richard Fall's mockery was a kind of encouragement. Thomas Dale, a poet himself, was more interested in English literature than in the classics. Now, in Ruskin's teens, the possibility of publication arose. Charles Richardson, the eldest of the Croydon cousins, was apprenticed in the publishing company of Smith, Elder. Charles used to come to lunch every Sunday, often bringing with him new books that his firm had published. Smith, Elder would have seemed an estimable firm to John James. He knew their offices in Fenchurch Street, just around the corner from his own premises. He knew that the successful business had been built up by ambitious, hard-working, cultivated young Scotsmen. George Smith came from Elgin, Alexander Elder from Banff. Smith, John James's near contemporary, had begun in publishing by working for John Murray: on one occasion he had delivered proofs to Byron himself. Smith, Elder had been founded in 1816. By the time that Charles Richardson came to them in the early '30s they had developed an interesting list and were vigorously promoting their books. They were especially proud of the quality of the steel engraving in expensive art books, views by Clarkson Stanfield, or 'the Byron Gallery'. Another speciality was the keepsake annual. These books appeared every autumn and contained verse, some short pieces of prose and a large number of engravings. They were popular Christmas presents, especially for women, and the phrase that was often used in advertising them, that they presented 'sentiment refined by taste', is a good indication of their style.

Smith, Elder's annual, *Friendship's Offering,* was edited by Thomas
Pringle. A superannuated poet, he had once mixed in the great Edin-
burgh circles of Scott and Lockhart but had been put out to grass after
the failure, for which he was responsible, of the first issues of *Black-
wood's Edinburgh Magazine.* Pringle it was who now in 1835 printed
Ruskin's verse. The young man was proud enough to have his poetry
in such a place as *Friendship's Offering.* Between 1835 and 1844 he
published some twenty-seven pieces in the annual, as well as con-
tributing to similar productions such as the *Amaranth*, the *Keepsake*,
and the *Book of Beauty*.

Pringle took Ruskin to visit Samuel Rogers at his home in St James's
Place, a signal honour. Ruskin was sufficiently inattentive to his
manners to warmly congratulate the poet on the quality of the illustra-
tion of *Italy*. This was a rudeness, for the accurate jibe against Rogers
was that the success of his poem, unnoticed when it appeared, was
solely due to the format in which its second edition was published. As
they left the breakfast party, Pringle warned Ruskin that he must be
more deferential to great men. Another acquaintance of Pringle (and
of Alexander Elder) was James Hogg, the 'Ettrick Shepherd', the
contributor to *Blackwood's* and friend of Scott. When Hogg made his
last visit to England he drove out to Herne Hill and was struck with
Ruskin's talents. A little later on, while writing to John James, he
enquired about the young poet's progress. The elder Ruskin replied in
a proud but guarded manner:

> I will venture to say that the youth you were kind enough to notice,
> gives promise of very considerable talent. His faculty of composi-
> tion is unbounded, without, however, any very strong indication
> of originality . . . I have seen productions of youth far superior, and
> of earlier date, but the rapidity of composition is to us (unlearned in
> the ways of the learned) quite wonderful. He is now between 14 and
> 15, and has indited thousands of lines. That I may not select, I send
> his last 80 or 100 lines, produced in one hour, while he waited for
> me in the city . . .[62]

Correspondence ensued, more verses were sent. Hogg wrote to
Ruskin with advice, told him that he was leaning heavily on Scott and
Byron, and invited him to come to stay in Scotland. The invitation
produced a peculiar response, one that says much for the self-
sufficiency of the Ruskin family:

> I cannot sufficiently thank you for your kind, your delightful
> invitation, one which it would have been such a pleasure, such an

honour for me to have accepted. Yet I cannot at this period make up
my mind to leave my parents even for a short time. Hitherto I have
scarcely left them for a day, and I wished to be with them as much as
possible, till it is necessary for me to go to the university . . . I love
Scotland, I love the sight and the thought of the blue hills, for
among them I have passed some of the happiest days of my short
life; and although those days have passed away like a summer-
cloud, and the beings which gave them their sweetness are in
Heaven, yet the very name of Scotland is sweet to me . . . But it is
best not to think of it, for as I before said, I do not wish to leave my
parents, and they are equally tenacious of me, and so I can do little
but thank you again, again, and thrice again . . .[63]

To refuse such an invitation from a famous poet was perhaps
over-reticent. But the literary ambitions of the young Ruskin were
well served by a kind of society that existed between Herne Hill and
the City of London. Its members were enthusiastically bookish,
though often connected with commerce. They were Scottish or Irish,
liberal in their interests but tory in every matter of principle. They
inclined towards the Evangelical party in the Church but they dis-
trusted enthusiasm. They opposed reform. They were bluff, hearty
and convivial. These are the people we find at John James's dinner
table, at parties which he might give three or four times a week. Here a
minor literary world mingled with friends in the wine business. These
backgrounds often overlapped. The Ruskins were good friends with
Mr and Mrs Robert Cockburn, the first of whom *Præterita* describes as
'primarily an old Edinburgh gentleman, and only by condescension a
wine-merchant'.[64] His wife was the Mary Duff of Lachin-y-Gair, a
distant cousin of Byron's and reputedly the first of his loves. Another
favourite guest was the Reverend George Croly. This Orange Irish-
man was renowned for his wit. John James thought him the most
amusing man he had ever known, and wrote of his contribution to one
party — at which the Cockburns were also present — 'Our table holds
only Ten else there was fun for thirty if we could have had them.'[65]
Croly was the rector of St Stephen's, Walbrook, in the City of Lon-
don. He was not known for his piety, but rather for the zeal with
which he held the ultra-Tory position that the constitution of 1688 was
perfect and that England was the 'fortress of Christianity'.[66] He also
had literary standing. He was a contributor to *Blackwood's Edinburgh
Magazine* and was the author of poetry, fiction and expensively illus-
trated travel books: these last were published by Smith, Elder. Croly
was of John James's age, and his poetry was now dated. In truth it had

never been very fresh, and its derivation from Byron had earned him a
derisive assault in *Don Juan*. [67] About this matter Croly cared not one
fig.

Although he never wished to admit it, Ruskin owed much to
Croly's belligerent opinions: they appear, for instance, in *The Stones of
Venice*. As he grew up, the clergyman's acquaintances were to expand
John Ruskin's knowledge of men of the world. This happened at an
earlier age than *Præterita* would lead us to believe. Through Croly
Ruskin met, for instance, Sir Robert Harry Inglis, an amateur of the
arts and steadfast Tory Member of Parliament for the University of
Oxford. Again through Croly, he touched the outside circle of those
raffish Orangemen who organized the Tory press of the 1830s. They
were people like William Maginn and Stanley Giffard, who had a
background in *Blackwood's* and whose political views were identical
with those of the Ruskins. Maginn had been a founder of *Fraser's
Magazine,* which was read with appreciation in Herne Hill. But he was
known for his intemperance and for his debts. Such a person could
never be acceptable at the Ruskins's table.

A tory *littérateur* who was acceptable, and admirably so, now
entered the family circle. After Thomas Pringle's death, Croly had a
hand in the succession of the editorship of *Friendship's Offering*. It went
to W. H. Harrison, who lived near to the Ruskins at Camberwell
Green. This conservative-minded man spent his time between com-
merce and letters. He worked for the Crown Life Office and was
registrar of the Royal Literary Fund. Now began a long-standing
literary relationship, for Harrison not only went through Ruskin's
poems with him, word for word, but looked after every detail of his
manuscripts and saw them into press until 1870. In 1878, after his
death, Ruskin wrote in 'My First Editor' an account of *Friendship's
Offering,* Harrison's 'Christmas bouquet', in which he would assemble

> . . . a little pastoral story, suppose, by Miss Mitford, a dramatic
> sketch by the Rev. George Croly, a few sonnets or impromptu
> stanzas to music by the gentlest lovers and maidens of his acquain-
> tance, and a legend of the Apennines or romance of the Pyrenees by
> some adventurous traveller who had penetrated into the recesses of
> these mountains, and would modify the traditions of the country to
> introduce a plate by Clarkson Stanfield or J. D. Harding . . .[68]

This was a slightly mocking description of the publication, for it was
written at a time when Ruskin was inclined to deride his own early
pretensions. He had forgotten, or chose to forget, how exciting those
pretensions once had been.

★ ★ ★ ★

The first poems that Pringle printed in *Friendship's Offering* were inspired by the tour the Ruskins made in the summer of 1835. In the next year their route was through France to Geneva and Chamonix. From Innsbruck they crossed the Stelvio to Venice, which Ruskin now saw for the first time. They were in Venice in October, then came home through Salzburg, Strasbourg and Paris, reaching London on 10 December. Since they had left England on 1 June this was more than a holiday. For Ruskin it was an extended period of pure delight, perhaps the most important of the early family tours and a model for those long sojourns on the Continent which produced so much of his writing.

Ruskin now began to keep a diary. It was a practice he continued for the next fifty-four years, until he could write no longer. One or two of these diaries were lost, and occasionally pages were cut out of them. But they exist almost in their entirety and in many ways are an invaluable record of Ruskin's personal and intellectual life.[69] They say less about his private feelings than do his letters: nor do they tell us more about his mind than do his published writings. But in them we can often trace the origins and progress of his books, or sense the various moods of determination, or boredom, or sometimes exhilaration, that belong to the solitary work of a writer. This first volume of the diaries was clearly bought to make a serious record of the travels of 1835. In its 172 pages (nicely bound in red leather) there is no mention of any other member of the family party. Ruskin's aims were scientific. They were mostly inspired by his fifteenth-birthday present. This had been Horace-Bénédict de Saussure's *Voyages dans les Alpes* (1779-96). The Swiss geologist had expanded Ruskin's interests into landscape. Before, he had collected stones. Now he was interested in the orographic, the study of whole mountain ranges. Ruskin was always to feel that de Saussure was a kindred spirit. He 'had gone to the Alps, as I desired to go myself, only to *look* at them, and describe them as they were, loving them heartily — loving them, the positive Alps, more than himself, or than science, or than any theories of science.'[70] The diary is nonetheless dry. It begins with the 'stiff white clay containing nodules of radiating pyrites' he found at the bottom of the cliffs of Dover;[71] notes the sandstone tract in which lies Fontainebleau and the limestone, quartz and ironstone at Bar-le-Duc. At Poligny he began to study how the Jura mountains rise from the plain; and in the Alps he makes notes on glaciers and snow. By the time the Ruskins reached Chamonix there are diary entries three thousand words long

describing mountain formations. These entries are accompanied by drawings and geological maps.

Another book carried on this tour contained a different form of expression. Ruskin was writing poems about what he saw. But he found his verse to be inadequate, too much bound to his stylistic models.

> I determined that the events and sentiments of this journey should be described in a poetic diary in the style of Don Juan, artfully combined with that of Childe Harold. Two cantos of this task were indeed finished — carrying me across France to Chamonix — where I broke down, finding that I had exhausted on the Jura all the descriptive terms at my disposal, and that none were left for the Alps.[72]

And so only 'Salzburg' and 'Fragments from a Metrical Journal' found their way into *Friendship's Offering*. The geological diary was sent whole to John James's friend J. C. Loudon to see if there was anything in it that might be extracted for his *Magazine of Natural History*. Loudon had already published Ruskin's short piece on the colour of the Rhine but seems not to have been attracted by the diary. He was nonetheless encouraging to his would-be contributor: he would print two long letters from Ruskin in 1836 and was soon to publish his first adult work, *The Poetry of Architecture*.

Ruskin's drawing became more interesting during this six-month stay on the Continent. Some sheets are scientific *aides-memoire,* or were meant to accompany putative geological articles; but others, especially of Unterseen, Fribourg and the Jungfrau are of artistic competence. A view of the Ducal Palace, though out of perspective, shows a talent for architectural drawing. He had probably benefited from a change of drawing master. In June 1834 he had left Runciman to study under Copley Fielding, the President of the Society of Painters in Water-colours, often called the Old Water-colour Society. This was a trade association and exhibiting society of minor artists who, by reason of their medium, were excluded from the Royal Academy. They were very largely landscapists, and had no interest in the large historical and mythological *machines* demanded by Academy taste. Their patrons were to a great extent middle class. They gave drawing lessons and supplemented their income by illustrating keepsake annuals and travel books. John James and his son were exactly of their time and class in their appreciation of Fielding, of Prout's picturesque views of the Rhine, of David Roberts (whom Ruskin was to copy), of James Duffield Harding (who was to be the last of his drawing masters).

Ruskin remembered them, in 1879, with the same affectionate and
slightly satirical tone that he had used the year before in his memorial
of W. H. Harrison and *Friendship's Offering*:

> What a simple company of connoisseurs we were, who crowded
> into happy meeting, on the first Mondays in May long ago, in the
> bright large room of the Old Water-Colour Society; and discussed,
> with holiday gaiety, the unimposing merits of the favourites, from
> whose pencils we knew precisely what to expect, and by whom we
> were never either disappointed or surprised. Copley Fielding used
> to paint fishing boats for us, in a fresh breeze, 'Off Dover', 'Off
> Ramsgate', 'Off the Needles' — off everywhere on the South Coast
> where anyone had been last Autumn; but we were always pleas-
> antly within sight of land, and never saw so much as a gun fired in
> distress. Mr Robson would occasionally paint a Bard, on a heathery
> crag in Wales; or, it might be, a Lady of the Lake on a similar piece
> of Scottish foreground — 'Benvenue in the distance'. A little fight-
> ing, in the time of Charles the First, was permitted to Mr Catter-
> mole; and Mr Cristall would sometimes invite virtuous sympathy
> to attend the meeting of two lovers at a Wishing-gate or a Holy
> Well. But the farthest flights even of these poetical members of the
> Society were seldom beyond the confines of the British Islands . . .
> It became, however, by common and tacit consent, Mr Prout's
> privilege, and it remained his privilege exclusively, to introduce
> foreign elements of romance and amazement into this — perhaps
> slightly fenny — atmosphere of English common sense. In contrast
> with our Midland locks and barges, his 'On the Grand Canal,
> Venice' was an Arabian enchantment; among the mildly elegiac
> country churchyards of Llangollen or Stoke Poges, his 'Sepulchral
> Monuments at Verona' were Shakespearian tragedy; and to those of
> us who had just come into the room out of Finsbury or Mincing
> Lane, his 'Street in Nuremburg' was a German fairy tale . . .[73]

<p style="text-align:center">★ ★ ★ ★</p>

At the beginning of 1836 Pedro Domecq came to England with his
four younger daughters, Adèle-Clotilde, Cécile, Elise and Caroline.
John James invited him to leave the girls at his home while he travelled
to call on some of his English customers. John Ruskin was now
sixteen, and approaching his seventeenth birthday on 8 February.
When he had met the Domecq daughters in Paris two years before, he
had been socially at a loss. Now he was old enough to fall in love. The
four extraordinary girls took possession of the house in Herne Hill.

John Ruskin thought all the sisters beautiful, but Adèle-Clotilde the most beautiful of them all. She was fifteen, fair-haired, graceful. She had been born in Cadiz but educated in France. She spoke French, Spanish and a peculiar broken English. She was accustomed to society in Paris; and her clothes, all Parisian cuttings and fittings, were from another world. Many years later, and in guarded terms, Ruskin confessed what had happened to him. He had never been 'the least interested or anxious about girls — never caring to stay in the promenades at Cheltenham or Bath, or on the parade at Dover; on the contrary, growling or mewing if I was ever kept there, and off to the sea or the fields the moment I got leave'.[74] Romantic love he knew only as a literary convention. That illusion was now shattered. He had never felt a great desire that was unfulfillable. But now the certainty, the safety and happiness of his young life all suddenly vanished. Adèle reduced him 'to a mere heap of white ashes in four days. Four days, at the most, it took to reduce me to ashes, but the *Mercredi des cendres* lasted four years.'[75]

Most youths desire girls before they first fall in love. John Ruskin, sheltered and innocent, experienced his sexual awakening like a blow. Ruskin said that it took him four years to recover, but it may have been very much longer than that. His first love was hopeless, as was to be the great love of his life. Adèle was physically near and in every other way remote. He could hardly converse with her, and she — through sophistication, or embarrassment — would have nothing to do with him. 'I endeavoured', wrote Ruskin, 'to entertain my Spanish-born, Paris-bred, and Catholic-hearted mistress with my own views upon the subjects of the Spanish Armada, the Battle of Waterloo, and the doctrine of Transubstantiation.'[76] It was a mistake to try to impress Adèle with his writing. He read aloud from his prose romance *Leoni: a Legend of Italy* and she laughed at it. All his attempts to please brought only 'rippling ecstasies of derision'.[77] She was not old enough, or perhaps nice enough, to have handled the business with whatever tact or kindness was demanded. Ruskin was made to feel that he was despised. The whole household was in chaos. John was besotted, Mary discomfited. The girls' French maid was in dispute with Scottish Anne Strachan. There had to be special arrangements for meals, there were difficulties about church services, and the girls were amazed at the morning Bible readings. All this incompatibility increased the bewilderment with which Ruskin met his humiliation. To make matters worse, his parents failed him. For they too had been living in a kind of innocence of his adolescence. One would have expected more from John James, especially when the obtuse Pedro Domecq raised the

idea of a marriage, blithely going to his partner and 'offering to make his daughter a protestant'.[78] Such discussions were not precisely cut off; and John James and Margaret Ruskin merely waited for Adèle to go away and for it all to pass over.

Præterita tells us how, fifty years later, Ruskin could remember nothing more of what happened after Adèle's departure from Herne Hill. Benumbed by love at seventeen, he did not like to recall his suffering at the age of sixty-seven. In fact he had turned to literature. Under a mulberry tree in the Herne Hill back garden he set up a desk and wrote some of a Venetian tragedy, *Marcolino,* in which Adèle appears as the heroine Bianca. Several poems addressed to her, like 'The Mirror', 'Nature Untenanted', and 'Remembrance' went to *Friendship's Offering*. But love, though it prompts adolescents to write, does not teach them how to do it. Fortunately Ruskin now found a new kind of literary instruction. He now began to attend lectures and tutorials at King's College in the Strand. He was following an old schoolmaster. Thomas Dale was rising in the Church and had become the first Professor of English Literature and History in the new university foundation. His new incumbency was of St Bride's, Fleet Street. This was regarded as a significant position in the hierarchy of the Church of England. The professorship was also an important post. It had been offered to Southey, then Poet Laureate, before Dale was approached.

In this way, the lovesick Ruskin became one of the very first university students of English Literature, for Dale in King's College was the originator of English as an academic discipline. A letter to John James describes the beginning of the course.

> Four lectures on this subject have spoken of four celebrated authors of old time — Sir John Mandeville, Sir John Gower, Chaucer, and Wickliffe. We are made acquainted with their birth, parentage, education, etc; the character of their writings is spoken of, and extracts are read as examples of their style . . .[79]

After the lectures Ruskin, with two other students, went for tutorial discussions with Dale in his rooms in Lincoln's Inn Fields. Ruskin felt some antagonism towards his wholesome pedagogy. For he and Dale were in fact literary rivals. Dale too had a hand in keepsake annuals. He was the editor (and his wife's father was the publisher) of an annual called the *Iris*. This publication was in competition with *Friendship's Offering*, which Dale attacked in one of his prefaces, scorning such a 'Gorgeous Gallery of Gallant Inventions, or a Paradise of Dainty Devices, or a Phoenix Nest, or even a Garden of the Muses'.[80] Dale's

own version of the keepsake format was dreary. The poems and tales were all religious, and were mostly by himself. His illustrations came not from the contemporary romantics of the Water-Colour Society but were engraved after Poussin, Correggio and Benjamin West.

After Dale's death one of Ruskin's essays was found among his papers. It was a heated defence of some contemporary authors. One of Dale's publications was an edition of the Reverend John Todd's classic *Student's Guide,* to which, in 1836, he contributed a foreword. Todd's manual contains a section entitled 'Beware of Bad Books' which condemns, among others, Byron, Scott and Bulwer. The essay Dale had set Ruskin was 'Does the perusal of works of fiction act favourably or unfavourably upon the moral character?', a title which gave the young author his first opportunity to write polemic. Ruskin began by attacking the censors of literature, first 'the old maid of jaundiced eye and acidulated lip, whose malice-inwoven mind looks on all feelings of affection and joy as the blight looks on the blossom . . . and makes amends for the follies of her youth by making her parrot say "Amen" to her prayers', and then the 'haughty and uncharitable sectarian' as well as 'home-bred misses who had set up for being pious because they have been set down as being ugly'. Most of the rest of this spirited essay is devoted to the proposition that Scott's fiction humanizes and polishes the mind, and that its effect is moral. Straying from fiction, Ruskin then attacked those who are 'filled with such a horror of Byron's occasional immorality, as to be unable to separate his wheat from his chaff' and concluded, 'We do not hesitate to affirm that, with the single exception of Shakespeare, Byron was the greatest poet that ever lived . . . His mind was from its very mightiness capable of experiencing greater agony than lower intellects, and his poetry was wrung out of his spirit by that agony.'[81]

Thus was dismissed Ruskin's English Literature tutor. His first writing on art dates from these months: it is rather like the essay he wrote for — against — Dale. This was an equally vigorous defence of Turner. Ruskin's admiration for the engravings after Turner in Rogers's *Italy* had not at first encouraged him to find out more about the artist. He copied them, but he did not seek out more examples. He had seen original Turners from 1833, when he first went to the Royal Academy exhibitions, but he had received mixed impressions from them. In 1835, before going on the continental tour, he was even nonplussed. *Keelmen Hauling in Coals,* for instance, which is a night piece, contrasted too oddly with Turner's version of Virgilian romance in *The Golden Bough.* The extravagant *Burning of the Houses of Parliament* Ruskin simply could not grasp: he was silent about the

painting for the rest of his life. In 1836, however, Turner exhibited *Juliet and her Nurse, Rome from Mount Aventine* and *Mercury and Argus*. At seventeen, full of love and poetry, intellectually provoked by his new studies with Dale, he now had a new kind of æsthetic encounter. It was not passive: it was critical. It was the knowledge of being convinced by excellent painting. As he later explained, it was 'not merely judgement, but sincere *experience*' of Turner that he had now found.[82] When, therefore, in October of 1836, he read the review of the pictures in *Blackwood's Edinburgh Magazine* he was aroused not only by its wrongness but by its insincerity. The notice of the Royal Academy exhibition was by the Reverend John Eagles, an amateur artist and regular reviewer for the paper. He wrote of 'confusion worse confounded' in *Juliet and her Nurse*; in the Roman picture he found 'a most unpleasant mixture, wherein white gamboge and raw sienna are, with childish execution, daubed together'; while of *Mercury and Argus*, he pronounced,

> It is perfectly childish. All blood and chalk. There was not the least occasion for a Mercury to put out Argus's eyes; the horrid glare would have made Mercury stone blind . . . It is grievous to see genius, that it might outstrip all others, fly off into mere eccentricities . . .[83]

Ruskin's angry reply was in championship of the wronged. It was also elevated. He immediately made the highest claims for Turner. His imagination was 'Shakespearian in its mightiness'. For the first time we hear the voice of that extravagance in prose that would subsequently be an effortless attribute of his writing. He could now describe a painting like this:

> Many coloured mists are floating above the distant city, but such mists as you might imagine to be ætherial spirits, souls of the mighty dead breathed out of the tombs of Italy into the blue of her bright heaven, and wandering in vague and infinite glory around the heaven that they have loved. Instinct with the beauty of uncertain light, they move and mingle among the pale stars, and rise up into the brightness of the illimitable heaven, whose soft, and blue eye gazes down into the deep waters of the sea for ever . . .[84]

In such a way Ruskin's defence went beyond the inadequacies of Eagles's article. In its assertions of mightiness and attempts to write exalted descriptions of paintings we find the beginning of Ruskin's lifelong endeavour to celebrate Turner above all other artists.

John James thought that the reply ought to be shown to Turner before it was sent to *Blackwood's*. His son's writing was accordingly

forwarded to the painter through Smith, Elder. This meant that there
was a kind of contact between Turner and his champion. Soon Ruskin
received a letter from him. It read:

> My dear Sir,
> I beg to thank you for your zeal, kindness, and the trouble you have
> taken on my behalf, in regard to the criticism of *Blackwood's
> Magazine* for October, respecting my works; but I never move in
> these matters, they are of no import save mischief and the meal tub,
> which Maga fears for by my having invaded the flour tub.
>
> P.S. If you wish to have the manuscript returned, have the
> goodness to let me know. If not, with your sanction, I will send it
> on to the possessor of the picture of Juliet. [85]

This characteristic letter closed the episode. The manuscript, the germ
of *Modern Painters,* was not returned, and was not discovered for
another sixty years. This was no great disappointment to Ruskin. He
had not really thought that he would appear in *Blackwood's.* And he
now had other things to think about, for a week after receiving
Turner's letter he went up to Oxford to matriculate.

CHAPTER TWO

1837–1840

At the beginning of 1837, when John Ruskin left his family home to go into residence at Christ Church, he was just eighteen years old. A rather tall — five feet eleven — and slight young man, he had blue eyes, a thin face, a prominent nose and reddish hair. His hands were long and nervous. There was a scar on his lower lip where a dog had bitten him in childhood. His courteous manner was a combination of formality and attentiveness. There was something deliberate in his speech, however casual the conversation. The manner of rounding off his sentences was the legacy of the Bible readings and his mother's insistence on correct and meaningful pronunciation. From his father's Scottish accent perhaps came his burring way of pronouncing his 'r's. He was slightly dandyish. He enjoyed dressing up for special occasions. His clothes were not fashionable, usually, but they were distinctive. Two items of his dress were not to be altered throughout his life. He always wore a slim greatcoat with a brown velvet collar and never appeared without a large, bright blue neckcloth. Interested in other people, young Ruskin nonetheless had a certain conceit in himself. He was quite ambitious: he had started to think of winning the Newdigate prize for poetry before he matriculated. He was eager to learn but already preferred to go about learning in his own way. He was sufficiently sure of himself not to be put out by differences of social class, though he was certainly aware of such differences. He was kind, but self-willed. People noticed him, and he quickly made friends: nonetheless there was something about Ruskin which discouraged the hearty friendships of youth. In some ways he was simple and innocent, compared to his public school–educated contemporaries. But he was more advanced than they in other of the world's sophistications. He was an accomplished draughtsman, a published geologist and a published poet. He knew people in the London literary world: he was much travelled, and he was in love with a *Parisienne*. All in all, it is little wonder that few people understood this talented, complicated young man as he began his university career.

* * * *

Readers of *Præterita* will recall how 'Christ Church Choir', the chapter of autobiography devoted to Ruskin's Oxford education, invokes the regular morning worship of that collegiate body,

> . . .representing the best of what England had become — orderly, as the crew of a man-of-war, in the goodly ship of their temple. Every man in his place, according to his rank, age and learning; every man of sense or heart there recognising that he was either fulfilling, or being prepared to fulfil, the gravest duties required of Englishmen.[1]

The whole passage is more a vision than a memory, for these were the sentiments of a much older Ruskin. The Christ Church Ruskin knew at the end of the 1830s was not orderly, and duties were not much thought of. The buildings were dirty and dilapidated. Learning was perfunctory, undergraduates idle and riotous as often as not. The very choir of which Ruskin speaks was used to store beer, and dogs had to be chased from the chapel before services could begin. As elsewhere in Oxford, the customs of the eighteenth century lingered in Christ Church. An antique learning prevailed, and a sedentary Anglicanism hardly touched by the fresher piety of Evangelicalism. Wines, gambling and hunting were the undergraduate amusements. There were good men and conscientious students, of course: Christ Church was even then, as much as Oriel or Balliol, nurturing the first generation of great Victorian dons: but it was not an inspiring environment for such an eager young man as Ruskin.

Writing *Præterita*, the distinguished honorary student of Christ Church felt that he ought to say something positive about his undergraduate days in the college. Ruskin found this extremely difficult. He had not greatly enjoyed his Oxford career and he knew that his formal higher education had not been a significant part of his life. Ruskin had already had experience of a more liberal university course, one more suited to the future author of *Modern Painters*, at King's College. The routines of the classical curriculum at Christ Church were by comparison dull. Ruskin exaggerated when he said that he could only just grasp Greek verbs and that his Latin was 'the worst in the University'.[2] But the Christ Church Collections Book indicates that his attainments were little more than average. Perhaps he was too independent: he instinctively approached the ancient authors as he would read modern literature, liking some books and dismissing others. A cancelled passage of *Præterita* reveals that

> Both Virgil and Milton were too rhetorical and parasitical for me; Sophocles I found dismal, and in subject disgusting, Tacitus too

hard, Terence dull and stupid beyond patience; — but I loved my Plato from the first line I read — knew by *Ethics* for what they were worth (which is not much) and detested with all my heart and wit the accursed and rascally *Rhetoric,* — which my being compelled to work at gave me a mortal contempt for the whole University system.[3]

Learning by rote was unwelcome to the young poet. The classical authors did not fit a sensibility that had already been formed by more modern literature. Even Ruskin's genuine love of Plato did not emerge for another twenty years. The learning that filled and inspired his earlier books came from the Herne Hill library, from architecture and painting and from a half-scientific observation of nature. At Oxford, therefore, his emergent powers are most to be seen in his letters to friends; in his poetry and drawing; and in the beginning of such independent prose writings as *The Poetry of Architecture.*

Of all Oxford colleges Christ Church is nearest to the Anglican establishment of Church and State. So numerous are its ties with government and the throne that the college, especially to its members, seems almost a part of the British constitution. Its undergraduate body is aristocratic: on occasion it is royal. The Visitor of Christ Church is the reigning monarch: the college's chapel is Oxford Cathedral. Its own constitution, with a dean, eight canons and subordinate officers, dates from its foundation by Cardinal Wolsey and Henry VIII. To enter this society was to renounce the nonconformist heritage of the Ruskin family. Moreover, John Ruskin entered Christ Church at the summit of its own hierarchies. He was a gentleman-commoner. This was a rank, which John James purchased, and was generally the province of sons of the nobility. Gentlemen-commoners had special privileges, the best rooms, sat together at separate tables, and were given distinctive gowns and mortar-boards (Ruskin preserved his, and wore it when he was Slade Professor). The social incongruity of a merchant's son among this aristocratic class was obvious. Yet Ruskin took his place without embarrassment. His contemporaries were tolerant young men. He was derided when he unwisely mentioned Adèle's aristocratic French connections: but there is otherwise no record at all that he was treated as a parvenu. Such friendliness was remarkable: G. W. Kitchin, later Dean of Durham, who was at Christ Church only five years later than Ruskin, had to become ingenious to explain it. He wrote in his *Ruskin at Oxford* that Christ Church was 'very like the House of Commons in temper; a man, however plain of origin, however humble in position, is tolerated and listened to with respect, if he is sincere, honest and "knows his subject" '.[4] This was

not true of Christ Church, and did not cover Ruskin's case. The fact is that he maintained himself socially — as he would do all his life — by being exceptional.

John Ruskin cared next to nothing about what appeared to others as his peculiarities. To wish for his mother's company might seem unusual in a young man in a male society. Yet when Ruskin went into residence in Christ Church, his family came to Oxford with him. Margaret Ruskin and Mary Richardson moved into lodgings in the High Street, where John James joined them at weekends. Every evening, as his student life allowed, Ruskin went after hall to sit with his mother and cousin until Great Tom, the bell of the college, called out that its gates were closing. This arrangement continued throughout his three years as an undergraduate. What could more demonstrate the unity of the Ruskin family, and their disregard of other social forms? The naturalness of the Ruskins's dependence on each other was soon accepted by other students. Often enough, young men of the nobility came to the lodgings to meet Margaret Ruskin. There was something so frank and powerful in her, this innkeeper's daughter, that snobbishness was beside the point. The same was true of John James. For their part, the elder Ruskins took a lively interest in their son's friends, whether they met them or not. They were especially gratified that he got on well with such aristocrats as Lord Kildare, Lord March or Lord Somers — this last, Charles Somers Cocks, a friend with whom Ruskin was to have a lasting acquaintance. John Ruskin's social success was the triumph of the whole family: it represented the culmination of all that Margaret and John James had done together since the dark days, never mentioned, in Scotland.

Ruskin knew few people from other colleges, but within Christ Church the range of his acquaintance was wide. He belonged to none of those 'sets' which for G. W. Kitchin define college life. He would certainly not have allied himself to an 'idle or vicious set'; yet he was on terms with the gamblers, 'men who had their drawers filled with pictures of naked bawds — who walked openly with their harlots in the sweet country lanes — men who swore, who diced, who drank, who knew *nothing* . . .';[5] on terms too with the sportsmen, for we find him one day in an alehouse over Magdalen Bridge with Bob Grimston (later famous on the turf),

> . . . to hear him elucidate from the landlord some points of the horses entered for the Derby, an object only to be properly accomplished by sitting with indifference on a corner of the kitchen table,

5. Ruskin's Rooms at Christ Church, Oxford, by John Ruskin, 1839.

and carrying on the dialogue with careful pauses, and more by winks than words.[6]

These people were not really his friends, and those who were closer to Ruskin were still unlike him in temperament. Thus it was at Christ Church, so it would be all through his life. Ruskin became friendly with two of his tutors. The Reverend Osborne Gordon would remain a mentor to Ruskin until his death in 1883. He was the Censor of Christ Church and University Reader in Greek. His classical knowledge was more up-to-date, if less magisterial, than that of Thomas Gainsford, the Dean of Christ Church. The Dean was famed for his Greek scholarship yet knew no German, the language of all modern contributions to the knowledge of Greece. But it was not Gordon's more alert attitude to the study of the ancient world (it was not that much more alert) that made him important to Ruskin, but rather his deft, conscientious way of bringing a spirit of enquiry to his students. Gordon was a dry, rather amusing man, not too likely to be impressed; not so much argumentative as disinclined to be taken by other people's certainties. He was very sharp, almost cynical. But his personal kindness was not disguised by his quizzical ways. Ruskin learnt much from Gordon, and John James was delighted with him.[7]

Osborne Gordon was first among the people who knew the Ruskins socially in Oxford and also became visitors at Herne Hill. His earlier visits to south London were made to give Ruskin extra tutorials in the vacations. He was not paid for this help, but John James's account books show that in 1862 he gave the college the almost extravagant sum of £5,000 in Gordon's honour: it was to be used for the augmentation of poor college livings. The extra tuition indicates both that Gordon felt Ruskin's talent and that he feared that he would fall at the hurdles of the examination system. Side by side, in the Herne Hill parlour as in the rooms of the Peckwater quadrangle, they worked through the texts in which the older man found so much more pleasure than did Ruskin. Afterwards, as they walked in the familiar paths to Dulwich and Norwood, or from Oxford to Shotover and Forest Hill, Ruskin would expatiate on his religious beliefs: he was young enough to think that fervour would impress his tutor. Gordon, though, addressed himself on these walks 'mainly to mollifying my Protestant animosities, enlarge my small acquaintance with ecclesiastical history, and recall my attention to the immediate business in hand, of enjoying our walk, and recollecting what we had read in the morning'.[8] Ruskin found a similar attitude in another of his tutors. The Reverend Walter Lucas Brown was stimulating to Ruskin because he had an interest in aesthetic discussion. Like Gordon, he taught

Ruskin Greek (possibly a more wearisome task because of his charge's belief — reiterated in early volumes of *Modern Painters* — that a pagan civilization could produce nothing to compare with Christian art), and tried to win him from an inclination towards extreme Protestantism. He made Ruskin read Isaac Taylor's *Natural History of Enthusiasm* (1829), a now forgotten classic of Anglican moderation and caution against millenialism and suchlike notions: ideas which were greatly unwelcome in Christ Church but common enough in south London chapels which Ruskin knew well.

It is possible that Brown and even Gordon might have felt themselves a little under scrutiny when in the company of John James Ruskin. The wine merchant commanded any social gathering. His complete self-assurance, candid manner and outspoken opinions gave the impression of a man with whom one contends; but what made people yield to him was his good nature, however rough, and his desire of that fellowship which exists between people who love books. Evidently a man of the world, he still retained, even in his fifties, some of the ardours of his youth. John James was good company for younger men, and his enormous pride in his son was so unadorned as to be infectious: people thought more of Ruskin himself through knowing his father. His weekends in Oxford gave John James new opportunities to test his views on men and manners. He did not feel amiably towards eccentrics and he disliked lazy people in privileged positions. For these reasons he was likely to be taken with undergraduates. A contemporary of his son whom he especially liked was Henry Acland. This well-meaning medical student breathed outdoor virtues. He was not a sportsman but was brave at sailing and riding. Acland came from the Devon baronetage but had decided to stay in Oxford, where he also had family connections, to promote the study of the medical sciences. These plans had come to him early in life: he was the sort of man who plans his life. His association with Ruskin, who by comparison was quicksilver, was in many ways unlikely. It probably began because the slightly older Acland took Ruskin under his wing. But the friendship was permanent: more than forty years later *Præterita* recorded that it 'has never changed, except by deepening, to this day'.[9] While they were undergraduates, Acland guided Ruskin in the ways of Christ Church, discussed science with him, but most of all listened to him. Thereafter, Acland's more pedestrian mind was often exercised in keeping up with Ruskin. This had far-reaching consequences for them both, and for Oxford: it was Acland who first realized that Ruskin had the makings of a great teacher.

What Acland saw in Ruskin, Henry Liddell saw too, but his interest was to turn to suspicion. Liddell, whose name was once known to

every schoolboy for his Greek lexicon, was to become the Dean of
Christ Church. At this time he was a young tutor there, about to be
ordained, and was already discussing with Henry Acland the changes
they expected to make in the university. From a letter he wrote in 1837
we have a glimpse of Ruskin as he appeared to Liddell:

> I am going to . . . see the drawings of a very wonderful
> gentleman-commoner here who draws wonderfully. He is a very
> strange fellow, always dressing in a greatcoat with a brown velvet
> collar, and a large neckcloth tied over his mouth, and living quite in
> his own way among the odd set of hunting and sporting men that
> gentlemen-commoners usually are . . . [He] tells them that they
> like their own way of living and he likes his; and so they go on, and I
> am glad to say they do not bully him, as I should have been afraid
> they would.[10]

Liddell's appreciation of Ruskin's drawing was genuine, and he
made sure that Dean Gainsford saw the numerous architectural and
topographical studies with which Ruskin was engaged. He probably
introduced Ruskin to the great collections of old master drawings
which belonged to Christ Church and were then stored, in no particu-
lar order and with inexact attributions, in the college library. Liddell
knew rather a lot about classical art, as Ruskin had to recognize. But
his cool and Olympian manner did not encourage Ruskin to seek him
out: he merely provided Ruskin with a minor lesson in growing up,
his first experience of disliking someone without having good
grounds for doing so.

It is clear that Ruskin lacked a friend who would be a comrade to
him in the romantic discovery of literature and art. There could have
been such a person — many of them, perhaps — in London, but they
were not to be found in Christ Church. Here is one of those cases in
which an 'advanced' taste belongs not so much to a younger genera-
tion as to a different class. Ruskin's outlook on art had more in
common with his father, who was now in his late fifties, than with his
peers at Oxford. In this connection the Ruskins's long and friendly
acquaintance with Charles Newton is of interest. Newton, most
famous today for his excavation of the Mausoleum at Halicarnassus,
one of the wonders of the ancient world, was three years Ruskin's
senior at Christ Church. He left the university to take a post in the
rapidly expanding British Museum at the end of Ruskin's first year.
They scarcely had the opportunity to become intimate, therefore, but
they maintained a friendship for many years. The great difference
between the classicist Liddell and the archæologist Newton was in

temperament. Newton was entirely jovial. His opposition to Ruskin's picturesque, romantic and naturalist views was always cast in the form of a joke. This was often exasperating to Ruskin, though it was good for him to be laughed at; and so they concealed their differences in jests until, in the late 1860s, they simply drifted apart. At Oxford, Newton gave a shock to what Ruskin called his 'artistic conceit' when he asked him to draw a Norman arch to illustrate a talk at the local architectural society. The result, full of Proutian mannerism, was not adequate as illustration. It was salutary, Ruskin later reflected, to realize that his drawings had shortcomings. They might be admired elsewhere in Oxford, but that was not good enough. His progress as an artist had of course been halted during the time he attended the university.

Another person who found a use for Ruskin's ability with pen and brush was Dr William Buckland, the geologist and mineralogist who was a canon of the cathedral and the college. For Buckland Ruskin made diagrams. He was probably the only don at Christ Church that Ruskin had heard of before matriculating at the university, for he was a geologist of considerable repute. Ruskin had almost certainly studied his work at about the time that he was going to Dale's classes in English Literature. Buckland was perhaps as eccentric as any don in the annals of Oxford: at any rate, his eccentricities are amply recorded in those annals. In his house at the corner of the great quadrangle of the college he kept a bear, jackals, snakes and many other beasts and birds. These he ate. He claimed to have 'eaten his way through the animal kingdom'.[11] He also served his pets to his guests. It is not surprising that there are many stories about Buckland and his menagerie. They became Christ Church legends; and some of them were later transformed by Charles Dodgson into scenes in *Alice's Adventures in Wonderland* and *Through the Looking-Glass,* stories first told in the 1850s to the Alice Liddell and Angie Acland who were the daughters of Ruskin's contemporaries. Henry Liddell despised 'poor Buckland' and considered that he had not the intellectual calibre to occupy a chair in the university.[12] That is as may be. What is certain is that Ruskin's acquaintance with Buckland expanded his geological knowledge, and that this was an intellectual inspiration at a time when such inspiration was not easily found. At his table (where Ruskin managed to miss 'a delicate toast of mice') the undergraduate met 'the leading scientific men of the day, from Herschel downwards',[13] and was introduced to Darwin, thereby initiating a respectful debate between the two men that would last for decades.

We should remember that geology in the 1830s was a new and exciting science. The Geological Society, whose meetings Ruskin

eagerly attended, was in the intellectual vanguard of early Victorian
London. The science's dependence on field-work, its interest in
natural phenomena and demand for close observation were suited to
one part of Ruskin's temperament. His ambition to become President
of the Geological Society was perhaps not unrealizable. For in this
company the contributions of amateurs could be as valid as those of
professionals, and a young man would be heard alongside seasoned
practitioners. Ruskin's experience in geology later on gave him confi-
dence to approach another new science in which he was an amateur,
economics. The difference was that he did not expect to enjoy the
study of political economy. Geology was pleasure, a wonderful com-
bination of discovery and recreation. For this reason we should be
wary of the theory that geological work now made progressive
attenuations of his Christian faith. The bearing of geological research
on the literal interpretation of Genesis did not trouble Ruskin at this
stage. It might well have distressed his Calvinist mother, but both
Ruskin and his father were skilled at avoiding the issue when they
spoke with her about such matters. In any case, she could see nearer
enemies. Her son's days as an undergraduate coincided with the
headiest time of the Oxford Movement. Romanism was claiming
many a young man. Margaret Ruskin greatly feared that her son
might be touched by the scarlet attractions of this foreign religion.
And yet we find that Ruskin, who already had a relish for theological
controversy, had no interest whatsoever in the Tractarian debate.
While Newman was preaching his famous sermons in the university
church opposite Margaret Ruskin's lodgings, her son scarcely knew
who he was. It was not that Ruskin considered the position taken by
the Tractarians and then rejected it. He ignored them completely. A
great religious current simply passed him by.

There was a Ruskin family tradition that Margaret, like the biblical
Hannah, had dedicated her new-born son to the service of God. While
he was at Oxford it was still her hope that he would enter the ministry.
John James was non-committal on the subject, and kept quiet about
his heart's desire, that his son should become a poet. Ruskin thought
about the Church, but not as much as he thought about Adèle and
poetry. He wanted to win the Newdigate. If Ruskin were to take a
university prize it would not be in the classics. The prize for English
verse therefore had to be his aim. When he looked at the previous
winners he could see fair hope of success. The problems were that the
subject was not of his own choosing and that the required length was
greater than the lyric to which he was accustomed. But fluency and
'correctness' were highly regarded, and here Ruskin's experience of

polishing verses with W. H. Harrison would no doubt help. Nonetheless, he failed to win the prize in the first two years that he entered the competition. He was beaten in the first year by another pupil of Dale's, J. H. Dart (in later life a translator of the *Iliad*), and in the second by Arthur Penrhyn Stanley, later Dean of Westminster. It is interesting to note that the second place in the year that Ruskin won the Newdigate was taken by Arthur Hugh Clough. The two men were never to become friends despite some shared interests. Their common task in 1840 was to write about 'Salsette and Elephanta'. These are Indian islands which were converted to Christianity. The obscure subject required research, some of which was undertaken by John James. Of the completed and victorious poem there is not much to say, except that the translation of recondite material to literary form was doubtless a useful exercise for the future author of *Modern Painters* and *The Stones of Venice*.

Ruskin's Newdigate poems are not interesting. Nor, in truth, are the verses from Oxford which are to be associated with Adèle. But we should not confuse their conventional sentiments with the real feelings of their author. Ruskin's love for Adèle was genuinely painful. It was also long-lasting. The new environment of Oxford did not help him to forget her. And if he lived a more adult life there, it did not equip him to control his despondent and yearning emotions. When Ruskin wrote his autobiography he looked back on those days with horror. Some passages which refer to Adèle were cancelled because of their bitterness. It is significant that they associate her with his ambition to carry off the Newdigate. Both were desired and both desires were vain. 'To be a poet like Byron was no base aim, at twelve years old,' Ruskin wrote, 'but to get the Newdigate at nineteen, base altogether.' So it was with his love: 'The storm of stupid passion in which I had sulked during 1836 and 1837 had passed into a grey blight of all wholesome thought and faculty, in which a vulgar conceit remained almost my only motive to exertion.'[14] Unfortunately, during Ruskin's second Oxford year Pedro Domecq sent his daughters to England for their further education. They were placed in a convent school at Chelmsford. John James had been asked by his partner to assume their guardianship and the girls were therefore brought into the Ruskin family. They came again to Herne Hill and stayed for weeks over the Christmas of 1838. Once again Ruskin was put on the rack. *Præterita* cannot conceal the feelings of waste evoked by the memory of that Christmas.

> Every feeling and folly, that had been subdued or forgotten, returned in double force . . . and day followed on day, and month

to month, of complex absurdity, pain, error, wasted affection, and rewardless semi-virtue, which I am content to sweep out of the way of what better things I can recollect at this time, into the smallest possible size of dust heap, and wish the Dustman Oblivion good clearance of them.[15]

Relations with the Domecqs were further complicated when Pedro Domecq died in an accident at the beginning of the next year. We do not know how John James's guardianship then stood. But it is unlikely that he was involved in the negotiations which now took place for the betrothal of Adèle to a Baron Duquesne. She had never met the man, but appears to have readily acquiesced in her arranged marriage. Perhaps she was spiritless: one cannot tell. John James's concern for his son's sufferings appears in a letter to Margaret Ruskin:

I wish John could have seen enough of Adèle to cure of the romance & fever of the passion. I trust my Dear Child will not suffer an Injury from the violence of feeling. I am deeply affected for him because I cannot bear that he should by anything have his feelings wounded. Please not to say anything until we know more.[16]

Thus John's parents adopted the policy of telling him nothing of what was happening. He did not know of the marriage plans for many more months. During this time he imagined that there was still hope that he might, some day, win some affection from her. When at last he discovered the truth the shock was brutal. There is only the bleak note in his diary, 'I have lost her'.[17] Two years later, on the anniversary, the diary records 'that evening in Christ Church when I first knew of it, and went staggering along down to dark passage through the howling wind to Childs' room, and sat there with him working through innumerable problems'.[18]

These 'problems' were from Euclid: as he would do all his life, Ruskin sought solace from love in work. He used study to drive out thoughts of Adèle. The official routines of a Christ Church education now seemed even more divorced from the real concerns of his life. His parents' hope that he would excel at the things that are highly regarded in Oxford meant that neither he nor they thought highly enough of the best achievement of his undergraduate years. This was the collection of papers known as *The Poetry of Architecture*.

Although it was not published within two covers until many years later (in an American pirated edition in 1873, and in England in 1893, when it was issued under W. G. Collingwood's supervision), we will say that Ruskin wrote a book when an undergraduate. It is a bold

rumination on the picturesque. The origins of the book are in the first summer tour Ruskin made with his parents after matriculating. Between June and August of 1837 they drove together through Yorkshire, the Lake District and the Derbyshire Dales. The cottage scenery suggested a piece of writing to him: so also did the domestic architecture he noted when on a tour through Scotland and England the following year. The papers were written up in Oxford and were immediately printed in J. C. Loudon's *Architectural Magazine*. Ruskin signed them with the pen–name 'Kata Phusin', or 'According to Nature'. They attracted some attention, and the notice taken of them ought to have been gratifying. *The Times* wrote that the author 'has the mind of a poet as well as the eye and hand of an artist, and has produced a series of highly poetical essays'.[19] That was indeed so: *The Poetry of Architecture* is distinctively a poet's book, even though much of its prose style derives from Johnson's essays in the *Idler* and the *Rambler*, the Ruskins's favourite reading while on tour.

The Poetry of Architecture appears significant today because of its place in the picturesque tradition and because it announces the themes of such later writings of Ruskin's as, most notably, *The Seven Lamps of Architecture*. At the time of its composition, however, only the Newdigate seemed important, and Ruskin had little interest in his prose publication. When Ruskin took the Newdigate, in the summer of 1839, the prize was handed to him after a public recitation by none other than Wordsworth. Margaret Ruskin did not dare attend this ceremony, so splendid was it. John James wrote to Harrison, 'There were 2000 ladies and gentlemen to hear it: he was not at all nervous, and it went all very well off. The notice taken of him is quite extraordinary.'[20] Ruskin did not enjoy his triumph, for he was inconsolable about Adèle. Back at Herne Hill in the vacation his parents made uncharacteristically worldly attempts to put other girls in his path. Ruskin was polite to them. He seemed to be progressing in the world's honours, but his spirits were very low. On a family tour in Cornwall he spent hours looking at the sea. He was made a Fellow of the Geological Society: this was no comfort. In February 1830 he came of age, was given an income of £200 a year by his father and also received from him Turner's *Winchelsea*. The gift contained a dark augury, Ruskin later thought: 'The thundrous sky and broken white light of storm round the distant gate and scarcely visible church, were but too true symbols of the time that was coming upon us; but neither he nor I were given to reading omens, or dreading them.'[21]

Ruskin was referring to his first experience of breaking down after a prolonged spell of work: and he writes thus sombrely because he was

reminded of more recent failures of his health and mind. In Ruskin, as
in other literary people, overwork was usually self-imposed, almost
self-willed. He seems almost to have courted its outcome. The break-
downs followed a rising pattern in which long hours of concentration
were accompanied by nervous tension which in the end, straining and
tightening, could not sustain the labour. Since Ruskin always filled his
waking hours with mental activity, only those most sensitive to him
could tell when danger was approaching. Nobody around him now
realized how close he was to collapse. They were interested in the
possibility that he might take a first. Soon after his twenty-first
birthday, after consultations with Walter Brown, all parties agreed
that Ruskin should not spend a further year at Oxford but should try
to graduate with a splendid degree at the end of the next academic
term. Ruskin, now living in rooms in St Aldate's, returned to his
classical texts, his work coming 'by that time to high pressure, until
twelve at night from six in the morning, with little exercise, no
cheerfulness, and no sense of any use in what I read, to myself or
anybody else: things progressing also smoothly in Paris, to the abyss'.
By this Ruskin means Adèle's marriage. Three weeks after she was
wed to another man, Ruskin was troubled late one evening by 'a short
tickling cough . . . followed by a curious taste in the mouth, which I
presently perceived to be that of blood'.[22] He immediately walked
round to his parents' lodgings in the High Street; and the next day he
was in London, with doctors.

CHAPTER THREE

1840—1841

Although he returned there eighteen months later to complete his residence and take his degree, this was the abrupt and slightly inglorious end of Ruskin's first career in Oxford. The doctors did not agree about his condition. He might seem tubercular: but there was no more blood. Certainly he was in a state of nervous exhaustion. Everyone thought that he should rest, and that he should winter abroad. At Herne Hill, feeling the empty relief that comes after prolonged intellectual exertion, Ruskin quietly obeyed medical advice. Occasionally he went into town. Then, at the dealer Thomas Griffith's home, on 22 June 1840, there was a momentous meeting. Ruskin's diary records:

> Introduced to-day to the man who beyond all doubt is the greatest of the age; greatest in every faculty of the imagination, in every branch of scenic knowledge; at once *the* painter and poet of the day, J. M. W. Turner. Everybody had described him to me as coarse, boorish, unintellectual, vulgar. This I knew to be impossible. I found in him a somewhat eccentric, keen-mannered, matter-of-fact, English-minded — gentleman: good-natured evidently, bad-tempered evidently, hating humbug of all sorts, shrewd, perhaps a little selfish, highly intellectual, the powers of the mind not brought out with any delight in their manifestation, or intention of display, but flashing out occasionally in a word or a look.[1]

'Pretty close, that, and full, to be seen at a first glimpse, and set down the same evening', Ruskin later added when he copied out the entry.[2] So it was: but of course he had thought many times about the probable character of the artist. He had also been studying Turner at the home of one of his connoisseurs, B. Godfrey Windus. In the light and airy library of his villa on Tottenham Green this retired coachbuilder had collected some fifty Turners, as well as work by such artists as J. D. Harding, Clarkson Stanfield, J. B. Pyne and Augustus Calcott. Ruskin had obtained from the benevolent Windus *carte blanche* to visit the collection at any time he liked. From Windus he learnt not only about the pictures, their dates and subjects, but also about Turner himself. He heard many stories about the labyrinthine ways of selling work that were habitual both to the painter and his dealer. As the Herne Hill collection of paintings expanded, this was

useful knowledge to the Ruskins. *'Be on your guard'*, said Windus of Griffith, Turner's agent, to John James at a private view, 'He is the cleverest & the deepest man I ever met with.'[3] This kind of talk seemed to make it the more difficult to approach Turner. Windus was not the sort of man to talk about the deep significance of Turner's art: Ruskin was left with the feeling that there were many great mysteries behind the evident beauties of his work. When he met Turner he did not suddenly realize anything about the man. The meeting told him what he had already suspected (and was well placed to know, with a father like John James) that rough and half-educated men can be as full as anyone of tenderness and imagination. So he observed Turner without venturing much conversation: certainly he did not tell him that it was he who had written the defence of his pictures three years before.

Ruskin had written the reply to the *Blackwood's* article just before he went up to Oxford: now he had met Turner immediately after leaving the university. These coincidences might have helped to persuade him that he had been wasting his time there, but since 'many people, including myself, thought I was dying, and should never write about anything', he was too preoccupied with his own health to think of Turner in connection with his literary career.[4] The annual continental tours had also been interrupted by Oxford: for three years the Ruskins had driven only through England and Scotland. As a winter in a Mediterranean climate had been prescribed, John James decided that the family should tour through France, rest in December on the Italian coast, and then tour home again the next spring. When autumn approached the Ruskins prepared to leave the Herne Hill house to the servants and the Billiter Street business to the clerks. They crossed the Channel in September of 1840 and did not return to England for ten months.

⋆ ⋆ ⋆ ⋆

In 1883, when Ruskin wrote down that rather dramatic reminiscence, that 'many people, including myself, thought I was dying', he happened to be travelling through France with his young friend, W. G. Collingwood. Their discussions often concerned universities, and his companion caught a sense of the bitterness Ruskin could still feel about his departure from Oxford. His biography of Ruskin used a poem of 1838-40, 'The Broken Chain', as 'a fit emblem of the broken life which it records'.[5] The poem, which appears to be derived from Coleridge's 'Christabel', was indeed begun in Oxford and finished on the Italian journey. But it is not especially autobiographical, whatever its deathly

themes, and no public or private writings indicate that Ruskin was
now afraid of dying. His diaries of that date are of some interest.
Ruskin did not keep a journal in Oxford, but in his last days there
began a new notebook on whose first page we find the declaration:

> I have determined to keep one part of diary for intellect and another
> for feeling. I shall put down here whatever is worth remembering
> of the casual knowledge that we gain so much of every day, in
> conversation, and generally lose every to-morrow. Much is thus
> lost that can never be recovered from books.[6]

This proposal has led some commentators to believe that some-
where there must be another diary with 'feeling' in it. But the exis-
tence of such a manuscript is unlikely. Ruskin closed his notebook of
conversations after he had written the entry recording his first meeting
with Turner. He then bought a new, red leather volume in which to
write up notes on his foreign tour. The first thirty-four pages of this
book have at some stage been cut out, and it begins now at Pontgibaud
on 7 October 1849, as the party made their way through France to the
Riviera. It describes weather, landscape and antiquities: the writing is
almost entirely dry and factual.

The journey through France took six weeks. In Italy their route lay
through Pisa, Florence and Siena. References to works of art in the
diary now become more frequent. But there is little sense of engage-
ment. At Florence,

> I still cannot make up my mind about this place, though my present
> feelings are of grievous disappointment. The galleries, which I
> walked through yesterday, are impressive enough; but I had as soon
> be in the British Museum, as far as enjoyment goes, except for the
> Raphaels. I can understand nothing else, and not much of them. At
> English chapel, and mass in the palace; fine music as far as execution
> went, but of German school . . . English sermon very good, a little
> slow. Walked after dinner, but weather very cold for Italy, and
> windy, and streets strangely uninteresting.[7]

From such entries, which are quite free of pretended appreciation,
we would not expect a display of 'feeling' written down in another
book. Ruskin's more formal writing at this date consists of letters to
Edward Clayton, a Christ Church contemporary, and to Thomas
Dale. The letters to Clayton were published with Ruskin's acquies-
cence in 1894, as *Letters of a College Friend,* when their sharper com-
ments on theological subjects were omitted. Those addressed to Dale
were found with the essay on Byron Ruskin had written at King's

College. They were edited and published by Dale's granddaughter in 1893. The letters are carefully composed and express conventional Protestant views. On architecture, however, Ruskin becomes more vehement. Writing from Rome, he comments,

> St Peter's I expected to be *disappointed* in. I was *disgusted*. The Italians think Gothic architecture barbarous. I think Greek heathenish. Greek, by-the-bye, it is not, but has all its weight and clumsiness, without its dignity or simplicity. As a whole, St Peter's is fit for nothing but a ballroom, and it is a little too gaudy even for that . . .[8]

Neither Rome nor Naples, at this date or any later date, were to win one word of approval from Ruskin. It was not merely that they contained so little painting or architecture that he liked: he felt an exaggerated revulsion from what he imagined to be the spirit of their civilization. To Dale he wrote of Rome:

> There is a strange horror lying over the whole city, which I can neither describe nor account for; it is a shadow of death, possessing and penetrating all things . . . you feel like an artist in a fever, haunted by every dream of beauty that his imagination ever dwelt upon, but all mixed with the fever fear. I am sure this is not imagination, for I am not given to such nonsense . . .[9]

Given such attitudes, it is not surprising how closely the Ruskins held to the English colony in Rome and Naples. They seem to have made no attempt to meet any Italians. In their letters, and in the diary of Mary Richardson, there is one repetitive theme: foreign disease and morbidity is contrasted with English health, Protestant honesty compared to Catholic superstition. Mary's diligent diary provides many reports of the sermons in English churches. In Turin she gives an account of a sect who were to be rather important to Ruskin's religious attitudes. There the family went to

> . . . a French Protestant service at the Prussian ambassador's . . . there were many of the poor Waldenses present, nearly all the women of the poorer class (who wore caps only) were of that interesting race who have suffered so much from Popish persecution . . . their church is said to be the purest of all Christian churches, but they are miserably poor . . .[10]

In Rome, 'I have today witnessed one of the grandest Church Ceremonies to be seen in the world — with the Pope in St Peters,' John James wrote home to W. H. Harrison. 'How infinitely I would prefer a sermon from Dr Croly.'[11] His son was in correspondence with

Croly (who, like Harrison, had never been in Italy) during this sojourn in Rome, and was exchanging views with him on these patriotic and anti-Catholic matters. The seeds of *The Stones of Venice* were being sown.

The English colony encouraged (as is the way in such communities) expatriate sentiments to harden into prejudice. Mary Richardson often reports on social evenings with such leading figures of the colony as

> Mr Rugg, quite a character, been in Naples for 11 years, was a martyr to rheumatism until he came here . . . a great admirer of Pitt whom he used to go and hear debate almost every night. Quite a man of the old times, a great Tory . . . does not approve of the High Church principles prevalent at Oxford . . .[12]

There were many like Mr Rugg, snobbish, curious to meet visitors, patriotic though an emigré, clinging to the politics of a previous generation. The colony was just large enough to have its own social stratifications. The Ruskins did not quite enter the height of English society in Italy. They took apartments in the same building as the aristocratic Tollemache family but were not on visiting terms. One of the Tollemache daughters, the beautiful Georgina, was greatly admired by Ruskin. He looked at her in church and later confessed that he followed her through the streets: but he could not meet her. The Ruskins inclined towards the artists. Mary tells us of studio visits they made, mostly to painters and sculptors now forgotten, but also to 'another English artist's, a Mr Lear, also young and promising . . .'.[13] One of these meetings was to be so significant as to reverberate through the rest of Ruskin's life. He had a letter of introduction to Joseph Severn (given to him by Acland), the painter friend of Keats, who twenty years before had brought the poet to Italy, and who himself had remained there ever since:

> I forget exactly where Mr Severn lived at that time, but his door was at the right of the landing at the top of a long flight of squarely reverting stair . . . Up this I was advancing slowly, — it being forbidden me ever to strain breath, — and was within eighteen or twenty steps of Mr Severn's door, when it opened, and two gentlemen came out, closed it behind them with an expression of excluding the world for ever from that side of the house, and began to descend the steps to meet me . . . One was a rather short, rubicund, serenely beaming person; the other, not much taller, but paler, with a beautifully modelled forehead, and extremely vivid, though kind, dark eyes. They looked hard at me as they passed, but

in my usual shyness . . . I made no sign, and leaving them to
descend the reverting stair in peace, climbed, at still slackening
pace, the remaining steps to Mr Severn's door, and left my card and
letter of introduction with the servant, who told me he had just
gone out. His dark-eyed companion was George Richmond . . .[14]

As they passed him on the stairs, Ruskin had heard Severn say to his
companion of him 'What a poetical countenance!'[15] The remark recalls
us to Ruskin's artistic life, and his precarious health. Severn's friend
was George Richmond, also a painter and one who many years before
had known a great poet. With Samuel Palmer and others, Richmond
had been a disciple of Blake: he had attended his deathbed and closed
his eyes.[16] Two new acquaintances such as Richmond and Severn —
they all met a day or two later — could not but prompt thoughts of the
lives and deaths of poets. John James went with his son to the Protes-
tant cemetery to visit Keats's grave. He afterwards reflected that
young John Ruskin was made of 'sterner stuff' than the poet.[17] But
when his symptoms returned and Ruskin coughed blood for three
successive days the comparison with Keats was inescapable. The
Ruskins's new friends were entirely sympathetic: Richmond espe-
cially showed a tenderness for the young and worried man. Thus, in
grave circumstances, was born a friendship that would bind the Rus-
kins, the Severns and the Richmonds for years and decades to come.
Joseph Severn's son Arthur would marry Ruskin's cousin Joan
Agnew: his daughter Mary would be the bride of Ruskin's college
friend Charles Newton. Generations of the Richmonds, neighbours of
the Ruskins in Clapham and the Lake District, were always to be
family friends: and when Ruskin was old and insane, Joan Severn
would look to them for understanding and comfort.

It was the strain of writing the Oxford chapter of *Præterita* that
brought about Ruskin's attack of madness in 1885. The autobiography
alternates sour memories of the university with pleasing portraits of
friends from these Roman days. Its composition was confused by
Ruskin's mental breakdown, and this perhaps is why it does not dwell
on the change that came over his spirits, and his health, when the
Ruskin party left the south of Italy in the spring of 1841 and drove to
Venice. Here he found a glad excitement such as he had not experi-
enced before in a city. He was old enough now to feel connections
between the buildings of Venice and a world of imaginative literature,
romantic history and Turnerian art. What before had been only a
foreign place, however picturesque, now sparkled with cultural
implication. *Præterita* could not quite recapture the feeling. But an

almost contemporary letter to Ruskin's Venetian friend Count Zorzi
is eloquent of his rapture:

> Of all the happy and ardent days which , in my earlier life, it was
> granted me to spend in this Holy Land of Italy, none were so
> precious as those which I used to pass in the bright recess of your
> Piazzetta, by the pillars of Acre; looking sometimes to the glimmer-
> ing mosaics in the vaults of the Church; sometimes to the Square,
> thinking of its immortal memories; sometimes to the Palace and the
> Sea. No such scene existed elsewhere in Europe, — in the world; so
> bright, so magically visionary, — a temple radiant as the flowers of
> nature, venerable and enduring as her rocks, arched above the
> rugged pillars which then stood simply on the marble pavement,
> where the triumphant Venetian conquerer had set them . . .[18]

Many long hours were spent in exploration of Venice, in drawing
and note-taking. The diaries take on a different tone. Ruskin was on
the mend: he had been rescued by his feelings for Venice's beauty. His
convalescence seemed to be over. He became more active, even
energetic, and the family set off for England. Their route on this return
journey was through the Alps. The first day that they spent among the
hills was a turning point in his life:

> I woke from a sound tired sleep in a little one-windowed room at
> Lans-le-bourg, at six of the summer morning, June 2nd 1841; the
> red aiguilles on the north relieved against pure blue — the great
> pyramid of snow down the valley in one sheet of eastern light. I
> dressed in three minutes, ran down the village street, across the
> stream, and climbed the grassy slope on the south side of the valley,
> up to the first pines. I had found my life again; — all the best of it.
> What good of religion, love, admiration or hope, has ever been
> taught me, or felt by my best nature, rekindled at once; and my line
> of work, both by my own will and the aid granted to it by fate in the
> future, determined for me. I went down thankfully to my father
> and mother and told them I was sure I should get well.[19]

CHAPTER FOUR

1841–1844

After this tour, Ruskin writes in *Præterita*, 'a month was spent at home, considering what was to be done next'.[1] He felt that to be 'free in mountain air' would restore him, and sought leave from his parents for an independent expedition. He planned to tour Wales with Richard Fall. They would be attended by a new family servant, the resourceful John Hobbs (known always as George to distinguish him from his master). Ruskin's parents asked him to call on the renowned Leamington physician, Dr Jephson, on his way to Wales. This he did: but his report of the interview persuaded his father that he should immediately return from his rendezvous with Fall in the Welsh Marches to place himself, until further notice, under Jephson's care. Thus began an odd six weeks in Ruskin's life, most of it spent in a lodging house near the Leamington medicinal wells. Jephson's regimen stipulated many glasses of these spa waters, a slender diet and regular hours. Ruskin observed these routines without interest. He took walks to Stratford and to Warwick Castle. His father came to visit him, as did Osborne Gordon. Ruskin scarcely considered preparations for the Oxford schools, which he now thought to sit the following Easter, but read Walter Scott, drew, and studied Louis Agassiz's *Recherches sur les poissons fossiles*. Out of boredom, he now wrote what was subsequently the most popular of his books, the short tale for children called *The King of the Golden River*. This story, 'a fairly good imitation of Grimm and Dickens, mixed with a little true Alpine feeling of my own', was written in fulfilment of a promise to a little girl, Euphemia or 'Effie' or 'Phemy' Gray, who had visited Herne Hill earlier in the year.[2] She was the daughter of George Gray, a Perth lawyer who administered the trust which controlled the affairs of Jessie Richardson's children. In seven years' time she would become John Ruskin's wife, and *The King of the Golden River* was published in 1850, in the second year of their marriage.

One detects an irresolution in Ruskin in Leamington. But he left Dr Jephson's care with a serious purpose in mind. He went to visit his tutor of two years before, the Reverend W. L. Brown. Now in his mid-thirties, Walter Brown had recently married. He had therefore been obliged to leave Christ Church for a college living at Wendlebury, a grey, distressed village, often flooded, nearer Bicester than

Oxford. His position there was no advertisement for a career in the Church, as Ruskin must have noted. For he had come to talk to Brown about his religious vocation. As he approached the end of his Christ Church career, the question of whether he should take orders was pressing. Certain of his contemporaries had entered the Church. His admired Osborne Gordon was just about to do so. His college friend Edward Clayton, to whom he was now writing long and serious letters, was ordained in this year: and Clayton, like many others, expected that Ruskin would follow him into the ministry. Margaret Ruskin would have been delighted to see her son in orders. But John James had reservations. He could not feel that his son's ardent temperament was fitted for the Church, for ardour in religion he mistrusted. He had written to Ruskin at Leamington, 'It sounds paradoxical but these Heavenly subjects require to be approached in the most worldly way. We must hold to the anchor of Rationality, stick to our Humanities.' Again — prophetically — he warned that 'too much enthusiasm in Religion ends in Selfishness or Madness'.[3] Ruskin's own views were not dissimilar. And Brown himself was a man of some caution in religious matters: he was the tutor who had made Ruskin read that dampening book, *The Natural History of Enthusiasm*. We know less than we might wish about the movements of Ruskin's mind in thinking of a religious vocation. No doubt he discussed the matter in prayer, and perhaps he was affected by a pleasure he took in disputing with Brown: however that may be, their subsequent correspondence shows that he left Wendlebury much doubting his suitability for a life in the Church.

His commitment to poetry also weakened in these few months. He began to realize that for him it had been an adolescent preoccupation. John James, tactfully, allowed his son time to sense that his real ambitions lay elsewhere. At no time did his father urge Ruskin towards any particular career. To say, as he now sometimes did, that he longed for his son to be a poet was scarcely to guide him towards professional opportunities. Nobody imagined that Ruskin's aspirations would lead to art criticism. But the notion of a principled attachment to art was growing in him. He would never be a professional artist, but at the same time he was determined to be more than a gentleman amateur. After his return to London in the autumn of 1841, Ruskin began drawing lessons with a new master. This was James Duffield Harding. To seek his tuition represented an æsthetic and almost a political decision. First, Harding brought Ruskin nearer to Turner. His current practice was to some extent based on Turner's art. Harding knew Turner: Ruskin had met his idol only once since their

introduction more than a year before. Decades later, considering this, the writer of *Præterita* lamented that he had not known even a hint of instruction from Turner himself after their first meeting: 'If he had but asked me to come and see him the next day! He would have saved me ten years of life, and would not have been less happy in the close of his own . . .'[4] The older Ruskin knew how mechanical Harding's interpretation of Turner was. In 1841, however, his instruction seemed apposite. It also had a didactic element which, for a time, commended him to the Ruskins. Harding held an ideological view of post-Renaissance painting. His taste had a nationalist and Protestant bias. His beliefs may be crudely stated since they were themselves crude. He believed that nature and 'truth' were available only to contemporary Englishmen. He associated falsity in art with Catholicism, falsity in religion. He despised Claude's classical landscape and thought the Dutch schools ignoble. Such opinions, belligerently stated, had an effect on the young Ruskin.[5] Amplified and expanded, they would soon reappear in the first volume of *Modern Painters*.

<p style="text-align:center">★ ★ ★ ★</p>

Today, it seems an absurdity to speak of Turner and Harding in the same breath. One we know to have the grandeur of a major artist: the other is a drawing master, who draws like a drawing master. But the first volume of *Modern Painters* is full of such juxtapositions. Ruskin's book rises to heights of appropriate eloquence in describing Turner and the old masters; then, immediately, we are in the company of Clarkson Stanfield, David Roberts, Copley Fielding, Samuel Prout, the minor domestic artists Ruskin saw on the walls of the Old Water-Colour Society. From his knowledge of art one would not anticipate a poetic or a magisterial book. *Modern Painters* was not written from great galleries, print-rooms and libraries: it was written from suburban south London. It is remarkable how *Modern Painters* can soar away from Ruskin's personal experience of art. It strikes great chords; but in it one finds still that boyish greed for painting and talk about painting that now began to overtake Ruskin, that made him haunt those places where he could see pictures, that directed him more and more to the Richmonds's in Clapham, where the talk was of nothing but art, that made him listen with more respect to Samuel Prout (often a visitor at Herne Hill), that sent him to Tottenham and Camberwell to call on Mr Windus and Mr Bicknell, collectors who liked to show off their treasures to this eager young man.[6]

Of course, it was Turner's acquaintance that Ruskin most desired.

The old painter was not easily approached. But he seems to have shown kindness on the earlier occasions when he met his admirer. The diary entry which records their second meeting is of 6 July 1841, just before Ruskin left town for Wales and Leamington. He writes, 'Dined with Turner, Jones and Nesfield at Griffith's yesterday. Turner there is no mistaking for a moment — his keen eye and dry sentences can be the signs only of a high intellect. Jones a fine, grey, quiet, Spectator-like "gentleman".'[7] Thomas Griffith, who that evening entertained not only Ruskin and Turner but also the water-colourist William Nesfield and the Royal Academician George Jones, attracted many an artist and connoisseur to his home at Norwood.

John James Ruskin was never among them, however: nor did he ever invite Griffith to Herne Hill. Probably the sherry merchant disliked the commercial style of the picture dealer. 'My father could not bear him,' Ruskin simply records.[8] As Ruskin's appetite for Turner grew John James's hostility to Griffith caused many difficulties. Griffith was Turner's sole agent, and John James was for that reason the less inclined to spend his money on Turner's paintings. This soured as nothing else could the tender relations Ruskin enjoyed with his father. One incident in particular remained with him all his life. It somehow grew in his imagination, filling him with resentment, a feeling that he had been thwarted in more than material possessions; a feeling that was replaced in later years by the sadness with which, in 1886, he set down the story:

In the early Spring of [1842], a change came over Turner's mind. He wanted to make some drawings to please himself; but also to be paid for making them. He gave Mr Griffith fifteen sketches for choice of subject by any one who would give him a commission. He got commissions for nine, of which my father let me choose at first one, then was coaxed and tricked into letting me have two. Turner got orders, out of all the round world besides, for seven more. With the sketches, four finished drawings were shown for samples of the sort of thing Turner meant to make of them, and for immediate pur-chase by anybody.

Among them was the 'Splügen', which I had some hope of obtaining by supplication, when my father, who was travelling, came home. I waited dutifully till he should come. In the meantime it was bought, with the loveliest Lake Lucerne, by Mr Munro of Novar.

The thing became to me grave matter for meditation. In a story by Miss Edgeworth, the father would have come home in the nick

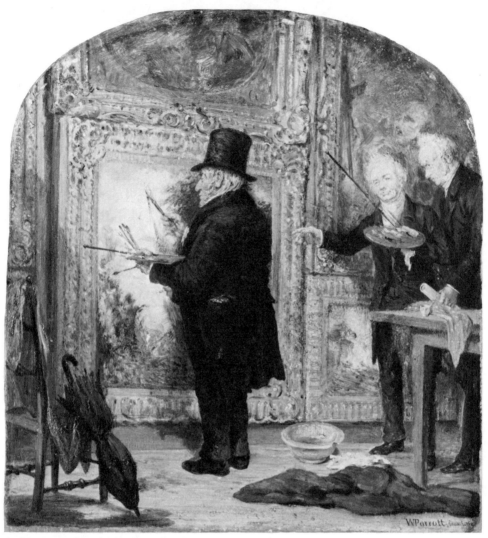

6. *Turner on Varnishing Day*, by S. W. Parrott, 1848.

of time, effaced Mr Munro as he hesitated with the 'Splügen' in his hand, and given the dutiful son that, and another. I found, after meditation, that Miss Edgeworth's way was not the world's, nor Providence's. I perceived then, and conclusively, that if you do a foolish thing, you suffer for it exactly the same, whether you do it piously or not. I knew perfectly well that this drawing was the best Swiss landscape yet painted by man; and that it was entirely proper for *me* to have it, and inexpedient that anyone else should. I ought to have secured it instantly, and begged my father's pardon, tenderly.

He would have been angry, and surprised, and grieved; but loved me none the less, found in the end I was right, and been entirely pleased. I should have been very uncomfortable and penitent for a while, but loved my father all the more for having hurt him, and, in the good of the thing itself, finally satisfied and triumphant. As it was, the 'Splügen' was a thorn in both our sides, all our lives. My father was always trying to get it; Mr Munro, aided by dealers, always raising the price on him, till it got up from 80 to 400 guineas. Then we gave it up, — with unspeakable wear and tear of best feelings on both sides.[9]

Ruskin exaggerated the loss of the 'Splügen'. However, like all his many exaggerations, this one has the truth of being heartfelt. The 'Splügen' meant more than it ought to have done. All his life Ruskin was liable to confuse his personal history with the history of art. He was able to take certain works — like this Turner drawing, or della Quercia's Ilaria di Caretto tomb at Lucca, or Carpaccio's painting of St Ursula — and give them a private value that over-emphasized their cultural importance. This was usually in looking back over his life. In years to come, Turner's late Swiss drawings were to signify every-thing that he owed to his father. But in the spring of 1842 they were revelatory. Elegiac though they are, Ruskin could not now feel that they were the sunset of Turner's career, for he was gripped by the realization that they belonged to the dawning of his own. So strong was this feeling that it persisted long after Turner's own death in 1851, when Ruskin was still inclined, against all the evidence, to interpret the drawings as the beginning of a new stage in Turner's career, his 'third period', and would even force them on painters younger than himself, the Pre-Raphaelites, as a progressive example for their own art.

In Pre-Raphaelitism, again, Ruskin found the significance of an experience which *Præterita* recalls as of this time, the spring before he began to write *Modern Painters*.

One day on the road to Norwood, I noticed a piece of ivy around a thorn stem, which seemed, even to my critical judgement, not ill 'composed'; and proceeded to make a light and shade pencil study of it in my grey paper pocket book . . . When it was done, I saw that I had virtually lost all my time since I was twelve years old, because no-one had ever told me to draw what was really there! All my time, I mean, given to drawing as an art; of course I had the records of places, but had never seen the beauty of anything, not even of a stone — how much less of a leaf![10]

Two pages further on in *Præterita*, Ruskin writes of how he came to draw an aspen tree in the forest of Fontainebleau a month or two later:

> Languidly, but not idly, I began to draw it; and as I drew, the languor passed away: the beautiful lines insisted on being traced, — without weariness. More and more beautiful they became, as each rose out of the rest, and took its place in the air. With wonder increasing every instant, I saw that they 'composed' themselves, by finer laws than any known of men. At last, the tree was there, and everything that I had thought before about trees, nowhere . . .[11]

Præterita attaches great importance to these experiences. But this section of the autobiography was written in 1886, after Ruskin's fourth mental breakdown, and without the *aide-memoire* of his diary. 'To my sorrow and extreme surprise,' he then noted, 'I find no diary whatever of the feelings or discoveries for this year. They were too many and bewildering, to be written.' Ruskin had forgotten that in 1872 he had given the diary in question to Charles Eliot Norton.[12] Had he been able to consult it, he would have found no reference to this moment in Fontainebleau. Nor can we now trace any drawing of an aspen, or of ivy, that would correspond with these reminiscences. Ruskin in old age was describing (as is not uncommon in *Præterita*) a gradual change of mind as a sudden conversion. The development of Ruskin's drawing from the picturesque towards naturalism was steady rather than dramatic. Certainly it cannot have been effected by a revelation while actually drawing. But it is clear that he was developing a theory of naturalism. Perhaps this contributed to a dissatisfaction with his rather artificial verses, though he nowhere says as much. He usually discussed naturalism in terms of his drawing. He wrote to Edward Clayton this year, 1841,

> Time was (when I began drawing) that I used to think a picturesque or beautiful tree was hardly to be met with once a month; I cared for nothing but oaks a thousand years old, split by lightning or shattered by wind . . . *Now*, there is not a twig in the closest-clipt hedge that grows, that I cannot admire, and wonder at, and take pleasure in, and learn from . . . Now this power of enjoyment is worth working for, not merely for enjoyment, but because it renders you less imperfect as one of God's creatures — more what He would have you . . .[13]

That is distinctly the voice of *Modern Painters*, the book that Ruskin could now have been considering, were he not distracted by his final Oxford examinations.

Ruskin returned to Oxford to take schools in the spring of 1842. He was far past his undergraduate life. Not even the proud John James cared much about the examination results. Ruskin took a peculiar degree. It was an honorary double fourth, which indicated success and failure in about equal measure.[14] John James brought the Dean of Christ Church a hamper of wine and took his son back to Herne Hill. Ruskin this spring seems pointedly the 'Graduate of Oxford', the pseudonym with which *Modern Painters* was to be signed. There were many things that he wanted to do in London. His examinations interfered with the Water-Colour Society opening, the Royal Academy opening, a Wilkie private view. His interests more and more inclined him towards such events and the kind of company he would find there. Although it is tricked out with Oxford learning, the first volume of *Modern Painters* has the flavour of Ruskin's return to early Victorian London; and its hero, the barber's son from Covent Garden, is lauded for wisdom and imagination quite beyond the cramped instruction of the university.

★ ★ ★ ★

The Ruskin family, now reunited, were looking forward to their annual summer tour. Their destination in 1842 was Switzerland. The diary Ruskin kept as they travelled from Calais through Rouen, Fontainebleau, Sens and Auxerre to Geneva, reveals a conscientious tourist. It is not an artist's diary. It is the notebook of a natural scientist, a geologist, a student of the Bible. But Ruskin had not forgotten English art. He left England with Turner's Swiss drawings in his mind, and had seen Turner's work at this year's Royal Academy exhibition, two Venetian subjects together with *Snow Storm, Steamboat making Signals, Peace – Burial at Sea* and *War: The Exile and the Rock Limpet*. A parcel of English newspapers sent on to Switzerland now inflamed his memories of the paintings. In one of them was a review which attacked Turner's contributions. The same morning that he read the review, in the Protestant church in Geneva, Ruskin knelt to pray. There he resolved to write a reply. This was to have been a pamphlet. Hot for battle, Ruskin thought to write it at Chamonix the next day. But an immensity of theme came between him and his task. It was nature. Among the rocks and the pines and the great mountains, Mont Blanc above and the green valleys below, Ruskin found that he could not confine what he had to say to a few pages. That *Modern Painters* was begun among the Alps has its significance. As from a vantage point, there spread out before him the whole length of Europe, its cities and long rivers, its seas and the island kingdom in the

North. Such vistas, which reappear ever afterwards in his writing,
were early on imagined by the 'cockney cock-sparrow', as Ruskin
later described himself at this age. Perhaps feeling a little shy of his
resolution, he said nothing about his new writing to Osborne Gordon,
who had now joined the Ruskins. Not until *Modern Painters* was
actually published did he confess to his tutor how his holiday work
had developed as they turned for home through Germany.

> I meditated all the way down the Rhine, found that *demonstration* in
> matters of art was no such easy matter, and the pamphlet turned
> into a volume. Before the volume was half way dealt with it
> hydrized into three heads, and each head became a volume. Finding
> that nothing could be done except on such enormous scale, I deter-
> mined to take the hydra by the horns, and produce a complete
> treatise on landscape art.[15]

<p align="center">★ ★ ★ ★</p>

Modern Painters was written in a new home. John James Ruskin had for
some time been looking for another house. He wanted one more
appropriate to his social standing, a home in which he could entertain
the friends his son had made at Christ Church. At the same time there
was a lack of pretension in his choice. After inspecting properties in
Tooting, Penge and Fulham, he bought the lease of a house less than a
mile from Herne Hill. It was No. 163 Denmark Hill, situated on the
crest of this northern outcrop of the Surrey Downs, looking down to
Dulwich in one direction and Camberwell in the other. John James
had never aspired to own land, as one might have expected in a
self-made tory of his temper. Nor had he ever wished for a town
house. But he was well suited in Denmark Hill, the 'Belgravia of the
South'. The Ruskins's new home was three storeys tall. There was a
lodge, and the house itself was set among seven acres of land, half of it
meadow, the rest divided into flower gardens, kitchen gardens,
orchard. There were cows in the meadow, pigs and hens in the
out-houses. Margaret Ruskin delighted in her farm management. She
was also pleased to increase the number of servants. We will come to
know them well, for these servants' lives became more and more
interwoven with the Ruskins's, ever afterwards. David Downs, for
instance, a Scotsman who came to Denmark Hill as head gardener and
in later years was a factotum for all Ruskin's outdoor schemes —
crossing-sweeping, road-building, moor-draining — died in Ruskin's
service, as did the Tovey sisters, who were to manage Ruskin's
teashop; while some, such as George Allen, married other Denmark

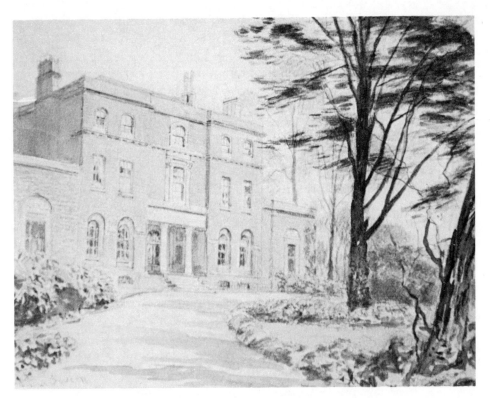

7. 163 Denmark Hill, Ruskin's home from 1842 to 1871, by Arthur Severn.

Hill servants, in his case George Hobbs's sister Hannah, and thus became part of the extended family network. No-one was ever cast off. At Denmark Hill they now settled into the routine of life that was to last, with disturbances, for thirty years, while in his study above the breakfast-room, looking over a view 'inestimable for its help in all healthy thought', Ruskin began the series of books that would take him from his writing apprenticeship to the Slade chair in Oxford.[16]

Ruskin said nothing to people outside his immediate family about his resolve to write on Turner. Only his parents and Mary Richardson knew what he was doing. The first volume of *Modern Painters* was composed privately, in effect secretly. Osborne Gordon, one of the first guests at Denmark Hill, was still kept in ignorance. Acland, Newton, Liddell, intellectual Christ Church men Ruskin occasionally met in the months when he was writing the book, had no idea that what was passing through his mind was being committed to paper. W. H. Harrison and all mutual acquaintances of the Ruskins and Turner were equally unaware of his labours. A consequence was that *Modern Painters* was written without any kind of professional advice.

This perhaps helped Ruskin to find his own originality: certainly it meant that nobody counselled him to be cautious. Reticent about his own large ambitions, Ruskin now listened to people but did not seek instruction from them. We have a fair idea of his life at the time when he was preparing his book. He had much talk with Richmond about art, for he was now sitting for a portrait which John James had commissioned. Richmond's son Willie recalled Ruskin at this period as a 'gaunt, delicate-looking young man, with a profusion of reddish hair, shaggy eyebrows like to a Scotch terrier, under them the gleaming eyes which bore within them a strange light, the like of which I have never seen except in his',[17] a description not very like his father's water-colour portrait, later entitled 'The Author of *Modern Painters*', which shows a rather stiff, formally-dressed person, pen in hand, sitting at a desk in the middle of a field. Ruskin was occasionally with Harding, but the lessons were more like conversations. He read Coleridge. He often called on Windus and Griffith. He took many a walk over the fields to Dulwich College picture gallery, whose collection of baroque and Dutch art is therefore much discussed in *Modern Painters*. He listened attentively to the Reverend Henry Melvill's sermons: he was the incumbent of Camden Chapel in Walworth Road, Camberwell. In Richard Fall's company he was often at the Geological Society. As his twenty-fourth birthday approached in February of 1843 he ventured to invite Turner to the celebratory dinner. His diary records, 'Turner happy and kind; all else fitting and delightful — but too late to sit writing.'[18] A few days later he 'called at Turner's . . . Insisted on my taking a glass of wine, but I wouldn't. Excessively good-natured today. Heaven grant he may not be mortally offended with the work!'[19]

This is one of the few references to *Modern Painters* in the diary. By March of 1843 the journal peters out, and we understand that Ruskin is in the final stages of his book. It resumes on 1 May. 'Couldn't write while I had this work for Turner to do; had not the slightest notion what labour it was. I was at it all April from 6 morning to 10 night, and late to-night too — but shall keep on, I hope.'[20] The completed manuscript now required a publisher. John James, who until his death in 1864 was to act as his son's literary agent, first of all approached John Murray. Without looking at the book, Murray gave as his opinion that a volume on the Nazarenes would be more popular. 'He said the public cared little about Turner,' John James wrote to W. H. Harrison, 'but strongly urged my son's writing on the German School, which the public were calling for works on.'[21] John James, not a man to be thus slighted, took the book immediately to Smith, Elder and Co. A

bargain was quickly struck; George Smith changed the title from Ruskin's *Turner and the Ancients* to *Modern Painters: Their Superiority in the Art of Landscape Painting to the Ancient Masters*; edited it, as far as one may judge, hardly at all; sent it to press: and in the first week of May of 1843 the book itself was in the shops.

The reaction to *Modern Painters*, by 'a Graduate of Oxford', was not immediate, nor did the book at first sell widely. But in the first year of its life it won a distinguished audience. Wordsworth (from whose *Prelude* its epigraph was taken) thought it the work of 'a brilliant writer', and recommended it to visitors to Rydal Mount.[22] In other literary circles, we find Tennyson writing to the publisher Moxon:

> Another book I very much long to see is that on the superiority of the modern painters to the old ones, and the greatness of Turner as an artist, by an Oxford undergraduate, I think. I do not wish to buy it, it may be dear; perhaps you could borrow it for me out of the London Library, or from Rogers. I saw it lying on his table.[23]

Samuel Rogers may have pressed the book on readers other than the thrifty Tennyson. It was perhaps he who had sent a copy to Robert and Elizabeth Browning in Italy. To Mary Russell Mitford, who had also told them of it, Elizabeth Browning wrote,

> The letter in which you mentioned your Oxford student caught us in the middle of his work on art. Very vivid, very graphic, full of sensibility, but inconsequent in some of the reasoning, it seemed to me, and rather flashy than full in the metaphysics. Robert, who knows a great deal about art, to which knowledge I have of course no pretence, could agree with him only by snatches, and we, both of us, standing before a very impressive picture of Domenichino's (the 'David' — at Fano), wondered how he could blaspheme so against a great artist. Still, he is no ordinary man, and for a critic to be so much of a poet is a great thing. Also, we have by no means, I should imagine, seen the utmost of his stature.[24]

This was a more independent view than that of other literary women. Mrs Gaskell and Charlotte Brontë read Ruskin together, and Charlotte Brontë (also a Smith, Elder author) could write to W. S. Williams at the firm,

> Hitherto I have only had instinct to guide me in judging of art; I feel now as if I had been walking blindfold — this book seems to give me eyes. I *do* wish I had pictures within reach by which to test the new sense. Who can read these glowing descriptions of Turner's works without longing to see them? . . . I like this author's style

much; there is both energy and beauty in it. I like himself, too, because he is such a hearty admirer. He does not give himself half-measure of praise or vituperation. He eulogizes, he reverences with his whole soul.[25]

And from George Eliot we have the first occasion on which Ruskin is referred to as a prophet. 'I venerate him', she wrote, 'as one of the great teachers of the day. The grand doctrines of truth and sincerity in art, and the nobleness and solemnity of our human life, which he teaches with the enthusiasm of a Hebrew prophet, must be stirring up young minds in a promising way.'[26]

These opinions were all privately expressed. Ruskin himself had no notion of them. The public reaction to the book, when it came, was not from such notable pens. John James, now pasting his son's reviews into a large ledger, was satisfied. They were unanimously flattering. They were not however of much intellectual weight.[27] The Ruskins were gratified by the *Britannia*'s notice, which they rightly guessed to be by Dr Croly, but the major journals gave no space to the book. Neither the *Athenæum* nor *Blackwood's* seemed to be aware of its publication. Turner was once again maligned for his contributions to the Royal Academy exhibition that May. And the painter himself said not one word to Ruskin about what he had written, about his 'labour for Turner'. Ruskin was not comforted to reflect that it was quite in Turner's character to say nothing on such an occasion, for the rest of his artistic acquaintance were slow to speak well of the book, whether or not they knew that it was his. *Præterita*, exaggerating somewhat, says,

> The sympathy of the art-circles, in praise of whose leading members the first volume of *Modern Painters* had been expressly written, was withheld from me much longer than that of the general reader . . . Taken as a body, the total group of Modern Painters were, therefore, more startled than flattered by my schismatic praise; the modest ones, such as Fielding, Prout, and Stanfield, felt that it was more than they deserved, — and, moreover, a little beside the mark and out of their way; the conceited ones, such as Harding and De Wint, were angry at the position given to Turner; and I am not sure that any of them were ready to endorse George Richmond's consoling assurance to my father, that I should know better in time.[28]

A personal effect of the appearance of *Modern Painters* was that it revealed to Ruskin his power as a writer. He now knew, as he had not quite known before, that writing was to be his instrument, his sword.

His desire to be valiant had found its expression. That so many people thought of his book as literature was welcome indeed to a young man who was now abandoning his poetic ambitions: he knew that there would have been no reaction to a book of his verses. To some extent this compensated for the moderate admiration of the artists he knew. Ruskin now began to find that to be known as an author gave him a special position. For a time, as it became an open secret that *Modern Painters* was his, he was a literary celebrity. He entered the world where fashion and culture were one. Under chandeliers, we find him in the company of Sir Robert Inglis, Richard Monckton Milnes, Samuel Rogers — it now was ten years since Henry Telford had given him Rogers's *Italy* — dining here, breakfasting there, leaving cards, accepting and returning invitations. This phase did not last long. As was to be the pattern throughout his life, a spell of party-going was followed by a return to his study, where he felt most at home. In any case, he was not perfectly suited to this company. He was not at ease with the women he met at such gatherings. Rogers was jealous and quarrelsome, Milnes a dilettante. There were tories 'of the old school' and Evangelicals around the dinner table at Sir Robert Inglis's. But the sentiments Ruskin heard there were somehow too worldly, too close to Parliament. Partly in reaction, he developed a hostility towards the book that had given him the *entrée* to such a world. In it, he told Liddell, 'there is a nasty, snappish, impatient, half-familiar, half-claptrap web of young mannishness'.[29] More publicly (and perhaps *Modern Painters*'s anonymity helped him here) he defended his book. Ruskin replied to the criticism which was published in the October number of *Blackwood's*. He also prepared a preface to the second edition of *Modern Painters*. But he had already realized that what was needed was a second book. With commendable self-discipline he now ignored his success and began to think again about his real, lonely, career as a writer.

<p style="text-align:center">★ ★ ★ ★</p>

A book as various as *Modern Painters* could give its author a variety of suggestions for a sequel. Ruskin's first book is in a grand sense miscellaneous. It is philosophy and æsthetics, and much more than that. It is poetry. It is prose. It is a treatise. It is a great pamphlet. It is a defence, or rather a vindication. It is a sermon. It is art criticism, art history, a commentary on recent exhibitions, or an introduction to certain collections. It is a meditation on landscape, or an exercise in how the eye may examine nature. Ruskin did not think to choose

between his various interests: hardly any book of his belongs to a
genre. The second volume of *Modern Painters* was to be a more compact
book than the first, but he prepared for it by a wide range of studies.
To his irritation, the 'Graduate of Oxford' had to return to the univer-
sity after the publication of his book. This was to keep the term he had
lost through illness. Ruskin stayed in rooms and, he improbably
claimed, 'learnt a great deal of Raffaele at Blenheim'.[30] There was
more stimulus in London than in Oxfordshire. Now began Ruskin's
lifelong association with the British Museum, its collections and their
keepers, for he went there to talk to Charles Newton, now a member
of its expanding staff. Newton's passion for classical archæology, so
little in accord with Ruskin's developing tastes, gave them plenty to
argue about. His knowledge of painting was growing in these quiet
months after the appearance of *Modern Painters* I, yet there was some-
thing that was not quite fresh about his studies. He took notes from
two books which he felt would give him a firmer knowledge of the
schools of European art and, perhaps, their relevance to English
painting of the day. Both were by foreigners. The first had not yet
been translated. Alexis Francis Rio's *De La Poésie Chrétienne* (1836)
became well known after 1854, when it appeared in England as *The
Poetry of Christian Art*: it was probably the widely read Liddell who
introduced it to Ruskin at this early date. Ruskin also studied G. F.
Waagen's *Works of Art and Artists in England* (1838). Waagen was
Director of the Berlin Gallery, and his book was written with author-
ity. It was not sufficiently appreciative of Turner, however, and
Ruskin's diary noted, 'I have had the satisfaction of finding Dr Waagen
— of such mighty name as a connoisseur — a most double-dyed ass.'[31]

 With Turner himself Ruskin's relations were increasingly cordial,
although the old man's moods and crotchets often baffled his admirer.
The relationship between the Ruskins and their favourite painter was
in large part commercial, the more markedly so since Turner had still
not acknowledged Ruskin's writing. John James's account book re-
veals that the new house on Denmark Hill was being filled with
Turner water-colours of the larger and more finished sort. In that year
he bought the *Llanthony Abbey, Dudley Castle, Land's End, Constance*
and *Derwent Water,* for prices ranging from fifty to one hundred
guineas. They were not enough for his son. Towards Christmas of
1843, when the Grays from Perth were once more staying with the
Ruskins, John took the fifteen-year-old Phemy (as she was generally
called) to see Windus's much larger collection. There, as usual, he was
struck with an acquisitive jealousy. Two days earlier, his diary had
recorded a meeting with Turner:

Very gracious: wanted me excessively to have some wine, but ambiguous as to whether he would or would not part with any of the works in his gallery. Couldn't make him out, and came away in despair. Says he fears there will be no sketches this spring; I shall be sadly disappointed. Phemy is a nice creature; played all the evening for me . . .[32]

Ruskin was perhaps attempting to buy directly from Turner without going through Griffith and without consulting his father. John Ruskin and John James Ruskin could not be in accord when thinking of buying Turners. If they talked together about possible purchases, it seemed always as if the father were making half-promises to the son. Neither of them, ever, dealt in half-promises. The discussions were painful to them both, and each feared the possibility of the other's resentment. Thus it was that John James now kept his own counsel in meditating a major acquisition. It was to be a congratulatory present. *The Slave Ship*, shown at the Royal Academy in 1840, was available through Griffith. Since he had the authority of his own son's book John James could not doubt that this was the right choice. *Modern Painters* said of the picture that it was 'the noblest sea that Turner has ever painted, and, if so, the noblest certainly ever painted by man'; and, further, that 'if I were reduced to rest Turner's immortality upon any single work, I should choose this'.[33] The price was only 250 guineas. Negotiations with Griffith went smoothly enough. The painting was brought out to Denmark Hill and, in Scottish fashion, was presented to Ruskin on New Year's Day.

The painting's full title was 'Slavers throwing overboard the dead and dying — typhon [sic] coming on', a theme probably suggested by an incident recounted in Thomas Clarkson's *History of the Abolition of the Slave Trade* (1808). One would look far to find a less domestic subject, and the painting appeared strangely in the entrance hall at Denmark Hill. Ruskin came down to it every morning on his way to the breakfast-room, then went upstairs past it on his way to his study. Perhaps its presence was a constant reminder to him that he should pitch high his writing. The passage in *Modern Painters* that described the picture had a kind of fame. Samuel Prout, who had seen the painting when it was still with Griffith, stood before it for some time and then exclaimed, 'by heaven all that Mr R[uskin] said of it is true!'[34] What Ruskin had in fact said (while relegating the overt subject of the picture to a footnote) was this:

It is a sunset on the Atlantic, after prolonged storm; but the storm is

partially lulled, and the torn and streaming rain-clouds are moving
in scarlet lines to lose themselves in the hollow of the night. The
whole surface of sea included in the picture is divided into two
ridges of enormous swell, not high, nor local, but a low broad
heaving of the whole ocean, like the lifting of its bosom by deep-
drawn breath after the torture of the storm. Between these two
ridges the fire of the sunset falls along the trough of the sea, dyeing it
with an awful but glorious light, the intense and lurid splendour
which burns like gold, and bathes like blood. Along this fiery path
and valley, the tossing waves by which the swell of the sea is
restlessly divided, lift themselves in dark, indefinite, fantastic
forms, each casting a faint and ghastly shadow behind it along the
illumined foam. They do not rise everywhere, but three or four
together in wild groups, fitfully and furiously, as the under strength
of the swell compels or permits them; leaving between them
treacherous spaces of level and whirling water, now lighted with
green and lamp-like fire, now flashing back the gold of the declin-
ing sun, now fearfully dyed from above with the undistinguishable
images of the burning clouds, which fall upon them in flakes of
crimson and scarlet, and give to the reckless waves the added
motion of their own fiery flying. Purple and blue, the lurid shadows
of the hollow breakers are cast upon the mist of night, which
gathers cold and low, advancing like the shadow of death upon the
guilty ship as it labours amidst the lightning of the sea, its thin masts
written upon the sky in lines of blood, girded with condemnation in
that fearful hue which signs the sky with horror, and mixes its
flaming flood with the sunlight, and, cast far along the desolate
heave of the sepulchral waves, incarnadines the multitudinous
sea.[35]

The passage prompts declamation: and like many another set piece in
Modern Painters had been written aloud, as Ruskin paced the fields and
gardens of his neighbourhood. Its literary background is not only
dramatic — from, of course, Macbeth's

> This my hand will rather
> The multitudinous seas incarnadine,
> Making the green one red[36]

— but is also to be found in an amount of English poetry from
Thomson to Coleridge, a type of verse that includes Turner's own
epic 'The Fallacies of Hope'. Self-conscious about the passage, worry-
ing over the connections between poetry, 'truth', and the factuality of
painting, Ruskin was to defend his description to Walter Brown. 'If I

had been writing to an artist in order to give him a clear conception of
the picture, I should have said':

> Line of eye, two-fifths up the canvass; centre of light, a little above
> it; orange chrome, No 2 floated in with varnish, pallet-knifed with
> flake white, glazed afterwards with lake, passing into a purple
> shadow, scumbled with a dry brush on the left, etc. Once leave this
> and treat the picture as a reality, and you are obliged to use words
> implying what is indeed only seen in imagination, but yet what
> without doubt the artist intended to be so seen; just as he intended
> you to see and feel the heaving of the sea, being yet unable to give
> motion to his colours. And then, the question is, not whether all
> that you see is indeed there, but whether your imagination has
> worked as it was intended to do, and whether you have indeed felt
> as the artist did himself and wished to make you . . .[37]

The letter reflects a more practical interest in oil painting. Ruskin's
own few experiments with the medium belong to the period after the
publication of *Modern Painters* I. They came to nothing, or next to
nothing, for he did not fully enjoy the medium. Like many other
excellent critics and teachers, Ruskin was only half a creative artist. He
responded to art, he could urge art on, but he did not like to fashion
things. With Edmund Oldfield, he had a scheme to design stained
glass windows for Camberwell Church. But this gave him no more
real pleasure than did oil painting. He liked to draw; and a pen or fine
pencil line, supplemented by body-colour or water-colour, was
always to be his true medium. Drawing was closer to his instincts for
recording, measuring and classifying. It was drawing that linked his
love of geology with his love of art. Geology had the feeling, for
Ruskin, of a science in its youth, a science in which all might be
discovered. The foreign tour of 1844 was in essence an expedition to
Chamonix and the Simplon. Ruskin's diaries witness his studies in the
Alps, and an autobiographical chapter in *Deucalion,* his book devoted
to geological matters, records a memorable meeting that summer.
The Ruskins were staying at an Alpine inn:

> . . . my father and mother and I were sitting at one end of the long
> table in the evening; and at the other end of it, a quiet, somewhat
> severe-looking, and pale, English (as we supposed) traveller, with
> his wife; she, and my mother, working; her husband carefully
> completing some mountain outlines in his sketch-book. Whether
> some harmony of Scottish accent struck my father's ear, or the
> pride he took in his son's accomplishments prevailed over his own
> shyness, I think we first ventured word across the table, with view

of informing the grave draughtsman that *we* also could draw. Whereupon my own sketch-book was brought out, the pale travel- ler politely permissive. My good father and mother had stopped at the Simplon inn for me because I wanted to climb to the high point immediately west of the Col, thinking thence to get a perspective of the chain joining the Fletschorn to the Monte Rosa. I had brought down with me careful studies . . . of great value to myself, as having won for me that evening the sympathy and help of James Forbes. For his eye grew keen, and his face attentive, as he examined the drawings; and he turned to me instantly as to a recognized fellow-workman, — though yet young, no less faithful than himself . . . He told me as much as I was able to learn, at that time, of the structures of the chain, and some pleasant general talk followed; but I knew nothing of glaciers then, and he had his evening's work to finish. And I never saw him again.[38]

To James Forbes's position in Alpine exploration and geology we will return, as did Ruskin. He knew his fellow guest in the Simplon inn as the author of *Travels through the Alps of Savoy and other parts of the Pennine Chain* (1843), which had extended the studies of the Louis Agassiz Ruskin had read in Leamington. Forbes was to be a controver- sial figure for thirty years yet, and Ruskin his distant ally, for indeed their paths were not to cross again. Now, the Ruskins hired an Alpine guide who became much more than a servant to them, and who remained a family friend until his death in 1874. Joseph Couttet, whom Ruskin called 'the captain of Monc Blanc', was of the race of guides who were becoming famous in these early years of the English conquest of the high peaks. His father had been de Saussure's guide. Joseph himself, a veteran of the Napoleonic armies, was fifty-two in 1844. Reliable, thrifty, avuncular, he soon had all the Ruskins's confi- dence. 'For thirty years he remained my tutor and companion', says *Præterita*. 'Had he been my drawing master also, it would have been better for me . . .'[39] Osborne Gordon joined them at Zermatt, and under Couttet's guidance the party became even a little adventurous, supping on black bread and sour milk under the Riffenberg, and then 'my mother, sixty-three on next 2nd September, walking with me the ten miles from St Nicholas to Visp as lightly as a girl. And the old people went back to Brieg with me, that I might climb the Bel Alp (then unknown), whence I drew the panorama of the Simplon and Bernese range . . .'[40]

It is in *Deucalion,* Ruskin's compendious geological volume, that one quarries further reminiscences of this summer in the Alps and its

steady, joyful work; for instance, above the gorge of the Aletsch torrent — making some notes on it afterwards used in *Modern Painters*, 'many and many such a day of foot and hand labour having been needed to build that book'.[41] He kept Cary's Dante by him as he worked: he was using it to elevate his thoughts. He was full of love for the mountains and after long weeks among them was depressed by the thought of dustier work that lay before him in the Louvre on the way home. From Paris he told George Richmond, 'I have been on the hills some ten hours a day at the very least' and 'in this garret at Meurice's, the memory of snow and granite makes me testy'.[42] He was writing to Richmond to ask which pictures he should study in the Louvre. There are some notes on Venetian art in the travel diary that Ruskin had begun in Geneva on 1 June and was to close on his return to London on 20 October. One senses how perfunctory were his visits to French galleries and palaces. But the last entry in the journal is a happy one:

> Have not written a word since returning from Chamouni, for my days pass monotonously now. Only I ought to note my being at Windus's on Thursday to dine with Turner and Griffith alone and Turner's thanking me for my book for the first time. We drove home together, reached his house about one in the morning. Boylike, he said he would give sixpence to find the Harley St. gates shut, but on our reaching his door, vowed he'd be damned if we shouldn't come in and have some sherry. We were compelled to obey, and so drank healths again, exactly as the clock struck one, by the light of a single tallow candle in the under room — the wine, by the bye, first rate.[43]

1845–1846

Just as some events in life, however unexpected, seem to confirm or explain what had preceded them, so Ruskin's tour to Italy in 1845 gave a shape to what had only been stirring in his mind. The first purpose of the tour, a reaction from his disappointing visit to the Louvre in the previous year, was to study Italian painting *in situ*. But he learnt more, and more about himself, than he imagined he might. He was to be away from home, and from his parents, for seven months. It changed him. Interests became convictions. His taste became active, and with added historical understanding. But some experiences of art this summer touched him so vividly that they had the effect of precluding further modulation of his taste. It was one of the ways in which his opinions on art became frozen. Inflexibility was already a danger to his sensibility. He half realized this, but explained it away by saying that he had to learn more. George Richmond attempted to make him look for good qualities in painting he instinctively disliked. But Ruskin was too impatient. He would listen to Turner, of course, but the painter was scarcely concerned to train young art critics. He often told his eloquent champion that 'all criticism was useless'.[1] He told Ruskin of his disapproval of the strictures in *Modern Painters* on his lesser contemporaries: 'You don't know how difficult it is.'[2] It was true that Ruskin knew little about working in oil. But he had a fair idea about drawing and water-colour. In the winter of 1844-5 he was working from Turner's own *Liber Studiorum*. Although the diaries are sparse, one has the impression that he saw Turner quite often. The conversations between the two men are unimaginable. What Ruskin records of them hints that they were approaching the mysterious slight on Ruskin's integrity for which, he later told Carlyle, 'I never forgave him'.[3] On the other hand, there is such a quantity of Turnerian lore in Ruskin's later writing, and of such a type, that one feels that it must derive from conversations in the studio. Ruskin later said that these were intimate. Certainly Turner was enough of a friend of the Ruskin family to give family advice. He knew how alarmed Ruskin's parents would be at the thought of their son travelling abroad without them. He constantly attempted, Ruskin later recalled, to dissuade him; and so, 'When at last I went to say good-bye, he came down with me into the hall in Queen Anne Street, and opening the door just enough for

me to pass, laid hold of my arm, gripping it strongly. "Why will you go to Switzerland — there'll be such a fidge about you, when you're gone." '4

This of course was the first time that Ruskin had travelled abroad — or scarcely anywhere — without the company of John James or Margaret. He was twenty-six. Perhaps with reason, his parents were concerned about his safety, for which they made arrangements. He was to travel with George Hobbs and with Couttet. They would meet the Swiss guide at Geneva, and he would act as courier and watch over Ruskin's health. To travel apart from his family did not trouble Ruskin: geographical separation from those he loved never meant much to him. For his parents, however, it was painful. His eager and vital presence in Denmark Hill brightened their lives. It did more than that. For the son's constant activity had an invigorating effect on the father. When Ruskin was away from home John James was a lesser man. Margaret Ruskin felt this in her turn, for she was far more responsive to her husband's moods than to her son's. John James was hypersensitive to the movements of Ruskin's opinions. The old lady usually ignored what he was thinking. She now packed Bunyan's *Grace Abounding to the Chief of Sinners* in his bag, though he had told her often enough of his dislike for the book. Mildly and subserviently he remonstrated with her. It made no difference. This was often how theological matters were left to rest. Had she known them, she would have been alarmed at Ruskin's religious opinions this winter. Just before Christmas of 1844 he had spent a couple of days in his parish with the recently ordained Edward Clayton. His Christ Church friend's rather grim religious views prompted Ruskin to write to Henry Acland as follows, for Acland had many friends and relatives in the high church party:

I have been in the country — for a day or two — with Edward Clayton . . .
. . . Now you know — Acland, that I wish as far as may be in my power — to keep with the highest Church supporters — but I hope to heaven this is not their general doctrine . . . For — I am no ultra Protestant — on the contrary — I am far too much inclined the other way — I dispute not transubstantiation — I refuse neither to fast nor to confess myself — I would not check at praying to the Virgin — I abhor not the invocation of saints — I deny not the authority of the Church — But there are two things that I *do* deny — yea, I will deny — so long as I have sense — the first — that man can forgive sins — the second — that God can behold iniquity — i.e. — the doctrines of

a purchased absolution — and a *merited* redemption. In these two —
& in them only — it seems to me the power & poison of the Papacy
rests — and as soon as the priest becomes the arbiter instead of the
Performer of our righteousness — then and there I think the axe is
laid to the root of our religion — and the way opened for all manner
of blasphemy & sin.[5]

These remarks are so startling that the letter was suppressed by
Ruskin's first editors. Those who best understood him, like Acland,
knew that he would say something quite different to the next friend.
To Ruskin, religious belief was often a matter for argument. Many
men in holy orders were to rue his delight in being contentious. If he
felt falseness in another man's God, he was capable of arguing a
different view with a strange, pitiless gusto. But he had a sense of
divinity in others. His feeling for George Herbert — not all that
common in the earlier part of the nineteenth century — is one exam-
ple. He had discussed his poetry with Clayton at Christ Church. He
now used Herbert to try to show his mother how *Grace Abounding*
suffered from the narrowness and inflexibility of its conviction. She
took no notice, but George Hobbs probably did. Their life abroad had
one constant feature. Every morning young Ruskin would read with
his young servant a chapter or two of the Bible, and the English
service. They would then talk about the meaning of the Scripture. We
must imagine them in a Paris hotel room, taking the purity of English
religion with them, in chapters and verses. As they drove south,
Ruskin approached the papist Continent as though he bore St
George's own banner. That did not prevent him from travelling
luxuriously. His coach was a marvel, a *calèche* drawn by two horses,
shining black and gilt. There were good coach-builders in Camber-
well, before the railways ruined everything. The roof opened to the
sun, the springs were buoyant, here was the buggy and here was the
rumble-seat. Inside were any number of pockets and drawers and little
bookcases; a place for his writing-case (the only part of his luggage
Ruskin ever packed for himself) and clever leather frames to hold the
selection of Turner water-colours he took with him wherever he
went. Who could not be happy as the day is long, to travel in a vehicle
such as this? At Champagnole Ruskin had two trout from the river, a
woodcock, then soufflé, with a bottle of Sillery *mousseux*.

Meanwhile the sun was sinking gradually, and I was warned of
something equally perfect in *that* direction & way, by seeing my
champagne suddenly become *rose*. And a beautiful sunset it was —
glowing over the pinewoods, and far up into sky, long after the sun

went down. And as I came back to my souffle & sillery, I felt sad at
thinking how few were capable of having such enjoyment, and very
doubtful whether it were at all proper in me to have it all to myself.[6]

<div align="center">★　　★　　★　　★</div>

The changing urgencies of the tour were only half understood by
Couttet and George, compelled by their young master to linger in
some places and flee from others. Sometimes there was a relaxed halt,
but not often. One such produced the interesting drawing of the
Italian maritime pine, done at Sestri as they passed from the French
and Italian rivieras and approached the Carrara hills (Plate 8). Thence
they sought Lucca, 'where I settled myself', *Præterita* says, 'for ten
days, as I supposed. It turned out forty years.'[7] Ruskin meant that he
found his life's interests there. His stay at Lucca was for little more
than a week. But it gave a vivid prelude and direction to his studies of
mediæval painting and architecture. Lucca also gave him the contrast
between the old Italy and the new, between mediæval order and
restive modern conditions. In 1845 the city was governed as a duchy.
Soldiers lounged outside the ducal palace: a military band played.
Beggars were everywhere. And in the church of San Frediano,

> Such a church — so old — 680 probably — Lombard — all glorious
> dark arches & columns — covered with holy frescoes — and gem-
> med gold pictures on blue grounds. I don't know when I shall get
> away, and all the church fronts charged with heavenly sculpture and
> inlaid with whole histories in marble — only half of them have been
> destroyed by the Godless, soulless, devil hearted and brutebrained
> barbarians of French — and the people here seem bad enough for
> anything too, talking all church time & idling all day — one sees
> nothing but subjects for lamentation, wrecks of lovely things des-
> troyed, remains of them unrespected, *all* going to decay, nothing
> rising but ugliness and meanness, nothing done or conceived by
> man but evil, irremediable, self multiplying, all swallowing evil,
> vice and folly everywhere, idleness and infidelity, & filth, and
> misery, and desecration, dissipated youth & wicked manhood &
> withered, sickly, hopeless age . . .[8]

In San Frediano Ruskin first thought to trace and copy frescoes
before they rotted or fell to pieces, or were simply destroyed to make
way for new tombs, new monuments. At the same time he worried
that this might waste his time, that paintings in the next church might
be desecrated even at that moment. In search of a general knowledge
of Italian art, he now found two works that kept a symbolic meaning

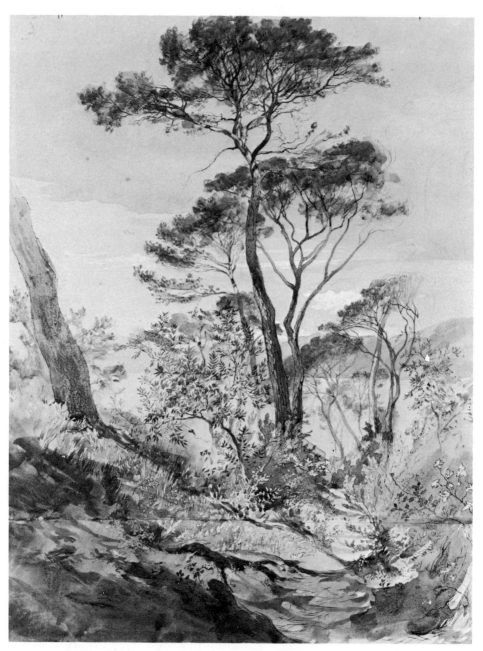

8. *Stone Pine at Sestri*, by John Ruskin, 1845.

for him all through his life. One was a painting, the other a recumbent statue. In the Dominican church of San Romano he stood before the Fra Bartolommeo *God the Father with Mary Magdalene and St Catherine of Siena*. This is not a picture of the first quality, and was not in fact what he called it: 'the first example of accomplished sacred art I had seen'.[9] But it gave him a serene, lofty ideal: it was a token that there had been a whole realm of art, centuries of it, that had belonged to God. A similar realization, only a day or two later, came from a piece of sculpture. This was Jacopo della Quercia's tomb of Ilaria di Caretto (Plate 9). It dates from the early fifteenth century and is perhaps more Gothic than early Renaissance in feeling. Ruskin was enraptured. It seemed to him that he had never experienced sculpture before. Nor, it seems to us, was he ever to have any feeling for sculpture that surpassed this early delight. It became a touchstone, and perhaps too much of a touchstone. The young wife lying in death had a haunting impression on Ruskin. In years to come her image would be confounded with that of Rose La Touche; and as one reads the description of the monument that Ruskin now sent to his father, one senses not only the tone but also part of the inspiration of later, desolate, marmorial writing.

> This, his second wife, died young, and her monument is by Jacopo della Querce, erected soon after her death. She is lying on a simple pillow, with a hound at her feet. Her dress is of the simplest middle age character, folding closely over the bosom, and tight to the arms, clasped about the neck. Round her head is a circular fillet, with three

9. *Tomb of Ilaria di Caretto*, by Jacopo della Quercia, at Lucca, by John Ruskin, sketched in 1874.

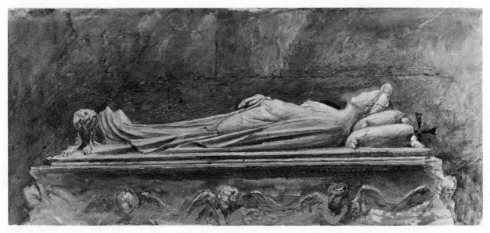

star shaped flowers. From under this the hair falls like that of the
Magdalene, its undulation *just* felt as it touches the cheek, & no
more. The arms are not folded, nor the hands clasped nor raised.
Her arms are laid softly at length upon her body, and the hands
cross as they fall. The drapery flows over the feet and half hides the
hound. It is impossible to tell you the perfect sweetness of the lips &
the closed eyes, nor the solemnity of the seal of death which is set
upon the whole figure. The sculpture, as art, is in every way perfect
— *truth* itself, but truth selected with inconceivable refinement of
feeling. The cast of the drapery, for *severe natural* simplicity &
perfect grace, I never saw equalled, nor the fall of the hands — you
expect every instant, or rather you seem to see every instant, the last
sinking into death. There is no decoration or work about it, not
even enough for protection — you may stand beside it leaning on
the pillow, and watching the twilight fade over the sweet, dead lips
and arched eyes in their sealed close. With this I end my day, &
return home as the lamps begin to burn in the Madonna shrines; to
read Dante, and write to you. [10]

In Ruskin's response to the Fra Bartolommeo and the della Quercia
there was a feeling for their location, their placing in quiet holy places
of the town. Lucca itself, Ruskin noted, had within its rampart walls
'upwards of twenty churches . . . dating between the sixth and twelfth
centuries'. [11] His short stay included some drawing of these churches.
He afterwards believed that this marked the beginning of his architec-
tural studies. *The Poetry of Architecture,* since its stance was both
English and picturesque, had to be forgotten. The change is marked
by a different kind of drawing, especially of façades. Ruskin's graphic
style became more notational as he looked at the church of San
Michele (Plate 10). The drawings were scarcely composed and there
was no attempt to finish them once the detail had been caught. In this
respect they closely correspond to the visual experience of looking at a
Gothic church with a will to consider it in part rather than in whole. In
Pisa, where the party travelled next, he used his notebooks more fully
and the study of such churches is accordingly more complete. He was
teaching himself how to grasp architecture, preparing for those won-
derful notebooks from which he was to write *The Stones of Venice.*

Ruskin was surprised to find how much his reactions had changed
since he was last in this part of North Italy in 1840. Lucca then he had
reckoned 'an ugly little town'. Pisa 'as *town* is very uninteresting'. [12]
The Campo Santo in Pisa he had been 'thoroughly disappointed in: it
is very narrow, not elegant, and totally wanting in melancholy or in

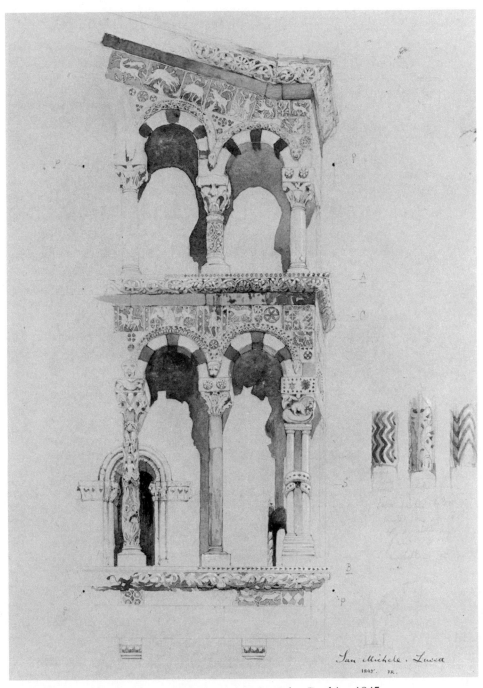

10. Part of the façade of S Michele in Lucca, by John Ruskin, 1845.

peace, the more so for being turned into a gallery of antiquities'. [13] In 1845 it was the Campo Santo above all that moved him: 'My mind is marvellously altered . . . everything comes on me like music.'[14] The simile had to do with the way that *quattrocento* art had displayed itself to him. It was grave sometimes, sweet sometimes, seraphic always. Ruskin gave himself up to the frescoes. Yet he was almost equally stirred by his conviction that they were all threatened. His letters are alternately filled with ecstatic descriptions of the paintings and expressions of rage at their probable fate. In his more meditative moments he found that he could make an alliance between his Protestant mind, his searching in antiquity, fresh enthusiasm, and a kind of realism he found in the pictures. The Campo Santo was a graphic Bible. In it there was an ancient truthfulness. He wrote to his father,

> I never believed the patriarchal history before, but I do now, for I have seen it. You cannot conceive the vividness & fullness of conception of these great old men . . . Abraham & Adam, & Cain, Rachel & Rebekah, all are there, the very people, real, visible, created, substantial, such as they *were,* as they must have been — one cannot look at them without being certain that they have lived — and the angels, great, & real, and powerful, that you feel the very wind from their wings upon your face, and yet expect to see them depart every instant into heaven . . .[15]

Most of these impressions are taken from paintings by Benozzo Gozzoli, but he passed swiftly to others. On 18 May he could report of his progress, 'Benozzo I have done, & Giotto I am doing, then I have Simon Memmi, Antonio Veneziano, & Andrea Orgagna [*sic*].'[16] Some of Ruskin's attributions were wrong, and remained wrong. This scarcely mattered. He had found a new way of looking at the world.

Art historians of Ruskin's and later generations knew what tact, guile, patience and willpower are needed to have a scaffolding erected in an Italian church. Ruskin, with his money, charm, and servants, somehow managed it immediately. He soared above difficulties. Couttet and George sorted things out at ground level. He drew and traced from the frescoes, aware as he did so that the whole shape and the whole subject of the next volume of *Modern Painters* was now quite changed. What the book would contain he could not foretell: but in some way he changed his plans and his itinerary in accordance with his feelings for it. A few more days, he imagined, and he might get to the end of 'my *resumé*' of Pisa: it was as though (as writers and lecturers sometimes can) he was able to feel already the further end of his

peroration. The relationship between this tour and *Modern Painters* II is obvious and can be demonstrated in one hundred details. Behind that, there is a similarity in the pace and the vision of the book and the tour. There were high points and more high points, and scarcely more than breathing spaces between them. In Lucca and in Pisa, as everywhere else in Italy, he found that there was more to be done, more to be understood, than ever he had imagined. Probably it was now that he realized that *Modern Painters* would have more than two volumes. He also realized that he had thrown away parts of his past life. The first volume of his book was effaced from his mind. So was his poetry: he had no time for it. Oxford he had no thought for: he was learning more in a few months than he had in years at the university. He wrote to Osborne Gordon to say that he did not wish to meet him. Suddenly, Rogers and his *Italy* seemed beside the point. He quoted Rogers to his father, but he no longer believed in him. John James, reading his daily letters (that took the place of Ruskin's diary entries) in Billiter Street, could not keep pace with his son's discoveries. This disturbed him so much that he redoubled his warnings about health. Ruskin told his father that he would eat no figs, that he drank clean water, that his scaffold was safe. He sent him accounts of what he spent, and scarcely ever failed to be dutiful, entertaining and reassuring.

In Florence, where he arrived at the end of May, he had most need to tell his parents of his safety. There were signs of strain which could not be kept out of the letters home. Neither of his servants had any control over his mental activity. He was often at work in the churches at five o'clock in the morning and did not cease until mid-evening. Nor was this merely a tourist's long day. Only by taking the notebooks and drawings in one's own hand, and then by attempting to cover the same ground, can one appreciate the ferocity of his study. But this is to simplify. He had a different pace for different uses of the pen. Script, one can tell, is extraordinarily rapid. One gathers this not so much from the handwriting as by taking any lengthy sentence and then by discovering how its subordinate clauses, as one transcribes it, take one beyond the point where one can recall its initial impetus. Meanwhile, we note of his drawing in 1845 that it tends to be more cursive in landscape subjects such as the Sestri pine, while the study of architectural detail and outlines of paintings are of necessity drawn more slowly. They are not, however, laborious; and many personal recollections of Ruskin when drawing indicate that his pen and brush were more fluent than most people's.

In Florence, much of his time was spent in drawing. He wrote his last poem, 'Mont Blanc Revisited', feeling that his time was being

wasted. 'I haven't time if I draw to see half the things — and I must draw too, for my book,' he wrote to his father,[17] adding next day that 'there is so much to be read and worked out that it is quite impossible to draw, except the little studies for my book. I regret this the more because unless I draw a bit of a thing, I never arrive at conclusions to which I can altogether trust.'[18] Thus it went on, Ruskin now adding to his labours by borrowing books from the library of Santa Croce. For relaxation he sometimes helped the monks at their haymaking, on the hill of Fiesole. But for two months, almost without remission, he was absorbed in Giotto studies, in the Ghirlandaio chapel of Santa Maria Novella, finding Masaccio and Fra Filippo Lippi in the Brancacci Chapel and Fra Angelico in the Convent of San Marco.

<p style="text-align:center">★ ★ ★ ★</p>

Ruskin was tired by this effort. Advised by Couttet, he decided not to remain in Italy in midsummer. 'I begin to feel the effects of the violent excitement of the great art at Florence — nothing gives me any pleasure at present, and I shall not recover spring of mind until I get on a glacier.'[19] The party went up through Milan to Como and finally to Macugnaga in the Val Anzasca. Here, high in the mountains, Ruskin rented a chalet, little more than a hut. It was next to a torrent, approached by a stony path and a pine bridge, rocks and waterfalls to one side, pines and 'stunted acacias' on the other. In Switzerland they again found haymaking. Ruskin walked on the mountains from dawn and gave his hand to the peasants in the evening. The valley was his. He conceived the idea of asking Turner to stay with him there. Affecting the casual, he enclosed the invitation in a letter to John James, saying 'is the gentleman doing anything — if he isn't, tell him he may as well come here & catch fish and climb hills with me . . .'.[20] In truth, he wanted to stand at Turner's shoulder to see how he drew mountains. But the artist would not come; and Ruskin buried himself in Shakespeare.

In all Ruskin's books there are more references to Shakespeare than to any other writer, excepting only Dante. Like other great English-men, Ruskin learnt Shakespeare early and knew ever afterwards that he was part of his own mind: one does not often find occasions when Ruskin deliberately sat down to study him. Nor did he often write directly about the plays. The dispersion of his comments has the effect of obscuring how complete a Shakespearian he was. In 1886, looking back on his days in Macugnaga, and writing in sadness and defeat, Ruskin observed:

. . . the writer himself is not only unknowable, but inconceivable; and his wisdom so useless, that at this time of being a speaking, among active and purposeful Englishmen, I know not only who shows a trace of ever having felt a passion of Shakespeare's, or learnt a lesson from him.[21]

Thus the despairing *Præterita* recalls but slightly perverts what indeed was Ruskin's experience of the weeks in Macugnaga in 1845: that there were no *lessons* to be drawn from reading Shakespeare that summer. And while he knew that he needed to relax, Ruskin had still a desire for books that would cut a path for him. 'Formerly I hated history, now I am always at Sismondi,' he now told his father. 'I had not the slightest interest in political science, now I am studying the constitutions of Italy with great interest . . .'[22] Jean-Charles-Leonard Simonde de Sismondi's *Histoire des républiques italiennes au moyen age* (1838), whose three volumes Ruskin carried with him, can be added to Rio's *Poésie Chrétienne* as a book which shaped Ruskin's growing mediævalism. He had an instinct and a desire for such writing. Shakespeare was put away, and study resumed.

Before he left the Alps Ruskin spent much time in that kind of work, half scientific and half artistic, which he had invented for himself, pursuing observations of sky or granite, glacier or woodland. One day 'I stopped 5 hours, watching the various effects of cloud over the plains of Lombardy, after getting the forms of the mountains that I wanted above the valley of Saas.'[23] A day or two later, from Faido, St Gothard, he writes of his location of a Turner site: 'I have found his subject, or the materials of it, here; and shall devote tomorrow to examining them and seeing how he has put them together.'[24] Ruskin was on his way to Baveno, where he had a rendezvous with J. D. Harding. They met: and sketching as they went, attended still by Couttet and the exhausted George, the two water-colourists went by Como, Bergamo and Verona to Venice. Ruskin was drawing now in genuine rivalry with his former master. But the interest they took in each other's work was brought to a halt by the experience of Venice. Ruskin's first reaction was negative: it was one of horror at modern improvements. Approaching the city, deliberately, from the pictures-que angle that he recalled from 1835, he suddenly found the new railway bridge from Mestre 'entirely cutting off the whole open sea & half the city, which now looks as nearly as possible like Liverpool at the end of the dockyard wall . . .'.[25] Everywhere he seemed to find neglect of the Venetian treasures, and signs that it would shortly become even like an English manufacturing town. It wrung from him

the cry that would be repeated in the first sentence of *The Stones of Venice* a few years later: 'Tyre itself was nothing to this.'[26]

For a few days, Ruskin could not settle to the study of painting, beyond noting how he could find 'among the wrecks of Venice, authority for all that Turner has done of her'. He told his father, 'I have been in such a state of torment since I came here that I have not even thought of Titian's existence.'[27] He would not much do so. Nor would he much consider the Bellinis, nor look as he had intended for Giorgione. He was to have the revelation of a quite different artist.

I have had a draught of pictures today enough to drown me. I never was so utterly crushed to the earth before any human intellect as I was today, before Tintoret. Just be so good as to take my list of painters, & put him in the school of Art at the top, top, top of everything, with a great big black line underneath him to stop him off from everybody — and put him in the school of Intellect, next after Michael Angelo. He took it so entirely out of me today that I could do nothing at last but lie on a bench & laugh. Harding said that if he had been a figure painter, he never could have touched a brush again, and that he felt more like a flogged schoolboy than a man — and no wonder. Tintoret don't seem to be able to stretch himself till you give him a canvas forty feet square — & then, he lashes out like a leviathan, and heaven and earth come together. M Angelo himself cannot hurl figures into space as he does, nor did M Angelo ever paint space itself which would not look like a nutshell beside Tintoret's. Just imagine the audacity of the fellow — in his massacre of the innocents one of the mothers has hurled herself off a terrace to avoid the executioner & is falling headforemost & backwards, holding up the child still. And such a resurrection as there is the rocks of the sepulchre crashed all to pieces & roaring down upon you, while the Christ soars forth into a torrent of angels, whirled up into heaven till you are lost ten times over. And then to see his touch of quiet thought in his awful crucifixion — there is an *ass* in the distance, feeding on the remains of strewed palm leaves. If that isn't a master's stroke, I don't know what is. As for *painting,* I think I didn't know what it meant till today — the fellow outlines you your figure with ten strokes, and colours it with as many more. I don't believe it took him ten minutes to invent & paint a whole length. Away he goes, heaping host on host, multitudes that no man can number — never pausing, never repeating himself — clouds & whirlwinds & fire & infinity of earth & sea, all alike to him — and then the noble fellow has put in Titian, on horseback at one side of

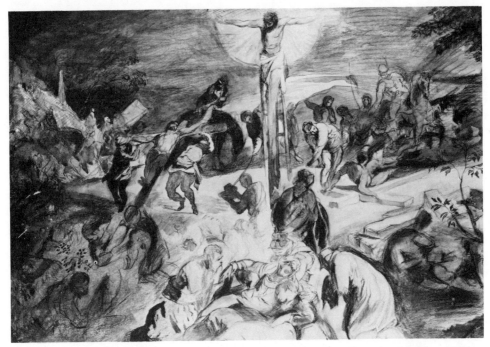

11. Copy after the central portion of Tintoretto's *Crucifixion*, by John Ruskin, 1845.

one of his great pictures, and himself at the other, but he has made Titian principal. This is the way great men are with each other — no jealousy there . . .[28]

Experiencing the physicality and great size of the paintings in the Scuola di San Rocco, Ruskin was so overwhelmed that he could not make the correct comparisons with Titian. In truth there is not much that is essential to Tintoretto's art that had not been more beautifully expressed by Titian. But Ruskin was not able to think in such terms. All life long he overrated Tintoretto, as if in honour of this experience. Now as ever afterwards his response was personal and partial, and in expression overstated. His judgements on painting were scarcely ever tempered by the local and comparative methods of the art historian. And he now began to pit himself — as always he would — against the founders of this new intellectual discipline. The tour of 1845 produced some writing that was never collected, Ruskin's additional notes to Murray's *Handbook for Travellers in North Italy*. This material appeared in the 1847 edition signed only as '(R)'. Sir Francis Palgrave, the compiler of the original work, is bitingly criticized in his own book.

Ruskin now met another classifier and recorder, Mrs Anna Jameson, who was working on the Venetian sources of her *Sacred and*

Legendary Art. He also made the acquaintance of the English connoisseur, William Boxall, who was later to be Director of the National Gallery. The three made expeditions together. Boxall knew Wordsworth, and Ruskin rather admired him. Mrs Jameson, however, 'knows as much of art as the cat'.[29] She was older than Ruskin and had much determination. But he found that his understanding of the Italian schools was way beyond hers. Boxall was to remain a friend, though a distant one, for many years. *Præterita* remembers Mrs Jameson kindly. *Sacred and Legendary Art,* however, is a poor thing in comparison with the truly spiritual second volume of *Modern Painters,* just as her book on Shakespeare's heroines falls limply beside only two pages of comment on Shakespeare which Ruskin incorporated in the Alpine passages of the fourth volume of his earliest great work.

There is a touch of arrogance in Ruskin's dealings with Mrs Jameson. This is only to be expected. The revelations of the past few months had demanded something from Ruskin's sensibility and from his personality: he had responded with the kind of effort that a man can perhaps only make in his twenties. He had matched his own potential against his discoveries. A young man can learn, and become more learned. He can find things in life of which he was unaware. Ruskin had done these things, and had done more than that. He had enlarged himself. This could not protect him from the consequences of his overwork. Couttet, with a gentle care that Ruskin could often inspire in other men, had warned him of the reaction that might come. Harding left, Boxall left, but Ruskin stayed on to make further studies in the city. For the first time he used daguerrotypes to record buildings, but most of his labour was in drawing and making voluminous notes. Almost feverishly, he sought to capture as much of Tintoretto and Venice as he could. On the way home, after seven months abroad, he succumbed. He was ill at Padua and again, after bidding farewell to Couttet, on the journey to Paris. He did not visit the Louvre but hurried straight home, arriving at Dover on 5 November.

★ ★ ★ ★

Much of the tension that Ruskin felt during his tour concerned his obligations to his parents. His dutiful letters to Denmark Hill give almost daily reassurances about his health and safety. Towards the end of his long stay the messages from his parents often asked him to come home. One letter in particular made him think of his mother and her grief: it told him of two deaths, of his cousins Mary and John, of the Croydon Richardsons. When he opened his next year's diary, half-

12. *Corner of St Mark's after Rain*, by John Ruskin, 1846.

way through the composition of *Modern Painters* II, Ruskin wrote an honest analysis of his feelings at the time:

I ought to note one circumstance — a series of circumstances — connected with the past year which ought to be as important, as any that ever happened to me. From about the close of September at Venice, to the 26th of October, or thereabouts, at Vevay, I had been kept almost without letters, except one or two at Brieg full of complaints of my stay at Venice. I was much vexed at Vevay by finding no letter of credit there and the next day I received the news of my cousins' deaths (Mary and John) — Sufficiently uncomfortable in these several respects and not very well. I received in passing through Lausanne (and that by chance, having doubted whether I should send George to post a letter half way down the town, and only let him go because I was busy drawing some figures at a fountain and couldn't interrupt myself) a short letter from my Father, full of most unkind expressions of impatience at my stay in Venice. I had been much vexed by his apparent want of sympathy throughout the journey, and on receiving this letter my first impulse was to write a complaining and perhaps a bitter one in return. But as I drove down the hill from Lausanne there was something in the sweet sunshine between the tree trunks that made me think better of it. I considered that I should give my father dreadful pain if I did so, and that all this impatience was not unkindly meant, but only the ungoverned expression of extreme though selfish affection. At last I resolved, though with a little effort, to throw the letter into the fire, and say nothing of having received it, so that it might be thought to have been lost at Brieg, whence it had been forwarded. I had no sooner made this resolution than I felt a degree of happiness and elation totally different from all my ordinary states of mind, and this continued so vivid and steady all the way towards Nyon that I could not but feel there was some strange spiritual government of the conscience; and I began to wonder how God should give me so much reward for so little self-denial, and to make all sorts of resolves relating to future conduct. While in the middle of them we stopped to change horses at Rolle, and I got out and sauntered down, hardly knowing where I went, to the lake shore. I had not seen Mont Blanc all the journey before, and was not thinking of it, but when I got to the quay there it was, a great and glorious pyramid of purple in the evening light, seen between two slopes of dark mountain as in the opposite page [where there is a drawing] — the lake lying below as calm as glass. In

the state of mind in which I then was it seemed a lesson given by my own favourite mountain — a revelation of nature intended for me only.[30]

Further notes in this diary reveal how Ruskin then devoted himself to spiritual exercises, 'continuing in earnest prayer and endeavour, or determination to do right',[31] while fighting the physical effects of what was surely a nervous illness. His sense that he was called to do great work was never in perfect concord with what his parents expected of him. There is for this reason a slight element of expiation in *Modern Painters* II, which was written in London in the winter of 1845-6 and published the following spring. If the whole of *Modern Painters* is Ruskin's great gift to his father, then its second volume is a subsidiary gift to his mother. More formally religious than the first volume, and much more like her religion than like John James's, it reads as though its intention was to gladden her. At the same time, the book could not quite present an explanation to John James of how his son had stepped away from him. Both of them knew that this had happened, and neither could do anything about it. Ruskin promised his father that the next year they would all travel together and he would show them the wonderful things that he was now writing about. But there was still a gap between them. *Modern Painters* II is in some respects a solitary book, for it is the record of one young man's pilgrimage and the formation, by revelation, of a most personal taste. What the book has to say about this is of importance. 'True taste is for ever growing, learning, reading, worshipping, laying its hand upon its mouth because it is astonished, lamenting over itself, and testing itself by the way it fits things.'[32] It is a bold image, the more so for being active and physical, a youthful thought that belongs (as Ruskin himself belongs) to the period between Romanticism and the beginnings of a modern apprehension of art. Ruskin cultivated the self-awareness of such taste. Of necessity, it was his alone.

But the reading that contributed to *Modern Painters* II was a different matter. This was shared and discussed. Osborne Gordon had recommended Hooker to him, Ruskin later recalled. He ascribed to Hooker an ornateness of language in the book. Perhaps this was to exaggerate the influence. A nearer and more potent example would be in the sermons of Henry Melvill. These were read, listened to, and discussed in Denmark Hill. They had so much effect on Ruskin that he could dream about them forty years later, and their combination of artificial language and religious fervour was surely present in the young art critic. In the early 1880s, when he looked back on *Modern Painters* II,

Ruskin thought that the book might be of interest to 'the literary student' as well as to an art lover.[33] W. G. Collingwood, whom Ruskin probably had in mind, was inclined to think that the book was 'really a philosophical work' and wished to place it 'as a reflex of the great movement of German philosophy and as the completion of the English school of æsthetics begun by Coleridge'.[34] However that may be, it is certain that much of Ruskin's university reading, which he discussed with Acland and Newton as well as with Gordon during the composition of *Modern Painters* II, finds a place in his æsthetic system. His formal æsthetic was always to be of more interest to Ruskin than anyone else, however; the popularity of *Modern Painters* II was mostly in 'passages' that were known, for a time, as glories of English prose. Such extracts rather annoyed the later Ruskin, who did not like to be famous for mellifluous sentences. He believed, rightly, that the importance of the book was in its introduction of a taste for early Italian art and for Tintoretto. Ruskin was neither the first nor the sole discoverer of early Italian art. But he was by far the most persuasive, as the respectful reviews of his book (excepting still the *Athenæum*'s notice) indicate. At the age of twenty-five he had established an artistic authority that was crusader-like. This could excite his contemporaries. Acland, writing to Liddell as another young don who hoped to change Oxford, now for the first time suggested that Ruskin be brought back to the university. Ruskin himself had no such desire. He was eager for other things. As soon as he had finished the second volume of *Modern Painters* he began the studies of architecture that were to absorb him until the end of his marriage in 1854. Not waiting to see the publication of his book but entrusting all to W. H. Harrison, Ruskin left with his parents for the Continent. This was in April of 1846: they would not return to England until six months later.

<p style="text-align:center">★ ★ ★ ★</p>

When looking back on those days in *Præterita* Ruskin quite accurately stated:

> I had two distinct instincts to be satisfied, rather than ends in view, as I wrote day by day with higher-kindled feeling the second volume of *Modern Painters*. The first, to explain to myself, and then demonstrate to others, the nature of that quality of beauty which I now saw to exist through all the happy conditions of living organism; and down to the minutest detail and finished material structure naturally produced. The second, to explain and illustrate the power of the two schools of art unknown to the British public, that of Angelico in Florence, and Tintoret in Venice.[35]

Only by forcing arguments could Turner be introduced to such a scheme, and he makes only a minor appearance in this second volume of *Modern Painters*. Ruskin did not write again publicly about Turner until 1851, when the painter was dying. In some other ways Turner seems now to have lost his place in Ruskin's life. We hear next to nothing about the relations between the artist and the critic. Ruskin made no record of any of his conversations with Turner, nor any record of their meetings. So distant do the painter and critic seem that one cannot imagine how they corresponded; and in fact it is likely that many of their exchanges by letter were conducted through the medium of John James Ruskin. Evidence of Turner's visits to Denmark Hill is in John James's correspondence and diary rather than in his son's diary. It seems that the painter was at the Ruskins's on New Year's Day of 1846, when according to Finberg's biography of Turner he might have discussed his will with John James;[36] and was there again on 8 February, 'Mr John's' birthday. John James's diary reveals that he dined at Denmark Hill on 19 March of 1846, just before the publication of *Modern Painters* II, with Mrs Colquhoun, a Mr Young, William Boxall, George Richmond and Joseph Severn. He next visited (it appears) at Ruskin's birthday party the following 8 February, when the other guests were Charles Newton, W. H. Harrison and Mrs Cockburn; then again on 3 June of 1847, when he met William Macdonald, the son of an old Scottish friend of John James's, the water-colourist Joshua Cristall, George Richmond, C. R. Leslie, Samuel Palmer and Effie Gray; and just before Ruskin's marriage to this last, at his 1848 birthday dinner, Turner sat down with Richmond, Boxall, Sir Charles Eastlake and the Reverend Daniel Moore who had succeeded Henry Melvill as incumbent of the Camden Chapel. It will be seen that these were hardly intimate meetings. Of Ruskin's more personal relations with Turner in these years, we have little idea. He would have seen something of him at Griffith's, and we know that he had — at times — access to Queen Anne Street. But when the snatches of evidence for such meetings are accumulated, it is noticeable that Ruskin had far less to do with the artist he most admired than would have been expected.[37]

The reasons for this lack of contact might be the obvious ones: the difference in age and temperament between the two men. But one other piece of evidence suggests that their relationship had been damaged. Twenty years after this time Ruskin found himself estranged from an older man whom he revered. This was Carlyle. A dispute between them lasted for some weeks. At the height of their quarrel, Ruskin wrote to Carlyle in the hottest anger: wildly, almost, but with the anger of a man whose personal honour has been damaged. In this

letter Ruskin tells Carlyle that Turner had once called his honour into question, and that he had never forgiven him. Ruskin gave no further explanation and we cannot know what had happened. But it is significant that the matter should have come to the surface at this emotional point. As long as he lived Ruskin never again mentioned that something had come between himself and Turner. One can only guess at what it was. It could have been something to do with purchasing: here was an area of Turner's life where goodwill could often fail. It could have been to do with Ruskin's writing. Turner's extraordinarily reserved attitude to Ruskin's heartfelt books cannot but have been a psychological difficulty to the writer who claimed to understand his art. Ruskin never had much to say about Turner's interest in him and his writing. But for five years of his life this must have mattered to him far more than any kind of public success. Later, Ruskin was to make an unusual and rather sinister claim about Turner's health in these years. He felt that the painter had then been not merely in physical decline but suffered from 'mental disease', whose onset he could date: 'The time of fatal change may be brought within a limit of three or four months, towards the close of the year 1845.'[38] This was the period when Ruskin was back in London and writing the text of the second volume of *Modern Painters*. Something may have passed between them then. At any rate, Ruskin felt that he could not hope for the painter's affection during his declining years. After Turner's death, Ruskin was in correspondence with Griffith. Turner's agent had gone out of his way to let Ruskin know that the painter did have some regard for the writer. Ruskin wrote back that he was 'deeply gratified . . . by what you say of Turner's having cared something for me. My life has not been the same to me as you may well imagine since he has gone to his place — nor will it ever be to me again what it was — while he was living . . .'[39]

From 1845 onwards, or after he had finished writing *Modern Painters* II, Ruskin might have thought of putting his knowledge of Turner into manageable form, with the aid of notebooks, drawings, reproductions and the like. But this approach was never congenial. The classical methods of the art historian (such as they were, at this date) found no adherent in the young art critic. He disliked systems and when he made catalogues they tended to the eccentric. Furthermore, he believed that to understand Turner it was more important to study nature than old oil paintings. At the same time, Ruskin was liable to find new enthusiasms outside art, or to return to his old pursuits in the geological sciences. When *Modern Painters* II was published in April of 1846, he was already on a different intellectual tack. The notices were

almost overwhelmingly flattering. One of them brought a new friend, a doctor and writer who for the rest of his life would attempt to keep up with Ruskin's imagination. This was John Brown of Edinburgh,[40] who had reviewed the book for the *North British Review* and had written privately to its author. Ruskin received Brown's letter on the Continent, for he had taken his mother and father away from England before publication day. One part of him wanted to show his parents what he had been writing about. But he was also in search of knowledge that as yet was undefined to him: historical, religious, sculptural, architectural, or some combination of these things. Landscape art became less interesting. No further volume of *Modern Painters* would appear for ten years.

CHAPTER SIX

1846–1847

Between 1846 and 1856 Ruskin was mostly concerned with architectural studies. These are the years which saw *The Seven Lamps of Architecture* (1849), the three volumes of *The Stones of Venice* (1851-3), various lectures and occasional writings on building, and the collaborative venture of the construction of the Oxford Museum. Ruskin's interest in architecture was lifelong, of course: it extends from *The Poetry of Architecture,* written when he was an undergraduate, to the last of his Oxford lectures in the 1880s. But this decade gave him his central position in the Gothic Revival. He was led to architecture by his reading of mediæval history, by his increasing concern with the history of the Christian Church, and by a study of architecture in Turner's water-colours. His own increased ability to draw buildings also played a part in his new interest. Ruskin was now confident enough of his own drawing to show some water-colours this year, 1846, in a mixed exhibition at the Graphic Society. It is recorded that 'a member of the Royal Academy, after examining the subjects with much attention, exclaimed in our hearing — "The man who can draw like that may write anything he pleases upon art"'.[1] Ruskin might not have taken this as a compliment. His drawing had direct connections with his writing. The ability to grasp architectural subjects by the process of recording them in drawing now began to give a new kind of authority to his connoisseurship of building. His studies of architectural details, mouldings, doorways, arches, pinnacles, far outnumber the drawings he made from paintings, or sculpture; and they gave him an apprehension of building that seems to have a unique combination of the optical with the tactile.

Ruskin benefited from the scholarly attention to mediæval architecture that, in England, had preceded the analysis of earlier schools of painting. His serious introduction to Gothic building was made with the help of a book that had been published as long before as 1835, Robert Willis's *Remarks on the Architecture of the Middle Ages, Especially of Italy.* When he bought this book is not known: but many notes and drawings in his current diary testify to a careful interest in Willis. As the Ruskins travelled down the Continent towards the goal of their tour, which was Venice, we may see how he attempted to apply the method of Willis's *Remarks* to French and German buildings. In 1880,

in a supplementary footnote to a new edition of *The Seven Lamps of Architecture,* Ruskin acknowledged that Willis 'taught me all my grammar of central Gothic' and that in his book on the flamboyant style he had anticipated Ruskin in the 'grammar of the flamboyant I worked out for myself'.[2] As usual, Ruskin's reading had been extensive but piecemeal. If this was to his disadvantage as an architectural historian, the lack was more than balanced by his industry before the *motif* of the buildings he studied. Nor should we underestimate the value of his distance from the architectural profession, for this allowed him to ignore all the practical problems of architecture. Ruskin made the literature of the Gothic Revival inseparable from the general revival of the arts in mid-nineteenth-century England, and gave it a spiritual inspiration that in many other writers and architects was sectarian or merely perfunctory.

John James Ruskin had not anticipated this new involvement with architecture and the effective abandoning of Turner studies. He had trouble in following his son's enthusiasms. One purpose of the tour of 1846 was for Ruskin to be able to show his father all that had excited him in his great expedition the previous year. There is no doubt that Ruskin felt guilty that his long absence abroad had distressed his parents. This loving and dutiful son could not feel content with himself until he had once again made a sort of comrade of his father. To this end he wished to show him the main subjects of his newly published book, the 'angel choirs' of *quattrocento* painting and the turbulent visions of Tintoretto. Many English travellers would go to Italy with Ruskin's famous book as their guide. John James, in Venice and Pisa, was the first but not the most appreciative of them. There is some humour in the way that Ruskin later described his reactions:

> We had been entirely of one mind about the carved porches of Abbeville, and living pictures of Vandyck; but when my father now found himself required to admire also flat walls, striped like the striped calico of an American flag, and oval-eyed saints like the figures on a Chinese teacup, he grew restive . . .[3]

In fact John James was distressed. It was becoming apparent to both father and son that Ruskin's first tour without his parents had erected a greater barrier between them than either had realized. John James now swung back to his old longing for his son to be a poet. W. H. Harrison, still editing *Friendship's Offering,* had written to Venice to ask if there were any lines — a song, perhaps, or a picturesque description — that he could publish in his annual next Christmas. Ruskin was far beyond such things. John James had to reply:

I regret to say there is no chance of this; my son has not written a line of poetry and he says he cannot produce any by setting himself to it as a work — he does not I am sorry to say regret this — he only regrets ever having written any. He thinks all his own poetry very worthless and considers it unfortunate that he prematurely worked any small mine of poetry he might possess. He seems to think the mine is exhausted and neither gold nor silver given to the world. He is cultivating Art at present searching for real knowledge but to you and me this knowledge is at present a Sealed Book. It will neither take the shape of picture or poetry. It is gathered in scraps hardly wrought for he is drawing perpetually but no drawing such as in former days you or I might compliment in the usual way by saying it deserved a frame — but fragments of everything from a Cupola to a Cartwheel but in such bits that it is to the common eye a mass of Hieroglyphics — all true — truth itself but Truth in mosaic . . .[4]

This 'mass of Hieroglyphics' was the notebook in which Ruskin was making his architectural studies. As his father lamented, he had no interest in making frameable and finished drawings of whole buildings or scenes: he wanted to avoid settings and the picturesque. Instead, he concentrated on the details of individual forms. Here was born the knowledge of Venetian architecture that was the strong foundation of *The Stones of Venice*. However, the epic history of her building was not yet in Ruskin's mind. He was thinking of making his new studies into a chapter or section of the next volume of *Modern Painters*. The integrity of his sequence was a problem at Venice in the summer of 1846. Ruskin was now revising his text for the third edition of the first volume, and found it awkward to accommodate Titian and Tintoretto. Writing from Lucerne on the way home, he confessed to George Richmond that 'I have got some useful bits of detail . . . especially in architecture — though in Italy I lost the greater part of my time because I had to look over the first volume of *Modern Painters,* which I wanted to bring up to something like the standard of knowledge in the other . . .'.[5]

The party returned to England at the end of September 1846. The elder Ruskins would never go to Italy again. Their son had garnered much information in the summer months, but it felt miscellaneous. It took another year and more for his architectural feeling to gell into the extended essay which is *The Seven Lamps of Architecture*. Ruskin had not yet realized a simple truth about himself: how easy it was to write a book on anything that interested him at the time. For this reason, his literary production in the next two years was comparatively meagre.

The autumn of 1846 was taken up with studies in the British Museum. We might note here that this great institution was Ruskin's best-loved museum. He always enjoyed his visits to Bloomsbury more than those he made to the National Gallery. He did not neglect the country's foremost painting collection, and was often there for professional reasons. But it was too much associated with the Royal Academy and with the traditions of baroque painting. For this reason he often urged the National Gallery to buy examples of earlier Italian art. He did so with a novel and urgent authority, and often by speaking directly to the gallery's trustees and other interested parties. The identity of the 'Graduate of Oxford' had still not been revealed on Ruskin's title-pages, but there can have been few people in art circles who did not know that he was the author of *Modern Painters*. He had renown, and for that reason was invited to many a drawing-room. Ruskin's regular complaints about evenings in society no doubt tell us of his dislike of fashionable salons: they also show that he kept accepting the invitations. This pleased his parents. It also gave relief from another kind of social life which he undertook and of which he never complained. His parents entertained a great deal but never themselves dined away from home: Ruskin went to other people's houses on their behalf. Thus, many a night and for many a year, he spent hours with family friends who were a generation older than himself. They were Scottish, or in the wine trade, or were clergymen. This circle included Dale and Croly, whose conversation — if not their sermons, for Ruskin went to hear Dale preach every Tuesday until 1848 — he might well have found repetitive. Society in great London houses off Hyde Park was in comparison tinsel. That was why it was sometimes welcome.

A house Ruskin sometimes frequented was Lady Davy's, in Park Street. She was Sir Humphrey's widow: garrulous, well-connected on the Continent as well as in London, quite near to the court. But her receptions, Ruskin tells us, also 'gathered usually, with others, the literary and scientific men who had once known Abbotsford'.[6] There Ruskin met a young woman who attracted him. She was Charlotte Lockhart, Sir Walter Scott's granddaughter and the daughter of James Lockhart, the novelist's biographer. Ruskin had met the father and daughter before, in 1839, when he had dined at the Cockburns's.[7] Charlotte had been scarcely more than a child then, and Ruskin an undergraduate. Now the 'little dark-eyed, high-foreheaded' Charlotte was of age, and Ruskin looked at her with interest. His later recollections of their meetings at Lady Davy's are confused, and it is not now possible to estimate the relations between them. They were, in an

empty kind of way, romantic. But they had nothing to say to each
other. 'I could never contrive to come to any serious speech with her,'
says *Præterita*.[8] He wrote to Charlotte instead, in letters which have
not survived. Some of them were probably sent from Ambleside,
where Ruskin went with George Hobbs in March of 1847. At the
Salutation Inn he sat down to write a book review that had been
commissioned by Charlotte's father. Lockhart was eminent in what
Ruskin called 'the old Scott and John Murray circle' not only by virtue
of his biography but also by his editorship of the *Quarterly Review*.[9] He
had asked Ruskin to write about Lord Lindsay's *Sketches of the History
of Christian Art*. The invitation was somehow confused with the
young critic's feelings for his daughter; and so, as *Præterita* sardoni-
cally records, Ruskin 'with my usual wisdom in such matters, went
away into Cumberland to recommend myself to her by writing a
Quarterly review'.[10]

Lord Lindsay's book had been on Ruskin's mind. He had heard of it
long before its publication. In 1845 he had written to his father from
Florence asking him to enquire of George Richmond what it would
contain, 'for the artists here talk very much about what he is going to
do & write about old art . . .'.[11] Ruskin had thought that Lindsay's
plans 'may in some degree influence me in the direction I give to parts
of my book'.[12] Richmond had replied to John James that he liked Lord
Lindsay, admired his scholarship and that his book was to be 'a history
of Christian art from the revival of paintings up to the time of
Raphael'.[13] But *Modern Painters* II was not affected by Lindsay's plans.
We should not think of the two authors as being in competition.
Ruskin had already become so individual a writer that the question of
rivalry simply did not arise. He and Lindsay had similar interests.
Lindsay is referred to in Ruskin's books, always favourably, for years
to come. They met occasionally at meetings of the Arundel Society
and the like, but struck no sparks from each other. Ruskin's review is
rather prophetic of their relationship. It is flat, measured, and
anonymous. It strikes the manner of the current reviewers only too
successfully. Were it not that the sentiments were so accordant with
Modern Painters II one would hardly know that it was by Ruskin. It is
significant that Lockhart asked him to 'cut out all my best bits'.[14] The
editor also excised a hostile reference to the architectural writer Gally
Knight, who was a John Murray author. Ruskin tells us that 'this first
clear insight into the arts of bookselling and reviewing made me
permanently distrustful of both trades': and though he was to notice
Sir Charles Eastlake's writing for the *Quarterly* he never thereafter
reviewed a book in his life.[15]

Ruskin chose the romantic setting of Ambleside for the mundane task of his book review to separate himself from distractions in London. He also, consciously or half-consciously, went there to test his feelings for Charlotte Lockhart. As things turned out, any burgeoning love or distant contemplation of her 'harebell-like' beauty was swept away by a deadening depression of his spirits.[16] *Præterita* records: 'I fell into a state of despondency till then unknown to me, and of which I knew not the like again till fourteen years afterwards.'[17] Ruskin's autobiography, pledged to avoid painful memories, says no more. But the cause of his depression in the Lake District, where he balanced sentences in the mornings and rowed every afternoon amidst 'black water — as still as death; — lonely, rocky islets — leafless woods — or worse than leafless — the brown oak-foliage lying dead upon them; gray sky; — far-off, wild, dark, dismal moorlands', was the thought of Adèle Domecq.[18] His parents knew of his interest in Charlotte. But they simply feared the effect Adèle still had on him. Ruskin could only speak of her to his parents in broad hints. 'It makes me melancholy with thinking of 1838,' he told his mother.[19] That was when he had last been at Ambleside, when he had most suffered from love nearly ten years before. Just as he had decided to recommend himself to Adèle by his writing, so he had recently sought to impress Charlotte. But the memory of the waste and futility of his love for the French girl now made Charlotte appear trivial. When he returned to Denmark Hill from the Lakes John James realized what was wrong with his son and saw how long-lasting had been the effects of Adèle's disastrous intrusion into their lives. He wrote frankly to a friend that 'the passion however was powerful and almost threatened my son's life — various journies abroad have scarcely dissipated his chagrin nor repaired his health . . .'.[20]

The recipient of this letter was George Gray, John James's old business friend from Perth; and the subject of his son's affections was particularly in his mind because a guest at Denmark Hill was Gray's daughter Euphemia, 'Effie', the girl Ruskin would eventually marry. John James had immediately sensed that the presence of the most attractive Effie might add a further complication to Ruskin's desolation over Adèle and uncertain attitudes towards Charlotte. His early suspicions turned out to be correct, as in the three or four weeks to come the two young people came to know each other. It is important that the three affections of Ruskin's young days — Adèle, Charlotte, Effie — were present in his mind concurrently during these weeks. For her part, Effie did not at first think that John's affairs of the heart had anything to do with her. The letters she sent to Perth afford amused

glimpses of the (to her) bizarre household at Denmark Hill together
with overawed accounts of Ruskin's visits to town:

> I am enjoying myself exceedingly although in a quiet way, Mr
> Ruskin is as kind as ever and as droll — Mrs Ruskin is the same but I
> think she is beginning to feel old age a good deal, she sleeps so badly
> during the night that she falls asleep in the evenings. She is always
> saying that she is afraid I will weary with her but we get on
> admirably and she is always giving me good *advices* which I would
> repeat had I not so much news to tell you. John I see very little of
> excepting in the evening as he is so much engaged but he seems I
> think to be getting very celebrated in the literary world and to be
> much taken notice of. On Saturday he was at a grand reunion of Sir
> R. Peel's where everyone was, the Duke of Cambridge was there
> boring everybody with his noise. Sir Robert Peel and Lady Peel
> were there the whole time and extremely affable. On Friday John is
> going to a private view of the Royal Academy, the ticket is sent to
> him by 'Turner' who is one of the 30 Academicians who have a
> ticket at their disposal so that it is the highest compliment paid to
> any man in London. They have got home a very fine Picture by the
> above artist yesterday of Venice which is the largest they have and
> must have cost *something* . . . The Cuisine here is conducted admir-
> ably . . . Mrs Ruskin approves most graciously of my toilette, she
> says I am well dressed without being at all fine or extravagant . . .[21]

Since her London holiday in 1841, when little 'Phemy' had chal-
lenged Ruskin to write the fairy story that became *The King of the
Golden River,* he had met her only twice, and then briefly. The first
occasion was in 1843, when Effie was fifteen, and stayed at Denmark
Hill with her brother George. The second was a visit she had made in
the previous year, just before the publication of *Modern Painters* II, and
probably before the time when Ruskin had met Charlotte at Lady
Davy's. Now, in this spring of 1847, she presented a more adult charm
and confidence. She had left her school, Avonbank, near Stratford-
on-Avon, quite well-read and with musical accomplishments; she had
helped her mother to manage a large house and family; she knew she
was attractive and she knew what it was to have admirers. From
Effie's lively letters to Perth we see that she was inclined to laugh a
little at John's evident lack of interest in Charlotte:

> Mrs Ruskin told me of John's affaire the first night I came but I did
> not tell you as I thought she perhaps did not wish it to be known but
> she did not tell me who the Lady is and John never hints of her. He is

13. Euphemia Ruskin, by John Ruskin, 1848 or 1850.

the strangest being I ever saw, for a lover, he never goes out without grumbling and I fancy the young lady cannot be in London . . .[22]

This was written on 4 May, shortly after Effie arrived at Denmark Hill. She could not at first decide about Ruskin. On the one hand she thought of him as 'such a queer being, he hates going out and likes painting all day';[23] on the other, she was impressed by his fame and brilliance. It took her only a little time to become relaxed in his company. She then saw his charm and came to welcome his attentions. For Ruskin also relaxed. Pleasing Effie was a pleasure to him. He put aside his objections to poetry in order to present the stanzas *For a Birthday in May* on her nineteenth anniversary. He drew her portrait.

Together they went to the opera to hear Jenny Lind. Charlotte Lock-hart did not exist. John and Effie's fate was being cast. They slipped into romance because they enjoyed each other but also because there was an atmosphere of betrothal all around them. Mary Richardson had just left her adopted home in Denmark Hill to marry the lawyer Parker Bolding, a connection of the Scottish Richardson family. Ruskin's near contemporary at Christ Church, Henry Liddell, came out to dine. He brought with him his bride Lorina: she, like Effie, was nineteen years of age. Suddenly the atmosphere at Denmark Hill was youthful. Charles Newton came for the night and delighted Effie: 'He amuses us beyond expression and went on with John this morning, he is a great genius.'[24] Another guest was young William Macdonald, who is tantalizingly described in *Præterita* as 'the son of an old friend, perhaps flame, of my father's, Mrs Farquharson'.[25] Ruskin hardly knew Macdonald, but he now arranged to go to stay with him at his hunting lodge in the Highlands later that summer. Ruskin was no sportsman, but his journey to the Highlands would inevitably take him past Effie's home in Perth. It was almost a rendezvous, almost a declaration. Macdonald was later the best man at their wedding.

Effie was due to return to Scotland. John would go there later in the summer, but he first had an engagement at a meeting of the British Association in Oxford: he was to attend the geological section of this learned conference. We do not know how the two young people parted, but it seems that Ruskin was agitated by something that was not love. One querulous and unhappy letter survives from this date. Writing to his friend Mary Russell Mitford, the gentle author of *Our Village,* he announced that

> I have most foolishly accepted evening invitations, and made morning calls, these last four months, until I am fevered by the friction. I have done no good, incurred many obligations, and suffered an incalculable harm. I know not what is the matter with me, but the people seem to have put a chill on me, and taken my life out of me. I feel alike uncertain and incapable of purpose, and look to the cottage on Loch Tay not as an enjoyment, but a *burrow*.[26]

This does not seem the mood of a man who is optimistically in love: more the opposite; and when Ruskin arrived in Oxford the pall of his Ambleside depression once again settled on him. His pleasures with Effie were forgotten, replaced with the sense of failure and frustration, the twin memory of his disappointment with his university career and his love of Adèle. He now wrote to his parents:

> I am not able to write a full account of all I see, to amuse you, for I

find it necessary to keep as quiet as I can, and I fear it would only annoy you to be told of all the invitations I refuse, and all the interesting matters in which I take no part. There is nothing for it but throwing one's self into the stream, and going down with one's arms under water, ready to be carried anywhere, or do anything. My friends are all busy, and tired to death. All the members of my section, but especially Forbes, Sedgwick, Murchison and Lord Northampton — and of course Buckland, are as kind to me as men can be; but I am tormented by the perpetual feeling of being in everybody's way. The recollections of the place, too, and the being in my old rooms, make me very miserable. I have not one moment of profitably spent time to look back to while I was here, and much useless labour and disappointed hope; and I can neither bear the excitement of being in the society where the play of mind is constant, and rolls *over* me like heavy wheels, nor the pain of being alone. I get away in the evenings into the hayfields about Cumnor, and rest; but then my failing sight plagues me. I cannot look at anything as I used to do, and the evening sky is covered with swimming strings and eels . . .[27]

Practically all the period of Ruskin's courtship was one of neurasthenic depression, of great worry about his health and his future. This return to Oxford threw him into an illness that seems as much nervous as physical. He felt no better when he returned to London. Quiet pursuits at Denmark Hill failed to restore his spirits. Eventually it was decided that he should return to Dr Jephson's establishment at Leamington Spa. Once again Ruskin submitted himself to the regime that had seemed helpful after his breakdown in 1841. At that time he had written *The King of the Golden River* for Effie; during this stay he found no comparable amusement. The diary reveals that he drew, botanized, and worked on his second commission from the *Quarterly Review*, an account of Charles Eastlake's *Materials for a History of Oil Painting*. But the diary now gives the impression of boredom rather than of agitation, and only once among its flat descriptions do Effie's initials indicate that Ruskin was, perhaps, a lover.

I have spent a somewhat profitless day; owing, as I think, to coldness and wandering of thought at morning prayers. I must watch if this be always the case. After drawing at Warwick Castle, I went over there again in the afternoon, and walked some distance on the road beyond, past the sixth milestone from Stratford (thinking much more of ECG than of Shakespeare, by the bye). There was much most beautiful in the fresh meadows on each side of the

road; and a little divergence from it, once, brought me to the side of the Avon, a noiseless, yet not lazy stream, lying like the inlet of a lake between shadowy groups and lines of elm and aspen, quiet and something sad.[28]

At some point in the months that Ruskin spent at Jephson's he was joined by William Macdonald. His later recollection was that the young Scotsman had also come to take a cure. It is more likely that he had called on his way from London, and was encouraging Ruskin to come up to his shooting lodge at Crossmount. From this point Macdonald began to have a kind of presiding influence over Ruskin's courtship. Without him, Ruskin probably would not have gone to Scotland to woo Effie in her own home. Eventually Jephson discharged him and he travelled north. At Dunbar, where he arrived on 18 August, he made a remarkable drawing of seashore rocks that (together with his review of Eastlake's book) is a significant part of the early history of Pre-Raphaelitism. But art was not on his mind. After finishing the drawing he felt 'dispirited and ready to seek for any excitement this evening'.[29] A day or two later he was in Perth, where he called on Effie's father at his office but made no attempt to see her. That night his journal records,

> I have had the saddest walk this afternoon I ever had in my life. Partly from my own pain in not seeing E.G. and in far greater degree, as I found by examining it thoroughly, from thinking that my own pain was perhaps much less than hers, not knowing what I know. And all this with a strange deadly shadow over everything, such as I hardly could comprehend; I expected to be touched by it, which I was not, but then came a horror of great darkness — not distress, but cold, fear and gloom. I am a little better now. After all, when the feelings have been so deadened by long time, I do not see how the effect on them can be anything else than this.[30]

In the days to come many letters were exchanged between Ruskin, his father, his mother, and Mr Gray. The letters between Ruskin and his parents discuss Effie's character and suitability: they also dispel some lingering doubts about Charlotte Lockhart. At the Crossmount shooting lodge, high in the hills above Lochs Rannoch and Tunnel, Ruskin made one or two dispirited efforts to join in the sport. Soon he gave up following the guns in favour of drawing thistles. Thus he occupied himself for more than a fortnight before he wrote to the Grays proposing to visit them at Bowerswell. They replied immediately; and at the beginning of October, three and a half months after he had parted from Effie, Ruskin presented himself to her at the house which once had belonged to his grandfather.

CHAPTER SEVEN

1847–1849

'A man should choose his wife as he does his destiny,' Ruskin later wrote, at the time when he was begging to marry Rose La Touche.[1] His marriage to Effie was to cast a shadow over all his later life, and indeed over all his biographers' attempts to explain that life. In October of 1847 that destiny was unimaginable. He had no conception of himself at the age of fifty, or sixty, no thought of himself as a man in the prime of life or in old age. No doubt he did not differ, in this, from any other young man who is about to wed. But there was nonetheless an element of calculation in his approach to a proposal. This he owed to his parents. He could not imagine his own marriage without thinking of the most perfect marriage known to him, that of his father and mother. Nor could John James and Margaret believe that the mould of his marriage might differ from their own. For this reason the atmosphere became charged with the difficulties of a union between two families. It was as if the young people were being asked to take more responsibility than they had thought of. When John arrived at Bowerswell Effie did not quite know what was going on. Her reaction was to be cool to the man who had not declared himself as her suitor. It was a difficult few days, in which everything was left unsaid. When Ruskin left to go back to London nothing had been clarified, for of course he wished to talk to his father. Back at Denmark Hill, with John James's blessing, he must have decided to be firm, to take his destiny in his own hands. Characteristically, he did so by writing. About a week after returning home he sent a letter to Effie that contained an offer of marriage. He was immediately accepted.

> It would be doing dishonour to my own love — to think that — when I had leave to express it — it was not intense enough to deserve — to compel — a return — No — I cannot doubt you any more — I feel that God has given you to me — and he gives no imperfect gifts — He will give me also the power to keep your heart — to fill it — to make it joyful — Oh my treasure — how shall I thank *Him*?

wrote Ruskin shortly afterwards.[2] Such letters that have survived from the engagement maintain, when they can, a religious tone and a pure, literary passion. It was in the nature of John and Effie's union, unconsummated as it was, that the engagement should be as impor-

tant as the marriage itself; and in their searching for higher things at
this time there was a happy seriousness they were not to know again.
However, there were times when Ruskin became worried and querul-
ous. Unconsciously or not, he wished Effie to feel the same anxieties
for him that his parents felt. He may have been right to believe that his
intellectual labours had an effect on his second book review, a long and
thoughtful account of Charles Eastlake's *Materials for the History of Oil
Painting*. The effort he put into the research and writing was consider-
able, and when it was finished he felt the need to recuperate by the sea.
At Folkestone, slightly depressed, he wondered whether he had lost
the feeling for nature that had so possessed him in past years, when he
was writing *Modern Painters*. As the date of their wedding approached
more problems arose. The political revolutions on the Continent
greatly disturbed Ruskin. Effie's father's finances suddenly took a
sharper turn for the worse. He had speculated in railways, which in the
Ruskins's view was the height of imprudence. But Ruskin's real fear
was for many years in the same state, and it ended in his secluding
body there was lodged the belief that he was not well, and that in his
marriage he had to hold himself away from any kind of excitement.
Only a month before the wedding he addressed his fiancée in these
terms:

> There are moments when I think you have been a foolish girl to
> marry me — I am so nervous, and weak, and — dreamy — and
> really ill & broken down — compared to most men of my age, that
> you will have much to bear with and to dispense with — my father
> was for many years in the same state, and it ended in his secluding
> himself from all society but that which he sees in his own house I
> inherit his disposition — his infirmities, but not his power — while
> the morbid part of the feeling has been increased in me by the very
> solitude necessary to my father. At this moment, the dread I have of
> the bustle of Edinburgh is almost neutralizing the pleasure I have in
> the hope of being with you — it amounts to absolute *panic*. And —
> above all — in speaking of me to your friends, remember that I am
> really not well. Do not speak of me as able (though unwilling) to do
> this or that — but remember the real frets — that late hours — &
> excitement of all kinds are just as direct and certain *poison* to me as so
> much arsenic or hemlock and that the *least* thing excites me. From a
> child, if I turned from one side to another as I slept, the pulse was
> quickened instantly and this condition has of late years been aggra-
> vated by over work — and vexation. I have been four years doing
> the mischief — and it will be two or three at any rate, before, even

with the strictest care, it can be remedied.— Take care that you make people understand this as clearly as possible.[3]

* * * *

Neither of Ruskin's parents wished to attend his wedding. Margaret Ruskin's horror of Bowerswell had not been dispelled by her son's engagement to the daughter of the house.[4] Nor did John James wish to return there. He wrote to Mr Gray,

> You expect that Mrs Ruskin and I should come to Perth and nothing can be more reasonable — I at once acknowledge we ought to come; but with Mrs Ruskin's feelings and prejudices I scarcely dare contend — for my own part, I am sincerely desirous of coming, but on the best consideration I can give the subject — I have decided to keep away . . . I can only exist in the absence of all excitement — that is by leading a quiet life — it is just 30 years this 1848 since I slept in a friend's house. I take mine ease at an inn continually and I go on with my business pretty well — I have thought I might come to Perth but if I were unwell — I should only be in the way — a marplot and a nuisance . . .[5]

There was some lameness in these excuses; and John James's attempts to be tactful to the Grays would always be at odds with his native bluntness. But as the wedding approached the elder Ruskins and Grays were content with their children's obvious contentment with each other. The celebrations in Perth were not spoilt by the absence of John James and Margaret Ruskin. To Effie, it made the occasion seem more like a family party for the Grays. None of John's old friends went to the wedding. One would have expected him to have asked Henry Acland or Richard Fall to be best man. Instead, William Macdonald performed this duty. Ruskin never saw him again after the wedding day. The ceremony itself was Scottish, and not elaborate. John and Effie were married in the drawing-room at Bowerswell on the morning of 10 April. The guests sat down to the wedding dinner after the couple left in the late afternoon. A letter from Mrs Gray to Margaret Ruskin describes how happy they looked as they drove off to Blair Atholl, where they were to spend the first night of their honeymoon.

The marriage was not consummated that night, nor ever afterwards. Both John and Effie wrote down why this was so at the end of the marriage six years later. Effie said in a letter to her father of 7 March 1854,

> I had never been told the duties of married persons to each other and knew little or nothing about their relations in the closest union on

earth. For days John talked about this relation to me but avowed no
intention of making me his Wife. He alleged various reasons,
Hatred to children, religious motives, a desire to preserve my
beauty, and finally this last year told me his true reason (and this to
me is as villainous as all the rest), that he had imagined women were
quite different to what he saw I was, and that the reason he did not
make me his Wife was because he was disgusted with my person the
first evening April 10th.[6]

Ruskin's statement was written out for his lawyers at the time of the
annulment. He states, no doubt correctly, that Effie had been upset by
her father's financial problems, and that the fortnight before the
wedding had been particularly harrowing for her.

Miss Gray appeared in a most weak and nervous state in consequ-
ence of this distress — and I was at first afraid of subjecting her
system to any new trials — My own passion was also much sub-
dued by anxiety; and I had no difficulty in refraining from con-
summation on the first night. On speaking to her on the subject the
second night we agreed that it would be better to defer consumma-
tion for a little time. For my part I married in order to have a
companion — not for passion's sake; and I was particularly anxious
that my wife should be well and strong in order that she might be
able to climb Swiss hills with me that year. I had seen much grief
arise from the double excitement of possession and marriage travel-
ling and was delighted to find that my wife seemed quite relieved at
the suggestion. We tried thus living separate for some little time,
and then agreed that we would continue to do so till my wife should
be five and twenty, as we wished to travel a great deal — and
thought that in five years time we should be settled for good.[7]

Thus, early in the honeymoon, something was decided between
them. Effie's letter to her father further relates, 'After I began to see
things better I argued with him and took the Bible but he soon silenced
me and I was not sufficiently awake to what position I was in. Then he
said after six years he would marry me, when I was 25.'[8] John's
deposition says:

It may be thought strange that I *could* abstain from a woman who to
most people was so attractive. But though her face was beautiful,
her person was not formed to excite passion. On the contrary, there
were certain circumstances in her person which completely checked
it. I did not think either, that there could be anything in my own
person particularly attractive to *her*: but believed that she loved me,
as I loved her, with little mingling of desire.[9]

It is not clear from these accounts when it was that Ruskin said he would consummate the marriage when Effie was twenty-five: her phrase 'after I began to see things better' surely refers to some time later than the honeymoon. She probably began to argue with Ruskin about their sexual life after she and her husband visited France that summer: only then did she realize the extent to which he was bound to his parents rather than to her. The matter of Ruskin's 'disgust' with Effie's body is mysterious. There is no evidence, apart from his, to suggest that Effie was in any way malformed. The doctors who examined her at the time of the annulment reported, 'We found that the usual signs of virginity are perfect and that she is naturally and properly formed and there are no impediments on her part to a proper consummation of the marriage.'[10] Later in life, she bore Millais eight children. One must enquire what deficiencies there might have been in Ruskin himself, or whether he held ignorant or even fantastic notions of femininity. He might have been impotent. Or he might have been rendered impotent by something which he, in his ignorance of women, found shocking. It is possible that Effie was menstruating on their wedding night. But is it possible that Ruskin could still believe menstruation to be abnormal after six years of marriage? He and Effie shared a bed during all this time. We cannot now expect to know what Ruskin's sexual feelings were. But it is fair to say that on his wedding night his sexual impulses were in some part limited, or directed, by his ignorance of sexual matters. One wonders what John James had ever told him. Ruskin's father was a direct man, and there is ample evidence that he was no prude. Ruskin must have heard discussion of sex at university, if not at school. And would he not have gathered something of what girls are like from Mary Richardson, who came to Herne Hill when she was fourteen, and he ten?

Ignorance and shyness affected John and Effie's honeymoon. This was no exceptional thing in many young married couples. But in the Ruskins's marriage the things that were misunderstood, or never said, hardened into the unpleasant principles of the union. We know of one thing that was vehemently stated. When Effie's letter to her father mentions 'hatred to children' she was speaking of her husband's aversion to babies. After middle age Ruskin liked babies as much as people normally do: but in his earlier years he found them repulsive. Sometimes he describes his dislike with a humorous note that makes one suspect that there was pretence in his hatred of the newly-born. More often one is struck by the weirdness of his attitude. He refused to go to see his cousin Mary's child. Effie then wrote: 'I tried to enforce on John that we ought to call on her, but he won't as he says he can't

bear lumps of *putty* as he terms babies . . .'[11] Effie later reported
when she finally prevailed,

> John allows it to be passable for a baby because it has eyes like rat's
> fur and he likes it a little because it is not like a baby at all, but has a
> black face like a mouldy walnut, which is a great deal for him as it is
> quite against his principles to admire any of them at all . . .[12]

Ruskin claimed that it made him sick to be in the same room as Henry
Acland's baby. It is possible that the revulsion he felt was connected in
his mind with sexual intercourse. And other interpretations are poss-
ible. But Effie was unable to help Ruskin out of his psychological
difficulties. She was baffled: and as the marriage went on, her baffle-
ment was transformed to a bitter sense of the injustice and unnatural-
ness of her own sexual unhappiness.

<p align="center">★ ★ ★ ★</p>

John and Effie toured in the Highlands for a few days. It was early in
the season and the inns were empty. From Scotland they went to
Keswick, whose vicar's sermons Ruskin admired.[13] As his father was
in Liverpool on business, Ruskin invited him to come to the Lakes.
This John James declined. The young couple returned to London three
weeks after their wedding day. A splendid reception awaited them at
Denmark Hill. The head gardener was at the gate with a bouquet of
orange blossom for Effie: he, Margaret Ruskin and all the other
servants welcomed the bride to her new home. A German band (John
James's favourite music) played in the garden. There was a celebration
dinner. Effie, John James wrote to Mr Gray, was

> . . . very well and in her usual spirits or way which we never wish
> to see changed — my son is stouter and better than we have ever
> seen him in the whole course of his Life — They are in appearance
> and I doubt not in reality extremely happy and I trust the union will
> prove not only a source of happiness to them but of satisfaction and
> comfort to us all . . .[14]

Effie was able to write to her mother that Mrs Ruskin 'bids me say
how happy she is to have me here and she hopes I will feel quite a
daughter to her'.[15] In the next few days old Mrs Ruskin gave Effie so
many presents, mainly household treasures, that the girl became
embarrassed. Their purpose was functional. Mrs Ruskin said that she
might as well have them now since they would in any case be left to

her. The young Ruskins were now using the top floor of Denmark
Hill while John James was looking for somewhere they could live.
This was not to be in the Denmark Hill area. John James was conscious
that his son was famous, would become more famous, and that he
would now need to entertain in some style. He accordingly searched
for properties in the most fashionable parts of London.

Effie was a social success. She first appeared in public at the private
views in May of the Royal Academy summer exhibition and the
exhibition of the Old Water-Colour Society. The first people she met
as a married woman were artists: Copley Fielding, Clarkson Stanfield,
David Roberts, Landseer and Prout. One day she and John went to
breakfast at Samuel Rogers's, where the old poet introduced her to
those knowing, witty and well-known *littérateurs* whose company he
most enjoyed. Ruskin took her away from the party quite early. On an
impulse he decided to call on Turner. From Rogers's elegant rooms in
St James's Place they went to the painter's dirty, shuttered house in
Queen Anne Street. The door was at length opened by Turner him-
self. Effie was taken aback by his bare and miserly accommodation:
but warmed to him as he produced wine, drank her health, then took
her to see his painting of *The Fighting Téméraire*. A few days later Lady
Davy, in whose house Ruskin had met Charlotte Lockhart, gave a
dinner in honour of the newly married couple. Lockhart himself was
there, and the rest of the company was no less distinguished. Around
the table were Lord Lansdowne, a member of the Cabinet and a trustee
of the National Gallery; Walter Hook, the famous vicar of Leeds, now
half-way through the eight volumes of his *Dictionary of Ecclesiastical
Biography*; and Henry Hallam, the mediæval historian for whose son
Tennyson had written *In Memoriam*. Effie was not in the least over-
whelmed by such men, and they found her charming. Invitations
multiplied. John James Ruskin was pleased with the way that John and
Effie had begun to spend their evenings. He told Mr Gray, 'I am glad
to see Phemy gets John to go out a little. He has met with some of the
first men for some years back but he is very indifferent to general
Society and reluctantly acknowledges great attentions shown to him
and refuses one half . . .'[16]

★ ★ ★ ★

Months before the wedding, it had been decided that John and Effie,
together with Mr and Mrs Ruskin, would go on a continental tour in
the summer. The plan was abandoned as the news came to England of
the 1848 revolutions in Europe. Republican movements were so wide-

spread that it seemed as if the whole of Europe would soon be at war. At the beginning of March, Ruskin had thought that he should marry as quickly as possible and set off for Switzerland immediately. Since Savoy, with other parts of Charles Albert's kingdom, Piedmont and Sardinia, was at war with Austria, it was now dangerous to travel to Chamonix, the place Ruskin most wished to show Effie. The earlier part of their marriage was overshadowed by political uncertainties. On their wedding day, the Chartists had marched to Westminster in demand of reform. The Bourbon monarchy had collapsed. The streets of Paris were barricaded by revolutionaries: Louis-Philippe and his queen had fled to England. By the summer, Hungary and all of the Lombardo-Veneto had revolted against Austrian rule. Manin's republic had been declared in Venice. All this was greatly disturbing to the Ruskins. It was republicanism, therefore evil. And what would be the consequences for the wine trade? Ruskin feared that it might be ten years before they could travel freely in Europe again. He was aware, of course, that the Napoleonic wars had kept Turner at home for just as long. And so, with much political foreboding, the Ruskins decided to take their summer tour in a calmer atmosphere, visiting the cathedrals of southern England.

Now began the period when Ruskin was most absorbed in architecture, the years of *The Seven Lamps* and *The Stones of Venice*. It was a time of deepening religious and political consciousness, but it coincided with his marriage, a time of human and personal failure. During his marriage Ruskin was thoughtless and insensitive to others as at no other period of his life. It was as though he had entered some strange second adolescence, learning rapidly but failing to be adult. Effie Ruskin now had to follow her husband as he pursued what to her were eccentric interests. Before going on the family tour round the English cathedrals, John and Effie spent a fortnight in Dover. Thence they proceeded to Oxford, calling on Miss Mitford on the way. They had been invited to stay at the Aclands's house in Broad Street. There, Ruskin took the liberties allowed to an old friend. He ignored the Aclands's baby, argued vehemently against Henry Acland's high church leanings, and read a book while they were at a concert. From Oxford John and Effie went on to a rendezvous with the elder Ruskins in Salisbury. The weather was bad. Salisbury Cathedral was damp. John began coughing badly and was annoyed at his drawings. A family expedition to see a new church at Wilton was not a success. John grumbled, his mother scolded and his father fussed and interfered. Effie was astonished to see how all three Ruskins behaved. Finally John took to his bed, where he remained for a week while Effie

slept in a different room. Mrs Ruskin also had a cold and John James was suffering from stomach upsets. Effie became irritated and lost her temper with her mother-in-law. For this outburst Ruskin gravely rebuked her. The holiday became grimmer and it seemed best to go home. Very soon the whole party returned to Denmark Hill.

In such circumstances Ruskin had been meditating his work on building. He had not been engaged on a book since the spring of 1846, when he finished the second volume of *Modern Painters*. That summer's continental tour had produced many architectural notes, probably as a relaxation from his labours on the Italian primitives and Tintoretto. From that time until his wedding the thought of an architectural book had remained with him. His notes were of a practical and visual type, but in a current diary we find an undated passage that indicates the themes that also occupied him:

> Expression of emotion in Architecture as Monastic — peaceful — threatening — mysterious — proud — enthusiastic.
> Expression of ambition — Difficulty cutting, vaulting, King's College, etc., raising of spires, etc.
> Consider luscious architecture: How far beautiful.
> General style. What constitutes its greatness. First, mere labour; patience, skill and devotion (Sacrifice). Then labour of *thinking* men; if nothing be lost, nothing valueless; consider if under this head one might not have a 'Spirit of Husbandry' (consider also, awe and mystery and their spirit under head of Power). Yet it is fine to see work for work's sake, or rather for completion of a system sometimes.[17]

Readers of *The Seven Lamps of Architecture* will recognize that in these jottings lie the first thoughts of that famous book, and may reflect on the ability of Ruskin's architectural writings to make numinous notions rather specific. Perhaps this was because much of what he now wrote on architecture was derived from urgent personal experience. While preparing the second volume of *Modern Painters*, he had been appalled by the destruction of ancient buildings. A long note to the second volume's chapter on the 'Theoretical Faculty' — which Ruskin later, in 1883, cancelled in despair that his warnings had not been heeded — lists some of the recent losses. All had personal associations for him. The old houses at Beauvais, the wooden loggias at Geneva, mediæval houses at Tours and the church of St Nicholas at Rouen had all gone. Ruskin recounts how the 'restoration' of the old Baptistery at Pisa had been done so clumsily and cheaply that the building was ruined.[18] His discovery of ancient art brought with it a furious realiza-

tion that the modern world had no regard for its safety. In Pisa, he saw
bricklayers knocking down a wall in the Campo Santo on which
frescoes had been painted. In Florence, he found that the old street
running towards the cathedral had been torn down: in its place was a
row of kiosks selling knick-knacks and souvenirs. The old refectory of
Santa Croce was being used as a carpet factory. Ruskin saw rain
beating through the windows of the Arena Chapel in Padua and
dripping into buckets in the Scuola di San Rocco. It filled him with a
literally religious horror. In a letter to his father in 1845 he broke into a
quotation from Revelation:

> I think verily the Devil is come down upon earth, having great
> wrath, because he knoweth that he hath but a short time. And a
> short time he will have if he goes on at this rate, for in ten years more
> there will be nothing in the world but eating-houses and gambling
> houses and worse . . . the French condemned the Convent of San
> Marco where I am just going, and all the pictures of Fra Angelico
> were only saved by their being driven out . . .[19]

A part of Ruskin's hatred of republicanism was that he felt that it
would bring with it the destruction of art and of ancient buildings. In
such a frame of mind *The Seven Lamps of Architecture* was written, and
painting for the moment abandoned. The preface to its first edition
explains that *Modern Painters* could not yet be concluded

> . . . owing to the necessity under which the writer felt himself, of
> obtaining as many memoranda as possible of mediæval buildings in
> Italy and Normandy, now in the process of destruction, before that
> destruction should be consummated by the Restorer, or
> Revolutionist.[20]

Ruskin was so anxious to get on with *The Seven Lamps* that he
decided that he and Effie should go to France. This they did, attended
by George Hobbs, almost as soon as they came home from the dismal
holiday in Salisbury. John James Ruskin accompanied them to
Boulogne, then crossed the Channel back to England. The French
port was full of rumours of war. An Englishman, going home, told
them that Paris was full of soldiers. It was said that France had declared
war on Austria, and that an army had marched over the Alps. John and
Effie went by rail from Boulogne to Abbeville. Here Ruskin began
work. 'I was dancing round the table this forenoon', he wrote to John
James,

. . . in rapture with the porch here — far beyond all my memories or anticipation — perfectly superb, and all the houses more fantastic, more exquisite than ever; alas! not all, for there is not a street without fatal marks of restoration, and in twenty years it is plain that not a vestige of Abbeville, or indeed of any old French town will be left . . . I got into a cafe and have been doing my best to draw the cathedral porch; but alas, it is not so easily done. I seem born to conceive what I cannot execute, recommend what I cannot obtain, and mourn over what I cannot save.[21]

Effie was delighted with her first visit to France. Like Ruskin, she enjoyed being abroad: unlike him, she took pleasure in practising foreign languages. She was a little upset to attend her first mass, but enjoyed the attentions given to them at the best hotel, where they were the only guests. Most of her time was spent idly. Ruskin worked assiduously on Norman architecture. She sat on a camp stool while he drew, measured, and took notes of buildings. In the evenings she was entrusted with making a fair copy of these notes. The political situation and the threat of war seemed real, yet distant. Ruskin began to think that he might venture further into Europe, and even take his parents to Italy. As he now wrote to John James, 'I trust the negotiations which France and England have together undertaken will pacify all and that we may have another look at Venice yet before the Doge's palace is bombarded.'[22]

From Abbeville John and Effie went on to Rouen. Here was one of those cities, 'tutresses of all I know', that Ruskin believed governed his life's work, and should always be approached with reverence. To a student such as himself, Abbeville was therefore 'the preface and interpretation of Rouen'.[23] Ruskin had been to the Norman capital in 1835, 1840, 1842 and 1844, on the summer tours with his parents that had formed his taste. All through his life Ruskin would reminisce about his walks through the city in 1842 in search of the Turnerian site for a plate in *The Rivers of France*, and how in 1857 he had been able to buy the original drawing. Rouen Cathedral he loved more than any other northern church: there and in the churches of St Nicholas, St Maclou, St Ouen, St Patrice and St Vincent, he nourished the non-Italian part of his architectural sensibility. This belonged to his youth as much as to his maturity, and he associated Rouen as much with Prout as with Turner. It was with Prout in mind that he wrote of it as

. . . a city altogether inestimable for its retention of a mediæval character in the infinitely varied streets in which one half of the existing and inhabited houses date from the fifteenth or early six-

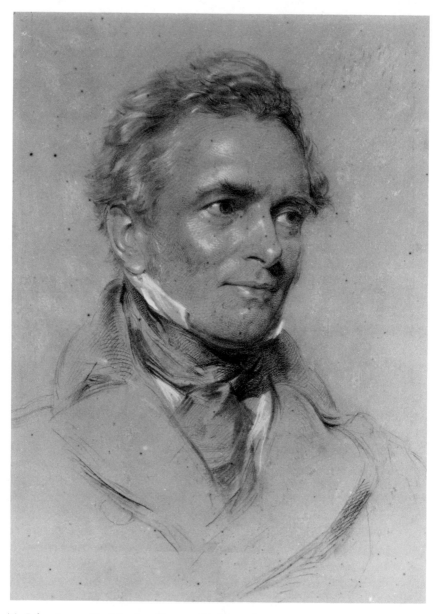

14. John James Ruskin, by George Richmond, 1848.

teenth century, and the only town left in France in which the effect of old French domestic architecture can yet be seen in its collective groups.[24]

The greater, therefore, was his rage when he and his wife arrived there in 1848. Effie reported to her parents:

John is perfectly frantic with the spirit of restoration here, and at other places the men actually before our eyes knocking down the time worn black with age pinnacles and sticking up in their place new stone ones to be carved at some future time . . . John is going to have some daguerrotypes taken of the churches as long as they are standing . . . he says he is quite happy in seeing I enjoy myself and if it were not for my gentle mediation he would certainly do something desperate and get put in prison for knocking some of the workmen off the scaffolding.[25]

In these trying conditions, in Rouen, at Falaise, Avranches, at Mont St Michel, Bayeux, Caen and Honfleur, sometimes patiently but more often urgently, Ruskin filled the eight notebooks and hundreds of sheets of drawing paper that were the basis of *The Seven Lamps of Architecture*. Absorbed in his work, he took little notice of Effie. It was some time before he noticed that she had become bored with sitting in churches. He was not sufficiently interested in her family problems. While they were in France, John James had been unhelpful with the problem of finding her brother a commercial position. Her father's affairs had not improved, and now she learnt that her Aunt Jessie was seriously ill. Of all this, Ruskin wrote to his father with the honesty of the totally self-engrossed:

Even when poor Effie was crying last night I felt it by no means as a husband should — but rather a bore — however I comforted her in a very dutiful way — but it may be as well — perhaps on the other hand, that I am not easily worked on by these things.[26]

Effie was tired of France. She wanted to go back to England and then go to Scotland to see her family. Ruskin said that his own health would not permit a winter journey to Scotland, but that she ought to go there with a companion. There the matter rested, for Ruskin now made an impulsive decision to visit Paris. It might be dangerous, and he had no love for the city, but he felt that he should compare Notre Dame with the northern churches. The Ruskins arrived in Paris in the aftermath of fighting. Their trunks were opened and searched for weapons. Few shops were open, the Tuileries deserted. There were marks of fighting in the street. The republican government had reorganized the Louvre in a manner which infuriated Ruskin. Paris was, he found, as a result of the recent 'slaughterous and dishonest contest', a society plunged in 'gloom without the meanest effort at the forced gaiety which once disguised it'.[27] A week later the Ruskins were back in Denmark Hill.

CHAPTER EIGHT

1849–1850

The house which John James Ruskin had found for John and Effie, and which he had taken on a three-year lease, was in Mayfair. No. 31 Park Street was three doors away from Lady Davy's and looked out over the gardens of the Marquess of Westminster's Grosvenor House. Effie was excited by her new home and the smart brougham that her father-in-law had provided for her. Ruskin was less interested in these fashionable surroundings. He organized a study for himself in Park Street, but did not move all his books and effects from Denmark Hill. Nor was he ever to do so. He could not think of Park Street as his home, and often used to drive out to Denmark Hill to dine and stay the night. However, a good number of the Ruskins's evenings were spent at London social occasions of one kind or another. This could often be a point of contention. But there was not a simple contrast between a bookish husband and a gay young wife. There was an intellectual élite among these Mayfair gatherings which welcomed the Ruskins. It consisted of statesmen, writers, public personages connected with the fine arts and senior members of the Church of England. The Ruskins met, for instance, Henry Milman, now a canon of Westminster but shortly to become Dean of St Paul's, previously Professor of Poetry at Oxford and author of the scholarly *History of the Jews*. Milman was friendly with the historian Henry Hallam, whom Effie and John had met at Lady Davy's; and another friend of Milman's was Thomas Macaulay, the first two volumes of whose history of England had just appeared. The Ruskins met Macaulay at a party given by Sir Robert Inglis at his house in Bedford Square, where literary and political figures, both liberal and tory, met on friendly and slightly competitive terms.

In such houses Ruskin's acquaintance among the 'leading men', as his father termed them, might have been greatly increased. But he made little attempt to win friends in this society. He was rude to Milman, scorned Hallam and took no notice of Macaulay. He thought they were worldly, that they loved neither nature nor art. At Park Street he entertained old friends from Christ Church days like Lord Eastnor and Osborne Gordon. One night the Richmonds came to dinner to eat snipe from Mr Telford's estate. It was the sort of evening

Ruskin would have enjoyed, if only it had been at Denmark Hill. Towards the end of 1848 he began to press Effie to spend more time in his old family home. While they were staying there for Christmas and the New Year of 1849 Effie's relations with her parents-in-law suddenly worsened. She fell foul of Mrs Ruskin. She became ill, lost her appetite, and felt miserable. One day Mrs Ruskin found her in tears when she should have been getting ready for dinner, and scolded her. Soon she developed a feverish cold and began coughing badly. The elder Ruskins treated her illnesses as self-indulgences. They held it against her that she did not come downstairs to attend their New Year's dinner party, when Joseph Severn, Tom Richmond (George's brother), and Turner were among the guests. Try as she might, Effie could not get better. Her own doctor and the Ruskins's family doctor gave her contradictory advice. Then her mother came to stay. Effie suddenly saw a way to recover her spirits. She decided to return to Scotland with her mother, leaving her husband behind in London. Ruskin, hard at work on *The Seven Lamps of Architecture*, was not at all displeased to be left in peace. He immediately moved out of Park Street and returned to Denmark Hill. As things turned out, he was not to see his wife for another nine months.

★ ★ ★ ★

While Ruskin was living in Park Street he was invited to join the council of the newly founded Arundel Society. Its originators were C. H. Bellenden Kerr, Sir Charles Eastlake, Edmund Oldfield and Aubrey Bezzi. We may think of them as the kind of men with whom Ruskin had sporadic professional rather than social relations. Kerr was a deaf and eccentric lawyer with artistic tastes. Edmund Oldfield was Ruskin's schoolfriend at Dr Dale's who knew so much about Gothic architecture: he now worked in the British Museum. Bezzi was the Society's secretary. He had republican sympathies and had fled from Italy with Panizzi, the future librarian of the British Museum: later on he would become a member of the government of the kingdom of Sardinia. Eastlake, a busy man, made little appearance at Arundel Society meetings. The wary respect he and Ruskin felt for each other had not yet been transmuted into open hostility.

The Society was begun with a didactic and æsthetic purpose. Its founders had a partial model for their enterprise in the Society for the Diffusion of Useful Knowledge, but their intention (so their prospectus announced) was to serve a revived interest in art by copying and

publishing reproductions of Italian paintings. Connoisseur-collectors who had assembled engravings after old masters in previous years had not had such an educational purpose. Nor had such connoisseurs commissioned engravings. The Arundel Society was to do this because it was their intention to concentrate on early painting rather than on the classical masters. The prospectus points out that

> . . . the materials for such instruction are abundant, but scattered, little accessible, and, in some instances, passing away. Of the frescoes of Giotto, Orcagna, Ghirlandajo, much of which has never been delineated, nor even properly described, is rapidly perishing.[1]

Other knowledgeable people who were asked to join the council of the Society at the same time as Ruskin were Samuel Rogers, Charles Newton, Lord Lansdowne and Lord Lindsay. They were Ruskin's natural colleagues. But he was in some measure the inspiration of the Society. A good number of its projected publications were taken from works described by Ruskin in the second volume of *Modern Painters*, such as Benozzo Gozzoli's frescoes of the *Journey of the Magi*, the Tintorettos in the Scuola di San Rocco, Fra Angelico's frescoes in San Marco and Ghirlandaio's in Santa Maria Novella. The Arundel Society was variously active until 1897. Ruskin was to write two monographs for it, *Giotto and his Works in Padua* (1853-60) and *Monuments of the Cavalli Family in the Church of Santa Anastasia, Verona* (1872); while its occasional publications in pamphlet form were to give him many ideas for the stream of pamphlets, illustrations and part-publications that he issued via Smith, Elder and, later, through his own publishing company.

* * * *

When Effie Ruskin went back to Bowerswell with her mother at the beginning of February 1849 she was still suffering from the illness that had come on her at Denmark Hill. She was tired, she suffered from feverish colds, her stomach was upset and she had blisters on her throat. We may believe that some of her complaints were generated by the strain of living with such a husband: but Margaret Ruskin knew that the girl had brought the illness on herself. Margaret was now beginning to think of the contrast between her own marriage, so immensely satisfying to her, and her son's. In one letter to John James she openly mentioned her disappointment, though to Ruskin himself

she as yet said nothing. At Bowerswell, the Gray family were suffering from bereavement. Effie's Aunt Jessie had died: now Effie lost her seven-year-old brother Robert. She was still unwell herself. In these circumstances she decided to stay with her family at Bowerswell and not return to accompany the Ruskins on the continental tour they planned to take that spring. This seemed sensible, if in some ways unsatisfactory. Ruskin wanted to work in Switzerland. Effie needed rest. And, as John James wrote to Mr Gray, it was not necessarily relaxing to be with Ruskin when he was working.

> It may be his pleasure but to be with him is other people's toil — out of doors at any rate. They must however arrange their comings and goings with each other. They will no doubt settle down very delightfully at last pleased with some house at home and I hope allow you and me to come to hear them in chorus singing dulce dulce domum.[2]

Ruskin was finishing the last pages of *The Seven Lamps of Architecture* as he and his parents set off for the Continent in the middle of April. He posted them to W. H. Harrison from Folkestone. Two of the etchings for the book were bitten in his hotel bedroom at Dijon. This year, the Ruskins were to be away for five months. The tour provided material for the next volume of *Modern Painters*, though the book would not appear for another five years. Ruskin dutifully wrote to his wife during their separation. One is struck by the artificial adoption of a romantic tone. The first letters emphasize how unreal his marriage was, not based on any physical or emotional fact.

> Do you know, pet, it seems almost a dream to me that we have been married: I look forward to meeting you: and to your *next* bridal night: and to the time when I shall again draw your dress from your snowy shoulders: and lean my cheek upon them, as if you were still my betrothed only: and I had never held you in my arms. God bless you my dearest.[3]

It is hard to imagine what Effie might have made of such a declaration. Was it a letter that announced physical intentions, or merely a flourish by someone who had been reading poetry? The assurance that 'I look forward to meeting you' was clearly untrue, since Ruskin was about to spend some months in his favourite places with his parents, his favourite people. The more Effie thought about her situation the less it seemed to her that she was truly married, in any way. She had strong

feelings for her own family yet the Ruskins tugged her away from them. She was too much put upon by the Ruskin parents and yet John Ruskin, her husband, in all ways eluded her. Ruskin himself could not understand this, nor begin to imagine what it might be like to be in Effie's position. Only a few days later he was writing to her in these terms:

> I often hear my father and mother saying — 'poor child — if she could but have thrown herself openly upon us, and trusted us, and would have made her ours, how happy she might have been: and how happy she might have made us all'. And indeed I long for you my pet: but I have much here to occupy me and keep me interested — and so I am able to bear the longing better perhaps than you, who have only the routine of home: I hope next summer I shall be able to make you happy in some way of your own.[4]

One explanation for Ruskin's behaviour towards Effie this time is that like many artists he became withdrawn and egotistical when nurturing his responses to nature, or to art, in preparation for some creative effort. A curious piece of self-examination is recorded in his diary the day after he sent this letter to Effie.

> It is deserving of record that at this time, just on the point of coming in sight of the Alps, and that for the first time in three years — a moment which I had looked forward to, thinking I should be almost fainting with joy, and should want to lie down on the earth and take it in my arms — at this time, I say, I was irrevocably sulky and cross, because *George had not got me butter to my bread at Les Rousses.*[5]

Whatever else we may feel about this confession, it is important to realize that Ruskin was in pursuit of his previous Alpine experiences. He believed that he was at a nexus of his imaginative life. 'The sunset of today', he recorded on 3 June, 'sank upon me like the departure of youth.'[6] This was not merely a grandiose remark. Not for the first time, Ruskin was thinking of Wordsworth's *Immortality* ode.[7] Following the poem, he also considered whether the intensity of his earlier feelings for nature could not be recaptured. Ruskin's diary this spring and summer tells us time and again how he went back to places where he had been deeply moved in previous years. He sought out the same paths, the same resting places that he had last visited three years before and, more significantly, had known as a boy in 1835. The exercise was not only to observe the landscape and weather. It was also to observe his own responses, to try to stand outside himself as an æsthetic being.

Sometimes he used personal inducements to bring his mind to an artistic state. At Blonay, amid 'lovely scenes', he

> . . . required an effort to maintain the feeling — it was poetry while it lasted — and I felt that it was only while under it that one could draw or invent or give glory to any part of such a landscape. I repeated 'I am in *Switzerland*' over and over again, till the name brought back the true group of associations — and I felt I had a soul, like my boy's soul, once again. I have not insisted enough on this source of all great contemplative art.[8]

Such self-explorations are the source for the discussion of the æsthetic emotion found in the tenth chapter of part four of the third volume of *Modern Painters*. In that volume, as also in the fourth, there are many passages which derive from Ruskin's studies in 1849 at Vevey, Chamonix, the Rhone Valley and Zermatt. The books were not published until 1856, seven years later, and were written in 1855: but they take the experiences of 1849 as their starting point. A passage on grass in *Modern Painters*, quite famous in the nineteenth century, may be taken as an example. The 1849 diary entry at Vevey reads:

> I looked at the slope of different grass on the hill; and then at the waving heads near me. What a gift of God that is, I thought. Who could have dreamed of such a soft, green, continual tender clothing for the dark earth — the food of cattle, and of man. Think what poetry has come of its pastoral influence, what happiness from its everyday ministering, what life from its sustenance. Bread that strengtheneth man's heart — ah, well may the Psalmist number among God's excellencies, 'He maketh grass to grow upon the mountains'.[9]

Five years later, in the course of a discussion of mediæval landscape, and just after some suggestive remarks about grass in Dante, Ruskin's diary note becomes a set-piece:

> Go out, in the spring-time, among the meadows that slope from the shores of the Swiss lakes to the roots of their lower mountains. There, mingled with the taller gentians and the white narcissus, the grass grows deep and free; and as you follow the winding mountain paths, beneath arching boughs all veiled and dim with blossom, — paths that for ever droop and rise over the green banks and mounds sweeping down inscented undulation, steep to the blue water, studded here and there with new-mown heaps, filling all the air with fainter sweetness, — look up towards the higher hills, where the waves of everlasting green roll silently into their long inlets

among the shadows of the pines; and we may, perhaps, at last know
the meaning of those quiet words of the 147th Psalm, 'He maketh
grass to grow upon the mountains'.[10]

In such ways, this fruitful tour of 1849 was the first stimulus of
writing that would occupy Ruskin for the next decade. If he could
strike his mood in these months he was beautifully alert to all he saw:
mountains, wood anemones, the darkness of pine forests, or the flight
of the grey wagtail. To return once again to the diary:

Friday 4th May. — Half breakfasted at Chambery; started about
seven for St Laurent du Pont, thence up to the Chartreuse, and
walked down (all of us); which, however, being done in a hurry, I
little enjoyed. But a walk after dinner up to a small chapel, placed on
a waving group of mounds, covered with the most smooth and soft
sward, over whose sunny gold came the dark piny precipices of the
Chartreuse hills, gave me infinite pleasure. I had seen also for the
third time, by the Chartreuse torrent, the most wonderful of all
Alpine birds — a grey, fluttering stealthy creature, about the size of
a sparrow, but of colder grey, and more graceful, which haunts the
side of the fiercest torrents. There is something more strange in it
than in the seagull — *that* seems a powerful creature; and the power
of the sea, not of a kind so adverse, so hopelessly destructive; but
this small creature, silent, tender and light, almost like a moth in its
low and irregular flight, — almost touching with its wings the
crests of waves that would overthrow a granite wall, and haunting
the hollows of the black, cold, herbless rocks that are continually
shaken by their spray, has perhaps the nearest approach to the look
of a spiritual existence that I know in animal life.[11]

On many occasions during the summer of 1849 Ruskin chose to be
solitary among the Alps. But he was enlivened by the arrival in
Switzerland of his boyhood friend Richard Fall. Together with Cout-
tet and George Hobbs, he and Fall went out on climbing expeditions.
At other times Ruskin left his parents for a few days and went with
George to draw and take daguerrotypes. He made notes on the angles
of various peaks, examined the flora, analysed the geology, ascer-
tained the movements of glaciers, watched the streams and clouds.
Some of this material was gathered into the diary, but many other
notebooks were used. Apart from sketched memoranda Ruskin made
forty-seven drawings which were highly enough finished for him to
catalogue, a rare procedure with his own work. This was the last time
that he was to draw landscape consistently for a number of years. The

15. *La Cascade de la Folie, Chamouni,* by John Ruskin, 1849.

best known of the drawings is *La Cascade de la Folie, Chamouni* (Plate 15). It is highly detailed, dramatically unfolding a vista of mountain scenery beyond and high above the plunging waterfall. These drawings were used a few years later to write the chapter on aiguilles in the fourth volume of *Modern Painters*. A number were executed during a memorable few days, full of difficult climbing, when Couttet took Ruskin on *le tour de Mont Blanc*. The young Englishman and his guide went by St Gervais and Contamines over the Col du Bonhomme to Chapui: thence ascended to the Col de la Seigne, 8,000 feet high, where Ruskin drew, before proceeding to Courmayeur. They then went over the Col Ferret to Martigny, and from Martigny to Zermatt, where Ruskin made the study of the cliffs of the Matterhorn that enabled him to write the chapter 'On Precipices' in the fourth volume of *Modern Painters*. He then spent three days in Montanvert, where after a day's Alpine note-taking he wondered if he had ever enjoyed an evening so much in his life, sitting 'at the window quietly today watching the sunset and the vast flow of ice, welling down the gorge — a dark and billowy river — yet with the mountainous swell and lifted crests that the iron rocks have round it'.[12]

This summer among the Alps also set Ruskin to consider peasant economy and culture. In a diary entry at St Martin's we find the origin of the great chapter in *Modern Painters* IV, 'The Mountain Gloom'. Ruskin was thinking then

> . . . what a strange contrast there is between these lower valleys, with their ever-wrought richness mixed with signs of waste and disease, their wild noon-winds shaking their leaves into palsy, and the dark storms folding themselves about their steep mural precipices — between these and the pastoral green, pure aiguilles, and fleecy rain-clouds of Chamouni . . .[13]

Natural life both intermingled and contrasted with the social order in the Alps. The peasants were poor, wretchedly so. There was much goitre and cretinism. How could there be such human misery in such divinely fashioned surroundings? It was this 'melancholy knowledge', Ruskin confessed in *Præterita*, 'of the agricultural condition of the great Alpine chain which was the origin of the design of St George's Guild'.[14] But that was far in the future, and in 1849 Ruskin could not quite bring himself to think independently about social problems. He was so absorbed by nature that even the evidence of war left him only a cool observer. Chamonix is in Savoy. At this date Savoy, with Piedmont, was part of the kingdom of Sardinia. In the 1848 revolutions Charles Albert, the King of Sardinia, had fought

against the Austrians. He had been defeated, had abdicated, and had given up his throne to his son Victor Emmanuel. The Ruskins saw the remains of Charles Albert's defeated army at Chambéry. John reported to Effie:

This place is full of soldiers, returned from the last battle: shabby fellows the Savoyard troops were always and look none the better for their campaign: and as the government cannot afford them new clothes, though it is getting them into some order again as fast as it can, they look slovenly and melancholy: more beggars on the road than ever, and the people seeming hard put to it — but a quiet and gentle people, and one that with a good religion, might be anything . . .[15]

In June, when John James Ruskin thought that he had never seen his son in better health, trouble started between the Ruskins and the Grays. Effie's illnesses were still troubling her. She decided to consult Dr James Simpson, Professor of Midwifery at the University of Edinburgh. It is possible that Simpson advised her to have children: he certainly did so later on. But when Effie wrote to Ruskin to tell him about the consultation she did not report to him what Simpson had thought. Ruskin was annoyed by this, and so were his parents. John James's letters to Perth changed from concern to condemnation: 'About your daughter Mrs Ruskin and myself must continue to be anxious and as I use no reserve I will confess to you that the feeling is mixed with sorrow and disappointment.'[16] Grievances were aired about Effie's clothes, housekeeping, and the like. For a little while, as this unpleasant correspondence continued, Ruskin was markedly kinder to his wife than his parents were. But it is plain that practically all his attention was given to the mountains, not to Effie's well-being. In the circumstances, Mr Gray showed great patience. He wrote to John James Ruskin,

If I may be permitted to hint a word by way of advice it would simply be that Mrs Ruskin and you should leave John and Phemy as much as possible to themselves — married people are rather restive under the control and supervision of parents tho' proceeding from the kindest and most affectionate motives.[17]

If this was generally so of married people, it was not so of John Ruskin. While he exchanged quite pleasant letters with his wife he made no attempt to calm the increasingly angry tone adopted by his father. Behind the whole quarrel was a simple question. Why was Effie not happier? Ruskin kept silent. One of John James's pleas was

for complete frankness. Mr Gray wrote of how his daughter hated hypocrisy. But the sexual position of the young couple was unsuspected by the parents. Had Ruskin ordered Effie not to tell her mother that he refused to make love to her? A great deal was not discussed. As far as one can gather from the many letters now exchanged, neither family mentioned children. But they said many other things to each other, and on the Ruskins's side said them harshly. Towards the end of his stay in Switzerland Ruskin was writing to Effie's father with an extraordinary interpretation of her unhappiness:

> The state of her feelings I ascribe now, simply to bodily weakness: that is to say — and this is a serious and distressing admission — to a nervous disease affecting the brain. I do not know when the complaint first showed itself — but the first I saw of it was at Oxford after our journey to Dover: it showed itself then, as it does now, in tears and depression: being probably a more acute manifestation, in consequence of fatigue and excitement — of disease under which she has long been labouring . . . an illness bordering in many of its features on incipient insanity. [18]

Ruskin had not seen his wife since February. When, in late August, the Ruskins started to make plans to go home, the Grays were anxious that John should go to Perth to collect Effie. There was a simple reason for this. There was much gossip in Perth, as well there might be, about Effie's marriage. The Grays wanted John to be seen there with his wife. The elder Ruskins objected to this proposal and Effie, once more, received a most un-uxorious letter.

> As for your wish that I should come to Scotland — that is also perfectly natural — nor have I the slightest objection to come for you: only do not mistake womanly pride for womanly affection: You say that 'you should have thought the first thing I should have done after six months' absence, would have been to come for you'. Why, you foolish little puss, do you not see that part of my reason for wishing you to come to London was that I might get you a couple of days sooner: and do you not see also, that if love, instead of pride, had prompted your reply, you would never have thought of what I *ought* to do, or your *right* to ask, you would only have thought of being with me as soon as you could . . .[19]

In the event, however, Ruskin did go to Perth. He arrived there towards the end of September, thin, sunburnt, slightly distracted. Relations were bound to be difficult. There was embarrassment in the air, though Ruskin did not feel it. Now Effie made a suggestion that

was both bold and sensible. She asked Ruskin to take her to Venice. It was perfectly possible. Nothing stood in their way. The bombardment of the city was over, Manin's republican government had fallen, and Venice was once more in Austrian hands. For Effie, the great advantage of going to Venice was that she could have John on her own. For Ruskin, too, there were good reasons for going there. He could continue his architectural studies at a time of relative political stability. He might never have another such opportunity. Dr Simpson was in favour of the plan. John James Ruskin wrote a sensible and generous letter giving them his blessing: he would, of course, be paying all their expenses. In this way the Ruskins's marriage was rescued for a time.

★ ★ ★ ★

Ruskin had scarcely been back in England for three weeks before setting off with Effie en route for Venice. Effie took a companion with her. This was Charlotte Ker, a Perth neighbour. In London, Effie got on perfectly well with the elder Ruskins. She busied herself with the exciting task of getting their two carriages ready, while Ruskin and George Hobbs packed books and daguerrotype equipment. From Boulogne, sometimes posting and sometimes travelling by rail, they travelled quickly towards Switzerland. Ruskin was at his most kind and charming. Effie wrote home with the news of her

> . . . first view of the Alps, the Plain of Geneva and the Lake seen from an elevation of 3,000 feet the most striking Panorama I ever beheld but curious to say I was not in the least surprised by the magnificence of the view as it was exactly like what I had always supposed it would be . . . John was excessively delighted to see how happy we were and went jumping about and executing *pas* that George and I agreed Taglioni would have stared her widest at.[20]

In the Alps, Effie and Charlotte were shocked by the condition of the peasantry. To have observed poverty in rural Scotland was no preparation for this. They saw children with no arms, women with huge goitres that had necklaces and crosses draped over them. The men were filthy and toothless. Chamonix was a cleaner village than most: it was one reason why the Ruskins stayed there so often. An arrangement had been made with Couttet to meet them there. He was delighted to see Ruskin again so soon, and even more delighted to meet Effie. Ruskin, alone, climbed up the Breven to a favourite site and took notes on the aiguilles across the valley. But he was conscious

that his *Modern Painters* work would have to be put aside for architectural research in Venice. Abandoning his aiguilles, he took up a local ghost story instead. Some Chamonix children had been frightened by the apparition of a woman dressed all in black. Ruskin, who derived from Anne Strachan an interest in ghosts that would remain with him all his life, sought out these children. He talked to them, interrogated the local priest, and even organized the digging of a large hole at the place where the spectre had been seen.

The party had paused in Switzerland to allow time for Venice to recover from the cholera epidemic that had spread through the city during the siege. As they moved on to Milan the effects of war became apparent. Roads were closed, churches had been commandeered, provisions were scarce. Austrian and Croatian troops were everywhere. Ruskin's diary now becomes filled with architectural notes, while Effie's letters home are packed with social detail. In Milan she and Charlotte were hoping to set eyes on Field-Marshal Radetzky 'as he is a *decided* lion'.[21] Radetzky was the Civil and Military Governor of the Lombardo-Veneto, an elderly soldier who had commanded the Austrian army which suppressed the Italian nationalist revolts. In Milan, Effie was not sure of her political feelings. She declared, 'I am a thorough Italian here and hate oppression.'[22] Very soon, however, she took the Austrian side, as did her husband. Ruskin was only slightly less vehement than his father in expressing dislike of republicanism. As English tories, they were without sympathy for nationalist aspirations. Ruskin's view was that the Italians, unhappy as they no doubt were, had brought the occupation on themselves by their past sins and follies, and that the Austrian government was probably as wise as one could hope for from a Romanist administration. He saw the suffering, but it did not engage him. He had, he confessed, 'no heart nor eyes for anything but stone'.[23]

The railway to Venice had been destroyed, so the party had to leave their carriages outside the city. George arranged the transfer of their luggage to the Hotel Danieli on the Riva degli Schiavoni. The hotel was only a hundred yards from St Mark's Square: from the windows of their suite they could see the Campanile and could hear the Austrian band that played in front of St Mark's every night. Ruskin immediately toured the major Venetian buildings to make sure they were still standing. To his relief, the damage was not as extensive as he had feared. Quite soon he left Effie and Charlotte, with their Murray's guide, to go exploring on their own. Effie searched for the Venice of Titian and Veronese. She was pleased with the *festa* of the Madonna della Salute, held every year since 1662 as a thanksgiving after the

plague. She was never to see the many festivals and holidays that commemorated Venice's proud past: the Austrians had suppressed them. The English party, since they sided with the Austrians, necessarily had a foreigner's view of the city's life, and hardly a sympathetic one. They were cut off from the proud Venetian nobility, except the collaborators, and also from most intellectuals. Effie now learnt the differences between the *italianissimi*, the patriots, and the *austriacanti*, Italians with Austrian politics. She saw how they never mixed, never went to the same social occasions, frequented different cafés. She learnt that the Austrian band in St Mark's Square was a symbol of Austrian supremacy: that was why all patriots left the square as soon as it started to play. One day she witnessed the burning of all the paper money, the *moneta patriottica*, that had been issued by Manin's government. It was an action designed to humiliate the Venetians. The city's economy was at a standstill. Thousands had no employment and nowhere to live. On the way back to the hotel at night Effie passed the homeless lying packed together at the end of bridges. 'The lower population here are exactly like animals in the way they live,' she wrote, 'and the fishermen's families live in rooms without an article of furniture and feed in the streets.'[24]

Ruskin was eager that Effie and Charlotte should go into Austrian society so that they would be safely occupied while he worked. He wrote to Lady Davy asking her to arrange some introductions. He had one contact of his own. John Murray had given him an introduction to a man who would be able to help him among Venetian archives. This was Rawdon Brown, who became a lifelong friend. Brown, ten years older than Ruskin, had lived in Venice since 1833. He was eccentric, quarrelsome, quite out of sympathy with his homeland and full of a detailed love of his adopted city. He had bought and restored a palace on the Grand Canal which he filled with Venetian art, documents and curiosities. When the Ruskins arrived in Venice he was practically the only English person there: the others, like most of the Venetian aristocracy, had left the city before the siege began. Brown's curiosity and eclectic mind had some effect on Ruskin, perhaps even beyond the writing of *The Stones of Venice*. For that book he was a guiding influence. Ruskin's researches were continually helped by him, both intellectually and practically. Brown had access to state papers and to the library of St Mark's and could show Ruskin how to use them. He also, shortly, introduced Ruskin to another English antiquary, Edward Cheney. This Shropshire landowner had a house in Venice which he visited every year. Cheney rather distrusted Ruskin's tastes — he was himself an admirer of the baroque — but opened his library

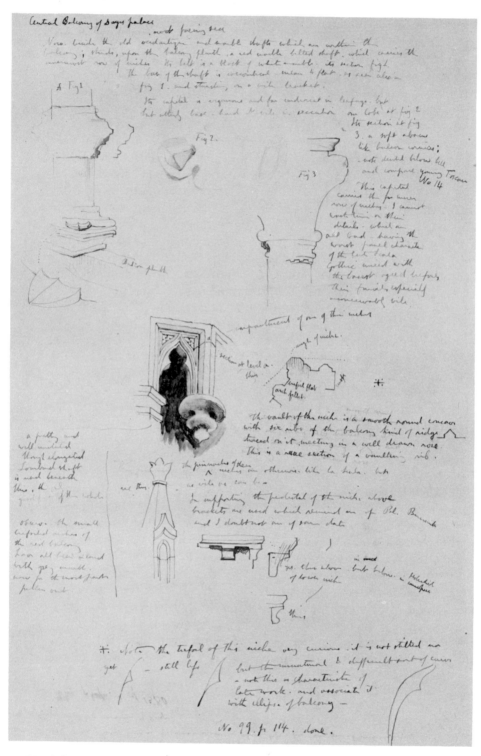

16. Worksheet no. 99. In preparation for *The Stones of Venice*: notes on the Ducal Palace, December 1849, by John Ruskin.

to him and sometimes sent a servant round to the Danieli with suggestions that he thought might be useful.

As Effie and Charlotte began to meet people in Venetian society, Ruskin became more deeply absorbed in his researches. They had some shared diversions: a picnic, improvised games of shuttlecock, trips to the islands, dinner with Brown. But they usually spent their days separately. 'I could hardly see less of him than I do at present with his work,' Effie wrote, 'and think it is much better if we follow our different occupations and never interfere with one another and are always happy . . .'[25] Effie was the centre of attention. She had beauty and high spirits. Eager to meet people, unabashed in foreign languages (she had to speak French, German and Italian), she made many friends, and certainly some admirers too. It seems that she attended parties and balls practically every night. Charlotte was a good chaperone, but Effie was not thereby the less noticeable as a woman who appeared everywhere without her husband. In the society in which she moved — enclosed, rich, cosmopolitan, full of intrigue — this could have been misunderstood. But Effie had cool feelings for propriety. She knew how to be charming without being flirtatious. Other women liked her. Mrs Gray was a little concerned, but Effie rejected her worries.

> I hope I have inherited a little of my father's sense and your discretion to some purpose. In fact John would require a wife who could take [care] of her own character, for you know he is intensely occupied and never with us but at meal times, so that we can do anything we like and he does not care how much people are with us or what attention they pay us. I understand him perfectly and he is so kind and good when he is in the house that his gentle manners are quite refreshing after the indolent Italian and the calculating German, but we ladies like to see and know everything and I find I am much happier following my own plans and pursuits and never troubling John, or he me.[26]

Effie loved Venetian society. She mixed with the officers of the occupying forces and their ladies, with the *austriacanti* nobility and with the visitors to Venice who moved in such circles. The very names that we find in her letters home are eloquent. There was the Madame Taglioni who once owned the palace in which Rawdon Brown now lived, Count Wimpffen, the Count and Countess Minischalchi, Baroness Hessler, the Countess Mocenigo and the Duc de Bordeaux. At a private musical performance attended only by Italians she met Prince Joseph Giovanelli. At balls she talked to the Baroness Wetzler, danced

with the young officers Holzammer and Montzig, but mostly with
Prince Troubetzkoi, whom she later decided not to see in London. She
chatted to the Saxon consul Herr Becker, to the Baron Urmenyi, 'my
handsome old friend who lives here in the hotel',[27] and to the Marquis
Selvatico, the President of the Venetian Academy. One might not
think that a twenty-year-old girl from Perth would mix naturally in
this society. Yet Effie did so with great success. Her vivid personality
carried her over her lack of sophistication. She had much Scottish
feeling for morals. She criticized the Baroness Gras du Barry, 'a Scotch
woman married to a Frenchman, just from Paris, a dashing woman
attended by a handsome young French count, the kind of person I
particularly dislike to see any countrywoman of mine become'.[28] Effie
would not call on Marie Taglioni, the ex-dancer, because her mother
felt it would be an impropriety (though she saw much of her in other
people's houses); she went to German Protestant services, read her
Bible in St Mark's, and refused invitations for Sundays.

Effie reported to Perth that Venetian society could not decide
whether her husband was mad or very wise. Ruskin took no notice of
anyone and would let nothing disturb him from his work. His
activities called forth comment. In crowded squares he could be seen
bent over his daguerrotype equipment, with a black cloth over his
head. He climbed up ladders and scrambled over capitals. He lay full
length on the floor to draw some awkwardly positioned detail. His
tape measure (which he kept until he died) was constantly in play. On
descending from climbs over buildings he would stand musing, or
attending to his notebook, while his gondolier dusted him down. He
became a figure of fun for 'the blackguard children who hinder me by
their noise and filth and impudence' as he paced around their favourite
playgrounds, the bombed and ruined churches.[29] Beggars followed
him everywhere. Much of his work was so laborious and irritating
that he was liable to fall out of love with the city. 'I went through so
much hard, dry, mechanical toil there', he wrote a few years later,

> . . . that I quite lost, before I left it, the charm of the place . . . I had
> few associations with any building but those of more or less pain
> and puzzle and provocation: — pain of frost-bitten finger and
> chilled throat as I examined and drew the window-sills which didn't
> agree with the doorsteps, or back of house which wouldn't agree
> with the front; and provocation from every sort of soul or thing in
> Venice . . .[30]

One person who did not provoke him was his wife. He was indifferent
to Effie's social occupations. After supper he went into his room to

write while Charlotte and Effie practised waltzes and polkas with
friends. If he was obliged to go out in the evening he took a book with
him, or wrote. The description of champfered edges that appears in
the first volume of *The Stones* was written at the opera. Ruskin,
normally a theatre-lover, now wrote to his father that

> . . . operas, drawing rooms and living creatures have become alike
> nuisances to me. I go out to them as if I was to pass the time in the
> stocks and when I am in the rooms, I say and do just what I must and
> no more: if people talk to me I answer them, looking all the while
> whether there is any body else coming to take them away. As soon
> as they are gone I forget their names and their faces and what they
> said and when I meet them the next day I don't see them. When I
> walk with Effie she is always touching me and saying that is so and
> so — now don't cut him or her as you did yesterday . . .[31]

When Effie was practising polka steps her partner was an Austrian
officer, a first lieutenant of artillery named Charles Paulizza whose
expertise had directed the final bombardment of the city. Paulizza
seems to have been a romantic type of officer. He was fair, with long
moustaches. He swirled his grey military coat lined with scarlet. He
was a poet, he could play the piano, and he drew. Ruskin quite liked
him, but as he could not speak English and his Italian was weaker than
Ruskin's, the two men found conversation difficult. Ruskin must have
summoned all his politeness when invited to admire Paulizza's draw-
ings, which appear to have been plans and diagrams for his attacks on
the city: but he was glad to use his influence to gain entrance to
buildings under military occupation. Effie and Paulizza conversed in
German. Soon he came to escort her everywhere. Her letters home are
full of him. Descriptions of his charm and his accomplishments alter-
nate with assurances that she is in no moral danger. A great friendli-
ness had sprung up between them. There may have been more than
that on Paulizza's side, but he behaved always with courtesy. Effie's
letters, so frank are they, bespeak that if she were not so content with
Ruskin — as, at this period, she was — she might have loved this man.
She wrote to her mother,

> He is very fond of me, and, as you say, were John unkind to me and
> not so perfectly amiable and good as he is, such excessive devotion
> might be somewhat dangerous from so handsome and so gifted a
> man, but I am a strange person and Charlotte thinks I have a perfect
> heart of ice, for she sees him speaking to me until the tears come into
> his eyes and I looking and answering without the slightest discom-

posure, but I really feel none. I never could love anyone else in the world but John and the way these Italians go on is perfectly disgusting to me that it even removes from me any desire to coquetry, which John declares I possess very highly, but he thinks it charming, so do not I . . .[32]

Effie's position was plain. But she knew what gossip was like, and she knew more about Perth gossip than Venetian gossip. She asked Charlotte not to mention her friendship with Paulizza in her letters home.[33]

Ruskin's work preparatory to the first volume of *The Stones of Venice* was coming to an end by March of 1850. Effie was not happy at the idea of returning to London. She could not imagine any life that could be as pleasant as was hers in Venice. The end of their stay came quickly, and Effie felt that they must soon come back to the city she had grown to love. While Ruskin finished off some work in St Mark's she looked forward to seeing Radetzky, and perhaps even meeting him. The military governor was due to make a short visit to Venice from his headquarters in Milan, and Effie knew that she would be invited to the same functions as the famous old soldier. The Ruskins had a farewell lunch with Paulizza. An embarrassment was that Ruskin's Italian bankers came to say goodbye at the same time. Patriots, they would not speak to an Austrian. Rawdon Brown gave Effie a brooch as they went by gondola to the railway. The next night the Ruskins were in Padua, and in Vicenza the night after that before staying for a few days in Verona. By 9 April they had reached Paris, where Effie made a visit that gave her much to think about. Ruskin took her to call on the Domecqs. Adèle was now twenty-nine, and married to Baron Duquesne. Effie thought her the least attractive of all five sisters. But she looked with a special interest at Adèle's young daughter, who spoke excellent English and was playing with a doll that Mrs Ruskin had sent her. A few days later John and Effie Ruskin were back in Denmark Hill.

CHAPTER NINE

1850–1852

When the Ruskins once more moved back to Park Street in the early summer of 1850 their life fell into a predictable pattern. Effie busied herself with her friends and her entertaining. Ruskin worked on his book and occasionally, grudgingly, accompanied her to parties. Most of his writing was done at Denmark Hill. He left Park Street after breakfast and did not return there until the evening. If he did not see his parents for a day or two, he wrote to them, and these letters often express his dislike of the society in which he moved:

> My dearest mother — horrible party last night — stiff — dull — large — fidgety — strange — run-against-everybody — know-nobody sort of party. Naval people. Young lady claims acquaintance with me. I know as much of her as of Queen Pomare. Talk. Get away as soon as I can — ask who she is — Lady Charlotte Elliott — as wise as I was before. Introduced to a black man with chin in collar. Black man condescending. I abuse several things to black man, chiefly the House of Lords. Black man says he lives in it — asks where I live — I don't want to tell him — obliged. Black man asks — go away and ask who he is. Mr Shaw Lefevre — as wise as I was before. Introduced to a young lady — young lady asks if I like drawing — go away and ask who she is — Lady Something Conyngham. Keep away with back to wall and look at watch. Get away at last — very sulky this morning — Hope my Father's better — dearest love to you both. Ever, my dearest mother, your most affec. son.[1]

There were many aspects of politics and public life of which Ruskin was simply ignorant. His 'black man' was Charles Shaw-Lefevre, the rather famous Speaker of the House of Commons. Effie, on the other hand, did not make mistakes of this sort. While she knew little of politics she was interested to know who was important. She had much talent as the mistress of a fashionable house. All the same, she longed to go back to Venice. One day in May she burst into tears as she and Ruskin were looking over some of Prout's sketches of the palaces and lagoons. Ruskin then promised her that they would return as soon as he had finished the first volume of his history of the city.

It was at this time that John and Effie met Sir Charles and Lady

Eastlake. Sir Charles had recently become the President of the Royal Academy. He had also married the formidable Elizabeth Rigby. Forty years old, six feet tall, she was the only woman contributor to the *Quarterly Review*, in whose pages she wrote pugnacious articles on art and other topics. She took to Effie at once, found Ruskin 'improving on acquaintance', but was soon to come to hate him.[2] Her husband and Ruskin knew that they were opposed on all æsthetic matters but managed to be polite to each other. Lady Eastlake sensed the hollowness of the Ruskins's marriage. She went out of her way to be kind to Effie, aware that kindness to one partner in a marriage can sometimes express malice towards the other. Effie could not always see why Ruskin distrusted people like the Eastlakes, for she had little understanding of his intellectual loyalty to his tastes. But she was sure that his artistic obsessions disturbed her social arrangements. They had an invitation to the country seat of Edward Cheney, whom they had met in Venice. Ruskin did not want to go: he knew the house would be filled with the wrong sort of art. Effie could not see that this mattered at all. And when Ruskin took her out of town to visit people with whom he wished to talk she was not properly entertained.

In April of 1851, they went together to Cambridge to stay with Dr Whewell, the Master of Trinity. The two men ignored her while they discussed architecture and theology. For many reasons Effie wanted to see her family in Scotland. She took the opportunity presented by another of her mother's pregnancies to leave London for Bowerswell. While she was there she went once more to see Dr Simpson, and it was after this consultation that she began to state publicly that she wished to have children but that her husband was opposed to her desire. She might have told Lady Eastlake: certainly she wrote to Rawdon Brown about it. She declared to him,

> I quite think with you that if I had children my health might be quite restored. Simpson and several of the best medical men have said so to me and your gracious permission to me against your prejudices amuses me not a little, but you would require to win over John too, for he hates children and does not wish any children to interfere with his plans of studies. I often think I would be a much happier, better person if I was more like the rest of my sex in this respect.[3]

This was speaking quite openly: it was close to confessing to the shrewd old man the real circumstances of her marriage.

* * * *

The first volume of *The Stones of Venice* was published in March of 1851. While there were some objections to it in the architectural press, several accusations of bigotry and an attack in the *Athenæum*, the book was on the whole well reviewed. That is perhaps because it was treated as literature. It is indeed literature: but, as Ruskin was to discover and lament, many people were so beguiled by his prose that they took little notice of what he was saying. In the book's mixture of history, politics, æsthetics and theological polemic, two things stood out most clearly to the average reader. They were Ruskin's style and his elevated conception of the importance of art. Charlotte Brontë was typical in her response. She wrote to a friend that

> *The Stones of Venice* seems nobly laid and chiselled. How grandly the quarry of vast marbles is disclosed! Ruskin seems to me one of the few genuine writers, as distinguished from bookmakers, of the age. His earnestness even amuses me in certain passages; for I cannot help laughing to think how utilitarians will fume and fret over his deep, serious, and (*they* will think) fanatical reverence for art.[4]

Ruskin had to resort to the less literary form of the pamphlet to convey the reality of his political views. Three days after the publication of *The Stones* he issued *Notes on the Construction of Sheepfolds*. This is an expansion of 'Romanist Modern Art', the twelfth appendix to the first volume of the parent book, which attacks the Roman Catholic A. W. N. Pugin. The latter was the architect who had done most to associate the English Gothic Revival with the Catholic revival and the Oxford Movement. Ruskin wished to dissociate his own work from any taint of Catholicism. But he went further than this: he wished to claim that his own establishment Protestantism was an active spiritual force, and could be the inspiration of true modern art.

Conservative Protestant politics after the 1848 revolutions give the background to both *The Stones of Venice* and *Notes on the Construction of Sheepfolds*. An immediate stimulus was the 'Papal Aggression' and the Anglican response. In 1850 Pope Pius IX appointed Cardinal Wiseman to be Archbishop of Westminster, placing twelve English bishops beneath his authority. This restoration of the Catholic hierarchy led to an outcry quite beyond its political importance. All Ruskin's associates, and he himself, believed that it was not only the constitution that was therefore threatened: the spiritual life of the island nation had been put at risk. George Croly thought that he saw the work of Antichrist:

> England, the Archiepiscopal Province of Rome! Does not the blood of every man in England boil at the idea? England cut up into

quarters like a sheep, for the provision of twelve Papists! England, mapped out like a wilderness at the Antipodes, for the settlement of the paupers of Rome! England, the farm-yard of the 'lean kine' of Rome![5]

Osborne Gordon was part of a deputation from Oxford which went to Windsor to protest to the Queen. While Ruskin and Effie had been at Cambridge the question had been discussed, Whewell assuring them that his undergraduates were even 'violent about the Papal aggressions'.[6] Ruskin's own views were much the same as Croly's. But they were given a far more cultured expression in the form of parallels with the history and art of Venice. *The Stones of Venice*, its appendices, and the *Sheepfolds* pamphlet all show how entangled were his political views with his literary ambitions. *The Stones* is an admonitory epic and a romantic spiritual journey. We can say with justice that it is inspired by Milton and Byron. At the same time it expresses the last vestiges of the toryism that had been defeated in 1829 and 1832 by Catholic emancipation and the Reform Bill.

Many of Ruskin's political views were inherited from his father and his father's friends. However fiery, they could have seemed quaint to men of his own age. But Ruskin was never interested in learning about politics from his own generation. He looked to older men. To John James Ruskin, Croly, and the like, we must now add the influence of Thomas Carlyle. In later years Ruskin could not remember how his knowledge of Carlyle had grown, so interwoven was his own thought with that of the man whom he liked to call his 'master'. He believed that it was George Richmond who first put a copy of *Past and Present* in his hands. In 1850 and 1851 it is probable that he was most affected by Carlyle's *Latter-Day Pamphlets* and especially the chapter on 'Parliaments'.[7] There he would have found an extremism which much of his own writing was concerned to refine and elaborate. Ruskin would never abandon such views as these. He reissued *Notes on the Construction of Sheepfolds* as lately as 1875. He had then long since thrown off his anti-Catholicism, but he still believed in many other aspects of his pamphlet. Its notions of wise monarchical government and Church discipline are a constant preoccupation of *Fors Clavigera* and would be a principle of the constitution of the Guild of St George.

Notes on the Construction of Sheepfolds resembles much of Ruskin's later writing in that it seems designed to force its readers into principled positions. There were a number of replies to *Sheepfolds*, among them another pamphlet by the painter William Dyce. It was also the occasion of some correspondence between Ruskin and F. D. Maurice.

The two men did not know each other. Maurice was at this date the Professor of Theology at King's College in the Strand, and was active in the Christian Socialist movement. Christian Socialism was so anti-pathetic to Ruskin's temperament that an intermediary was needed. This was F. J. Furnivall, the first of the many conciliatory messengers that Ruskin would require in his later career. Furnivall was a serious young man. He was in the chambers of Bellenden Kerr, the lawyer who had been among the founders of the Arundel Society. Furnivall one evening had met Effie, and she had invited him to Park Street. His description of Ruskin at this first meeting is interesting:

> Ruskin was a tall slight young fellow whose piercing frank blue eyes lookt through you and drew you to him. A fair man, with rough light hair and reddish whiskers, in a dark blue frock coat with velvet collar, bright Oxford blue stock, black trousers and velvet slippers — how vivid he is to me still . . ! I never met any man whose charm of manner at all approacht Ruskin's. Partly feminine it was, no doubt; but the delicacy, the sympathy, the gentleness and affectionateness of his way, the fresh and penetrating things he said, the boyish fun, the earnestness, the interest he showed in all deep matters, combined to make a whole which I have never seen equal-led.[8]

Furnivall was always abjectly devoted to Ruskin. He became a regular visitor not only to Park Street but also to Denmark Hill: there, he was given hearty treatment by John James, who liked him despite thinking him a fool. He was one of the few people who took Ruskin's side at the time of the annulment of his marriage, when Effie described him, accurately enough, an 'an amiable weak young man, a vege-tarian, Christian Socialist and worshipper of men of genius . . .'.[9] The letters which Furnivall carried between Ruskin and Maurice came to nothing, theologically. But they had a social effect. Quite soon, Furnivall was to bring to Denmark Hill the invitation to join the Working Men's College.

★ ★ ★ ★

Ruskin's protestations that he disliked going into society were exagg-erated. While he disliked the glittering occasions which so excited Effie, he was no hermit. He was often at the Carlyles's in Chelsea and he kept up with his many acquaintances from the circle around Samuel Rogers. He made such new acquaintances as Dickens, Thackeray, and the painter G. F. Watts, from whom he commissioned a portrait of

Effie. Although he did not often go there he was a member of the Athenæum. Ruskin maintained his father's practice of inviting literary and artistic acquaintances to dinner three or four times a week. He preferred to do this at Denmark Hill rather than Park Street, for the atmosphere was less formal and he could show off his Turners. A frequent guest was Coventry Patmore. He was a family friend, for he had married the daughter of Ruskin's old Camberwell tutor Dr Andrews. At this time — between the Ruskins's first and second stays in Venice — Patmore held a lowly position in the British Museum. He mixed with artists as much as with his fellow writers. He was admired by the painters who formed the Pre-Raphaelite Brotherhood. William Michael Rossetti recorded that he and his brother bought Patmore's first book of poems soon after it appeared in 1844, and urged it on William Holman Hunt, Thomas Woolner and John Everett Millais, other members of the Brotherhood. In 1849 Millais had begun *The Woodman's Daughter*, a painting which illustrates a poem from this volume; and soon he would paint Emily Patmore. As he was on easy terms both with these artists and with Ruskin, Patmore was the ideal person to introduce them to each other.

Ruskin's contact with the Pre-Raphaelites was not inspired by pure camaraderie, although his influence on their fortunes made it appear that he was almost one of their number. He was to be intimate with Millais and Rossetti and, later on, with Holman Hunt. He knew William Michael Rossetti slightly in later years. Since Ruskin was older than the members of the Brotherhood by a decade and more, it was difficult for him to mix with them on equal terms. Furthermore, he mixed with them separately, and consecutively. He saw much of Rossetti in the 1850s when he was no longer on terms with Millais, and he had no real contact with Hunt until his friendship with Rossetti ended. At the time when the Brotherhood was most cohesive Ruskin was abroad, or absorbed in other matters. He may even have contributed to the break-up of the Brotherhood by championing Millais to the exclusion of his comrades. However, Ruskin's writing had certainly given some inspiration to the PRB in its early days. In the summer of 1847 William Holman Hunt had read *Modern Painters*. He later claimed that 'of all its readers none could have felt more strongly than myself that it was written expressly for him . . . the echo of its words stayed with me, and they gained a further value and meaning whenever my more solemn feelings were touched'.[10] On the basis of what he had read in *Modern Painters* Hunt urged Millais towards a high sense of purpose and naturalistic principles. This crucial resolution had an effect on the first Pre-Raphaelite pictures, Hunt's *Rienzi* and Mil-

lais's *Lorenzo and Isabella*. However, when they were exhibited in the
Academy exhibition in 1849, Ruskin was in Venice. He first saw
Pre-Raphaelite painting in the Academy exhibition of 1850, where
there were hung Millais's *Christ in the House of his Parents, Ferdinand
lured by Ariel* and a portrait of James Wyatt, together with Holman Hunt's
Claudio and Isabella. At the private view he did not at first notice
Millais's picture. 'My real introduction to the whole school', he wrote
many years afterwards, 'was by Mr Dyce, R.A., who dragged me,
literally, up to the Millais picture of the *Carpenter's Shop*, which I had
passed disdainfully, and forced me to look for its merits.'[11]

Whatever Dyce made Ruskin see in Millais's paintings, the critic
then showed no particular interest in Pre-Raphaelitism. He did not
particularly like *Christ in the House of his Parents*: it is never mentioned
in his writings without great reservations as to, for instance, its
dwelling on 'painful conditions of expression, both in human feature
and in natural objects'.[12] No writing of Ruskin's ever mentions Mil-
lais's other work of that year, the Shakespearian illustration *Ferdinand
lured by Ariel*. It was not until 1851 that he looked at Pre-Raphaelite
painting carefully, three years after the formation of the Brotherhood.
At the Royal Academy that May Millais showed *Mariana*, *The Return
of the Dove to the Ark*, and *The Woodman's Daughter*. The newspaper
critics were hostile, as they had been the previous year when the
meaning of the initials 'PRB' had slipped out. The subject of *The
Woodman's Daughter* was from Patmore's poem 'The Tale of Poor
Maud'. Millais knew that Patmore was acquainted with Ruskin, and
boldly asked the poet to ask him if he would write something about
Pre-Raphaelite painting. Ruskin went back to the Royal Academy to
look again at the paintings, then sat down to write the first of two
letters to *The Times*. The journals were already full of comment on the
first volume of *The Stones of Venice* and *Notes on the Construction of
Sheepfolds*. Ruskin, the controversialist of the moment, now entered
another fray.

He did so with caution. Signing himself 'The Author of *Modern
Painters*', Ruskin put the case for Pre-Raphaelitism. His first letter,
though it ends with a large claim for the movement, is not at all
vehement and is careful not to be laudatory. He began by saying,

> I believe these artists to be at a most critical period of their career —
> at a turning point, from which they may either sink into nothing-
> ness or rise to very real greatness; and I believe also, that whether
> they choose the upward or downward path may in no small degree
> depend upon the character of the criticism which their works have
> to sustain.[13]

This might seem an ordinary remark, but it has its significance. The Pre-Raphaelites, in appealing to Ruskin, were conscious that public rejection was close to professional failure. They looked to Ruskin for promotional reasons. They were all of them eloquent young men, and they all wrote: two of them, William Michael Rossetti and F. G. Stephens, already had access to the press as writers on art. They were quite able to speak for themselves, but wished to exploit Ruskin's authority. But Ruskin's view of his authority was of a different sort. It was also original. For it had not been said before that new artists, in relating their work and their ambitions to the circumstances of the time, should be directed by art criticism rather than by their professional teachers. Nor had it previously been assumed, as Ruskin now did, that the critic's function was to inspire good art by unrelenting public didacticism. And this is the first time that one meets the modern notion of a young artist, or group of young artists, at a turning point: a point that could be a 'breakthrough' in a career. On all these matters, Ruskin was convinced of his own rightness. Now, in the year when the aged Turner no longer had the strength to exhibit, he suddenly became the arbiter of a new generation.

The Pre-Raphaelites were known to be a coterie bound by a common programme. Ruskin's defence therefore insisted that he was not their friend and did not share their tastes.

> Let me state, in the first place, that I have no acquaintance with any of these artists, and very imperfect sympathy with them. No one who has met with any of my writings will suspect me of desiring to encourage them in their Romanist and Tractarian tendencies . . .[14]

But he approved of their evident desire to avoid academic history painting and their naturalistic techniques:

> These Pre-Raphaelites (I cannot compliment them on common sense in choice of a *nom de guerre*) do *not* desire nor pretend in any way to imitate antique painting, as such. They know little of ancient paintings who suppose the work of these young artists to resemble them . . . They intend to return to early days in this one point only — that, in so far as in them lies, they will draw either what they see, or what they suppose might have been the actual facts of the scene they desire to represent, irrespective of any conventional rules of picture-making; and they have chosen their unfortunate though not inaccurate name because all artists did this before Raphael's time, and after Raphael's time did *not* this, but sought to paint fair pictures rather than represent stern facts, of which the consequence has been

that from Raphael's time to this day historical art has been in acknowledged decadence.[15]

Ruskin defended the Pre-Raphaelites against the charge that they made 'errors' in perspective drawing and closed by offering to find a larger number of errors in work by recognized academicians. A week later he wrote a further letter to *The Times*. It was to some extent modified by John James, but ended, as the first had not, with a ringing declaration of the Pre-Raphaelites' importance:

> I wish them all heartily good speed, believing in sincerity that if they temper the courage and energy which they have shown in the adoption of their system with patience and discretion in pursuing it, and if they do not suffer themselves to be driven by harsh and careless criticism into rejection of the ordinary means of obtaining influence over the minds of others, they may, as they gain experience, lay in our England the foundations of a school of art nobler than the world has seen for three hundred years.[16]

The Times was not convinced by Ruskin's two letters. Under the second they published an editorial rejoinder. It raised what would subsequently be the most common criticism of Ruskin's appreciation of Pre-Raphaelite painting: 'Mr Millais and his friends have taken refuge in the opposite extreme of exaggeration from Mr Turner; but, as extremes meet, they both find an apologist in the same critic.'[17]

Holman Hunt and Millais composed a letter to Ruskin in which they thanked him for his interest. The address given was Millais's; probably because he lived in Gower Street at his parents' house, while the other Pre-Raphaelites were in cheap lodgings. Very soon John and Effie Ruskin drove round from Park Street to call on Millais. The painter was twenty-two years old, a year younger than Effie and ten years younger than Ruskin: and he seemed younger than his age. With his curly fair hair, handsome profile and intense manner, Millais made an immediate impression. He always had. He had been a child prodigy, and his abilities had been recognized by the then President of the Royal Academy, Sir Martin Archer Shee. Thus Millais had become the youngest student ever to have been admitted to the Royal Academy Schools, at the age of eleven. Since then he had won every prize and distinction. A person as clever and as personable as Millais had found it quite easy to be a rebel: it was as easy as being a prodigy. He was proverbially lucky. In the next few weeks, he became good friends with the Ruskins. He visited them both at Park Street and at Denmark Hill. And there was a further invitation, although he may

not have seen its significance. Millais reported to his earlier patron
Thomas Combe that

> I have dined and taken breakfast with Ruskin, and we are such good
> friends that he wished me to accompany him to Switzerland this
> summer . . . We are as yet singularly at variance in our opinions of
> Art. One of our differences is about Turner. He believes that I shall
> be converted on further acquaintance with his works, and I that he
> will gradually slacken in his admiration . . .[18]

It was this connection between Turner and Pre-Raphaelitism that
Ruskin now attempted to elucidate, or rather to claim, in a further
pamphlet. It was entitled *Pre-Raphaelitism*, and was published in
mid-August, before the Royal Academy exhibition closed. It
occasioned more argument than had his letters to *The Times*. They had
been judicious. The pamphlet was eccentric, and its title was mislead-
ing. It was not about Pre-Raphaelite painting: Ruskin had scarcely
seen more than half a dozen examples of the school. It was largely
about Turner, and was the result of Ruskin's meditations on a visit he
had made to Farnley Hall that spring. This Yorkshire country seat had
been the home of Turner's friend and patron Walter Fawkes: it con-
tained around two hundred water-colours by Turner, including the
fifty-one drawings of the Rhine, and a number of oils. The house now
belonged to Walter's son Francis Hawkesworth Fawkes, to whom
Ruskin's pamphlet was dedicated. The treatise is prefaced by a quota-
tion from *Modern Painters*, the famous injunction to young artists to
'go to nature in all singleness of heart, and walk with her laboriously
and trustingly, having no other thought but how best to penetrate her
meaning; rejecting nothing, selecting nothing, and scorning
nothing'.[19] It seemed to Ruskin that Pre-Raphaelite painting was
inclined to follow this path: if it did not, then it should do so.

The pamphlet must have seemed beside the point to the Pre-
Raphaelites themselves. No painting by any member of the Brother-
hood is mentioned in it. And while fidelity to nature was a Pre-
Raphaelite principle, they were not landscape painters and had no
interest in Turner. Years later, Holman Hunt claimed that their neg-
lect of Turner was simply because they did not know much about him:
'Turner was rapidly sinking like a glorious sun in clouds of night that
could not yet obscure his brightness, but rather increased his magnifi-
cence. The works of his meridian days were then shut up in their
possessors' galleries, unknown to us younger men.'[20] But in fact
Turner had seemed irrelevant to the making of the new art. Millais and
Hunt wanted paintings of social action and emotion: they wanted

great detail, meticulous drawing, high-keyed colour, a minimum of modelling and a minimum of aerial perspective. Little in Turner could help this kind of painting. A desire to convert Millais into a Turnerian landscapist lay behind Ruskin's *Pre-Raphaelitism* pamphlet, as it lay behind the invitation to a holiday in Switzerland. But the plan rested on many kinds of misconception.

Ruskin would have been more attentive to Pre-Raphaelite art had his mind not been occupied with his Venetian history. There is a prayerful resolution in his diary on 1 May, the morning after he had been to the Royal Academy and had first seen the paintings he would write to *The Times* to defend: 'Morning. All London is astir, and some part of all the world. I am sitting in my quiet room, hearing the birds sing, and about to enter on the true beginning of the second part of my Venetian work. May God help me to finish it to His glory, and man's good.'[21] London was busy that morning because it was also the opening day of the 1851 Great Exhibition. Effie went to the celebrations, alone, with a ticket that had been procured for her by John James. She was not discontented with her life in Park Street, and at the moment she was on quite cordial terms with her parents-in-law. But she still longed for the day when she would leave for Venice. As controversy gathered over Ruskin's recent writings she was supervising household preparations for a six-month stay in Italy. They set off for the Continent at the beginning of August, leaving behind them the Park Street household (to which they never returned), leaving the Pre-Raphaelites busy about their own business, and all England marvelling, in Paxton's glass and iron sheds, at the exhibition of industrial and material progress.

<p align="center">★　　★　　★　　★</p>

Millais had declined the invitation to accompany the Ruskins as far as Switzerland because he had planned to spend the summer painting with Holman Hunt. The holiday party might or might not have suited him. Charles Newton travelled with the Ruskins, for he had been appointed vice-consul at Mitylene and was on his way to take up his post. Also of the party were the Reverend Daniel Moore, of the Camden Chapel, and his wife. In Switzerland other friends joined them, a Mr and Mrs Pritchard. He was the Member of Parliament for Bridgnorth: she was Osborne Gordon's sister. An art critic, an intelligent Anglican, an archaeologist rising in the consular service, an MP, all together with their ladies; here was a group of people thoughtful and cultivated beyond the ordinary. That is why they seem so out of

place when we see them in Switzerland. For here was no culture, here
was no society, no religion: poverty had made the people themselves
into monsters. At Aosta, one in five of the population were goitred.
Effie saw two funerals of children, their small coffins 'covered over
with wedding-cake finery and little boys as bearers. A fat priest led the
way with the Cross and was followed by a quantity of cretins and
horrid looking men and women, all looking as happy and good-
natured as could be and laughing like anything . . .'[22] At the Hospice
of St Bernard the beds were flea-ridden and the food disgusting: it was
what the peasants ate. As if to complete their contempt for the Cathol-
icism of the valley, all the party listened while Effie played an old piano
and made the monks sing merry, secular tunes. The experience dis-
turbed people in different ways. Ruskin pretended at the time that in
Aosta he soon forgot cretinism and everything else in the fields outside
the walls where he and Newton walked through vineyards to the
chestnut groves and looked up at the Matterhorn and Mont Velan. But
in fact he did not forget; and years later the origin of the Guild of St
George would be in his 'great plan' to bring health and revive agricul-
ture in these benighted Swiss valleys.

<p align="center">★ ★ ★ ★</p>

An important aspect of the *Pre-Raphaelitism* pamphlet is its interest in
human happiness: a theme that always afterwards would haunt Rus-
kin's writing. In Switzerland and Venice he now began to think
seriously about the ways in which society — whether Venetian, Swiss
or English — ought to be concerned with human felicity. His thoughts
were prompted by the miseries he saw around him. But he also began
to consider something that he now knew about himself: that he was
happy only when he was working, and working towards some noble
end. The question also troubled Ruskin because he had to wonder
whether the happiness his wife craved was not ignoble. When they
arrived in Venice they heard of the death of Effie's admirer Paulizza.
Ruskin perhaps was more distressed than she. During this visit to
Venice one senses — almost daily, on reading the letters home — that
there was a part of Ruskin's mind that was both darker and kinder than
heretofore. Of his wife, one notices her invitations. Effie had decided
that they would be more a part of Venetian society if they were not
lodged in a hotel. Their new home was to be in the Casa Wetzler, at the
side of the Grand Canal. They had a drawing-room and a double
bedroom, a dressing-room, a dining-room and a study. Underneath
were three servants' rooms and the kitchen. In this accommodation

John and Effie could entertain in a manner grand enough for most social ambitions. Once again Effie's letters home are full of the names of the aristocracy. She was thrilled and proud to meet the Infanta of Spain and, at last, Radetzky: he found her charming. Ruskin had little to do with these people. He was more interested in English visitors to the city. This year they were arriving in greater numbers, and practically all of them were in Venice for what might be called cultural purposes. Ruskin used them to test the arguments of the book he was writing, shifting his ground between English politics and art to his Venetian surroundings. With Sir Gilbert Scott, newly appointed surveyor to Westminster Abbey, he could have professional architectural conversations. With Thomas Gambier Parry, now just beginning to collect *quattrocento* paintings, he could talk about fresco techniques. David Roberts came to drink sherry. He and Ruskin understood each other rather well, and Ruskin was pleased to hear how this minor master of architectural painting had turned down Queen Victoria's request that he should paint the Crystal Palace for her. Some people fared badly in these discussions. One became an enemy. This was Henry Milman, the Dean of St Paul's, quite unable to defend Wren's building while Ruskin made comparisons with the Venetian Gothic around them.

Ruskin's letters give only bald accounts of these conversations, but provide a daily guide to his feelings as he plunged into the writing of the second volume of his Venetian cultural history. As always, he pointed out to his parents that he was not overtaxing himself. But sometimes he fails to reassure: and in Denmark Hill there were worries about his health. John James especially was pained to find how much he missed his son. He also worried that Ruskin's views of the world might be diverging from his own. Ruskin himself was no less worried that this might be so. For this reason some of his letters are full of the strident tones of the *Britannia*, John James's favoured political reading. Of the scene in St Mark's Square where the band proclaimed the Austrian supremacy he wrote,

Round the whole square in front of the church there is almost a continuous line of cafés, where the idle Venetians of the middle classes lounge, and read empty journals: in the centre the Austrian bands play during the time of vespers, their martial music jarring with the organ notes, — the march drowning the miserere, and the sullen crowd thickening round them, — a crowd, which, if it had its will, would stiletto every soldier that pipes to it. And in the recesses of the porches, all day long, knots of men of the lowest classes, unemployed and listless, lie basking in the sun like lizards; and

unregarded children, — every heavy glance of their young eyes full
of desperation and stony depravity, and their throats hoarse with
cursing, — gamble, and fight, and snarl, and sleep, hour after hour,
clashing their centesemi upon the marble ledges of the church porch
. . .[23]

Readers of *The Stones of Venice* will recognize how Ruskin could
transform such observations into more stately political sentiments.
Especially when writing in retrospect, he would always idealize poli-
tics. In 1859, thinking about the Habsburg imperial rule, he wrote of
Paulizza:

One of my best friends in Venice in the winter of 1849-50 was the
artillery officer who directed the fire on the side of Mestre in 1848. I
have never known a nobler person. Brave, kind and gay — as
playful as a kitten — knightly in courtesy and in all tones of thought
— ready at any instant to lay down his life for his country and his
emperor. He was by no means a rare instance either of gentleness or
of virtue among the men whom the Liberal portion of our daily
press represent only as tyrants and barbarians. Radetzky himself
was one of the kindest of men — his habitual expression was one of
overflowing *bonhommie* . . . For a long time I regarded the
Austrians as the only protection of Italy from utter dissolution
. . .[24]

Effie's politics, on the other hand, tended towards the personal. She
found that British foreign policy had an effect on her position in
Austrian society. In February of 1852 she wrote,

The Austrians are crowing over us finely just now at the brilliant
figure England is making of herself after her paltry, mean foreign
policy these last three or four years, and now she is without a
foreign friend with the Caffir War, the French panic, the imperti-
nence of the Roumanians, and last, not least, a Cabinet full of old
women to trouble her, and she will find out perhaps at some cost
what Lord Palmerston has in store for her. The feeling is so strong
against the English and their position on the continent. It is a very
different thing to what it was. Before, the English were all My
Lords and their word was law and every respect was paid to them
before any other nation. Now we are all considered traders and if
politeness is shown it is only to individual merit.[25]

Thus Effie on individual merit. It is now of interest to know how
she interpreted her husband's views. Ruskin told his father,

Effie says, with some justice, — that I am a great conservative in France, because there everybody is radical — and a great radical in Austria, because there everybody is conservative. I suppose that one reason why I am so fond of fish — (as creatures, I mean, not as eating) is that they always swim with their head against the stream. I find it for me, the healthiest position.[26]

The first public occasion when Ruskin decided to swim against the tide came towards the end of this second stay in Venice. It gave his father much alarm. In March 1852 Ruskin wrote to Denmark Hill, 'I am going for three days to give the usual time I set aside for your letter to writing one for the Times — on Corn Laws, Election and Education . . . If you like to send it, you can; if not, you can consider it all as written to you, but you must have short letters for a day or two.'[27] These letters were written, but John James did not send them on to *The Times*. Some parts of them are preserved. The third letter, which is missing altogether, was probably the foundation of the 'Notes on Education' which is the seventh appendix to the third volume of *The Stones of Venice*. From the first letter and a portion of the second we may see that Ruskin criticized Disraeli, at this date Chancellor of the Exchequer, supported free trade, advocated direct taxes, taxes on luxuries and a property tax. He felt that income tax ought to be '10 per cent on all fortunes exceeding £1000 a year, and let the weight of it die away gradually on the poorer classes'. His electoral schemes were complicated, giving more votes to the property-owning and educated classes than to others. Ruskin thought of a radical coachman who might have fifty votes, which he would then swamp with his own 'four or five hundred'.[28] The letter on education is coloured by Ruskin's experiences at Oxford. In the appendix to *The Stones of Venice* which derives from this letter — it is one of the appendices that have no relevance to Venetian history — Ruskin advocates the study at university of natural history, of religion and of politics. By religion Ruskin had in mind 'the "binding" or training to God's service' rather than the study of theology. Politics is understood as 'the science of the relations and duties of men to each other'.[29]

All this was distressing to John James Ruskin. He did not forward the letters and he wrote back in strong terms about their contents. But in fact — except in the matter of income tax — Ruskin's views did not differ very widely from his father's, and they must often have talked together about just the same problems that he wished to raise in the newspapers. Ruskin's proposals on the franchise, for instance, might seem eccentric today: but such schemes were not uncommon among

tories of the Ruskins's type in the years after the Reform Bill. It was not exactly a matter of political principle that most stirred John James's apprehensions. It was his suspicion that there was a dangerous connection between his son's thinking about the national exchequer and his inability to keep down his personal expenses. The Guild of St George, in later years, would most amply prove the justice of these fears. But in 1852 the immediate problem was his son's reputation:

> My feelings of attacks on your books and on your newspaper writing differ from yours in this way. I think all attacks on your books are only as the waves beating on Eddystone lighthouse, whereas your politics are Slum Buildings liable to be knocked down; and no man to whom authority is a useful engine should expose himself to frequent defeat by slender forces.[30]

There was already quite enough trouble in England about Ruskin's artistic writings. *Pre-Raphaelitism* had been unfavourably reviewed. The effect of the pamphlet had been to divert public debate away from Pre-Raphaelite painting and towards the peculiarity of Ruskin's opinions. The Pre-Raphaelites were now at the end of the short period when they were most criticized and least able to sell their work; and the abuse formerly directed towards them now fell on Ruskin. Many publications apart from *The Times* accused him of inconsistency. The *Daily News* and the *Builder* both spoke of contradictions. The *Art Journal* attacked the pamphlet as a 'maundering medley', and the *Athenæum* wrote of its preface that 'Rarely has any oracle's *ego* been stretched further in the demand for blind faith and acquiescence than in this pamphlet; — rarely has *ego* been more vain-glorious . . .'.[31] Ruskin wrote from Venice, considerably upset: 'When I read those reviews of *Pre-Raphaelitism* I was so disgusted by their sheer broad-faced, sheepish, swinish stupidity, that I began to feel, as I wrote in the morning, that I was really rather an ass myself to string pearls for them.'[32] John James had a vague idea that adverse reviews of his pamphleteering would be good for his son and would make him concentrate on his book. He may have been right. At all events, the matter of the letters to *The Times* was allowed to rest.

Since the publication of the second volume of *Modern Painters* Ruskin had occasionally been caught up in public arguments about the national collections. One of these had been an attack on the National Gallery conducted in 1846 and 1847 by William Morris Moore. Signing himself 'Verax', he had issued pamphlets criticizing the gallery's director, Sir Charles Eastlake, on the grounds that his cleaning policy was mistaken. Ruskin had entered this controversy. He did not do so

as an opponent of Eastlake on restoration, but with a plea that paint-
ings of the earlier Italian schools should be purchased. He wanted the
paintings by *trecento* and *quattrocento* masters to come to England.
Now, in Venice, Ruskin was anxious that the National Gallery should
acquire more paintings by the great Venetians. He had already
approached Eastlake suggesting that he should buy pictures for the
nation, and when he saw a firm opportunity of buying two Tintoret-
tos he wrote to him again. He also wrote to Lord Lansdowne, a trustee
of the National Gallery whom he knew slightly from the council of
the Arundel Society, and used Edward Cowper-Temple as an inter-
mediary in approaching Lord Palmerston, the Prime Minister. Here,
one might think, was the way to get things done: but in obscure
circumstances Ruskin's recommendations were rejected, and the
paintings were not bought.

 Ruskin's belief that the governing classes were not fit to be entrusted
with the artistic soul of the nation was now strengthened. He was to be
even more disillusioned by the affair of the Turner bequest. Turner
died in London on 19 December 1851. The news reached Venice as
Ruskin worked among the tombs of Murano, in the cemetery whose
long purple walls Turner once had painted. 'Every thing in the sun-
shine and the sky so talks of him,' Ruskin wrote to his father, 'their
great witness lost.'[33] He immediately began to think what might be
preserved from Turner's vast production. His thoughts were of some-
thing he had long dreaded, that the painter might have destroyed his
own work. Ruskin knew that the condition of the paintings would in
any case be perilous. He worried what mildewed canvases might be in
the cellars in Queen Anne Street, or locked away in rooms that he had
never seen opened. At the same time, he feared that many treasures
would immediately come onto the art market. He therefore wrote to
his father with instructions about possible purchases. But when
Turner's will was published these apprehensions were largely
banished. England's greatest artist had left everything to the nation.
At the same time Ruskin heard that he was to be one of the executors.
Turner's will was characteristic of the man. It was eccentric, blunt,
generous, miserly, and whole-hearted. For such a one as Lady East-
lake, 'It is a very stupid will — that of a man who lived out of the world
of sense and public opinion.'[34] She was wrong that it was stupid, but
the rest of her sentence is worth pondering. All the contents of the
Queen Anne Street house now became the nation's property. Turner
stipulated that the paintings were to be kept together and were to be
seen without charge. *Dido building Carthage* and *Sun rising through Mist*
were left to the National Gallery on condition that they were to be

hung next to two paintings by Claude. Ignoring his next-of-kin, who subsequently disputed the will, Turner left money to build alms-houses for painters, for the establishment of a professorship of land-scape in the Royal Academy schools, and for a dinner to be held annually in his memory.

Ruskin was left nothing except nineteen guineas to buy a mourning ring. This provoked John James to the sardonic comment 'nobody can say you were paid to praise'.[35] Ruskin's father had given considerable sums for the purchase of Turners over the last fifteen years, and he knew that his son's writings had helped to raise the artist's prices. But this kind of resentment was rather swept away when he found what was in the house. John James was one of the first people to go through Queen Anne Street, which he did with Turner's dealer:

> I have just been through Turner's house with Griffith. His labour is more astonishing than his genius. There are £80,000 of oil pictures, done and undone. Boxes, half as big as your study table, filled with drawings and sketches. There are copies of Liber Studiorum to fill all your drawers and more, and house walls of proof plates in reams . . . Nothing since Pompeii so impressed me as the interior of Turner's house; the accumulated dust of forty years partially cleared off; daylight for the first time admitted by opening a window on the finest productions of art for forty years. The drawing room has, it is reckoned, £25,000 worth of proofs, and sketches, and drawings, and prints . . . I saw in Turner's rooms, *Geo Morlands* and *Wilsons*, and *Claudes* and *portraits* in various styles, *all by* Turner. He copied every man first, and took up his own style, casting all others away. It seems to me you may keep your money, and revel for ever and for nothing among Turner's works . . .[36]

It is interesting that John James was so struck to find there the early works that reminded him of Morland and Wilson. Conceivably, Ruskin had talked so much of the 'truth to nature' and the imagination of his hero's work that John James scarcely realized that Turner had long painted in borrowed styles. Ruskin's letters home are slightly reserved at this point: and we do not know much about the way that he reviewed his responsibilities as executor. He started to make plans for a Turner gallery. His ideas were progressive. He wanted it to be top-lit, with all paintings hung on the line and given their proper immediate environment by using flats to subdivide the rooms. He also thought, for a short time, of a biography of Turner. This would have been a deeply interesting book, no doubt. But Ruskin thought that *Modern Painters*, in the course of time, would fulfil the proper part of

such a biography's function. There were things about Turner's life and his household that could not be told. As Lady Eastlake gleefully recorded, 'His life is proved to have been sordid in the extreme, and far from respectable.'[37] Effie Ruskin was opposed to a biography because 'what is known of Turner would not be profitable to any lady . . . the sooner they make a myth of him the better'.[38] It is not likely that Effie's views on books had much effect on her husband. But this remark about making a myth of Turner is relevant. Ruskin thought that he would best serve Turner's memory by a critical assertion of his genius. The quotidian drudgery of the biographer was not for him, and

> . . . there might be much which would be painful to tell and dishonest to conceal — and on the other hand — apart from all criticism of his works, probably little to interest — and all criticism I shall keep for *Modern Painters* . . . if I were not going to write *Modern Painters* I should undertake it at once, but I will make *that* so complete a monument of him, D.V., that there will be nothing left for the life but when he was born and where he lived — and whom he dined with on this or that occasion. All of which might be stated by anybody.[39]

Ruskin's position as executor seemed at first to offer him the means to make a full study of the work of the artist he admired above all others. But his commitment to Venice had grown so intense that he did not even make a quick trip to England to see what extraordinary treasures might be in Queen Anne Street. Soon, matters became even more confused. Turner's will was disputed by his next-of-kin. The legal complications indicated that there would be a long suit in Chancery. Ruskin felt that he could not become involved in legal matters.[40] As also did Samuel Rogers, he set about resigning his executorship. His immediate work was in Venice. He genuinely believed that the Ducal Palace would not stand for many more years. He could see no guarantee that the relative political stability of the Austrian occupation would hold. The revolutions of 1848 could be repeated, and with far more terrible results. But while it was necessary for him to save Venice, as far as he could, by writing of her architecture, he could also feel that to write of Gothic was to prepare for his praise of Turner's genius. So he explained *The Stones of Venice* as follows:

> I see a very interesting connection between it and *Modern Painters*. The first part of the book will give an account of the effects of Christianity in colouring and spiritualising Roman or Heathen

architecture. The second and third parts will give an account of the
transition to Gothic, with a definition of the nature and essence of
the Gothic style. The fourth part of the decline of all this back into
Heathenism: and of the reactionary symptoms attending the course
of the relapse, of which the strongest has been the development of
landscape painting. For as long as the Gothic and other fine architec-
tures existed, the love of Nature, which was an essential and pecul-
iar feature of Christianity, found expression and food enough in
them . . . when the Heathen architecture came back, their love of
nature, still happily existing in some minds, could find no more
food there — it turned to landscape painting and has worked
gradually up into Turner.[41]

This was a grand design, and perhaps it is one that is not fully spelt
out in Ruskin's more formal writings. For such a connection was in
the first place emotional. *The Stones of Venice* is written out of know-
ledge, out of archæological research and some acquaintance with the
city's archives. But it is bound together by passions. Ruskin did not
write it with a historian's deliberation, but let himself be carried by
his emotions. He knew that he had to guard himself against the
nervous excitement that accompanied such efforts: at the same time
his book was fashioned by such excitement. 'The thing I have to
watch', he told John James, 'is the tendency to excitement and sleep-
lessness — the aggravation of that excitability of pulse which my
mother so often used to notice when I was a boy: the least overwork
any day causing a restless feeling all over — and exhaustion after-
wards.'[42] Ruskin's letters from Venice pay so much attention to his
own health that they have sometimes been described as hypochon-
driacal. We may also believe that they record the urgent ministrations
of his creative self.

> I found first — that every hour of thought or work of any kind, but
> especially writing, was just so much acceleration of pulse — with
> slight flushing of cheeks and restless feeling all over — That I never
> was healthily sleepy at nights — and often could not sleep more than
> four or five hours, even if I went to sleep at a proper time. That any
> violent exercise would make me restless and excited for hours
> afterwards, instead of wholesomely fatigued — and that the sligh-
> test plague or disagreeable feeling in society would do the same — I
> got into a little dispute with Mr Cheney about some mosaics one
> day — and was quite nervous the whole day after — merely a
> question of whether the colours were faded or not . . .[43]

Day after day, while often he trembled with the strain, Ruskin went

on writing. Every evening George Hobbs made a fair copy of his text to send home to Denmark Hill. All this was done as though in a race against time. A strange bond of tension existed between Ruskin and his father as they both sought for the book's expression. Effie knew nothing or little about this, and probably did not wish to understand what was happening between the two men. But she was now being even further excluded from the union of the Ruskin family.

Years later, writing in his diary on 3 March 1874, and thinking over past books, Ruskin wrote, 'And yet the Venice work was good. Let me make the best fruit of it I can, since he so suffered for it.'[44] That was on the tenth anniversary of his father's death. Ruskin still then felt guilt that *The Stones of Venice* had been fashioned out of his father's pain. They needed many kinds of companionship. It was important to them that they could talk freely together about religion, especially since Margaret Ruskin's faith was so inflexible. John James knew that Ruskin had not believed absolutely in the authority of the Bible since he was at Oxford. He also knew that even when he was writing the second volume of *Modern Painters*, whose religious bias seems very close to Margaret Ruskin's, his faith had been confused by 'the continual discovery, day by day, of error or limitation in the doctrines I had been taught, and follies or inconsistencies in their teachers'.[45] Ever since 1845 there had been a difference between the theological confidence of Ruskin's writings and his private misgivings. One would not think that the author of *Notes on the Construction of Sheepfolds* had any difficulties of belief. But just after its publication Ruskin had written to Henry Acland,

> You speak of the flimsiness of your own faith. Mine, which was never strong, is being beaten into mere gold leaf, and flutters in weak rags from the letter of its old forms; but the only letters it can hold by at all are the old Evangelical formulæ. If only the geologists would let me alone, I could do very well, but those dreadful hammers! I hear the clink of them at the end of every cadence of the Bible verse . . .[46]

It was as well that Ruskin could feel like this. For it enabled him to understand how John James Ruskin, now in his old age, could fall into religious despondency as he contemplated his death and his life after death.

Ruskin's religious thinking changed during this second extended stay in Venice, as did his own character. To use crude terms, he became less 'Evangelical' and more considerate of other people's religious feelings: but this is not necessarily to say that his faith became attenuated, nor that (as his mother was to fear) he became closer to the

Roman Catholic Church. Rather, he began the true development of
his own faith, which in the years to come would range widely between
such positions, yet at no time give the impression of compromise. The
spirit of the *eirenikon* was not natural to Ruskin, but he would always
wish to assist another person's piety. There is little justice, at this point
in the two men's lives, in the notion of John James's 'domination' of
his son, for Ruskin was now enabled to act as a spiritual pastor to his
own father. He offered John James an especial comfort when his father
wrote to him about his doubts of the after life. We do not know much
about the nature of Ruskin's own doubts because we do not have
much direct evidence of his prayers. We know that in prayer he made
resolutions: that is how he began *Modern Painters*. In *Modern Painters*
we find his capacity for adoration, which is another component of
prayer, and we assume that his petitions would not greatly differ from
those of other thoughtful men. But of his contemplative prayer we are
in ignorance, except that we may say that in his understanding of God,
Ruskin's doubting was akin to a spiritual exercise, that it led to a
deepening of feeling and a realization that the boundaries of faith are
distinct from the nature of faith.

Ruskin's notes on his Bible reading help us to understand him at this
time. During his second stay in Venice his devotional thoughts were
dominated by study of the Book of Job, which he began in September
of 1851. By the beginning of December he had completed a commen-
tary on Job which occupied ninety pages of manuscript. This has
disappeared, but we should consider what was in his mind. Job is
about innocent suffering, wisdom and the acceptance of God's ways.
It is wise not to strain for a knowledge of God beyond that available to
human speculation. But we also wish to know about revelation,
which is both what God shows of Himself and the manner in which
His nature is disclosed. Thinking of Venice, but much more of the
Alps and of Turner, Ruskin enquired:

> . . . it seems to me that from a God of Light and Truth, His
> creatures have a right to expect plain and clear revelation touching
> all that concerns their immortal interests. And this is the great
> question with me — whether indeed the Revelation *be* clear, and
> men are blind . . . or whether there be not also some strange
> darkness in the manner of Revelation itself.[47]

He was beginning to think of those things that in the fifth volume of
Modern Painters he would write about in the mysterious chapter enti-
tled 'The Dark Mirror'.

Ruskin now felt himself prepared to look at Roman Catholicism

with some sympathy. Before, he had scarcely considered the matter. The appendix to the third volume of *The Stones of Venice* which deals with education mentions that four out of the twelve young men who had been his close friends at Oxford had converted to Catholicism. He himself had been quite untouched by the Oxford Movement as an undergraduate. But another Christ Church man, William Russell, now arrived in Venice. They had not been intimates at the university, and Ruskin was surprised to find that both Russell and his wife had become Catholics. Russell's wife died while they were in Venice. Ruskin saw something of him after his bereavement and they talked about religion. John and Effie had other acquaintances in Venice who were in a rather similar situation. They met Viscount Feilding and his wife. She was dying of consumption; he had been estranged from his family since becoming a Roman Catholic. Feilding was not much older than Ruskin and his wife was the same age as Effie. Ruskin felt sympathy for them, and discussed matters of doctrine with Feilding with more interest than he had with Russell. His curiosity was such that it led Feilding to believe that Ruskin might himself convert. It was in part due to conversations such as these that a change of tone occurs in the second volume of *The Stones of Venice*. The passage on the Madonna of Murano, for instance, with its enquiry into the spirit of Mariolatry, would not have been written a year earlier: nor would the appendix entitled 'The Proper Sense of the Word Idolatry'. The details of Ruskin's interest in Catholicism at this time are obscure. Who wrote, in Ruskin's private diary, Hail Marys in English and Latin? The writing is in pencil, not in Ruskin's hand, nor in Effie's. All this is not to say that *The Stones of Venice* is anything but a vehemently Protestant book. The trajectory of its argument could only have come from a background such as Ruskin's. Yet a broadness of spirit characterizes its well-known chapter 'On the Nature of Gothic'. As he began to think about that chapter, in February of 1852, Ruskin told his father, 'I shall show that the greatest distinctive character of Gothic is in the workman's heart and mind.'[48] The author of *Notes on the Construction of Sheepfolds* could not have said this. For the pamphlet's intolerance implied a denial of spiritual grace in others. It was this grace that Ruskin was now anxious to discover in the workmen who had built Venice, or in those who might build Gothic architecture in England.

⋆ ⋆ ⋆ ⋆

As the time approached when the Ruskins were to return to England, the many problems of their marriage came into sharper focus. On

Ruskin's birthday his father, fretting for his homecoming, gave a dinner party in his honour. From Venice on that same day, Ruskin wrote a long account of his health to Denmark Hill, and Effie wrote to her mother complaining about the elder Ruskins. She claimed that 'both he and Mrs R. send the most affectionate messages to me and all the time write *at* or *against* me and speak of the hollowness of worldly society and the extravagance of living in large houses and seeing great people . . .'.[49] This was true, and Effie probably felt that she would need some allies when she left Venice for London. She remembered a slightly indiscreet conversation she had had with Charles Newton during the holiday in Switzerland the previous year. Newton and Effie were genuinely fond of each other: and the clever, iconoclastic archæologist had not concealed from Effie that he found the old Ruskins rather absurd. He also warned Effie against their influence. Recalling this conversation, Effie wrote to her mother:

> They are so peculiar that, as Newton said to me when we were travelling together, he could not understand how I got on so well — he thought two days at Denmark Hill with Mrs Ruskin without prospects of release would really kill him and yet he thought her a very good woman but very queer — but he advised me never to let John away again so long with them without me. He said it did us both a great deal of harm and he knew the effects it had on all our acquaintances . . .[50]

Newton was of course right. For Ruskin to be truly married meant that he had to be separated from his parents. But neither Newton nor Effie fully realized that such a separation, for Ruskin, would be a separation from his own self.

Ruskin was determined not to go back to Park Street. It was too near to London society, which he had now decided made him physically ill. John James was perfectly happy to give up the Mayfair house. He was less pleased now than once he had been to see his son in the company of the great. Besides, the house was expensive. It had not been much used, and three servants were paid all the time that John and Effie were abroad. Ruskin wanted to live somewhere near his parents: not necessarily in the same house, but in a house within a short walking distance of them. Letters between all three Ruskins now became even more full of devotion for each other, while John James's letters to Perth relentlessly attacked Effie for extravagance. Effie was amazed to find a poem from Mrs Ruskin to her son, 'in a style almost of amatory tenderness, calling John her beloved and Heart's Treasure and a variety of other terms which only, I believe, a lover would do in

addressing a Sonnet to his Mistress . . .'.[51] At the same time, Effie was spoken of in Ruskin's letters to his father as if she were a difficult child. Perhaps this was because he was personally incapable of helping her make the transition from a fashionable hostess in Venice to a house-wife in Camberwell:

> I do not speak of Effie in this arrangement — as it is a necessary one — and therefore I can give her no choice. She will be unhappy — that is her fault — not mine — the only real regret I have, however is on her account — as I have pride in seeing her shining as she does in society — and pain in seeing her deprived, in her youth and beauty, of that which ten years hence she cannot have — the Alps will not wrinkle — so *my* pleasure is always in store — but her cheeks will: and the loss of life from 24 to 27 in a cottage in Norwood is not a pleasant thing for a woman of her temper — But this cannot be helped.[52]

The prospect of her future London life made Effie all the more loath to leave Venice. She was so filled with foreboding that she became frankly hostile to her parents-in-law. She felt that the Ruskins would all be much more happy and comfortable if they could simply exclude her from any of their plans. The conclusion was inescapable. She now wrote frankly to her father, 'I wish that I had been the boy and never left you — which I believe in the end might have been better for all parties.'[53]

The Ruskins's last weeks in Venice were filled with work and with a peculiar kind of social unreality. John and Effie went twice to Verona to attend Radetzky's balls. These were enjoyable occasions, in contrast to the Venetian carnival which Ruskin must have decided to attend because of its antiquity. But this pre-Lenten feast had long since fallen into corruption. The Ruskins put on 'dominoes', black and white masks, and wandered around Venice late in the evening. The squares were full. People were throwing things, men approached Effie and said things she could not understand. Ruskin went before her to the masked ball which once had been attended by all the great people of Venice. They were not there now, and he saw that the dancing was lewd. They walked further through the streets looking for entertain-ment that did not exist, until Effie became frightened that 'the canaille, not the masks' had surrounded them.[54] Shortly after this slightly disturbing evening came the news that two Austrian officers had fought a duel over Effie after her appearance at the ball in Verona. The Ruskins took no notice. But the dangerous side of Austrian military honour was now to touch them very closely. Just as they were packing

to leave Venice, Effie found that some of her jewels had been stolen. Suspicion fell on an English acquaintance of theirs, a Mr Foster. He was not precisely a soldier but had a position as an aide-de-camp to Radetzky. He was sufficiently close to the military establishment, therefore, for honour to be at issue. Foster's closest friend, a Count Thun, was under the impression that Ruskin had personally accused his comrade. He challenged the art critic to a duel. Ruskin mildly declined. Scandal grew. There was trouble in the Austrian garrison. The police were inefficient: Effie was hysterical. They found that they could not leave Venice. Edward Cheney came to their aid and smoothed the matter over. But it made an unpleasant end to their stay. Ruskin did not tell his father about it until they were back in England. John James Ruskin was horrified: all the more so when the story, wildly exaggerated, began to appear in the English newspapers. On 2 August 1852, Ruskin was obliged to write to *The Times* explaining as best he could the facts of the case. It is the only one of his public letters that was not subsequently collected and published. For Effie, the ludicrous aspects of the affair — augmented as they were by much gossip — made all the more bewildering her new life: a housewife, four years married and still a virgin, in a suburban villa to the south of London.

CHAPTER TEN

1852–1854

The new house that John James had found for his son and daughter-in-law was very close to his own. It was No. 30 Herne Hill. The property was next door to the house that the Ruskins had moved to when John was four, and was its duplicate. Although John James did not expect John and Effie to remain there for long he had spent much money on fittings. In doing so he acted with a thoughtlessness which often overcame him in matters concerning his son's marriage. He gave an interior decorator £2,000 and *carte blanche* to furnish the house as he thought best. The result was modern and vulgar. Ruskin, horrified, said that the house was only fit for a clerk to live in and that he would be ashamed to invite his friends there. Effie was also upset, and not comforted by the thought that it was in any case unlikely that London society would come out to Herne Hill. She made only one or two attempts to entertain in this new home. The guests there were usually Ruskin family friends like the Richmonds. To them, soon cheerfully reconciled to the suburbs in which he had grown up, Ruskin wrote in invitation:

> Ours is a most difficult house to direct anybody to, being a numberless commonplace of a house, with a gate like everybody's gate on Herne Hill — and a garden like everybody's garden on Herne Hill, consisting of a dab of chrysanthemums in the middle of a round O of yellow gravel — and chimnies and windows like everyone's chimnies and windows . . . all I can do is to advise you that some half mile beyond my father's there is a turn to the left, which you must *not* take, and after passing it we are some ten or twelve gates further on . . .[1]

More formal entertainment was carried on at Denmark Hill, as it always had been. But life there was not calm in the weeks after the long stay in Venice. There was trouble about the new house. John James was angry about the challenge to duel. He was not concerned with thoughts of physical danger: what upset him was that anyone might call his son's honour into question. Old Mrs Ruskin had taken fright after hearing about John's conversations with Catholics. As had the Feildings, she had somehow gained the impression that he was on the point of conversion. Her fears were greater because Ruskin was now

seeing Henry Manning, the most recent and spectacular of prominent
Anglicans who had turned to Catholicism. Manning and Ruskin (who
were to remain lifelong friends) had much to talk about. Manning was
a friend of Gladstone's: his book, *The Unity of the Church* (1842),
resumed many of the topics of Gladstone's *State in its Relations
with the Church* (1838). These matters had been the underlying concern
of *Notes on the Construction of Sheepfolds*. It was natural that Ruskin
should now wish to discuss them in the light of his recent study of the
history of Venice. John James could see the point of such discussions:
Margaret Ruskin and Effie could not. Effie's religious views, such as
they were, seem now to have become more pronounced. She too
believed her husband to be in some danger, but not from Catholicism.
She believed that it lay in pride. Effie disapproved of his

> . . . wish to understand the Bible throughout — which nobody in
> this world will ever do — and unless they receive it as a little child it
> will not be made profitable to them. He wishes to satisfy his
> intellect and his vanity in reading the Scriptures and does not pray
> that his heart and mind will be improved by them. He chuses to
> study Hebrew and read the *Fathers* instead of asking God to give
> him Light. His whole desire for knowledge appears to me to
> originate in Pride and as long as this remains and his great feeling of
> *Security* and doing everything to please himself he is ready for any
> temptation and will be permitted to fall into it. [2]

For a short period Effie found herself in the unaccustomed role of an
ally of her mother-in-law. Lady Eastlake, who now began to look at
the Ruskins with much curiosity, was able to report to John Murray
after dining at Denmark Hill that 'the old people are much kinder to
their pretty daughter-in-law than they were and look to her to keep
their son from going through some Ruskin labyrinth to Rome'. [3]

Margaret Ruskin's continual derogation of Catholicism eventually
began to irritate her son. To Mrs Gray, who also had expressed her
disquiet, he wrote a sharp, sensible letter:

> I simply set it down as something to the discredit of Protestantism
> that my mother is afraid after having bred me up in its purest
> principles for thirty four years, to let me talk for half an hour with a
> clever Catholic: but I shall certainly not permit this fact to tell for
> more than its simple worth — and that worth is really not much —
> for my mother's anxiety about my religion is much like that which
> she shows with respect to my health or safety — rather a nervous
> sensation than a definite and deliberately entertained suspicion of

danger in this or the other circumstance. Only I see that I must not blame Catholics for illiberality in refusing to argue with, or listen to Protestants.

The beginning of these perilous speculations of mine was only this — that one evening in St Mark's Place — getting into an argument with Lady Feilding — I was completely silenced by her — had not a word to say for myself — and out of pure shame, I determined at once to know all that could be said on the subject — and fit myself better for battle another day: as well as to look into some statements made by Protestant writers, which I had hitherto accepted undoubtingly, but which I found the Catholics denied just as indignantly as the Protestants affirmed them positively. And this I must do before I write any more against the Catholics — for as I have received all my impression of them from Protestant writers, I have no right to act upon these impressions until I have at least *heard* the other side. But I do not see why this should make either you — or any of my Protestant friends anxious. I can most strongly and faithfully assure you that I have no hidden leanings or bias towards Popery: that on the contrary I hate it for abusing and destroying my favourite works of art: my name and what little reputation I have, are entirely engaged on the Evangelical side, my best friends are all Puritans — including my wife — and all my life has been regulated by Protestant principles and habits of independent thought — I am as cool headed as most men in religion — rather too much so: by no means inclined either to fasting or flagellation: — past the age of Romance — and tolerably well read in my Bible: And if under these circumstances — you are afraid when you hear that I am going to enquire further into points of the Romanist doctrines of which I am ignorant — it seems to me that this is equivalent to a confession that Protestantism is neither rational nor defensible — if fairly put to the proof — but a pasteboard religion . . .[4]

No doubt it annoyed Ruskin to have to explain to his family that he needed his intellectual peers. But he had found a fruitful new regime for his writing. Every morning after breakfast he left his new home to walk the few hundred yards to Denmark Hill. There, in his old study, he worked all day on the second and third volumes of *The Stones of Venice*. It was to be a book that scarcely resembles anything else in Victorian literature. Yet it has a literary context. Ruskin was now expanding his acquaintance among contemporary writers. Manning's themes have a bearing on Ruskin's epic history. So have books by Carlyle. So also have a number of poems by Robert and Elizabeth

Browning. Ruskin first made Browning's acquaintance at Coventry Patmore's house at The Grove in Highbury. Effie was curious to know what the Brownings were like. She had no great interest in poetry. But she had noticed how Samuel Rogers, always jealous of other poets, had abused Ruskin when he saw that he was reading Elizabeth Browning's 'Casa Guido Windows'. Mrs Browning did not appear at Highbury that night, but Ruskin got on rather well with her husband. The talk was mostly of Italy. Ruskin had to acknowledge that, despite his liberal views, the poet knew much about the country that he did not. A few days afterwards John and Effie went to call on the Brownings at their lodgings in Welbeck Street. No record of the conversation remains. But it seems that Elizabeth Browning was not inclined to be appreciative of Effie. She wrote to a friend, 'Pretty she is and exquisitely dressed — *that* struck me — but extraordinary beauty she has none at all, neither of feature or expression.'[5]

Effie was beginning to realize that in London literary circles there was a competitive element she had not foreseen. She now came under the scrutiny of another intelligent woman who had formed an exceptional partnership with her husband. Jane Welsh Carlyle was no more impressed with her than Elizabeth Browning had been. Ruskin and Carlyle probably first met in 1850. On 6 July of that year, Mrs Carlyle's cousin John Welsh recorded in his diary that he had seen the Ruskins at the Carlyle home in Cheyne Walk, and that Ruskin had endeavoured to draw Carlyle out on the subject of religion. In December of 1850 Carlyle wrote that he had entertained 'Ruskin and wife, of the *Seven Lamps of Architecture*, a small but rather dainty dilettante soul, of the Scotch-Cockney breed'.[6] Carlyle was probably more appreciative of John James and Margaret Ruskin than he was of John and Effie. 'He used to take pleasure in the quiet of the Denmark Hill garden, and use all his influence with me to make me contented in my duty to my mother,' says *Præterita*.[7] In a few years' time Margaret Ruskin became convinced — and with justice — that Carlyle was responsible for some of her son's errant religious beliefs. But there was no feeling of distrust in the early 1850s. And Ruskin went out of his way to please the Carlyles. Cigars were produced after dinner: for no-one else but the author of *Past and Present* would such an infringement of the Denmark Hill rules be countenanced. In 1854, after Effie had run away, Jane Carlyle recalled how well they (and their dog) were entertained, when Ruskin

. . . twice last summer . . . drove Mr C. and me and *Nero* out to his place at Denmark Hill, and gave us a dinner like what one reads of in

17. Effie Ruskin, daguerrotype, taken in 1851.

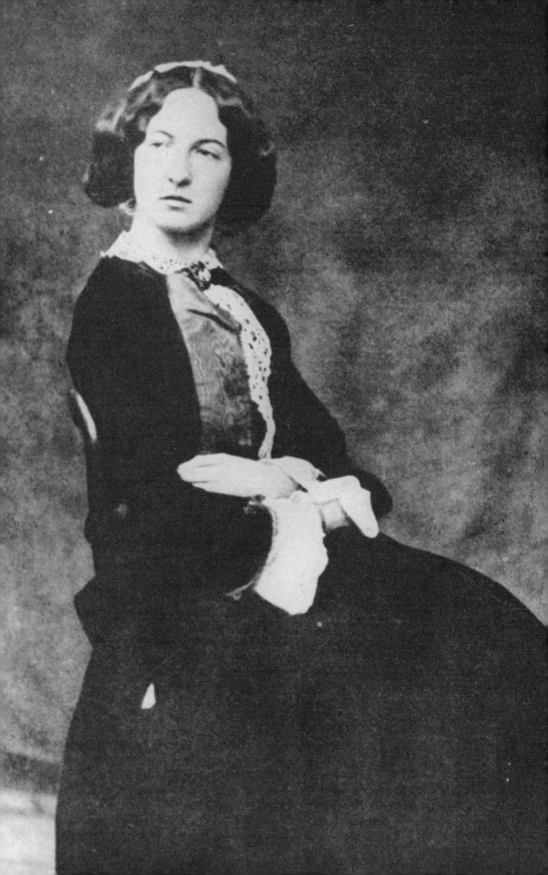

the *Arabian Nights*, and strawberries and cream on the lawn; and was indulgent and considerate even for Nero! I returned each time more satisfied that Mrs Ruskin must have been hard to please . . .[8]

That was of course a misreading of Effie's situation. It was quite a common one. Perhaps only Lady Eastlake among Effie's London acquaintances was inquisitive enough about her to guess at the truth. Effie kept her problems to herself. In Venice it had been easier not to think about them. But in the new Herne Hill home she had the apprehension that her life would be irremediably unhappy. There were some questions to which she could give no answer, and which she could not discuss with Ruskin. If she could imagine herself happy as a mother, could she imagine her husband as a father? If sexual relations began, would he come to love her more, and be less bound to his parents? Did he love her at all? Did she love him? Would sex be enjoyable, or not? While she thought about these matters she came to admit to herself not only that she disliked living where she was but also that she did not like Mr and Mrs Ruskin. There was a kind of comfort in realizing this. At the end of September of 1852 she went to Bowerswell for seven weeks while Ruskin stayed in London to work at *The Stones of Venice*. She then told her parents in detail about the difficulties of living with the Ruskins. As she did not dare to tell them of her sexual problems she emphasized the niggling disputes over accounts. Here was almost daily evidence of the Ruskins's unreasonableness, for she was pursued by letters from Herne Hill accusing her of extravagance. These complaints were almost certainly unjust: in any case they were insensitive. Ruskin himself had been spending freely on his own pleasures. He had brought back many works of art from Venice. He was forming a collection of missals. In six weeks he had spent £160 on plates from Turner's *Liber Studiorum* while Effie was attempting to economize in the house that had been so lavishly over-furnished. 'How is one to please them?' she wrote despairingly.[9]

* * * *

Effie's personal history now became intertwined with the public triumph of Pre-Raphaelitism. In the New Year of 1853 (as usual, changing his mind on this topic) Ruskin announced that he had decided to 'go into society' that coming season: he thought that he would have finished *The Stones of Venice* by then. This was in part for Effie's sake, but also because he wished to meet people who might possess either missals or paintings by Turner. Effie was pleased, the more so when Ruskin rented a house in Charles Street, Mayfair. She

did not know it, but this was to be her last appearance as a worldly success. The fashionable London season lasted from May until July, and its traditional opening was the private view of the Royal Academy exhibition. Here Effie shone both in person and portrayal, for she was seen to be the model in the painting of the year, Millais's *The Order of Release*.

Millais had become a most popular artist. In the previous year's exhibition there had been crowds all day long in front of his *Ophelia* and *The Huguenot*. Afterwards he wrote to the wife of his patron Thomas Combe that 'the immense success I have met with this year has given me a new sensation of pleasure in painting'.[10] His next picture, *The Proscribed Royalist*, was designed to be equally pleasing. Millais had begun to discuss his subjects with an agent before embarking on them: this painting of a hiding cavalier visited by a Puritan girl was not entirely his own invention. It was near completion when John and Effie returned from Venice in the autumn of 1852. Millais was then casting around for another subject. Finally he devised *The Order of Release*, in which a proud young wife meets her Highlander husband as he is released from jail. The painting is subtitled with the date 1746, the year of Culloden. Millais must have told the Ruskins about the painting: Effie described it as 'quite jacobite and after my own heart'.[11] Around Christmas or the New Year of 1853, probably when Effie returned from Bowerswell, Millais asked her to sit for the Highlander's wife. Etiquette demanded that he ask Ruskin first, and it is likely that Millais thought that the Ruskins might buy his picture. Determined to make a better portrait of Effie than those by Watts and George Richmond hanging in Denmark Hill, Millais began to paint her face in competitive mood. He took the picture from his own studio in Gower Street and worked on it in Herne Hill. He may sometimes have stayed the night, for Ruskin mentions in a contemporary letter that his house was crowded, had only one spare room and two attic rooms, and that he had 'promised one of these garrets to Millais, the painter, at all times when he chooses to occupy it'.[12]

One must imagine, then, that Millais moved his canvas, easel, brushes, paints, varnishes and so on into the best-lit room in Herne Hill. Effie sat to him from immediately after breakfast until dusk. Ruskin was meanwhile writing *The Stones of Venice* in his study in his parents' house. The question of chaperonage was not raised (in fact Effie was never chaperoned except when travelling) and the question of whether she should appear in a picture at all was smoothed over. It was not strictly decorous. The only acceptable way to appear in painting was as the subject of a commissioned portrait. Effie was not

quite in this position. She took her place in the Academy rooms beside professional models such as the Miss Ryan — Irish — who had posed for *The Proscribed Royalist* and the half-professional Westall, who sat for both the Highlander and the jailer in her picture, and who recently had been arrested for desertion from the army. Models were regarded as loose women: so they often were. The Ruskins did not mention the belief that 'the woman who was made an Academy model could not be a virtuous woman' until Effie had run away.[13] This shows their independence from the conventions of society. But there was nonetheless some strain. Effie thought that some of John James's remarks went beyond banter. After the painting was finished she wrote to her family that

> . . . he said he had taken pen in hand to John to expatiate on my perfections of appearance and manner, that in his life he had never seen anything so perfect as my *attitude* as I lay on the sofa the night before and that no wonder Millais etc etc, but it sickens me to write such nonsense as I could spare such writing and excuse it from a fool but from Mr R it sounded, to say the least, I thought, unnatural and rather suspicious.[14]

She had begun to wonder whether the Ruskins thought that her husband's protégé was not a dangerous young man for her to know.

If these were real social difficulties, they were quite swept away by the success of the painting. A Millais family tradition relates that a policeman had to be posted in front of *The Order of Release* to keep the crowds at a distance. Effie found herself and her portrait the centre of all attention. She wrote home to Perth that 'Millais's picture is talked of in a way to make every other Academician frantic. It is hardly possible to approach it for the rows of bonnets.'[15] Effie was everywhere complimented on her part in the picture, as though she had given Millais some active assistance. She had not: but she looked forward to being painted once again, and she liked to further Millais's social career. She talked of him to her friend Lord Lansdowne, who said that he would invite the painter to dine. A few days later, when she looked in at a party given by the Monkton Milnes at their home in Upper Brook Street, she was able to introduce both Millais and Holman Hunt to this aristocratic patron of the arts. In such gatherings Pre-Raphaelitism now flourished. What Ruskin thought of this social life, apart from the fact that it bored him, is not known. But at just the time that Millais was being lionized in Mayfair, he was finishing the third volume of *The Stones of Venice*, in which we may read his opinion that an artist 'should be fit for the best society, *and should keep out of it*',[16] explaining in a footnote:

Society always has a destructive influence on an artist: first, by its sympathy with his meanest powers; secondly, by its chilling want of understanding of his greatest; and thirdly, by its vain occupation of his time and thoughts. Of course a painter of men must be *among* men; but it ought to be as a watcher, not as a companion.[17]

<p style="text-align:center">★ ★ ★ ★</p>

The Order of Release is nowhere mentioned in Ruskin's published works. We do not know what he thought of it, but we do know that he hardly discussed it during the time that it was painted. He was absorbed in *The Stones of Venice* and Millais had said that he did not wish to show his picture to anyone until it was completed. But Ruskin had some thought of improving Millais's art when, once again, he invited the artist to go on holiday with him. Ruskin wanted to journey north, to see Farnley Hall once more, and to stay with some new friends, Sir Walter Trevelyan and his wife Pauline. He thought that he and Effie, and perhaps Millais too, would tour in the Highlands and visit Perth. The Edinburgh Philosophical Institution had invited Ruskin to give some lectures there that November. It occurred to Effie that she might be able to keep Ruskin in Scotland all summer and autumn. That would separate him, and her, from the maddening life between Herne Hill and Denmark Hill. The Ruskins decided to extend their invitation to Millais's brother William and to William Holman Hunt, whom they hardly knew. Effie's father was asked to find a house in the Highlands that they could rent. She wrote:

> John and the two Millais and Holman Hunt will be very busy sketching and walking over the mountains, and I shall accompany myself in trying to make them all as comfortable as I can, for we shall not have a very extensive establishment and there seems no certainty of anything to eat but trout out of the Tummel or the Garry, but it would amuse you to hear the Pre-Raphaelites and John talk. They seem to think they will have everything just for the asking and laugh at me for preparing a great hamper of sherry and tea and sugar which I expect they will be greatly glad to partake of in case of returning home any day wet through with Scotch mist . . .[18]

Effie liked the idea of looking after a household of artists as much as she liked the prospect of going to balls. Her husband prepared for the journey by idealizing his relationship with Millais and Hunt. He told his old tutor W. L. Brown:

> We shall stay for a couple of months with the young painters of whom perhaps you may have heard something under the name of

'Pre-Raphaelites'. I fought for them as hard as I could when most people were abusing them — and we have a kind of brotherly feeling in consequence, and shall be very happy, I believe, painting heather together. We are going to study economy. Effie is to cook, and we are to catch trout for Cook — and we are to count for dinner and breakfast on porridge and milk.[19]

However, Holman Hunt, who admired Ruskin without feeling 'brotherly' emotion, now decided that the course of his art should lead him to Syria rather than to Scotland. He had long wished to paint in the Holy Land. Nobody else thought this a good plan. Ruskin tried to dissuade him, but to no avail. Millais was particularly upset to bid farewell to his comrade. Hunt hesitated, then left hurriedly. The rest of the party lingered in London and cancelled the house that Mr Gray had rented. Now their plans were even more fluid. Finally, on 21 June 1853, they left for Wallington by train. In the party were John and Effie Ruskin, the two Millais brothers and Crawley, the Ruskins' new servant.

★ ★ ★ ★

So familiar were they that Ruskin was unable to recall, in later years, when he had first met the Trevelyans of Wallington. This strange couple were perhaps the dearest friends of the first half of his life. He now visited their home for the first time. It is a very large house. Much of it was at that date empty. Suites of uncarpeted rooms presented cheerless vistas. There was a Wallington ghost. It was said that if one found a corner and brought furniture to it one could be comfortable enough at Wallington. Otherwise, the best room in the house was Sir Walter's study. Here he kept his natural history collections, his fossils and stuffed animals, books and topographical pamphlets. He was tall, with drooping moustaches and fair hair that fell to his shoulders. He was reputedly a miser: in fact he gave large sums to charities and concerned himself with the condition of his tenantry. Sir Walter was a teetotaller, and some said that he had never been known to laugh. Yet not all of the many artists and literary people who visited Wallington preferred the company of his talented wife. There were those who found him fascinating. Staying at the house, Augustus Hare, the anecdotalist, wrote:

He knows every book and ballad that ever was written, every story of local interest that ever was told, and every flower and fossil that ever was found . . . His conversation is so curious that I follow him about everywhere, and take notes under his nose, which he does not

seem to mind in the least, but only says something more quaint and astonishing the next minute . . .[20]

Scientific and antiquarian interests, social concern, a liking for story and romance: these of course were common components of the Pre-Raphaelite æsthetic. Sir Walter had no particular views about the future of contemporary painting. But he shows how easily and naturally one might join Pre-Raphaelitism. Ruskin's advocacy was powerful. His writings and personal interest were inspiring. But it took no great change of sensibility to like the new painting, for that sensibility was already in existence. As Pauline Trevelyan's house guests assembled at Wallington one observes how different from each other — in age, interests and background — were the champions of Pre-Raphaelitism. We may also see that it was not accepted that Ruskin was its sole arbiter. The Edinburgh physician and man of letters John Brown, with whom Ruskin had corresponded for years, greatly admired the critic. But he disliked his tone and rejected his historical arguments. When Ruskin had published *Pre-Raphaelitism*, Brown wrote to Pauline Trevelyan:

> I am glad John Ruskin is coming back to his first and best love. I read the *Stones* carefully last week; it is a great work — in some respects his greatest — but his arrogance is more offensive than ever, and his savage jokes more savage than ever, and than is seemly or edifying, and his nonsense (and his father's) about Catholic Emancipation most abundantly ridiculous and tiresome. I once thought him very nearly a God; I find we must cross the river before we get to our Gods . . .[21]

Brown passed on to Pauline Trevelyan the *Pre-Raphaelitism* pamphlet: he did not feel like reviewing it himself. Pauline had Tractarian sympathies and was quite happy to take issue with Ruskin over his religious bias. Her notice was generally enthusiastic: she nonetheless pointed out:

> Mr Collins may not paint lilies in a convent garden, but the serpent is supposed to be hid under the leaves: and Mr Millais cannot decorate Mariana's room in the Moated Grange, with some indications of the faith of her country, but the author of *Modern Painters* finds the Pope behind the curtain.

Ruskin probably accepted these criticisms: Pauline Trevelyan was able to scold him, often in jest but sometimes in earnest. She had met Millais in London the previous year and was eager to talk to him again, for her writings had supported the fortunes of Pre-Raphaelitism north

of the border. When *Christ in the House of his Parents* and *Mariana* had appeared at the Royal Scottish Academy she had declared most positively for the religious subject, of which she wrote, 'It is about the most wonderful and daring picture that ever appeared on the walls of an exhibition room.'[22]

Millais, the painter of romantic Scottish history, had never been in Scotland. Here, in the Cheviot border country, he heard much of Scottish lore and legend. He felt welcome, and stirred. Ruskin was content. He wrote to his father,

> This is the most beautiful place possible — a large old seventeenth century stone house in an old English terraced garden, beautifully kept, all the hawthorns still in full blossom: terrace opening on a sloping, wild park, down to the brook, about the half a mile fair slope; and woods on the other side, and undulating country with a particular *Northumberlandishness* about it — a far-away look which Millais enjoys intensely. We are all very happy, and going this afternoon to a little tarn where the seagulls come to breed.[23]

On another day the party drove over to Capheaton, the home of Sir Charles Swinburne: his nephew Algernon, a boy at school at this date, was a devoted friend of Pauline Trevelyan. Everybody sketched. Millais drew both Trevelyans, then started on some portraits of Effie. He wrote to Holman Hunt, 'Today I have been drawing Mrs Ruskin who is the sweetest creature that ever lived; she is the most pleasant companion one could wish. Ruskin is benign and kind. I wish you were here with us, you would like it . . .'[24] Millais, Ruskin and Sir Walter walked the hills and discussed the world. One afternoon Effie borrowed a pony and rode by herself over the moors back to the tarn. Hundreds of gulls were just learning to fly.

From Wallington the Ruskins and the two Millais brothers moved on to Edinburgh. Both Millais — Everett, as they now called him, to distinguish him from Ruskin — and Effie were suffering from colds and a painful inflammation of the throat. They went together to see Effie's doctor, the distinguished Sir James Simpson. The party then set off for the Highlands. At the beginning of July they arrived at Glenfinlas, Brig o' Turk, some miles above Stirling. In this remote, beautiful, rather inhospitable spot Millais was obliged to make crucial decisions about his art. These concerned his relations with the Ruskins. John James Ruskin, back in London, would no doubt have been satisfied to hear that

> Millais . . . has been more struck by the castle of Doune than anything and is determined to paint Effie at one of its windows —

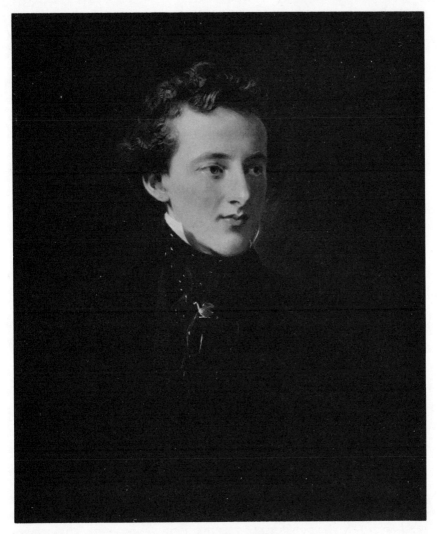

18. John Everett Millais, by C. R. Leslie, 1852.

inside — showing beyond the window the windings of the river and Stirling castle. He is going to paint *me* among some rocks — in a companion picture. I thought you would be glad to know he is doing something for you, though he does not seem up to a *composition* . . .[25]

The nature of companion pictures is now relevant. They are usually made in celebration of marriage, and in betrothal or wedding portraits are commissioned by the bridegroom's father. They are domestic: they are made to go on either side of a fireplace or door and their

composition is therefore complementary, the figure in the left-hand picture inclining towards the right, and vice versa. Millais thought this would be simple. But when he sketched Effie in the castle of Doune he saw that the complementary picture would be awkward to invent. The particularity of the naturalistic Pre-Raphaelite style tended to preclude such designs. He abandoned the idea and ordered only one canvas to be sent from London. On it he was to paint Ruskin rather than Effie. Suddenly the project had become quite different. Ruskin wrote triumphantly to his father:

> Millais has fixed on his place — a lovely piece of worn rock, with foaming water, and weeds, and moss, and a noble overhanging bank of dark crag — and I am to be standing looking quietly down the stream — just the sort of thing I used to do for hours together — he is very happy at the idea of doing it and I think you will be proud of the picture — and we shall have the two most wonderful torrents in the world, Turner's St Gothard — and Millais's Glenfinlas. He is going to take the utmost possible pains with it — and says he can paint rocks and water better than anything else — I am sure the foam of the torrent will be something quite new in art.[26]

The difference of ambition is clear. The painting would need to involve the 'utmost pains', as it would extend the range of Millais's art. He was not a landscapist, and never before had painted rocks or flowing water. This aspect of the picture would bring him into direct competition with Turner. Nobody had more to say about such matters than the critic whose portrait Millais now had to accommodate within a landscape setting. Ruskin's mention of the St Gothard drawing is significant. It was the water-colour that Turner had painted for him in 1843. In 1845, preparing for the second volume of *Modern Painters*, Ruskin had visited the site 'that I may know what is composition and what is verity'.[27] He had then taken stones, gneiss coloured by iron ochre, out of the torrent. For years he had meditated on what Turner, in conversation with him, had called 'that litter of stones which I *endeavoured* to represent'.[28] He had been back to the site the previous year, on his way home from Venice, to study the light there at different times of day. He sketched the same scene, drew, traced, and etched from the Turner original. At Glenfinlas Ruskin made drawings of the gneiss rocks in the stream. They are very like the background in the Millais picture. But they also resemble Ruskin's studies from Turner. This was the point of his increasing interest in his portrait. It was his opportunity to enforce, rather than merely assert, his old view that Pre-Raphaelitism was Turnerian.

Millais took some time to start the painting. He spent days on a smaller, more relaxed picture of Effie sitting on some rocks further down the stream. Amid the general *camaraderie* of the party an especial friendship was developing between the painter and the critic's wife. At first it was disguised by standing jokes. Millais adopted a chaffingly chivalric attitude towards Effie, referring to her always as 'the Countess': she fussed over him as though he were a great boy. On walks together they could be more straightforward. When not in the open air it became difficult. Millais, Effie and Ruskin, as they passed their evenings and as they slept, were very close to each other. For in their pursuit of economy they had moved out of the inn where they had at first lodged and had rented a small cottage. There was very little room in it. Millais and Effie slept in two boxed-in beds at either end of the parlour in which Ruskin made up his own bed. Effie described their arrangements:

> Crawley thinks Mrs Ruskin would be awfully horrified if she saw our dwelling. John Millais and I have each two little dens where we have room to sleep and turn in but no place whatever to put anything in, there being no drawers, but I have established a file of nails from which my clothes hang and John sleeps on the sofa in the parlour.[29]

In the daytime Millais and Effie were always together outside the house, while William Millais (who had remained at the inn) was happy with his fishing. Ruskin sat alone, making an index of *The Stones of Venice* and preparing the lectures he was to give in Edinburgh. One day Millais crushed his thumb when bathing in the stream: Effie bound it up for him. A little later, greatly daring, she sat him down and cut his hair. Millais began to find their physical proximity quite disturbing. Soon it would render him hysterical with longing.

<p style="text-align:center">★ ★ ★ ★</p>

Millais was on the brink of a quite novel, utterly illicit experience. At the same time he was longing to express himself. His painting was in abeyance, for his canvas had still not arrived. In any case he was bursting with creative desires quite unconnected with the projected portrait. Ruskin was puzzled by his protégé's thwarted hyperactivity. He wrote to his father:

> Millais is a very interesting study. I don't know how to manage him, his mind is so *terribly* active — so full of invention that he can hardly stay quiet a moment without sketching, either ideas or

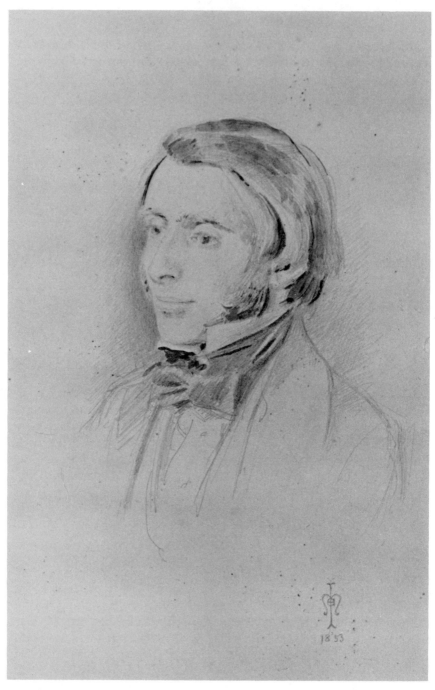

19. John Ruskin, by Sir John Everett Millais, 1853.

reminiscences — and keeps himself awake all night planning pictures. He cannot go on this way. I must get Acland to lecture him.[30]

Henry Acland was on holiday in Edinburgh at the time and was to spend a few days in the Glenfinlas hotel. He did not find that Millais needed medical advice but he was fascinated by his activity. What he found at Glenfinlas he wrote in daily letters to his wife. We should pay particular attention to these reports. For while it seems clear to us that the relationships at Glenfinlas were speeding towards a ruinous conclusion, Acland saw there one beautifully unifying bond. It was art. The doctor first of all explained to his rather strict, Evangelical wife that in this highly irregular household there was yet an especial propriety. This he could not quite define, but he felt that it had to do with the way that Millais appeared

> . . . a very child of nature — and oh! how blessed a thing is this. And that is just what Mrs Ruskin is — nothing could be more wholly unintelligible to my mother (and perhaps even to you) than her way of going on here with the boys as she calls the two Millais — but it is just like a clever country girl. Thoroughly artless, witty, unsophisticated to the last degree and tho' I cannot say I should like brought up as I have been to have you so! yet there is a certain charm in it in her which will presently delight me. It unites the company. Millais is a grown up Baby — and does and says in mere exuberant childishness now just what a very [illegible] and boisterous child would do & say . . .[31]

Rather pleased with his discovery that they were 'children of nature', a formulation which he repeats, Acland could make many a parallel with Pre-Raphaelite art as Ruskin taught it. He himself had given his hand to the diligent naturalism so much enjoined that summer.

> Ruskin I understand more than I have before: truth and earnestness of purpose are his great guide, and no labour of thought, or work is wearisome to him. He has knocked up my sketching for ever. I was quite convinced that the hasty drawings I have been in the habit of, are most injurious to the doer, in his moral nature. What I can try to do is to draw *correctly* really well. I hope to be well enough to try tomorrow a bit of rock & water . . .[32]

Such sentiments are pure Ruskinism. Acland felt that he too could become a Pre-Raphaelite.. It was an effect that Ruskin had on many amateur artists. But it was not possible for Millais to think in these

terms. He knew in his heart that such talk simply did not apply to him. In truth, he did not care much about either God or Turner. And the more he felt attracted to Effie the less inclined he was to feel virtuous when painting her husband's portrait to his satisfaction. At the end of July, Acland held the canvas while Millais, 'on his highest mettle' according to Ruskin, put down the first marks of the painting.[33] Ruskin's diary records his progress over the next seven weeks.[34] It went on inch by inch: technically, realist Pre-Raphaelitism was a very slow way of making a picture. In the first fortnight Millais was often painting for six hours a day with nothing much to show for his labour. Soon he decided to move to the hotel. The tension of sleeping in the tiny cottage was too much for him. He wanted to paint for Effie, but could not. The time he could spend alone with her became more and more precious, and the hours he spent at his easel more like toil.

Henry Acland was not the only visitor to Glenfinlas that summer. The Millais brothers had lunch one day with the picture dealer Ernest Gambart and the French painter Rosa Bonheur, whose work Gambart promoted in England. Millais was soon to form a profitable relationship with Gambart, and it may have been now that it was spelt out to him that his Pre-Raphaelite painting was being sold for the third or fourth time without commanding the price Gambart would give immediately for a slightly different kind of work. Millais was innocent about the rewards that painting might bring, but he did not wish to be innocent. He suspected that there was little worldly profit in the struggle to please Ruskin. But when he could interest the critic without making an effort he was delighted. On 17 August Millais wrote to his friend Charles Collins,

> You will shortly hear of me in another art besides painting. Ruskin has discovered I can design architectural ornament more perfectly than any living or dead party. So delighted is he that in the evenings I have promised to design doors, arches and windows for Churches etc etc. It is the most amusing occupation and it comes quite easily and naturally to my hand . . . Ruskin is beside himself with pleasure as he has been groaning for years about the lost feeling for Architecture. When I make a design he slaps his hands together in pleasure.[35]

There is some record of these activities in Ruskin's Edinburgh lectures. More heartfelt drawings are those in which Millais depicted Effie with natural ornament. He adorned her not with jewellery but with corn-ears, acorns and flowers. They went on long walks together over the hills, often not returning until after dark. Ruskin and William Millais stayed behind at the cottage. According to William, writing

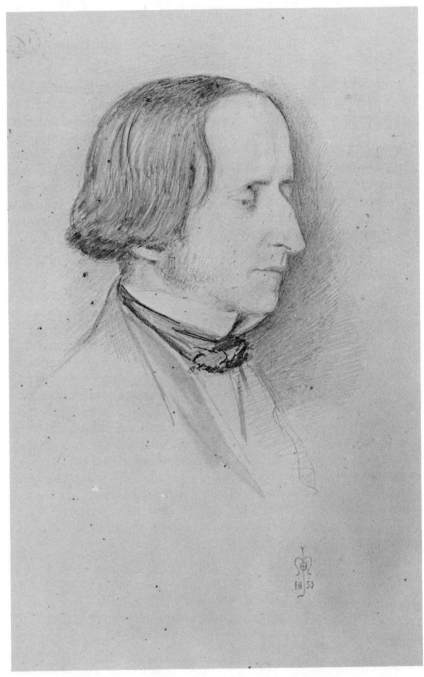

20. Dr Henry Acland, by Sir John Everett Millais, 1853.

years later, Ruskin should now have been more firm about the proprieties of the situation:

> I may say that I think that Ruskin did not act wisely in putting JEM and ECG continually together — Every afternoon by way of exercise Ruskin and I spent our time with pickaxe and barrow and spade to try to cut a canal across a bend in the river — whilst he preferred that ECG should roam the hills with JEM & presently they did not return until quite late — Ruskin's remark to me was, 'how well your brother and my wife gets on together'! — a very dangerous experiment & had it not been *for their integrity* evil consequences must have ensued. I may add that JEM returned home helplessly in love with ECG . . .[36]

This is confused, perhaps because the Millais family liked to believe that Ruskin was so wicked that he deliberately put his wife in the way of temptation. The truth was that he was oblivious of the fact that Effie and Millais were falling in love. When William left Glenfinlas in the middle of August Ruskin took even less notice of them. They occupied themselves and he got on with his work. All through September the three were alone together and yet were strangely separated. The weather was bad. Progress on the painting was ever more slow. Millais was coming to hate it. He continued his long walks alone with Effie. We do not know what declarations they made to each other, but we do know that she told him the truth about her marriage. This was a new intimacy between them which filled Millais with a confused sense of outrage: there was a sense in which he was glad that she had never had a physical relationship with her husband. In these weeks Effie seems to have remained calm enough, but Millais was shaking with tension. Ruskin was still blind to the situation. He wrote to his mother,

> I wish the country agreed with Millais as well as it does with me, but I don't know how to manage him and he does not know how to manage himself. He paints till his limbs are numb, and his back has as many aches as joins in it. He won't take exercise in the regular way, but sometimes starts and takes races of seven or eight miles if he is in the humour: sometimes won't, or can't, eat any breakfast or dinner, sometimes eats enormously without seeming to enjoy anything. Sometimes he is all excitement, sometimes depressed, sick and faint as a woman, always restless and unhappy. I think I never saw such a miserable person on the whole. He is really very ill tonight, has gone early to bed and complains of a feeling of complete faintness and lethargy, with headache. I don't know what to

do with him. The faintness seems so excessive, sometimes appear-
ing almost hysterical.[37]

Three days later Millais's condition was worse. Ruskin thought that
he should do something drastic to restore his spirits. Characteristi-
cally, perhaps, he assumed that the cause of the trouble lay in the
dissolution of the Pre-Raphaelite Brotherhood. He believed that Mil-
lais was suffering because he could not bear the idea of Holman Hunt
going abroad. He therefore decided to write to the other Pre-
Raphaelite. One cannot read this letter without feeling that Ruskin's
concern was genuine.

> My dear Hunt,
> I can't help writing to you tonight; for here is Everett lying crying
> on his bed like a child — or rather with that bitterness which is only
> in a man's grief — and I don't know what will become of him when
> you are gone — I always intended to write to you to try and
> dissuade you from this Syrian expedition — I suppose it is much too
> late now — but I think it quite wrong of you to go. I had no idea
> how much Everett depended on you, till lately — for your own sake
> I wanted you not to go, but had no hope of making you abandon the
> thought — if I had known sooner how much Everett wanted you I
> should have tried. *I* can be no use to him — he has no sympathy
> with me or my ways, his family do not suffice him — he has nobody
> to take your place — his health is wretched — he is always miserable
> about something or other . . . I never saw so strange a person, I
> could not answer for his reason if you leave him. Instead of going to
> Syria, I think you ought to come down here instantly: he is quite
> overworked — very ill — has yet a quarter of his picture to do in his
> distress — and we must go to Edinburgh — and leave him *quite alone*
> — next Wednesday. Think over all this.[38]

Hunt did not go to Scotland but delayed his departure for the Holy
Land. Millais did not know what to do or where to go. He was
tortured by the thought of Effie going to Edinburgh with her husband
and leaving him in Glenfinlas alone. Every thought of her increased his
confusion. What could he do? What could he say to her if she left? In
the event, he announced that he would leave the painting until better
weather the following March, when he would return to his place by
the stream and the rocks. The artistic household was dismantled.
Millais left with the Ruskins and accompanied them to Edinburgh. It
was while they were there that, blunderingly and almost inadver-
tently, he broke up the Ruskins's marriage.

* * * *

Ruskin's forthcoming Edinburgh lectures had been almost as much a part of the background of the Glenfinlas holiday as Millais's portrait. The four lectures had been written in the cottage, or in the open air outside the cottage, and their themes had been explored in conversation with Millais and Acland. Their delivery in the Philosophical Institution was to be the culmination of Ruskin's summer's work. That they were to be given in his father's home town was calculated to feed John James's pride, and thus allay his misgivings about appearances on public platforms. By contrast, Millais's picture was unfinished, and pretty clearly would not be finished in time to hang in the next year's Royal Academy exhibition. There was also the possibility that he might have to abandon it. The distraught Pre-Raphaelite seemed hardly in charge of his own destiny. Perhaps, if he had gone straight back to London, had gone abroad with Holman Hunt, he might have been more decisive about his life. He reflected that his best plan would be to forget about Effie and have nothing further to do with the Ruskins. This might also have been the honourable course to take. But he could not bear to distance himself from the woman he loved, and remained in the Scottish capital all the time that Ruskin was lecturing. The four addresses were on Architecture, Decoration, Turner and his Works, and Pre-Raphaelitism. They were afterwards collected into a book, *Lectures on Architecture and Painting*, which is a clear and balanced introduction to Ruskin's thinking at this time. Their success was gratifying. Over a thousand people filled the hall each time that Ruskin spoke and the press comment, comparing his message to that of a preacher, was exactly what the older Ruskins would have desired. But Ruskin himself was a little uninterested in the stir he was making. He was more concerned to take stock of his relations with Effie and with Millais. He wrote to his father, hearkening back to childhood reading:

> It is curious how like your melancholy letter — received some time ago, about our staying so long away, is to the 176th letter in Sir Charles Grandison. I wish Effie could write such a one as the 177th in answer. But I have had much to think about — in studying Everett, and myself, and Effie, on this journey, and reading Sir Charles Grandison afterwards — and then reading the world a little bit — and then Thackeray — for in 'The Newcomes' — though more disgusting in the illustrations than usual — there are some pieces of wonderful truth. The grievous thing that forces itself upon my mind — from all this — is the utter *unchangeableness* of people. All the morality of Richardson and Miss Edgeworth (and the longer

I live — the more wisdom I think is concentrated in their writings) seems to have no effect on persons who are not *born* Sir Charles's or Belindas. Looking back upon myself — I find no change in myself from a boy — from a child except the natural changes wrought by age. I am exactly the same creature — in temper — in likings — in weaknesses: much wiser — knowing more and thinking more: but in character precisely the same — so is Effie. When we married, I expected to change *her* — she expected to change *me*. Neither have succeeded, and both are displeased. When I came down to Scotland with Millais, I expected to do great things for him. I saw he was uneducated, little able to follow out a train of thought — proud and impatient. I thought to make him read Euclid and bring him back a meek and methodical man. I might as well have tried to make a Highland stream read Euclid, or be methodical. He, on the other hand, thought he could make me like PreRaphaelitism and Mendelssohn better than Turner and Bellini. But he has given it up, now . . .[39]

Such things Ruskin might say to himself, or to his father: but they were rationalizations of an emotional deadlock that could not be discussed. Effie and Millais could not speak together of their love. Ruskin now suspected that Effie had beguiled Millais, but he did not say this to his parents; and the etiquette did not exist which would allow him to warn his protégé of his wife's charms. Those charms were in any case no longer apparent to Ruskin. Effie sulked in his company. Ruskin could not resolve this situation: that is why he wished only that people were other than they were, and preferably like characters in Miss Edgeworth's improving novels. He rather badly wanted to be left alone. He was relieved when Effie went to Bowerswell and Millais left for London. With the lectures over and these troublesome young people departed he could begin to think once again about *Modern Painters* and the Ruskin family tour in the summer. The 'habits of steady thought' and the like, so often enjoined by Ruskin, had not been easy to maintain while the shallow-minded Effie and the headstrong young painter had been behaving so peculiarly. Millais, back in London, now heard that he had been elected an Associate of the Royal Academy. What Ruskin thought of this distinction is not recorded: he probably scorned it far more than did Millais's Pre-Raphaelite brethren. John James Ruskin, who entertained Millais at Denmark Hill while John and Effie were still in Scotland, was full of praise for him. 'What a Beauty of a Man he is and high in intellect but he is very thin,' he wrote to Ruskin.[40]

Millais had gone out to Denmark Hill because, once invited, he could not see how to refuse the invitation. In many ways he was still much indebted to the Ruskin family. He could think of many reasons for disliking and resenting Ruskin, and now had those feelings about him without looking for reasons. But the bluff, generous, honest John James could not be hated. There was talk of a portrait drawing of him, and no doubt Millais and the elder Ruskin discussed 'The Deluge', the proposed major painting that John had spoken of in his letters home from Scotland. However, these genial exchanges soon ended. For Millais took the bold step of writing to Mrs Gray, Effie's mother. He had met her only once, in Edinburgh, but now felt free to express his views on the marriage and on 'such a brooding selfish lot as these Ruskins'. About Effie, he wrote,

> The *worst of all is the wretchedness* of her position. Whenever they go to visit she will be left to herself in the company of any stranger present, for Ruskin appears to delight in selfish solitude. Why he ever had the audacity of marrying with no better intentions is a mystery to me. I must confess that it appears to me that he cares for nothing beyond his Mother and Father, which makes the insolence of his finding fault with his wife (to whom he has acted from the beginning most disgustingly) more apparent . . . If I have meddled more than my place would justify it was from the flagrant nature of the affair — I am only anxious to do the best for your daughter . . . I cannot conceal the truth from you, that she has more to put up with than any living woman . . . She has all the right on her side and believe me the Father would see that also if he knew all.[41]

Millais 'knew all' about the circumstances of Effie's marriage, but could not mention sexual matters to her mother. Nonetheless, in his correspondence with Mrs Gray he made it clear that there was a youthful, healthy intimacy between himself and Effie that contrasted with an unnaturalness in Ruskin. He hinted that Ruskin was a homosexual: this he may have believed. It cannot be said that Millais in this correspondence wrote naïvely or impetuously. If a break was to come, it had to be of Effie's own doing. But Millais carefully made it plain that he was not a neutral observer of the Ruskins's marriage. Effie knew this in her heart, and knew it the more surely because her mother told her what was in Millais's letters. When she and John returned to London she had another family link with Millais, for little Sophie, her ten-year-old sister, came south with them. Millais drew this sensitive, clever child in his studio in Gower Street. From her he gathered how tense the atmosphere was in Denmark Hill; and Effie gathered from Sophie something of her lover's movements. When

Ruskin came to Gower Street for work on the portrait he talked, as
usual. But in truth he and his portraitist were scarcely on speaking
terms, for Effie's behaviour at Herne Hill had at last made it plain to
Ruskin that she had come to loathe her husband and that she had fallen
in love with the artist. [42]

John James Ruskin now wrote what turned out to be his last letter to
Mr Gray, complaining of Effie's 'continual pursuit of pleasure', while
the unhappy girl found a *confidante* in Lady Eastlake. On 7 March,
surely not before time, after weeks of agonized life between Herne Hill
and Denmark Hill, she sat down to write to her father to tell him the
truth about her marriage:

> I have therefore simply to tell you that I do not think I am John
> Ruskin's Wife at all — and I entreat you to assist me to get released
> from the unnatural position in which I stand to Him. To go back to
> the day of my marriage the 10th of April 1848. I went as you know
> away to the Highlands. I had never been told the duties of married
> persons to each other and knew little or nothing about their rela-
> tions in the closest union on earth. For days John talked about this
> relation to me but avowed no intention of making me his Wife. He
> alleged various reasons, Hatred to children, religious motives, a
> desire to preserve my beauty, and finally this last year told me his
> true reason (and this to me is as villainous as all the rest), that he had
> imagined women were quite different to what he saw I was, and
> that the reason he did not make me his Wife was because he was
> disgusted with my person the first evening 10th April. After I began
> to see things better I argued with him and took the Bible but he soon
> silenced me and I was not sufficiently awake to what position I was
> in. Then he said after 6 years he would marry me, when I was 25.
> This last year we spoke about it. I did say what I thought in May. He
> then said, as I professed quite a dislike to him, that it would be *sinful*
> to enter into such a connexion, as if I was not very *wicked* I was at
> least insane and the responsibility that I might have children was too
> great, as I was quite unfit to bring them up. These are some of the
> facts. You may imagine what I have gone through — and besides all
> this the temptations his neglect threw me in the way of . . . [43]

After this revelation it became clear that Effie would have to escape.
Her parents' first thoughts were that Mr Gray should go to London to
confront John James. But what would be the profit in that? In the event
both Mr and Mrs Gray came to London to consult lawyers. They then
made clandestine plans with Effie, Lady Eastlake and Rawdon Brown,
who was in England to arrange publication of a book with Smith,
Elder. The flight was neatly arranged. Ruskin imagined, to his satis-

faction, that Effie was to take Sophie back to Scotland and stay there
while he and his parents took their summer tour of the Continent. He
accompanied her to King's Cross and put her on the train to Edin-
burgh. At Hitchin, the first stop, Effie's parents joined the train. At six
o'clock that evening court officials arrived at Denmark Hill to serve a
citation on Ruskin, alleging the nullity of the marriage. Effie's wed-
ding ring, keys and account book were delivered in a packet to John
James. There was a fortnight before the Ruskins were due to go
abroad. John James managed the legal side as best he could. There was
not much to do. The Ruskins intended no defence. They wanted to
end the matter as quickly and privately as possible. They determined
to behave in public as they normally would. Both John James and his
son attended the annual exhibitions of the Water-Colour Society and
the Royal Academy, after which Ruskin wrote two letters to *The
Times* outlining and praising the symbolism of two paintings by
Holman Hunt, *The Light of the World* and *The Awakening Conscience*.
These rather eloquent letters were widely regarded, especially among
the Eastlake circle, as proof of Ruskin's hypocrisy. Thus the marriage
ended, in bitterness and enmity, but with both partners glad to be free
once more. Millais managed to finish his portrait, but rejected Rus-
kin's offers of continued friendship and artistic collaboration. The
annulment was granted in the summer, while the Ruskins were
abroad; and in July of 1855, a little more than a year later, Millais and
Effie were pronounced man and wife.

CHAPTER ELEVEN

1854–1857

Long before Effie's departure, Ruskin had proposed to spend the summer in Switzerland. What reason had he now for changing his plans? A fortnight after his wife's flight he set out for the Continent in the company of his parents. As they left Dover, Ruskin opened a new vellum-covered notebook and diary for the year's fresh work.[1] Its first date is at Calais, on 10 May, John James Ruskin's birthday and the traditional family feast. The opposite right-hand page has been cut out. On it was the drawing of the jib of 'the old Dover packet to Calais'. Since this was reproduced in *Præterita* it is probable that Ruskin extracted it when looking up old diaries to write his autobiography. The illustration is puzzlingly undistinguished, and in *Præterita* is placed next to Ruskin's description of the tours of 1845 and 1846. But its personal meaning is clear. Departure from England in that spring of 1854 meant liberation. Still confusing the dates, *Præterita* confesses

> The immeasurable delight to me of being able to loiter and swing about just over the bowsprit and watch the plunge of the bows, if there was the least swell or broken sea to lift them, with the hope of Calais at breakfast, and the horses' heads set straight for Mont Blanc to-morrow, is one of the few pleasures I look back to as quite unmixed . . .[2]

This summer on the Continent was happy and productive because of the absence of Ruskin's 'commonplace Scotch wife', as he now called her: it was as though, with Effie gone, he could joyously return to *Modern Painters*, the book he owed his father but had abandoned during the years of his marriage.

'I never knew what it was to possess a father and mother — till I knew what it was to be neglected and forsaken of a wife,' Ruskin now wrote to Charles Woodd, an old family friend.[3] With different emphases, he also sent letters that were specifically about his marriage to Henry Acland (asking him to send the letter on to the Trevelyans), to Furnivall, to John Brown, and no doubt to others. Later this year, after his return to England, we find an especially revealing confession to Walter Fawkes.[4] None of this correspondence concerns us at the moment: how was Ruskin to know what issues it would raise when, a

decade later, he was a suitor for the hand of Rose La Touche? On 15
July his legal tie with Effie seemed to be cut. On that day she received
her decree. It read that the marriage 'or rather show or effigy of
marriage . . . solemnized or rather profaned between the said John
Ruskin and Euphemia Chalmers Gray falsely called Ruskin' was
annulled because 'the said John Ruskin was incapable of consummat-
ing the same by reason of incurable impotency'.[5] When Ruskin heard
of this annulment — a decision later to be of such emotional and legal
significance — he probably was only glad that the business seemed to
be over. We do not know what he and John James thought about the
legal aspects of his case, nor how they were advised by the family
solicitors. But it must always have been obvious to them that to
dispute such a decision would not only be unpleasant. For to vindicate
one's own honour in such a situation might mean that Effie would
remain bound to the Ruskins: or, worse, would come back.

The Ruskins's itinerary was from Calais through Amiens and
Chartres to Geneva; they then spent three months in Switzerland
before returning to England via Paris at the end of September. If this
seems by now a familiar route, we should note that to follow old paths
had a purpose. Ruskin was enabled to restart *Modern Painters* by
revisiting the country in which he had first found its inspiration. In the
years in which Effie and Venice had occupied him he had been lost to
his mountain places. He had not studied nature in his old way since
1849, the year when he had travelled abroad with his parents and
without his wife. These intervening years were now swept aside.
Ruskin's work in this summer of 1854 was glorious, as we may find in
every chapter of the third and fourth volumes of *Modern Painters* that
issue from his meditations in the Alps. In those chapters there is a
Christian spirit that is not at all like the darker, programmatic religious
undertow of *The Stones of Venice*. Happiness and prayer enabled his
love for natural creation to take precedence over his interpretations of
European culture. One would wish to know more about the manner
in which Ruskin generated this revival of an old mood of worship.
Perhaps it is significant that (as his diary reveals) his main devotional
reading was in the Beatitudes and in Revelation. The diary tells us that
at Lucerne, on 2 July, 'I . . . received my third call from God, in
answer to much distressful prayer. May He give me grace to walk
hereafter with Him in newness of life, to whom be glory for ever.
Amen.'[6] This 'call' means a joyous resolution about his writing. We
will remember that Ruskin had known such an answer to prayer on
two previous occasions. The first had been in the church in Geneva in

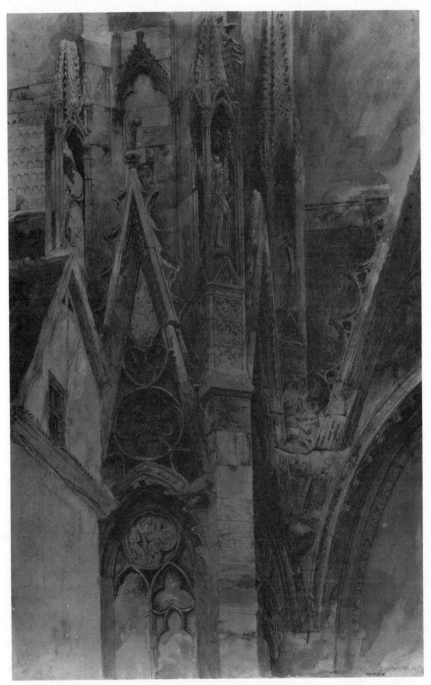

21. *South Transept, Rouen,* by John Ruskin, 1854.

1842, before he embarked on the writing of the first volume of *Modern Painters*. The second was in 1845, coming home from the Italian tour with the second volume in his mind. Now, in July and August of 1854, at Chamonix, Sallenches, Sion, Martigny and Champagnole, Ruskin took the notes that gave us the noblest passages in the continuation of his great work.

To say this is to admit that few of the most achieved parts of *Modern Painters* are directly concerned with painting. Ruskin's reaction to the Louvre is interesting. As so often, the party stopped in Paris on the way home: as so often, Ruskin gave the great picture collection only a cursory visit. His diary records,

> The grand impression on me, in walking through Louvre after Switzerland, is the utter *coarseness* of painting, especially as regards mountains. The universal principle of blue mass behind and green or brown banks or bushes in front. No real sense of height or distance, no care, no detail, no affection . . .[7]

During the next eighteen months, while he wrote the third and fourth volumes of *Modern Painters* and prepared their fifty plates, he returned time and again to the major intellectual difficulty of his earlier life: the fact that nature is one thing and art another. But there was much else to occupy him. Nature alone could not take up all his attention. Even in the Alps he had written a pamphlet on the preservation of ancient buildings, *The Opening of the Crystal Palace*, and had contemplated an illustrated book on Swiss towns and their history. In Paris, feeling that his work in England was only a week away, he quite suddenly became full of ideas. A letter to Pauline Trevelyan lists them:

> I am going to set myself up to tell people anything *in any way* that they want to know, as soon as I get home. I am rolling projects over and over in my head: I want to give short lectures to about 200 at once in turn, of the Sign painters — and shop decorators — and writing masters — and upholsterers — and masons — and brick-makers, and glassblowers, and pottery people — and young artists — and young men in general, and school-masters — and young ladies in general — and schoolmistresses — and I want to teach Illumination to the sign painters and the young ladies; and to have the prayer books all *written* again; (only the Liturgy altered first, as I told you) — and I want to explode printing; and gunpowder — the two great curses of the age — I begin to think that abominable art of printing is the root of all the mischief — it makes people used to have everything the same shape. And I mean to lend out Liber Studiorum & Albert Durers to everybody who wants them; and to

make copies of all fine 13th century manuscripts, and lend *them* out
— all for nothing, of course, — and have a room where anybody
can go in all day and always see *nothing* in it but what is *good*: and I
want to have a black hole, where they shall see nothing but what is
bad: filled with Claudes, & Sir Charles Barry's architecture — and
so on — and I want to have a little Academy of my own in all the
manufacturing towns — and to get the young artists — preRaphael-
ite always, to help me — and I want to have an Academy exhibition
— an opposition shop — where all the pictures shall be hung on the
line; in nice little rooms, decorated in a Giottesque manner; and no
bad pictures let in — and none good turned out and very few
altogether — and only a certain number of people let in each day —
by ticket — so as to have no elbowing. And as all this is merely by
the way, while I go on with my usual work about Turner and
collect materials for a great work I mean to write on politics —
founded on the Thirteenth Century — I shall have plenty to do
when I get home . . .[8]

Romantic and utopian as these ambitions might seem, there yet
were ways in which Ruskin's schemes could be tested. One was
presented to him almost as soon as he came home from Paris. F. J.
Furnivall, loyal to Ruskin throughout the time of the public furore
over his marriage, now approached him with the news of a proposed
Working Men's College. At a meeting to discuss its foundation Fur-
nivall had distributed a pamphlet which reprinted the 'Nature of
Gothic' chapter from *The Stones of Venice*. He was especially eager that
the experiment should have Ruskin's blessing. The other founders of
the college had probably not anticipated the critic's response to Fur-
nivall: he immediately offered to take a regular drawing class. Rus-
kin's outlook differed sharply from that of the college's establishment.
He was distant from its principal, F. D. Maurice, and from other
founders like Charles Kingsley and Thomas Hughes. He had nothing
to do with their Christian Socialism. However imaginative Ruskin's
view of politics, he was a tory of his father's type, opposed to democ-
racy and liberal reform. His Christianity was certainly not of the 'sane,
masculine Cambridge school' favoured by Christian Socialism and by
such guiding spirits of the college as Llewelyn Davies.[9] Ruskin might
therefore have brought contention into the new foundation. But this
did not happen, especially since nobody of Maurice's or Kingsley's
type was likely to think that art lessons were important. Ruskin
conducted his drawing class on his own terms, avoided his colleagues
and took little part in the management of the college. Thus he was able
to participate in the educational experiment quite contentedly, teach-

ing regularly from the autumn of 1854 until May of 1858, in the spring
of 1860, then sporadically for one or two years after that.

Ruskin's absorption in the classes in a house in Red Lion Square
might have had a rather personal motive. It is possible that he felt — as
he often would in years to come — that it was time to cease from
vanity and to work quietly at an elementary level, far from public
renown. In this way, the drawing class was a reaction from the fame of
his books and the glittering social life he had led with Effie. [10] A slower
pace and a less excited notion of what he might achieve were also
forced on him by the nature of his students. Before he began teaching
workmen he told Sarah Acland that he was considering 'whether I
shall make Peruginos, or Turners, or Tintorets, or Albert Durers of
them'. [11] Wiser and more limited ambitions soon prevailed, and Rus-
kin began to think in other terms. He now looked only for a skill in
drawing which might simply allow his pupils to enjoy looking at
natural objects. This became the official policy of his class. He expres-
sed it often, and in varying ways. A succinct summary of his pro-
gramme was given to a Royal Commission in 1857: 'My efforts are
directed not to making a carpenter an artist, but to making him
happier as a carpenter.' [12] But the contemporary existence of a drawing
class and much theoretical writing about drawing should not lead us to
believe that the former was an expression of the latter. For what really
happens in a class is that individual students manage different things
differently, and the master encourages or corrects them as best he
may. Ruskin was obviously good at it. Here are the recollections of
Thomas Sulman, a wood engraver, who attended the Working Men's
College from its earliest days:

> How generous he was! He taught each of us separately, studying the
> capacities of each student. For one pupil he would put a cairngorm
> pebble or fluor-spar into a tumbler of water, and set him to trace
> their tangled veins of crimson and amethyst. For another he would
> bring lichen and fungi from Anerley Woods. Once, to fill us with
> despair of colour, he bought a case of West Indian birds unstuffed,
> as the collector had stored them, all rubies and emeralds. Some-
> times it was a Gothic missal, when he set us counting the order of
> the coloured leaves in each spray of the MS. At other times it was a
> splendid Albert Durer woodcut . . . One by one, he brought for us
> to examine his marvels of water-colour art from Denmark Hill. He
> would point out the subtleties and felicities in their composition,
> analysing on a blackboard their line schemes . . . He had reams of
> the best stout drawing-paper made specially for us, supplying every

convenience the little rooms would hold. He commissioned William Hunt of the Old Water-Colour Society to paint two subjects for the class, and both were masterpieces . . .[13]

All this is genial; and Ruskin's appointment of the unskilled Rossetti to conduct a life class makes one further suspect that art education at the Working Men's College was as much light-hearted as it was theoretical. Of course, Ruskin's deep instinct for taking matters seriously could not be long suspended. Thus there was a variable relationship in the college between grave purposes and what Rossetti called 'fun'. Rossetti's presence helped to create a contradictory and exciting atmosphere. So did the students. Some were solemn, while others were simply happy to be dabbling with water-colours. All of them seem to have responded to Ruskin, especially at his improvised lectures. Ford Madox Brown, an occasional visitor at the college, reported that 'Ruskin was as eloquent as ever, and wildly popular with the men'.[14] That popularity accounts for numerous reports of the speeches in students' reminiscences. 'We used to look forward to these talks with great interest,' writes 'One who was often present'. 'Formless and planless as they were, the effect on the hearers was immense. It was a wonderful bubbling up of all manner of glowing thoughts; for mere eloquence I never heard aught like it.'[15]

These were some of the first occasions when Ruskin spoke spontaneously in public. As such, the lectures have an important place both in his life and also in his writing. John James had been hostile to the invitations to lecture Ruskin often received. He considered lectures vulgar. 'I don't care to see you allied with the platform', he wrote, '— though the pulpit would be our delight — Jeremy Taylor occupied the last & Bacon never stood on the former . . .'[16] The 'notion of a *platform* & an *Itinerant Lecturer*' offended John James's notions of the dignity of his son's books. Recently, Ruskin had dutifully declined to contribute to a series of lectures in Camberwell: the lectern was also to be occupied by a self-educated workman to whom the Ruskins charitably gave old clothes. In Red Lion Square, there were no similar problems. There, Ruskin found a way of lecturing that depended on a difference in social class. He also expressed himself more extravagantly than his father would have thought wise. This anticipates the pamphleteering of the later Ruskin. His manner to his students was improvised and freely expository; his thoughts were paradoxical and returned upon themselves in apparent contradiction; he employed anecdote, aphorism, and dramatic questions; the tone was both rhetorical and intimate. It was a style that Ruskin would explore in print in years to

come, in works that were nominally addressed to working-class audiences: to Thomas Dixon, the cork-cutter of *Time and Tide*, and then to all the 'workmen and labourers of Great Britain' in *Fors Clavigera*.

★ ★ ★ ★

The cold autumn of 1854 was followed by months of bitter weather, long afterwards remembered as 'the Crimean winter'. In the new year, for weeks on end, London was covered by ice and snow. That spring the hawthorn blossoms in the Herne Hill garden were perished by frosts as late as June. Ruskin was unwell. He was tired, feverish, and continually coughing. A short trip to Deal to look at ships and shipping — a visit which later produced *The Harbours of England* — failed to restore him. In late May of 1855 he went to his doctor cousin William Richardson at Tunbridge Wells. Richardson put him to bed, cured him in three days and told him not to be a fool. Perhaps Ruskin simply needed a change. Since the tour abroad the previous summer he had been trying to develop a fresh impulse for the next volume of *Modern Painters*. It was now nearly ten years since the last instalment had been published. Ruskin wanted to find a continuity with what he had then written: he also wished to clarify his experience of architecture and contemporary art during the past decade. But his plans for the book, always liable to modification and expansion, now became merely disparate. The third volume of *Modern Painters*, written at intervals between the summer of 1854 and January of 1856, is entitled 'Of Many Things'.

Ruskin lacked a direction in his life. It was now that he should have left the family home. But he did not: he could not see the point of such a personal emancipation. His writing had something to do with it. *Modern Painters* represented his continuing obligation to his father. Even if Ruskin had thought of independence, the fact that he was writing this book for John James would have discouraged a departure. The way in which he remained his parents' child now became all the more marked. Anne Strachan, his childhood nurse, still treated him as an infant. Little Sarah Angelina Acland, who came to visit Denmark Hill with her brother Harry, Ruskin's godson, tells us how 'Mrs Ruskin made us boats with walnut shells with which we had races in his bath. Anne the old maid who kept Mr Ruskin in great order, came in and said that he had no business to have water in his bath, and that as he had he must see to emptying it!'[17] Many other visitors remarked how close the Ruskin family was. The painter James Smetham, writ-

ing to a friend after an evening at Denmark Hill in February 1855, recounted that Ruskin 'has a large house with a lodge, and a valet and a footman and a coachman, and grand rooms glistening with pictures, mainly Turner's . . . his mother and father live with him, or he with them'. Smetham noticed how Ruskin deferred to parental authority, how 'Mrs Ruskin puts "John" down and holds her own opinions, and flatly contradicts him; and he receives all her opinions with a soft reverence and gentleness that is pleasant to witness'.[18]

Ruskin's dependence on his parents had a particular use after Effie's departure. Their protectiveness and pride upheld him. He had no need to consult his conscience and no reason to consider his self-respect. He now faced London and the world of what men were saying about him with equanimity. Mr and Mrs Ruskin had given their son a self-assurance in which there was a mixture of innocence and arrogance. But Ruskin's arrogance was seldom foremost. People were most struck by his openness. All through his life, in whatever circumstances, he very seldom showed signs of embarrassment. On only one occasion does he claim to be shy. This is in a letter of December 1853, written after he had inadvertently said something rude to the solicitor Bellenden Kerr at a council meeting of the Arundel Society. Asking Frederick Furnivall to help patch the matter up, Ruskin remarked, 'People don't know how shy I am, from not ever having gone into Society until I was seventeen. I forget who it is says that the mixture of hesitation and forced impudence which shy people fall into is the worst of all possible manners. So I find it.'[19] But usually Ruskin was without social inhibitions. It made him a more friendly man. His sensitivity to other people was interested and honest. This was not merely a charm of manner, though he had that. It was an appealing ability — in a man so egotistical — to deal with people on their own terms.

★ ★ ★ ★

A moving aspect of the personal history of Pre-Raphaelitism, so full of desperate and disappointed love, is the record of its friendships. 'True friendship is romantic, to the men of the world', Ruskin had declared in his Edinburgh lectures in 1853.[20] It was an idealistic view, given his current relations with Millais. But there are such friendships, and one may not consider Ruskin's life without regretting, as later he did himself, that in his youth and early manhood he had never known a fellow spirit of his own age and with his own enthusiasms. He had experienced nothing like the young *camaraderie* of the Pre-Raphaelite

Brotherhood. He was separated from the Brotherhood by his age and background. He knew its members only at the time when they were beginning to disperse. But he was able to sense the importance of their fellowship, and he tried to enter it. His attempts to maintain some cordiality with Millais had been rebuffed. Now, in the year after his alienation from Millais, he first became acquainted with Dante Gabriel Rossetti.

Two years after he had defended Pre-Raphaelitism in his letters to *The Times*, Ruskin had still not seen the work of one of the Brotherhood's foremost members. He became aware of Rossetti's art only in the new year and spring of 1853, just before he left for the fateful holiday at Glenfinlas. Ruskin soon found himself recommending Rossetti's drawings to Thomas McCracken, the Belfast shipping agent who was an early patron of Pre-Raphaelitism. In a letter written to Thomas Woolner in Australia, sent with the parcel of Pre-Raphaelite portraits that had been made at the very last meeting of the Brotherhood in 1853, Rossetti explains:

> M'C sent me a passage from a letter of Ruskin's about my Dant-
> esque sketches exhibited this year at the Winter Gallery, of which
> I spoke to you in my last. R. goes into raptures about the colour and
> grouping which he says are superior to anything in modern art —
> which I believe is as absurd as certain objections which he makes to
> them. However, as he is only half informed about art, anything he
> says in favour of one's work is of course sure to prove invaluable in a
> professional way, and I only hope, for the sake of my rubbish, that
> he may have the honesty to say publicly in his new book what he has
> said privately — but I doubt this. Oh! Woolner — if one could only
> find the 'supreme' Carlylean ignoramus, — him who knows posi-
> tively the least about art of any living creature — and get *him* to
> write a pamphlet about one — what a fortune one might make. It
> seems that Ruskin had never seen any work of mine before, though
> he never thought it necessary to say this in writing about the PRB
> . . .[21]

The evident desire for success is quite understandable. Woolner had left England because he could not make a living from his art. Rossetti, in the five years since the formation of the Brotherhood, had sold next to nothing. His painting *Ecce Ancilla Domini* had waited for three years before attracting wary interest from McCracken, who was offering only £50 for it. Millais, on the other hand, at this moment painting *The Order of Release* in Ruskin's own home, had been guaranteed eight times that amount before he even began his picture. Rossetti knew

well by now that the fortunes of Pre-Raphaelitism, in the more material sense, would not be his; that the triumphs would be in the Royal Academy, where he had never shown; that success would belong to Millais first, and then to Hunt, but not to him. He might well have been piqued that neither Millais or Hunt had never brought Ruskin to his studio; and in the earliest days of their acquaintance he had to call on the generosity of his nature to avoid such pique.

Rossetti was surprised that Ruskin was favourably disposed towards his art. It could not have seemed likely that the author of *Modern Painters* would appreciate either his vision or his means. Rossetti's drawings are awkwardly managed, out of perspective, and contain no landscape. They have not the technical command that Ruskin believed essential: nor do they have the appearance of seeking such a command. Rossetti's work was not that of an artist willing to 'go to nature, selecting nothing and rejecting nothing'; and his style could never be construed as that of a natural successor to Turner. In short, he was a living refutation of Ruskin's programmatic theories about Pre-Raphaelitism. Here was a contradiction. But Ruskin now gave his blessing not only to Rossetti's art but that of his associates and followers; the mystic unrealism of his wife Elizabeth Siddall; his friend Smetham (whose work Ruskin first saw in November 1854); and his disciple Edward Burne-Jones, whom Ruskin met two years later and who was to be his lifelong friend. Ruskin's support of these artists was largely private. He did not write about them until late in life. When he did so, his impulse was less critical than autobiographical. His memory of their painting was then wound into strange relations with his own youth. For the strain of English symbolist art was not new to Ruskin when he met Rossetti. His early acquaintance with the Richmonds had introduced him to those few people, like Samuel Palmer, who in the 1830s had kept alive the Blake tradition. George Richmond, he who had attended Blake's deathbed, had acted as intermediary when, in 1843, Ruskin had tried to buy a very bold selection of Blake's, 'the Horse, the owls, the Newton, and the Nebuchadnezzar . . . the Satan and Eve, and the Goblin Huntsman, and Search for the Body of Harold'.[22]

Forty years later, when sometimes he thought of himself as Nebuchadnezzar, Ruskin would associate his own madness with Blake. Now, in 1854, when he first went to Rossetti's rooms in Blackfriars, he was surely shown Rossetti's great treasure, the manuscript notebook containing writings and drawings by Blake that the Pre-Raphaelite had bought in 1847 from Samuel Palmer's brother. The similarities between the art of Blake and Rossetti are clear. It is

passionate, unnaturalistic, illustrational, made by a poet; it is religious, private, amateur, small in scale and avowedly symbolic. Ruskin quite understood its impulses, and was therefore well prepared for the second, non-naturalistic phase of Pre-Raphaelitism. He could talk to Rossetti in a way that left the young man stimulated as he had not been stimulated by certain of his Pre-Raphaelite brethren. Rossetti pretended at first that he was only interested in getting money out of Ruskin. This was not so: he was excited by him. This had nothing to do with what Ruskin wrote. When a large parcel came from Smith, Elder containing the eight volumes, three pamphlets and book of large folio plates that then constituted Ruskin's *œuvre* he did not really want to read them. But he was glad to make Ruskin a water-colour drawing in return. So began an unlikely partnership (in which Lizzie Siddall was included). Each man found the other exasperating beyond endurance, and yet the relationship was of great value to both. By May of 1855, Rossetti was writing of Ruskin, 'He is the best friend I ever had *out of my own family*.'[23] Although he did not say so, and perhaps would not have liked to admit it, Ruskin's friendship had given him a confidence in his art that he had not experienced in his years in the Pre-Raphaelite Brotherhood.

<p style="text-align:center">★ ★ ★ ★</p>

The four or five years between the end of Ruskin's marriage and his first meeting with Rose La Touche seem to be dominated by public and social interests. He taught at the Working Men's College, collaborated with architects, scientists and reformers, encouraged the building of the new Oxford Museum; he periodically issued *Academy Notes*, his commentary on new painting, and he worked at the National Gallery in cataloguing the Turner bequest. However, this was also the time — between 1854 and 1858 — when he was closest to poets. His literary acquaintances were many: they always had been. But the likes of Miss Mitford and W. H. Harrison were the minor writers of a previous generation. So were the two poets Ruskin had previously known best, George Croly and Samuel Rogers. They were behind him now, as he began to associate with those writers in the first major wave of Victorian poetry. The Rossettis, Coventry Patmore, Tennyson, William Allingham and the Brownings were all his acquaintances: so were less distinguished poets than these. Ruskin worked hard to keep up with their production. There was a special shelf in his bookcase for verse he was currently considering. He lost no opportunities to discuss their work with the poets themselves: for he could

admire them more easily than he could admire artists, and he believed that there were bright truths to be found in their company. Perhaps there were: in any case Ruskin learnt more in these years from poets than he did from reformers.

His attitude to his own verse was diffident. He was thinking of himself when he wrote,

> There are few men, ordinarily educated, who in moments of strong feeling could not strike out a poetical thought, and afterwards polish it so as to be presentable. But men of sense know better than so to waste their time; and those who sincerely love poetry, know the touch of the Master's hands on the chords too well to fumble among them after him . . .[24]

He was silent about his own early attempts as a poet. Probably only Coventry Patmore, as a family friend, would have seen the collection of Ruskin's own poems. This privately printed edition had been projected by John James Ruskin when, in 1847, he finally became reconciled to the idea that his son would write no more verse. It appeared in 1850. The book was not circulated, and Ruskin is said to have destroyed some of the edition of fifty copies.[25] Nonetheless, Ruskin felt able to criticize such a one as Patmore as a fellow practitioner. This was reasonable, given the prose he could write and the years he had spent in polishing diction and versification. Such matters he discussed with Patmore, telling him confidently, 'You have neither the lusciousness nor the sublimity of Tennyson, but you have clearer and finer habitual expressions and more accurate thought. For finish and neatness I know nothing to equal bits of the Angel.'[26] Ruskin was talking about 'The Betrothals', the first part of The Angel in the House, which had been published in 1854. He had an interest in this poem-sequence that was more than technical. He had known the person to whom it was addressed, Emily Patmore, since his boyhood. Patmore's poem concerns emotional and spiritual satisfaction in marriage. Ruskin's congratulatory letter regretted that 'the circumstances of my own life unhappily render it impossible for me to write a critique on it'.[27] Privately, he found the poem's attitudes rather consolatory. The more Ruskin sympathized with the ideal of The Angel in the House the less his own marriage seemed real to him. Patmore's Angel is an abstract of feminine docility, and could be easily fitted into Ruskin's idealized view of the marriage bond. Ruskin did not write about Patmore's poem until 1860. In that year a further instalment was published, 'Faithful for Ever'. A negative review in the Critic drew a response from him. He wrote to the editor to defend Patmore as 'one

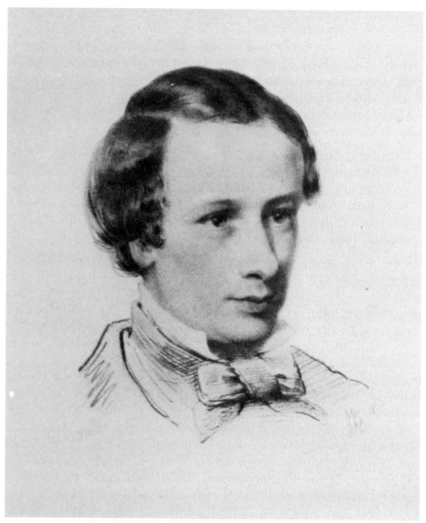

22. Coventry Patmore, from a drawing by J. Brett, R.A., 1855.

of the truest and tenderest thinkers who have ever illustrated one of the most important, because, commonest states of human life'.[28] Five years later, *The Angel in the House* would reappear in *Sesame and Lilies*, the book written expressly for Rose La Touche at the height of Ruskin's love for her. It is a poem that contributed to his disastrous assumptions about the girl he wished to wed.

It was through the Patmores that Ruskin had first met Robert and Elizabeth Browning; and we hear of memorable evenings at the Patmore home in Highbury. The poetaster Sydney Dobell stumbled into one of them. Patmore wrote:

We once had a small party consisting of Ruskin, Tennyson and Browning only. Sydney Dobell came in late in the evening, and sat down by my wife, and began talking cleverly and very predominantly, laying down the law about many things. Hearing my wife address Mr Ruskin by name, he asked in a whisper, 'Is that *the* Mr Ruskin?' and became a little less authoritative. After making similar enquiries when he heard the other names, he became quite shy . . .[29]

The question of authority was indeed an issue in this Olympian company. Ruskin's place there, and in the wider circles of Victorian literary life, was mostly as an art critic who had written wonderful books. Not everybody believed that he was always as wise about literature as he was reputed to be about art. These questions worried the Brownings a little. In the summer of 1855 they were often at Denmark Hill. On one occasion they brought Frederick Leighton with them, a young artist they had met in Italy: a month or two earlier Ruskin had given high praise to his *Cimabue's Madonna carried in procession through the Streets of Florence*. But was he as good a painter as they were poets? The Brownings could see that there was much that was immoderate in Ruskin's enthusiasms, and they were to find him unpredictable. His appreciations were evidently the judgements of a noble contemporary mind, but they lacked measure. 'I am going to bind your poems in a golden binding,' Ruskin wrote to Mrs Browning, 'and give them to my class of working men as the purest poetry in our language.' Not long afterwards, he was complaining about her 'designs on the English language'. The Brownings sensibly decided to enjoy his praise and to remain equable in the occasional storms of his criticism. When, in 1855, Browning sent a complimentary copy of *Men and Women*, Ruskin worried at the poems. He decided that he found them intellectually awkward. He made Rossetti, Browning's great champion among the younger poets, sit down with him and read them line by line. Still he could not feel their rightness. They were, he told Browning, 'absolutely and literally a set of the most amazing conundrums that ever were proposed to me'.[30] Browning took no offence, but explained his verse to Ruskin at great length. The critic was not convinced, but the episode gave him a valuable lesson in coming to terms with a sensibility unlike his own.

Ruskin knew Tennyson less well then he knew the Brownings, although their acquaintance extended over many years. Tennyson had been an admirer of Ruskin since 1843, when he first picked up *Modern Painters* from Samuel Rogers's library table. In 1855, the year in which

he succeeded Rogers as laureate, he expressed a desire to see Ruskin's famous collection of Turners. Thomas Woolner arranged an invitation to Denmark Hill. There was subsequently some correspondence between Ruskin and Tennyson. It consists mostly of polite notes, but Ruskin made occasional comments about Tennyson's poetry. He was interested in the reception that year of 'Maud' and 'The Charge of the Light Brigade'. Both poems were in Ruskin's mind as he brought the third volume of *Modern Painters* to its conclusion. This volume ends with some eloquent pages on the subject of the Crimean War. The Ruskinian prose is not unlike Tennyson's contemporary verse. Ruskin's thoughts about the war, which occur in a section entitled 'On the teachers of Turner', seemed to have little relevance to a book that was nominally about art. But Ruskin was extending his writing to include anything that currently concerned him. Much of this third volume is in fact about poetry. It can be regarded as his major contribution to that community of interest which existed between the artistic and the poetic worlds during the 1850s. And its thoughts about the politics of the Crimean War indicate that Ruskin — like Tennyson — was seeking a larger and more public stage for his writing.

<p align="center">★ ★ ★ ★</p>

It was common in all these poets (and this is an unremarked aspect of Victorian literary life) to take an interest in American literature. Ruskin too was welcoming to transatlantic writing. At one point in 1855 he had on his poetry bookshelf Dante, Spenser, Keats, Wordsworth, the two Brownings, Hood, George Herbert, Young, Shenstone ('By the bye, if Mr Browning would be a little more Shenstonian in *flow*, it would be all I want,' he wrote to Elizabeth Browning[31]), and beside them Longfellow and Emerson. He was also prepared to consider the possibility of American art. In 1851 he had been approached by the American artist and journalist W. J. Stillman, who had been impressed by Pre-Raphaelite painting on his first visit to Europe the previous year, had met Turner and had studied the first two volumes of *Modern Painters*. These were impressive credentials, and after some initial hesitation Ruskin encouraged Stillman's ambition to found a native school of art in America. If its inspiration was Turnerian and Pre-Raphaelite, and if it was true and thoughtful, then perhaps art might flourish wonderfully in a new country. Ruskin assured Stillman in 1855 that 'nothing gives me greater pleasure than the thought of being useful to an American',[32] and helped such travellers as J. J. Jerves, a Bostonian friend of the Brownings, and the collector Daniel Magoon,

though he was alarmed that Magoon was buying Turners to take to the New World. Stillman had founded an art magazine, the *Crayon*, of which eight volumes were published before it disappeared in the Civil War. Ruskinian æsthetics were its main inspiration. Ruskin did not contribute to the magazine , but he looked on the publication with benevolence. He recommended William Michael Rossetti to Stillman: Rossetti wrote for the magazine and introduced his fellow Pre-Raphaelite writer F. G. Stephens to its pages; and thus two contributors to the *Germ* found themselves proselytizing for the new art in a different continent that neither of them would ever see.[33]

It was at this time that Ruskin became acquainted with an American who was to be greatly important in his later life. Charles Eliot Norton was not an influence on Ruskin, but he was his confessor; and it was in that capacity, or his conception of it, that he came to act as Ruskin's literary executor. In *Præterita* Ruskin recounts that he met Norton in Switzerland in 1856. His memory was slightly at fault: Norton first went to Denmark Hill, with a letter of introduction from J. J. Jerves, in October of 1855. Here was a contrast with Stillman. The editor of the *Crayon* was the son of a redneck tradesman. One senses in him the vigour of an American without background who wished to make art his own. Norton was nothing but background. His family had been in New England since the seventeenth century. His father was the biblical scholar Andrews Norton, the 'unitarian Pope'. The family home was at Shady Hill, Cambridge, Massachusetts, only one mile from Harvard Yard. The young Norton, after his Harvard education and a period as a businessman, first approached the artistic and literary world of London in 1850. In Florence that year he met the Brownings. Arthur Hugh Clough became a friend, and lived at Shady Hill during his American years: Norton was staying with the Cloughs in London when he first went out to Denmark Hill. Such acquaintances confirmed Norton's literary interests. In further visits he met artists. Ruskin introduced him to Rossetti; and from Rossetti, and from friends of Ruskin's like William Allingham, he solicited contributions to a new American magazine. This was the *Atlantic Monthly*, founded by James Russell Lowell and others. Through Norton, Ruskin became acquainted with the work of Lowell, and later with the poet himself. In the last volume of *Modern Painters* he is referred to as 'my dear friend and teacher',[34] rather in the same way that Norton, in *Præterita*, was to become 'my first real tutor'.[35]

★　　★　　★　　★

Matthew Arnold was a mid-nineteenth-century poet and critic who lived at some remove from Ruskin and the circle of Pre-Raphaelite poets. Neither his tastes nor his aspirations were at all like Ruskin's. Their mutual interest in Oxford underlines both their temperamental and cultural differences. In the autumn of 1854 the poet of 'The Scholar-Gipsy,' was staying in Balliol, where he had been an undergraduate thirteen years before. He wrote to his mother of his reactions to the contemporary university:

> I am much struck with the apathy and poorness of the people here, as they now strike me, and their petty pottering habits compared with the students of Paris, or Germany, or even of London. Animation and interest and the power of work seem so sadly wanting in them . . . the place, in losing Newman and his followers, has lost its religious movement, which after all kept it from stagnating, and has not yet, as far as I see, got anything better. However, we must hope that the coming changes, and perhaps the infusions of Dissenters' sons of that muscular, hard-working, *unblasé* middle class — for it is this, in spite of its intolerable disagreeableness — may brace the flaccid sinews of Oxford a little.[36]

Ruskin had found no particular excitement in the Oxford Movement, nor would he have believed that the '*unblasé* middle class' were potential reformers. But while Oxford, as a symbol of culture and educational purpose, seemed inert to Arnold, for Ruskin it began to appear as a city in which many of his hopes might be realized. This was not a matter of the university reforms of the 1850s, Arnold's 'coming changes'. In Oxford, Ruskin now came to believe, masters and workmen, students and artists, might have a common purpose; art and nature might be brought together, wonderful architecture built, God served and glorified.

Such ambitions were stimulated by his old friend Henry Acland. As a doctor and a scientist, Acland had campaigned for some years for the extension of the study of natural history at Oxford. As an amateur artist and, after the Glenfinlas holiday, an aspirant Pre-Raphaelite, he also wished to introduce the study of art to the university. Since 1847 he had been asking for a new University Museum that would house the materials necessary for an honours school in the natural sciences. There were principled Tractarian objections in the way. Dr Pusey told Acland that he, Keble and others felt that the study of natural science was liable to engender 'a temper of irreverence and often of arrogance inconsistent with a truly Christian character'. Acland replied with Ruskinian arguments. In 1848 he used the second volume of *Modern*

Painters in his *Remarks on the Extension of Education at the University of Oxford*: he cleared his proposed academic discipline of any supposed impiety by advancing the Ruskinian notion that 'if the teacher of Natural Knowledge fulfil his mission as he ought, he is striving to lift up the veil from the Works of the Creator, no less than the Christian preacher from His Word'.[37] Acland's idea of a Gothic university museum that would serve both scientific and artistic purposes was created by his reading of *The Stones of Venice* and the Edinburgh *Lectures on Architecture and Painting*. Although he had left Glenfinlas by the time that Ruskin and Millais had started to design architecture, it is likely that he knew something of their collaboration. Ruskin, naturally, had been sympathetic to Acland's campaign. The appendix on 'Modern Education' at the end of the third volume of *The Stones of Venice* was a clear declaration of support. But he was slow to propose a specific type of building, even when the University Commissioners, in 1852, had finally agreed that a museum should be erected. In July of 1854 he sent Acland some copies of his pamphlet *On the Opening of the Crystal Palace*, adding, 'You don't want your museum of *glass* — do you? If you do — I will have nothing to do with it.'[38] Ruskin felt that the time had not yet come for the battle of the styles to be won. On 19 October 1854 he wrote to Acland's wife Sarah,

> . . . as for the plans, it is no use my troubling myself about them, because they certainly won't build a gothic Museum and if they would — I haven't the workmen yet to do it, and I mean to give my whole strength, which is not more than I want, to teaching the workmen: and when I have got people who *can* build, I will ask for employment for them.[39]

He did not become enthusiastic until the end of Acland's labours was in sight, when the entries to the competition to design the building had been reduced to two. One of these designs was Gothic, the other Palladian. The Gothic design, submitted under the motto *Nisi Dominus Aedificaverit Domum*, was championed by Acland in a pamphlet and by personal canvass among the members of Convocation; and when the verdict was given for Gothic, by only two votes in a poll of 132, he telegraphed the result to Ruskin, who wrote back that night

> I am going to thank God for it and lie down to sleep. It means much, I think, both to you and me. I trust you will have no anxiety, such as you have borne, to bear again in this cause. The Museum in your hands, as it must eventually be, will be the root of as much good to others as I suppose it is natural for any living soul to hope to do in its earth-time.[40]

★ ★ ★ ★

The architects who had won the competition to build the new
museum were Irish: they were the Dublin firm of Deane, Woodward
and Deane. The artistic spirit among the partners was supplied by
Benjamin Woodward, a civil engineer from Cork whose mediævalism
had led him to take up architecture. Ruskin may have heard of him, for
Woodward had already begun to design on Ruskinian principles. The
library of Trinity College, Dublin, which Woodward began in 1853,
was directly based on *The Stones of Venice*. William Allingham wrote
to Rossetti that it was

> . . . after Ruskin's heart. Style, early Venetian (I suppose), with
> numberless capitals delicately carved over holly leaves, shamrocks,
> various flowers, birds, and so on. There are also circular frames
> here and there in the wall, at present empty, to be filled no doubt
> with eyes of coloured stone . . .[41]

Ruskin thought that *Nisi Dominus* was 'though by no means a first-rate
design, yet quite as good as is likely to be got these days, and on the
whole good'. The great advantage to it was that Woodward, already a
Ruskinian, was malleable. 'Mr Woodward', Ruskin remarked to
Acland, 'is evidently a person who will allow of suggestion.'[42] His
enthusiasm was growing. Woodward's plans could be modified; more
money could be raised, and Pre-Raphaelite artists could be attracted to
the project.

> I hope to be able to get Millais and Rossetti to design flower and
> beast borders — crocodiles and various vermin — such as you are
> particularly fond of — Mrs Buckland's 'dabby things' — and we
> will carve them and inlay them with Cornish serpentine all about
> your windows. I will pay for a good deal myself, and I doubt not to
> have funds. *Such* capitals as we will have![43]

★ ★ ★ ★

Ruskin's pamphlet *On the Opening of the Crystal Palace* has one or two
passages that are not so much concerned with architecture as with
public health. In the latter part of 1854, at the time when he was
beginning his drawing classes at the Working Men's College and
corresponding with Acland about the Oxford Museum, Ruskin
attended a committee of eminent men organized by Arthur Helps, the
author of *Friends in Council* (1847), a book in dialogue form on the
nature of wise government. Their purpose was to organize relief from

the cholera epidemic that had broken out that summer. Ruskin's pamphlet has an interpolated question that was surely derived from the misery in the East End:

> If, suddenly, in the midst of the enjoyments of the palate and lightnesses of heart of a London dinner-party, the walls of the chamber were parted, and through their gap, the nearest human beings who were famishing, and in misery, were borne into the midst of the company — feasting and fancy-free — if, pale with sickness, horrible in destitution, broken by despair, body by body, they were laid upon the soft carpet, one beside the chair of every guest, would only the crumbs of the dainties be passed to them — would only a passing glance, a passing thought, be vouchsafed to them?[44]

The arrival of cholera could be predicted: one of Helps's pamphlets on the subject is entitled *Some Thoughts for next Summer*. The epidemic would strike slum districts with inadequate drainage in hot weather. Another member of Helps's committee, whom Ruskin now met for the first time, was John Simon. This intelligent, liberal-radical doctor, Medical Officer of Health for the City of London since 1848, had stated with horrible accuracy in which streets and courts people were likely to die.[45] Simon would soon begin to work with another man who also became a friend of Ruskin's, William Cowper. This future trustee of the Guild of St George was now beginning his political career at the Board of Health. Henry Acland, too, had been much concerned with cholera that summer, for the epidemic had visited Oxford. Like Ruskin's dinner guests, the Oxford slums had forced themselves upon the attention of the university. One might live in London and never visit the East End: the slums of Oxford are only at the other side of the garden walls of the colleges. St Ebbe's began immediately behind Pembroke and the Christ Church house in which the undergraduate Ruskin had lodged. Jericho is built against the walls of Worcester College. These districts were not served by the same water system as the university, and cholera raged in their undrained streets. Acland worked unceasingly to limit the number of deaths. But he lacked assistance and facilities. Families were lodged in compounds on Port Meadow: corpses were placed in hastily erected sheds: clothing was burnt or fumigated. Acland's experience that summer, with his analysis of the causes of the epidemic, appear in a short work he entitled *Memoir on the Cholera at Oxford in the Year 1854, with Considerations Suggested by the Epidemic*.

A remarkable feature of Acland's book, which is largely concerned

with provisions for sanitation, is that it ends with a plea for art. 'The Physician and the Philanthropist must desire the success of Schools of Design, and Schools of Art,' he argued, adding that Oxford needed a Professor of Art and that 'a new page of nature and of art has been opened to us through the works of Ruskin'.[46] Acland had been taught to feel that naturalism in art had something to do with the fight against disease. The study of natural science must lead to an ameliorated public health, and natural science should be studied in the same spirit that a Ruskinian artist looks at the world. Ruskin's and Acland's joint publication, *The Oxford Museum* (1859), indicates that for them both Pre-Raphaelitism and Gothic architecture were signs of spiritual health; that this was the root of good government; and that the university could

> . . . become complete in her function as a teacher of the youth of the nation to which every hour gives wider authority over distant lands; and from which every rood of extended dominion demands new, various, and variously applicable knowledge of the laws which govern the constitution of the globe . . .[47]

Now, in the summer of 1855, Rossetti came to Oxford to look at work on the museum. He complained that he was bored by Acland's constant topic of conversation, drainage, and perhaps was dissatisfied with other matters. For Ruskin had brought Lizzie Siddall to Oxford to be under Acland's care. After his second meeting with Lizzie (whom he then rechristened Ida, after the heroine of Tennyson's 'The Princess') Ruskin had decided that something had to be done about her health. His mother's home-made medicines, prepared to complicated recipes, had been urged on the listless beauty. But they had not been effective: and so Ruskin had turned to Acland. In May of 1855 he announced to him that 'I am going to burden you still with other cares on the subject of Pre-Raphaelitism, of which you have already had painful thoughts enough', and explained the relation between her and Rossetti as best he could. 'She has a perfectly gentle expression', he wrote, 'and I don't think Rossetti would have given his soul to her unless she had been both gentle and good. She has more the look of a Florentine 13th Century lady than anything I ever saw out of a fresco.'[48] Ruskin's plan was that Acland would examine her, and then perhaps send her to some cottage on the Acland family's Devon estates. Instead, Acland invited Lizzie to come to stay in Oxford.

The visit was not a complete success. Lizzie felt social apprehensions. The girl from the Elephant and Castle had coped with being taken up by the Pre-Raphaelites: to cope with people who had taken

up the Pre-Raphaelites was more difficult. Rossetti's letters from Oxford to his mother are at pains to emphasize Lizzie's social success. He reports that Acland

> . . . said he would introduce her into all the best society. All the women there are tremendously fond of her — a sister of Dr Pusey (or daughter) seems to have been the one she liked best. A great swell, who is Warden of New College, an old cock, showed her all the finest MSS in the Bodleian Library, and paid her all manner of attentions . . .[49]

Acland examined the mysterious and silent Miss Siddall, but could find little wrong with her. His vague diagnosis was that she was feeling the effects of 'mental power long pent up and lately over-taxed'.[50] She met many people, in the normal rounds of Oxford hospitality. But she was not able to feel at home at the Aclands's. Her ways were not theirs. Mrs Acland complained of the untidiness of her room, and perhaps of other things. She may have been asked to leave: for one letter from Ruskin offers to recompense the Aclands for their expenses on her behalf, and continues 'it is provoking that she can't be reasonable and take proper lodgings when she is bid'. In another letter Ruskin apologizes and makes excuses for her. The excuse is that she is a genius. 'I don't know how exactly that wilful Ida has behaved to you,' he wrote to Mrs Acland.

> As far as I can make out she is not ungrateful but sick, and sickly headstrong — much better, however, for what Henry has done for her. But I find trying to be of use to people is the most wearying thing possible. The true secret of happiness would be to bolt one's gates, lie on the grass all day, take care not to eat too much dinner, and buy as many Turners as one could afford. These geniuses are all alike, little and big. I have known five of them — Turner, Watts, Millais, Rossetti, and this girl — and I don't know which was, or is, wrongheadedest.[50]

There is little sign of genius in the drawing which Lizzie left behind her as a gift, and which the Aclands regarded as a curiosity. It is an incompetent illustration to Wordsworth's poem 'We Are Seven'. Ruskin wrote loyally that 'It is quite childish in comparison to what she *can* do. She will show you one day — if she gets better.'[51]

It is possible that a strained atmosphere between Rossetti and Lizzie and the Aclands explains why Rossetti made no contribution to the Oxford Museum, although some of his art was left in Oxford: for he now became friendly with Woodward and was to work with him on

his other Oxford building, the Union, two years later. On Ruskin's, Woodward's and Acland's behalf, Rossetti delivered an invitation to Millais, but his Pre-Raphaelite brother would have nothing to do with such a scheme. Ruskin himself took the Pre-Raphaelites' place in making plans for the museum's ornamentation. He produced many drawings and was in constant communication with Woodward. The architect often went to Denmark Hill, where he met Rossetti and other artists. He also had serious talks with F. J. Furnivall, the most favoured of Ruskin's colleagues at the Working Men's College. Illustrative material from Ruskin's own collection was urged on Woodward: a direct link exists between Ruskin's Venetian sketchbooks and the new building in the meadows north of Wadham. Neither Woodward's ground-plan nor his elevations were changed, but he was flooded with ideas for detail. One of Ruskin's gifts to the Gothic Revival was the lesson that ordinary designs might be wonderfully enlivened by decoration. This decoration could be carved, painted, or introduced by differently coloured brickwork and masonry. All these expedients were important, and Ruskin's help all the more necessary, because the university would pay for only the shell of the building. The problem of funds, and perhaps of wages, was raised in other ways. Acland, Woodward and Ruskin were all eager that workmen should be able to express themselves as artists while they were engaged on the building. But they knew nothing of problems on site. Woodward had brought a number of workmen with him from Ireland. Two of them, the O'Shea brothers, were talented. One brother carved a complicated window from a drawing by Ruskin. They also invented their own designs from nature. Tuckwell's *Reminiscences of Oxford* tells us how 'Every morning came the handsome red-bearded brothers Shea, bearing plants from the Botanic Garden, to reappear under their chisels in the rough-hewn capitals of the pillars.'[52] The O'Sheas were not in all respects obedient to Acland's authority, and they provide a number of amusing stories which have found their way into a type of Oxford lore. One of them seems to have been dismissed by Acland, then reinstated. This was James O'Shea; and in his case the line that separated the professional artist from the labourer was not distinct. This may have caused the friction. Or O'Shea (who significantly is not granted a Christian name in Acland's account) may simply have rebelled against the man who could write of 'the humour, the force, the woes, the troubles, in the character and art of our Irish brethren'.[53]

Ruskin, who liked O'Shea, preserved a scrap of one of his letters. It indicates that the Irishman was scarcely literate. What culture could be shared by the different classes? The museum began to teach Ruskin

how difficult this question was: the Working Men's College, on the other hand, seemed to have only facile answers to the question. A note from Ruskin's new valet Crawley (for George Hobbs had emigrated to Australia) to the Christian Socialist Furnivall has also been preserved. In this year, 1855, when Furnivall was most often a Denmark Hill guest, he gave presents of books to the servants. Crawley wrote to his benefactor:

> I am asshamed [sic] of miself for not writing by return of post to thank you for your kind present — which I feel deeply grateful for — I am reading Ruth to my fellow servants we are all delighted with it. The language is beautiful and deeply interesting and the morals it sets forth are very good and i trust that all who reads it will view it as a lesson and profit by so doing . . .[54]

Not all men of the working classes would be as acquiescent as Crawley. John James Ruskin was not opposed to his servants having books, but he wanted to know where it would all end. He had even heard mad talk of a Working Women's College. John James's approval of his son's ventures was in any case tempered by the large sums of money he was expected to contribute to them. But it was the sheer giddiness of the idea of a further Working Men's College at Oxford that now prompted him to write to Henry Acland:

> . . . the subject of a Working Mans College at Oxford . . . I trust no such absurdity will obtain a footing at Oxford. Mr Furnivall, a most amiable Radical & Philanthropist seems to have nothing to do but to start projects for others to work & he may have an Eye to Oxford — but I sincerely hope neither you nor my son will take any trouble about it. I think both your father and Mrs Acland must have been saddened to see the weight of work thrown on you by the Museum. That must be at least quite enough . . . My Son has enough to do with his writings and his London college. I became reconciled to the latter because he seems to do good service to some good and true men but neither kindness or charity require all plans to be made the scene of these amiable exploits — I should like these experimentalists to feel their way to go along gently and discreetly. It may be lack of enthusiasm in me makes me feel a lack of discretion in them. I hope in trying to drag up the low they will not end in pulling down the high . . .[55]

The 'absurdity' of such a college at Oxford was avoided for another half a century. When it was founded, three years after Ruskin's death in 1900, it would bear his name. Ruskin would not have approved of

that college; and it is an irony of his reputation that as his political and educational beliefs became more distinct from the ordinary they also were less understood. In the late 1850s, the condescending good will one associates with F. D. Maurice has an echo in the classes given to workmen on the museum site. Ruskin's personal difficulties may be found in an unpublished address he gave there in April of 1856. It is fluent, but his unease is nonetheless discernible. The political problems raised by the museum may have guided Ruskin towards a firmer expression of views that were increasingly isolated from those held at the Working Men's College. *The Political Economy of Art*, a book which alarmed the Christian Socialists, was written while Ruskin was helping at the museum in the summer of 1857. It is probably significant that in that long vacation there was a further decline in Ruskin's belief in the social power of Pre-Raphaelite art. He had always been reserved about the Pre-Raphaelite ambition to paint frescoes. He now distanced himself from an independent Pre-Raphaelite venture, the decoration of the interior walls of the Oxford Union. This was another new Woodward building. When Ruskin visited it he found Rossetti and many another young artist heartily at work. He thought of paying for another painting in the spandrels above the debating hall. But he did not: neither did he give advice about fresco technique.

In that summer of 1857 the young Pre-Raphaelite spree in the Union was evidently a more successful collaboration than had been achieved in the museum. Both Acland and Ruskin had to note that the artists had joined forces to adorn a monument to adolescent self-importance. These same artists had not been inclined to help with Acland's under-financed cathedral of the natural sciences. The doctor gave beds to some of them, in his rabbit-warren of a Tudor house in Broad Street. But Ruskin may have recognized apostasy. He never in his life, neither in writing nor, apparently, in conversation, mentioned Woodward's Union building. He also developed his aversion to staying in Oxford. In 1857 he lived in a rented cottage in Cowley, three miles outside the city; in 1861 he stayed at Beckley, six miles away; and when he was elected Slade Professor in 1871 he took up lodgings in a public house in Abingdon, six miles away in the other direction. He also distanced himself, in this summer of 1857, from Dean Liddell's plan to have Woodward design model cottages for workers living on land owned by Christ Church. He was learning that since one must expect disappointments in Oxford it is better to maintain one's own position than to compromise with a powerful person you distrust. At some point in the 1850s Ruskin gave away his drawings for the unfulfilled museum windows to Acland's small daughter Angie. He had already hinted to

the museum workmen that the only satisfaction they might find in their labour might be the vague one that they were 'laying the foundation of a structure which was calculated to exercise a very beneficial influence on succeeding generations'.[56] For his part, he might as well give his contribution to a child. Only one piece of writing came out of the museum project. The pamphlet, *The Oxford Museum*, was issued jointly by Ruskin and Acland in 1859. Its purpose was to raise more money. By this time Ruskin felt even further from the museum. But some of its lessons settled in his mind. In fifteen years' time, when he took hints from Acland for his road-mending project with undergraduates, it would be recalled. Then, he would attempt to give the experience a symbolic value: one that had no practical application, as it turned out, and which was executed by the amateur workmen who became (as no real workmen ever did) his 'disciples'.

CHAPTER TWELVE

1855–1857

During the 1850s Ruskin was often confronted by the kind of questions raised by O'Shea's artistic ability, or what there was of Lizzie Siddall's artistic ability. At the Working Men's College they could scarcely be avoided, except by saying (as Ruskin did) that he was not training professional artists. The real difficulty was in the definition of an amateur. But there were also problems concerning the status of fine art and its relation to those who might wish to own it, who would be wealthy, and those who ought to study it, who would often be poor. Ruskin, especially when addressing such an amateur artist as Lady Waterford, was inclined to hint that he did not believe that there should be a distinction between 'high' and 'low' art.[1] But he was wise not to enter this territory. It was enough that he recognized that such problems existed. His interest in the wide distribution of art came from his study of the social forms of architecture, its openness for all to see and use. At the beginning of his first letter in *The Oxford Museum*, Ruskin made some criticisms of private ownership of art. Many purchases, he argued, came about through 'acquisitive selfishness, rejoicing somewhat in what can NOT be seen by others', while he and the Gothic Revivalists hoped 'to make art large and publicly beneficial, instead of small and privately engrossed or secluded'.[2] But this was to compare painting (in this instance, two small Meissoniers) with an architectural project. The argument was hardly viable, and was not much pursued. Nonetheless Ruskin's mind was edging around the idea of a democratic art, and in *Academy Notes*, his series of criticisms on the Royal Academy summer exhibitions, it appeared that he looked to Pre-Raphaelitism for an art that would be for all men. 'The old art of trick and tradition', he argued, 'had no language but for the connoisseur; this natural art speaks to all men: around it daily the circles of sympathy will enlarge; pictures will become gradually as necessary to daily life as books . . .'[3]

Direct, immediate appreciation of 'this natural art' was not always possible for Ruskin, since he was not a contributor to magazines. But his letters to *The Times* on Pre-Raphaelitism had been successful enough for him to wish to repeat them. In the summer of 1854, while artistic London was full of the scandal of Effie's departure, Ruskin had written again to the newspaper. His two letters concerned another

member of the Pre-Raphaelite Brotherhood, William Holman Hunt, who was on distant but mutually appreciative terms with Ruskin. Hunt had sent *The Light of the World* and *The Awakening Conscience* to the Academy. Of the first, Ruskin wrote,

> Standing by it yesterday for upwards of an hour, I watched the effect it produced upon the passers-by. Few stopped to look at it, and those who did almost invariably with some contemptuous expression, founded on what appeared to them the absurdity of representing the Saviour with a lantern in his hand. Now, it ought to be remembered that, whatever may be the faults of a Pre-Raphaelite picture, it must at least have taken much time; and therefore it may not unwarrantably be presumed that conceptions which are to be laboriously realised are not adopted in the first instance without some reflection . . .[4]

Evidently enough, the picture required elucidation, which Ruskin then proceeded to give, concentrating on the symbolic iconography. Of Hunt's second picture he did much the same. 'I am at a loss to know how its meaning could be rendered more distinctly, but assuredly it is not understood. People gaze at it in a blank wonder, and leave it hopelessly . . .'[5] Ruskin was discovering that even the 'natural art' of Pre-Raphaelitism was often obscure to its audience; and for this reason his *Academy Notes* is often simply exegetical as well as critical.

Ruskin published *Academy Notes* annually between 1855 and 1859, and once more in 1875. The origin of the pamphlet, within Ruskin's own work, is in the *addenda* to the second edition of the second volume of *Modern Painters*, which was written in 1848. In this section of his book Ruskin commented on some works in the Royal Academy exhibition of that year which 'either illustrate, or present exceptions to, any of the preceding statements'.[6] Works by Linnell, Mulready, Stanfield and others are then examined within the context of the main theories of the book. The rise of Pre-Raphaelitism demanded publicity for paintings more important than these; and the effect of his letters on Hunt gave Ruskin the idea of a pamphlet published at the beginning of May every year that would pick out the best paintings and make claims for the art that he supported. No doubt this form of criticism appealed to the campaigner and reformer in Ruskin: that side of his which made a contemporary, in the *Saturday Review*, describe him as 'a Luther in the world of art, protesting against the errors of its teachers, and claiming for all the right of individual reading and understanding of its scripture — the book of Nature — unshackled by the arbitrary interpretation of others . . .'.[7] But it also appealed — and

this is not the same thing — to Ruskin's satisfaction in wielding his
personal authority. Convinced that his own abilities were superior to
those of other reviewers, he found a way of stating that his judgements
were above debate. 'Twenty years of severe labour, devoted exclu-
sively to the study of the principles of Art, have given me the right to
speak on the subject with a measure of confidence,' he claimed.[8] But
the growing number of his enemies suspected that he considered
himself infallible.

In comparison with other art criticism of the day, Ruskin's pamph-
let is splendid. In no way 'impartial', it carried the banner for the new
realist painting of the Pre-Raphaelite school. It divides artists into
those who belong to the movement, those who by greater effort
might join it, and those who are irremediably benighted. The first
Academy Notes, of 1855, opens with a hostile notice of a Pre-Raphaelite
enemy, Maclise, who had submitted *The Wrestling*, an illustration of
As You Like It. Ruskin commented, 'Very bad pictures may be divided
into two principal classes — those which are weakly and passively bad,
and which are to be pitied and passed by; and those which are energeti-
cally or actively bad, and which demand severe reprobation . . .'[9]
Maclise's picture fell into the second class. It was nothing new for art
reviewing to be so completely dismissive of paintings, by Academi-
cians or not. But Ruskin's moralism was new: so was his professional-
ism, for he assumed an understanding of art far above that of its actual
practitioners. Confidently, Ruskin's pamphlet prefers a marine scene
by J. F. Lewis to the Maclise picture, then passes to Sir Charles
Eastlake. Ruskin had learnt much since the time, just before his
engagement, when he had reviewed Eastlake's *Materials for a History of
Oil Painting*, and had respectfully applied himself to understanding
Renaissance ways with pigment. Now, looking at Eastlake's
Titianesque *Beatrice*, Ruskin remarked cuttingly, 'An imitation of the
Venetians, on the supposition that the essence of Venetian painting
consisted in method: issuing, as trusts in Method instead of Fact
always must issue, — in mere negation'. Ruskin found that Eastlake
'ends, as all imitators must end, in a rich inheritance of the errors of his
original, without its virtues'.[10] There was much justice in these
remarks. But Sir Charles Eastlake — and Lady Eastlake, who soon
would seek revenge — had no doubt that this was a personal attack:
especially since Ruskin blandly commended another portrait, scarcely
a better painting, by a Ruskin family friend, George Richmond, of a
man much admired by the Ruskin family, Sir Robert Inglis.

Academy Notes is much dependent on concepts, not of failure and
success, but of good and bad. A minor painting with minor intentions

might be good: the Lewis is better than the Maclise. Painters who have good in them can be corrected and put on the right path. J. R. Herbert and William Dyce, both artists of the high church, are now examined. Ruskin places Herbert's *Lear recovering his Reason at the Sight of Cordelia* in the category of 'passively bad' paintings and recommends that he 'limit his work to subjects of the more symbolic and quietly religious class, which truly move him'.[11] For Dyce (who, one recalls, had made Ruskin look again at his first Pre-Raphaelite painting, Millais's *Christ in the House of his Parents*), Ruskin had a dismissive comment. His *Christabel* was 'an example of one of the false branches of Pre-Raphaelitism, consisting in imitation of the old religious masters. This head is founded chiefly on reminiscence of Sandro Botticelli . . .'[12] Ruskin had always preferred contemporary realism in Pre-Raphaelitism. For that reason, probably, he gave surprising praise to Millais's *The Rescue*. This painting of a fireman taking a child from a blazing house was Millais's first appearance since he showed *The Order of Release* in 1853. It was also the first time that he had showed since Effie had left Ruskin. Perhaps Ruskin was, by praising this work, attempting to show his impartiality. For one cannot imagine that in a previous year he would have said, as he now did, that 'the execution of the picture is remarkably bold — in some respects imperfect' while defending this with the argument that 'there is a true sympathy between impetuousness of execution and the haste of the action'. His final judgement was that *The Rescue* was 'the only *great* picture exhibited this year; but this is *very* great. The immortal element is in it to the full'.[13]

In Ruskin's criticism of Millais, the 'greatness' of the picture is not elucidated. Neither here nor elsewhere did Ruskin give to contemporary artists the full power of his writing. There is no comparison between the sweeping rhetoric of *Modern Painters* and the clipped remarks in *Academy Notes*. In truth, Pre-Raphaelitism did not mean to Ruskin what Turner meant to him. In 1855 it was already beginning to fail his hopes for the movement. One picture this year was an indication that the future of English art might not lie with Pre-Raphaelitism. It was Frederick Leighton's *Cimabue*, the picture of the year to most people. William Richmond, George's son (who, then a schoolboy, had an ambition to become a Pre-Raphaelite) thought it 'so complete, so noble in design, so serious in sentiment and of such achievement, that perforce it took me by the throat'.[14] Rossetti wrote to William Allingham about the art politics of this hugely successful painting: 'The R.A.s have been gasping for years for someone to back against Hunt and Millais, and here they have him.'[15] Millais must have looked

nervously at this painting. He had already heard of Leighton: Thackeray had told him that there was a young artist in Rome who would be President of the Royal Academy before him. And we can imagine that Millais had felt some trepidation when opening *Academy Notes*. But Ruskin still awarded him his best praise, and was in comparison tepid about Leighton's picture. It had not

> . . . care enough. I am aware of no instance of a young painter, who was to be really great, who did not in his youth paint with intense effort and delicacy of finish. The handling here is much too broad . . . It seems to me probable that Mr Leighton has greatness in him, but there is no absolute proof of it in this picture . . .[16]

The first number of *Academy Notes* must have sold more copies than Smith, Elder had expected: for there was a second edition and then a third. To this third edition Ruskin added a supplement, in which he discussed or mentioned other paintings in the exhibition (none of them distinguished) which had been pointed out to him by friends — Rossetti was one — or which he had noticed on subsequent visits to the galleries of Burlington House. However, most of this supplement is taken up by a reply to the *Globe* newspaper, which had criticized some of Ruskin's remarks about local colour in a painting by David Roberts. Ruskin now stated, ominously, that in writing against a painting he never said 'half of what I could say in its disfavour; and it will hereafter be found that when once I have felt it my duty to attack a picture, the worst policy which the friends of the artist can possibly adopt will be to defend it'.[17] In the face of such arrogance, what would any artist's friend do? People now began to openly dislike Ruskin. Ford Madox Brown, to whom Ruskin talked in Rossetti's studio, and who answered, 'Because it lay out of a back window' when the critic asked him why he had chosen to paint Hampstead Heath,[18] now began his lifelong hostility, as did some others, especially if they had been noticed in *Academy Notes*. For Lady Eastlake, Effie's confidante and the wife of the painter whose work had been so denigrated, the time seemed right for an attack on the man she had come to loathe. She began to consider the whole of Ruskin's output, in preparation for a refutation. In the winter of 1855 she laboured over this extremely lengthy article. It was finished at the end of January 1856, after the third volume of *Modern Painters* had been published, and appeared anonymously in the *Quarterly Review* in March of that year.

Lady Eastlake's hate-filled article was the most complete and damning account yet given of Ruskin's writings and his position within the world of art and letters. Unfortunately, it is not illuminating. 'Mr

Ruskin's intellectual powers are of the most brilliant description; but there is, we deliberately aver, not one single great moral quality in their application.' And again, 'Mr Ruskin's writings have all the qualities of premature old age — its coldness, callousness and contradiction.' And again, 'his contradictions and false conclusions are from the beginning those of a cold and hardened habit, in which no enthusiasm involuntarily leads astray, and no generosity instinctively leads aright . . .'. And again, of *Academy Notes*, 'Nothing can be more degradingly low, both as regards art and manners, than the whole tone of this pamphlet, calculated only to mislead those who are as conceited as they are ignorant.'[19] Ruskin was not much troubled by this attack: he only observed, in the preface to his next year's pamphlet, that he, unlike Lady Eastlake, signed his name to his criticisms.

★ ★ ★ ★

Early in 1855 the dealer Ernest Gambart had approached Ruskin with a commercial proposition. Gambart was in possession of twelve Turner plates. His plan was to publish them in an expensive limited edition with an explanatory text by the author of *Modern Painters*. This was the origin of the book we now know as *The Harbours of England*. Ruskin might not have agreed to lend his pen to such a scheme. But it offered him a rare and possibly unique opportunity to complete a part of Turner's own work with one of the artist's own collaborators. For the plates were in the charge of the engraver Thomas Lupton, and the project was a revival of a plan he had made with Turner, as long ago as 1825, to issue a series entitled *The Ports of England*. Ruskin was further tempted by Gambart's offer of two fine Turner drawings in way of payment. The bargain was made: and he wrote the descriptions of plates of Sandwich, Sheerness, Falmouth and other seafaring towns while recuperating from illness at Deal in the spring of 1855.

The Harbours of England* was not published until the next year, a month or so after the third and fourth volumes of *Modern Painters* had appeared. Not surprisingly, it has a number of affinities with them. It also harks back to the sections on sea painting in the first volume, while its remarks on the 'Dover' and 'Scarborough' bear on much that is said of Turnerian topography and composition in the fifth and final volume of Ruskin's great exposition of landscape art. *Harbours*, the only book that Ruskin wrote to fulfil a commission, is both serious and an occasional piece whose intention is to captivate the reader. It contains magnificent things, thoughts that could only be Ruskin's, and sentences that he alone could write. However, some of the com-

mentary is almost light-hearted. In such a text one might overlook references to Ruskin's most personal experiences of Turner. Yet they are there. At one point, for instance, he mentions the studies of shipping that he had found in one of Turner's drawers. Ruskin had come upon these sheets after the artist's death, on one of the occasions when he had been to Queen Anne Street to look through the quantities of art that had been left there. Of these expeditions he was mysteriously silent: not until old age, and then in the delirium of his madness, did he speak of what he had found. Nor did he ever write directly of how he had searched the house. Only occasionally, in the privacy of his diary, do we stumble on the memory of his thoughts when he uncovered *The Fighting Téméraire*, lurid amid the dust and darkness of the abandoned studios. In *The Harbours of England*, the *Téméraire* is clearly and confidently judged as the last of Turner's paintings 'executed with perfect power'.[20] Ruskin thought more about the picture than that: *The Harbours of England* reminds us — as *Modern Painters* does not — how Ruskin was reluctant to relate all he knew about the painter he most admired.

When *The Harbours of England* was published Ruskin might have been gratified to read in the *Athenæum* that

> Since Byron's 'Address to the Ocean' a more beautiful poem on the sea has not been written than Mr Ruskin's preliminary chapter. It is a prose poem worthy of a nation at whose throne the seas, like captive monsters, are chained and bound. It is worthy of the nation of Blake and Nelson, of Drake and Howe, and true island hearts will beat quicker as they read . . .[21]

Ruskin's patriotism was not as simple as this, however, and much else in this favourable review would have annoyed him. From about the time of *Harbours* Ruskin (unlike his father, who still kept a book of press cuttings) paid less and less attention to his reviews. The history of his relationship with the press becomes increasingly an account of misunderstanding. But Ruskin probably felt benevolently towards one review which appeared in 1856. It was by two young men whom we may count not only as admirers but as followers of Ruskin. William Morris and Edward Burne-Jones, recent graduates of Exeter College, Oxford, had written enthusiastically in the *Oxford and Cambridge Magazine* about the third volume of *Modern Painters* in reply to Lady Eastlake's hostilities in the *Quarterly Review*. Out of a slough of conventional criticism, the authors wrote, 'this man John Ruskin rose, seeming to us like a Luther of the arts'.[22] This is the second time we have encountered the phrase; and it is to be found elsewhere in the late 1850s. It is as though those who valued the temper of Ruskin's

criticism were hard put to find a parallel, though they wanted to make a mighty and valiant comparison. Those without an extravagant admiration for Ruskin, a class which would include most regular reviewers, did not know what to make of him. But they did not lack reports of his current opinions. In 1856 much of Ruskin's thinking was expressed in lectures rather than in books; in addresses to the Working Men's College; to workmen employed in the building of the Oxford Museum; and in a lecture at the Society of Arts on 'The Recent Progress of Design as Applied to Manufacture'. These were fully reported in newspapers.

★ ★ ★ ★

From May until October of 1856 the Ruskins were on the Continent. This was the last time but one that they travelled abroad together. The tour itself was not particularly memorable. It is most marked by the cementing of the unusual friendship with Charles Eliot Norton, who for many years afterwards received some of Ruskin's most intimate letters. The Ruskins's outward route from Calais was familiar: they were met there by Couttet, who escorted them along the old road from Amiens to Senlis, to Rheims, and thence to Basle. They then spent nearly two months in the lakes of northern Switzerland and the Bernese Oberland. There Ruskin's parents rested, while he began work on a project that had been in his mind, vaguely, for some years. This was to be a Swiss book. Ruskin had much feeling for the subject, but he could not decide how to express himself. The most obvious course was to write a history of Switzerland. He had recently been rereading Sismondi: and one can imagine a romantic Swiss version of his *Histoire des républiques italiennes*. But Ruskin was more attracted by the idea of a portfolio publication. This would consist of engraved drawings of Swiss towns with a commentary. The inspiration for such a work was clearly Turnerian. The format would no doubt have been based on that of *The Harbours of England*. Perhaps the thought of matching his own drawings against Turner's example dissuaded Ruskin from his project. In any case, nothing came of it.

Evidence of Ruskin's work on the history and topography of Switzerland is to be found in some annotated books, in a handful of drawings — sketchy, not at all suitable for engraving — and in a new diary. This vellum-covered volume was opened when Ruskin left England in May: he used it for journal and notes for the next two years and more. It gives the impression of desultory and sporadic labour. Ruskin later told Lady Trevelyan that he had done little more than ten

days' work all summer. He was no doubt tired after completing the
middle volumes of *Modern Painters*. It was wearisome to have to look
after both his parents and Anne Strachan, who had travelled with
them. As usual, Ruskin indulged his father. John James showed little
interest in the Swiss illustrations. Once more he asked his son when
Modern Painters would be completed. This is probably why the party
now moved on to Geneva and Chamonix, the original homes of the
book. Here Ruskin resumed geological and cloud studies. But he also
had to conduct family outings. It was on a steamer in Lake Geneva, at a
cabin table 'covered with the usual Swiss news about nothing, and an
old caricature book or two' that Charles Eliot Norton reintroduced
himself to the party.[23] In his present, rather bored mood he found
Norton interesting. He was both eager and polite; an American cer-
tainly, but a gentlemanly American. Norton talked of literature and
art, as he imagined he was obliged to do, and the Ruskins listened to
him. Slightly puzzled that he had not been engaged in debate, Norton
wrote of his new acquaintance: 'He was apt to attribute only too much
value to a judgement that did not coincide with his own.' Ruskin had
let him talk on, feeling himself an older and wearier man. For his part,
Norton had decided that Ruskin was 'one of the pleasantest, gentlest,
kindest, and most interesting of men', adding, however, 'He seemed
to me cheerful rather than happy. The deepest currents of his life ran
out of sight.'[24]

We will come upon these 'deeper currents' in the vellum diary.
Norton was right to realize that they existed. But he would never give
them enough credit. He always afterwards relied too much on his first
impressions of Ruskin. He believed him directionless, a man he could
himself direct. Norton had attached himself to Ruskin at a watershed
in the critic's life. Ruskin was thirty-seven now, just at the beginning
of the crisis of his middle age. In Switzerland he was affected with
indolence and something near to depression. He was slightly indeci-
sive, in a state of not knowing, of waiting to be persuaded. Neither
people nor literature greatly affected him: and in Switzerland there
was no art to be seen. He met Harriet Beecher Stowe this summer: he
did not admire *Uncle Tom's Cabin*, and was not impressed by its
author. He read George Sand novels, one after the other, then read
them aloud to his mother for entertainment. He realized they were
bad, but what of that? Ruskin raised himself from his lethargic mood,
or at any rate attempted to combat it, by considering his father's age
and energy. John James was now seventy-one. Ruskin, considering
how his father had passed the three-score years and ten of the biblical
life span, decided to calculate how the 'perfect term of human life'

applied to himself.[25] This was in Geneva, on the Sunday morning of 7 September, in the same town — and perhaps on the way to the same chapel — where he had knelt to pray and vowed to write the vindication that became *Modern Painters*. The sums in the diary revealed that Ruskin could expect to live for 11,795 days. Thenceforward he wrote the diminishing figures in his daily entry, not abandoning the practice until (day 11,192) 8 July 1858: significantly, perhaps, at a time of religious uncertainty.

Quietly, (he did not announce his 'signal-word or watchword' until 1876[26]) Ruskin now replaced the *Age quod agis* on his father's coat-of-arms with a new personal motto. It was the single word 'Today'. He thought of it always with a corollary, the verse from the gospel of St John, 'The night cometh, when no man can work'. On the way home from Switzerland Ruskin gathered his forces, made sure to take notes in the Louvre, began to make new plans. Back in England, the diary suddenly indicates how full was his social and professional life. On 21 October (day 11,753) is the entry 'visit Morris and Jones'.[27] Guided no doubt by Rossetti, Ruskin had visited his young Pre-Raphaelite admirers at their lodgings in Red Lion Square. Edward Burne-Jones was simply overjoyed, especially since Ruskin proposed to call there regularly on his Thursday visits to the Working Men's College: 'Tomorrow night he comes again', wrote Burne-Jones, 'and every Thursday night the same — isn't that like a dream? think of knowing Ruskin like an equal and being called his dear boys. Oh! he is so good and kind — better than his books, which are the best books in the world.'[28] Ruskin made many other visits that autumn. We find him at the Prinseps's, where he 'heard sad report of poor Watts',[29] with Furnivall, with John Lewis; and dining at Gambart's with the celebrated French *animalier* Rosa Bonheur. In such company Ruskin was relaxed and garrulous. One might imagine him at ease with the world, were it not that the shadow of the Turner bequest had once again been cast over his mind. The National Gallery had organized a small exhibition of Turner's oil paintings. This was the first public appearance of any of the work that had been left in Queen Anne Street. The exhibition had a dramatic effect on Ruskin, with consequent damage to his health. By 28 November (day 11,716), he was ill. The diary notes 'curious illness attacking me in the afternoon of Saturday, before dinner, with shivering, weakness, loss of appetite, as if the commencement of a serious illness; feverish night with heat and quick pulse, but perspiration. Heavy headache and disgusted, incapable feeling all Sunday, going gradually off towards evening'.[30]

★ ★ ★ ★

The involved story of Ruskin's dealings with the Turner bequest is examined below. For the moment we should look at a book that was written in this winter of 1856-7, *The Elements of Drawing*. The book issues in part from Ruskin's Turner studies, in part from the activities at the Working Men's College; but its procedures come from Ruskin's correspondence with his admirers. Since the mid-1840s he had taught drawing by letter. The first of his pupils by correspondence were Henry Acland and the daughter of his Christ Church tutor Walter Brown: the most recent was Harriet Beecher Stowe's daughter. Whole sequences of these letters relating to drawing have survived, and such collections (lovingly mounted in albums, often enough) throw some light on *The Elements*. For of course they show how impractical and laborious such a method of instruction must be. They also indicate that the teaching was not progressive: it always returned to first principles. *The Elements of Drawing* reflects the way in which these lessons often ended in discouragement. The book was designed to relieve Ruskin from the many demands that were made on him, now that he had a class. It also had a remedial purpose. It opposed the numerous drawing manuals that demonstrated quick ways of composing picturesque landscape. In one way, the book is as near as we know to a Pre-Raphaelite manual. But its insistence on painstaking drawing from nature still meant only exercises. That they were of stones, flowers and leaves was refreshing. But they would not have taken a pupil very far. Certainly there is no intention of helping a reader of the book to become an artist. Ruskin was a better teacher (as all drawing masters must be) when he sat down side by side with someone. Then his instruction could be both efficient and inspiring. But he could not project teaching into independence and individual style. Here was one aspect of his confused and contradictory relations with Rossetti — and also with Burne-Jones, for the younger artist was now also brought into the Working Men's College. They were at one and the same time Ruskin's comrades, his colleagues and his pupils. But neither of them had anything to do with *The Elements*, and it is doubtful whether either of them could have performed its exercises. Ruskin still badgered Rossetti to correct his drawing. But he never criticized Burne-Jones, whose art was dependent on Rossetti's: not now, when Burne-Jones was in his novitiate, nor ever afterwards.

Given the principles of *The Elements of Drawing*, it is strange that Ruskin brought Rossetti and Burne-Jones to teach at the Working Men's College. He must have given them the duller or the quirkier students. He could not have let them plant bad habits or bohemian ways in the aspirant artist-workmen who were destined for duty in Denmark Hill. This is only one of many ways in which his notion of a

democratic art fell down. After their dinner at Gambart's, Rosa
Bonheur spoke of Ruskin from the point of view of a French profes-
sional artist. 'He is a gentleman,' she said, 'an educated gentleman; but
he is a theorist. He sees nature with a little eye — *tout a fait comme un
oiseau*.'[31] She had seen that, being a gentleman, he was an amateur; and
that his social position had made him insensitive to the ambitions of
easel painting. This combination infuriated a critic nearer home. Rus-
kin's theories were bitterly scorned by an art educationalist who was
near to Pre-Raphaelitism. William Bell Scott was a painter who was
Principal of the School of Design at Newcastle. Despite their common
friends at Wallington he and Ruskin could scarcely be polite to each
other, let alone agree about art. Bell Scott visited the Working Men's
College drawing classes and was appalled.[32] He too taught working
men. He knew how to encourage artists to make paintings. Ruskin, he
was convinced, did not. And it is true that Ruskin was of most use
when talking to women amateur water-colourists. Many technical
matters confirm this judgement. One is the problem of perspective. In
1859 Ruskin added *The Elements of Perspective* to *The Elements of
Drawing*. This was supposed to explain and demonstrate eternal rules.
But the problem for a realist painter in 1859 was that the more 'correct'
his perspective, the more his pictorial space looked like Renaissance
space, perhaps even like that of the despised Raphael. This is the kind
of painterly problem Ruskin did not enter. *The Elements of Perspective*
was not a help to contemporary painters. Significantly, it is based on
the exercises in Euclidean geometry that had pleased Ruskin when he
was a Christ Church gentleman-commoner.

In these earliest days of avant-garde culture, it is not surprising to
find great optimism for the future of art combined with the collapse,
or confusion, of traditional teaching practices. We would also expect
to find the most variable assessments of the worth of new art. Ruskin's
comments in *Academy Notes* show how alert he was to the merits of
contemporary painting. But these detached paragraphs, the most
direct art criticism he ever wrote, are scarcely important when we
think of the great flood of experience that formed his sensibility. That
experience was not modern: it was 'of the old school'.[33] It was also
provincial. As *Academy Notes*'s additional observations on the 'French
Exhibition' remind us, there is little profit in reading Ruskin on
modern foreign painting. He rather disliked German art, the first
nineteenth-century continental school he was aware of. He would not
come to dislike the Nazarenes until he looked at them in 1859, but he
knew before that there must be something wrong with the school: had
not John Murray asked him to write a book on them rather than on
Turner? His attitude to French painting was negligent. He never in his

life visited the *Salons*, the Parisian equivalent of the Royal Academy exhibitions. In Pall Mall, Gambart showed French paintings every year from 1854. Ruskin occasionally noticed them. In these years he most admired Edouard Frère, for his sentiment and his invaluable record of peasant life. French peasants were important to Ruskin, and his distrust of new French art was usually mixed with his attitude to vicious republican Paris. He loved France for its provinces and their architecture. In 1857, giving an address at the Working Men's College, he spoke of French 'manners' and cathedrals: these indeed were his real interests. But he also knew a surprising amount of modern French literature. In a few years' time, with help from Swinburne, he would acknowledge that there was talent in Baudelaire. He could not be so tolerant about art. Paintings always made him angrier than books: they as it were blinded him; and no help from Swinburne in the next few years could make him understand the French background of the most challenging artist he encountered in the years after Pre-Raphaelitism, who was of course Whistler.

CHAPTER THIRTEEN

1855–1858

Not far from the Royal Academy of Arts lay the Olympic, a public house with some music hall entertainment. Here, in June of 1855, George Butterworth had spent the evening after a visit to the annual exhibition. In his pocket was a copy of *Academy Notes*. Butterworth was a young carpenter. He had come to London from Lancashire and was living in lodgings in south London. He had enrolled at the Working Men's College art classes the previous year. His diary tells us much about the life of an artistically inclined young workman who had come under Ruskin's influence. One of its entries records the birth of the idea of the *Notes*:

> Went up to see Mr Ruskin who I heard had been to the Academy once more to look at Millais's picture, and had come back too unwell to go to college — he however would see me but for a few minutes as he said he had something on his mind which he intended to have [illegible] some criticisms of the pictures at the Academy which he intended to have [illegible] and sold at the doors along with the catalogues — the idea so tickled his fancy that he laughed aloud, he was in such good spirits that I not only got him to have two of the Turners home to work upon but his permission to take out of the frame the Carisbrooke . . .[1]

Butterworth framed for Ruskin and therefore had a good personal experience of the Denmark Hill collection. He also gave Ruskin woodworking lessons: the critic 'wanted it for exercise to keep him from thinking'.[2] Thus Butterworth came to carry away wine, money and pictures from Denmark Hill. Perhaps it is true, as Ruskin believed, that he was feckless. *Præterita* speaks darkly of him, or rather of 'the deadly influence of London itself, and of working men's clubs as well as colleges'.[3] When Butterworth's diary notes how he and a friend, another carpenter, had spent a Sunday afternoon discussing designs for an altar-piece and then reading aloud from the Working Men's College pamphlet of *The Nature of Gothic*, we might recognize a workman-artist cast in the perfect mould of the Ruskinian labourer. But the instinctive and relentless high tone of Ruskin's contact with the world prevented him from understanding the relaxations of working-class youths, particularly if they were artists. To one such,

J. J. Laing, he wrote at this time, 'The great lesson we have to learn in this world is to *give it all up*.'[4] Butterworth was too eager to experience the world to command Ruskin's good opinion. He felt it presumptuous in the young man to go on a painting holiday in Wales, or indeed to visit in his native Middleton the Turner patron John Hammersley. Butterworth thought to go up to Denmark Hill and please Ruskin with Hammersley's tales of the painter. But he was in error. He had mistaken his place.

At the Working Men's College, Butterworth had a slight acquaintance with George Allen, another northerner. Allen, a native of Newark, was already a highly qualified joiner, good enough to attract the best employment that his trade offered. Butterworth wrote in his diary that he had seen how Ruskin had an especial interest in him. 'I think he intends to make Allen into something.'[5] This indeed was so. George Allen's new career as Ruskin's *factotum* and, eventually, his publisher, began at the Working Men's College. In old age he looked back on his other opportunities with particular nostalgia. 'In the early days of the renaissance of industrial art,' he told J. W. Mackail, 'when the movement was first projected, Dante Rossetti asked me to join him and William Morris in the practical carrying out of their plans . . . I was obliged to forgo all thought of doing so having just then accepted Mr Ruskin's offer . . .'[6] In fact, Allen had himself made an offer which bound him to Denmark Hill. On Christmas Day of 1856 he married Hannah, Margaret Ruskin's maid and George Hobbs's sister. Ruskin now set Allen to learn new skills. He paid Thomas Lupton and J. H. Le Keux to teach him mezzotint techniques and line engraving. Le Keux was from an old family of engravers. Lupton had worked for Turner. Ruskin's intentions were obvious. In this way he established a direct artisanal link between Turner's work for engravers and the superb plates that illustrated his own books.

Thus, as Ruskin sensed his disillusionment with the Working Men's College, he more and more used it to recruit his personal labour force. Partly to mock the Christian Socialists, he now occasionally talked of a 'protestant convent', whose inmates would be engaged in art work and supervised by himself.[7] In practice, this meant that artists became Denmark Hill servants of a special sort. To Allen and Butterworth (who was sporadically employed until the '80s) we must now add the names of William Ward, Arthur Burgess and John Bunney. All three came from the Working Men's College and remained in Ruskin's employment until they died. Burgess was a wood-engraver who had been, according to the obituary notice Ruskin wrote, 'variously bound, embittered and wounded in the ugly prison-house of London labour'.[8] Ward had been a clerk in the City. Ruskin turned him into a

Turner copyist and drawing master, using him to teach pupils he had
no time for. Bunney also was a clerk. He was employed by Smith,
Elder. His contact with Ruskin therefore took him out of the commer-
cial side of the firm and into the direct artistic employ of its most
celebrated author. It was a foreshadowing of Ruskin's eventual deci-
sion to take all his publishing into his own hands.

★ ★ ★ ★

Letters of instruction and encouragement to these men are numerous.
Ruskin had been teaching people to draw by letter since the time of the
composition of the first volume of *Modern Painters*. It was a practice he
maintained all his life. Recipients of such letters must be numbered in
dozens, and some of these pupils must have received up to a hundred
separate missives. A feature of these letters is their relative uniformity.
Little or no account is taken of an individual's artistic predilections,
nor much of his or her relative advancement. It was all the same to
Ruskin: one and the same will was impressed on all. Of course, it was
only rarely that an independent professional artist would seek instruc-
tion from him. This helped Ruskin to maintain the illusion that the
same art should be made by everybody. Early in his acquaintance with
Louisa, Marchioness of Waterford, he declared 'I am not surer of
anything I know, than of this, that there is no real occasion for the
gulph of separation between amateur and artist.'⁹ It was a radical,
mistaken view, one of a number of misconceptions that lay behind
The Elements of Drawing.
 What purported to be a timeless book turned out to be utterly and
inescapably of its day. How could one expect any book of Ruskin's to
be anything but individual, or to belong to any time other than the
months in which it was written? *The Elements of Drawing* comes from
such concerns as his classes in Red Lion Square, his love of detail in
engravings after Turner, and his correspondence with such eager
amateurs as the Marchioness of Waterford. Embedded though it is in
this tiny corner of the history of drawing, the book still has a signifi-
cant position in the history of that sub-branch of art education which is
carried by drawing manuals. Such manuals belong to the post-
Renaissance period. *The Elements* is the last one to have relevance to
living fine art, and its terminal position is what confers on it a poignant
importance. For there is no such thing as a drawing manual within the
avant-garde tradition. Nor is such a thing quite conceivable. All
manuals after *The Elements* have been either academic or vulgar in
nature. Ruskin's book is in fact a witness of how fragile a period style
his realism was. It also reminds us of the problems of realism, how it

was troubled by compositional design and had difficulty in continuing the landscape tradition. To another young lady artist Ruskin explained, 'In general, persons who have drawn landscapes have merely blotted — and not drawn anything. And to them the book must imply the entire overturn of all previous thought or practice.'[10] In fact, anyone with serious pictorial ambitions would find in *The Elements* all the problems of becoming a modern painter, and few of the solutions. For schoolgirls and copyists, however, it had its uses. It provided them with exercises.

In the new year of 1857 there was demand for Ruskin the public man. We find him addressing the Architectural Association, then giving a lecture at St Martin's School of Art; making speeches to the committee for a memorial to the painter Thomas Seddon; and discussing plans with the council of the Arundel Society. More important than these activities was the matter of Turner's gift of his work to the nation, for the executors and lawyers had now completed their deliberations over Turner's simple and generous wishes. The question of Ruskin's resignation from his executorship was once more raised. But only a mind as narrow as Lady Eastlake's could still entertain the view that such mechanical duties should have been more Ruskin's concern than the vast spiritual exercise of which *Modern Painters* is the record. Four volumes of that book, and numerous miscellaneous writings besides, were by now the evidence of that endeavour. For those few who read him attentively, it must have seemed that Ruskin's effort to understand Turner was not distinct from his wish to understand everything about the world; its light and knowledge, its destiny. At the same time, however elevated Ruskin's conceptions, he moved in the circles of politics and administration. His bitter remark in the preface to the third volume of *Modern Painters*, that Turner's countrymen had buried 'with threefold honour, his body in St Paul's, his pictures at Charing Cross, and his purposes in Chancery' — a comment quite evidently directed at those who had charge over Turner's *œuvre* — announced that he would turn his attention to public artistic policy.[11]

Disregarding the niceties of an approach to the National Gallery's trustees, within whose purview Turner's legacy now belonged, Ruskin wrote to *The Times*. His letter offered to sort and arrange the whole of Turner's drawings and sketches: all his work, that is, not done in oil on canvas. Neither the trustees nor Sir Charles Eastlake, the National Gallery's director, responded to this letter. Ruskin then repeated his offer by approaching the newly elected Prime Minister, Palmerston. This proved effective. However, more than three months

were to elapse before Ruskin received an official invitation to arrange
the drawings. During this time (and repeating the strategy of *Academy
Notes*) Ruskin issued a rival catalogue to the brief official publication
that accompanied the first exhibition selected from the Turner
bequest. This is known as *Notes on the Turner Gallery at Marlborough
House*. Like *Academy Notes*, it comments on certain paintings in an
exhibition not chosen by Ruskin himself. These were all oils, for the
drawings were still unsorted and, indeed, not yet unpacked. This
catalogue is the shortest single work by Ruskin on Turner, yet con-
tains a wonderful amount of his understanding of the artist. One
notices, first, how much better this pamphlet is than *Academy Notes*.
Its judgements are surer, less wayward, more considered: they are also
loving. One is astonished by the set-piece with which it ends, on the
Téméraire of 1842. And everywhere, as the trustees of the National
Gallery must have seen, there is a complete assurance in Ruskin's
personal knowledge of the artist and in his ability to discriminate
between his works.[12]

This was in early January 1857. Ruskin was soon worrying that he
had made the wrong moves in his negotiations with the National
Gallery. He had perhaps sought too high a level, through over-
confidence and through disdain for Eastlake. An appendix to the
Marlborough House *Notes* had made challenging remarks to the effect
that 'the national interest is only beginning to be awakened in works of
art': this could have irritated the trustees.[13] When, therefore, they
invited him to make a trial selection, the framing to be done at his own
expense, he was pleased to agree. The small private exhibition he now
prepared was cleverly devised. Ruskin took one hundred drawings to
illustrate an imaginary tour (but to places he and Turner knew well)
from England up the Rhine, through Switzerland to Venice and back.
The catalogue he wrote to accompany the show is a curiosity. It is
marked 'for private circulation only' and was directed towards the
trustees, whom Ruskin now addresses as though they were children.[14]
One point of his selection was to demonstrate how much of his
expertise was topographical. The ability to identify Turner's sites
would be crucial to the cataloguing of the collection. But his proposals
for framing, preservation and presentation were also exemplary. He
had his own private work-force, in the persons of George Allen and
William Ward. In short, the trustees could hardly refuse him. There
was no possibility of Ruskin being a happy colleague of Sir Charles
Eastlake. But one can work in a museum without speaking to its
director, and Ruskin struck some kind of relationship with the keeper
of the collections, Ralph Wornum. This was not easily managed:

Wornum had attempted to persuade Ruskin that Lady Eastlake was not the author of the attack on himself and Turner in the *Quarterly Review*. But they got on well enough, for Wornum knew that he could not have done the work himself.

Ruskin had been right: the legacy required his special knowledge and commitment. Turner was not the first artist to have had an obscure and private career. But he was the first whose art had to be brought into the national heritage by a critic working in consort with a national museum. Ruskin was more aware of the implications of this situation than were his temporary colleagues. And thus, as the work he now began gave him a yet deeper feeling for Turner, it also alienated him from the routines of committees and administration, meetings and deliberations, that were part of the growing professionalism of museums and exhibitions.

Ruskin's involvement with the Turner bequest was much interrupted. *The Elements of Drawing* was concluded in the spring: some of it was written concurrently with the Turner catalogues. In *The Elements* there are traces of Ruskin's current work on Turner, just as in the Turner catalogue we will find addresses to students. The 1857 number of *Academy Notes* now had to be written. It is a little shorter than its usual length and is dominated by Ruskin's criticism of Millais's *Sir Isumbras at the Ford*. The critic objected to the new fluidity of Millais's application: 'The change in his manner, from the years of "Ophelia" and "Mariana" to 1857 is not merely Fall — it is Catastrophe; not merely a loss of power, but a reversal of principle.'[15] Ruskin added some kinder remarks. His beautiful iconographical explanation of the picture is a little akin in tone to what he had said of Turner in the Marlborough House *Notes*. Millais was of course unappeased by Ruskin's suggestive remarks about his themes. The brevity of the rest of *Academy Notes* almost made it appear that the pamphlet had been issued with the sole purpose of condemning his painting. Ruskin's relations with the Pre-Raphaelite movement as a whole were, as usual, difficult. A further cause of friction and misunderstanding was now provided by the increased number of independent exhibitions. This year an exhibition was held in Fitzroy Square. It was in effect the only Pre-Raphaelite group show. Ruskin might have made the exhibition more successful: but since the organizing force behind the show was Ford Madox Brown, he had to keep his distance. When he helped with the memorial exhibition for Thomas Seddon he was good at raising money for the widow. But he was more prominent personally than other friends of the artist had wished. At a *conversazione* held in May of 1857 he delivered an address on the dead artist, whom in fact he had not

known very well. Ruskin's speech is known from a newspaper report.
It was rather long, and only a part of it was about Seddon himself. The
artists' death (from dysentery, in Cairo, while on a painting expedi-
tion) set Ruskin off on a disquisition that introduces the themes of his
later political writing. The *Journal of the Society of Arts* reports it thus:

> The simple sacrifice of life had in it nothing unusual — it was, on the
> contrary, a melancholy thing to reflect how continually we all of us
> lived upon the lives of others, and that in two ways, viz., upon lives
> which we take, and upon lives which are given. It was a terrible
> expression to use — this taking of life, but it was a true one. We took
> life in all cases in which, either for higher wages, or by the compul-
> sion of commercial pressure, men were occupied without sufficient
> protection or guardianship in dangerous employments, involving
> an average loss of life, for which life we paid thoughtlessly in the
> price of the commodity, which, so far, was the price of blood. Nay,
> more than this, it was a well-recognised fact that there was scarcely
> an art or science in the present day, in which there was not some
> concomitant circumstance of danger or disease, which science had
> not striven to abate proportionably with the endeavours to advance
> the skill of the workmen. And thus, though we had abolished
> slavery, we literally bargained daily for the lives of our fellowmen,
> although we should shrink with horror at the idea of purchasing
> their bodies; and if these evils, arising partly from pressure of
> population, but more from carelessness in masters and consumers,
> from desire of cheapness, or blind faith in commercial necessities —
> if these evils went on increasing at the rate it seemed but too
> probable they would, England would soon have to add another
> supporter to her shield. She had good right still to her lion, never
> more than now. But she needed, in justice, another, to show that if
> she could pour forth life blood nobly, she could also drink it cruelly;
> she should have not only the lion, but the vampire . . .[16]

Perhaps John James's fear of his son's lectures came from a realization
that Ruskin was always likely to say something inapposite. The Sed-
don address was a case in point. One might agree with these senti-
ments, or not: one would still doubt that this were the right occasion
to express them. Ruskin had also agreed to give two lectures in July at
the Art Treasures exhibition in Manchester. He was unconcerned that
what he said might not relate to the art that was exhibited. He did not
attend the opening of the exhibition. Instead he took lodgings in a
farmhouse in Cowley, then a village three miles outside Oxford.
There, 'in the middle of a field, with a garden of gooseberries and

orange lilies; and a loose stone wall round it, all over stone-crop', he began to write the lectures which became *The Political Economy of Art*.[17] Charles Eliot Norton was in Oxford at the time, and later claimed that Ruskin discussed his writing with him. If so, this was the first occasion on which the young Bostonian had ventured to tell Ruskin what he ought to be thinking and saying. It is more likely that Ruskin had helpful conversations with Henry Acland, whom he saw almost daily, for they still had much work to do on the University Museum. Ruskin tried his hand at building Acland's study: 'I built a great bit yesterday, which the bricklayer my tutor in a most provoking manner pulled all down again. But this bit I have done today is to stand.'[18] Ruskin felt the more protective of the museum because it was just now that Liddell, who had recently become Dean of Christ Church, was restoring and erecting new buildings there. Pointedly, he had not asked for Ruskin's advice. The circumstances would be bitterly recalled in an unpublished draft of *Præterita*. Ruskin now parted company with the college in which he had been educated. In this year he was elected an honorary student of Christ Church in company with Gladstone and Acland. He valued the honour in an abstract fashion: he would not go there. When at last he spent an evening in hall in 1883 he remarked that he had not dined in his own college for thirty years.

This was the Pre-Raphaelite summer in Oxford. Ruskin was calling himself a 'PRB' as though he were a member of the defunct Brotherhood, and addressing Jane Simon, the wife of John Simon, as a 'PRS', a sister in art.[19] He had a little contact with many of the artists, William Morris among them, who were working in the Union. He may also have met Swinburne for the first time. But Ruskin was not close to them and left Oxford in early July to give his Manchester lectures.[20] He travelled afterwards to Wallington and thence to Edinburgh, where he had rendezvous with his parents for a tour of Scotland. In Manchester he left behind him an amount of consternation. In 1880, when he reissued *The Political Economy of Art*, Ruskin changed its title to *A Joy for Ever (and its Price in the Market)*. Keats's phrase and the sardonic addition were employed to reassert a radicalism that had been somewhat forgotten in the previous two decades. Much that Ruskin declared in Manchester became common currency not much later on. But to reread the 1857 lectures is still to be struck by their vigour and attack. To assert that one can talk of art and political economy in the same breath, to open an art lecture with comments on poverty, was to announce, all suddenly, a political position.

John James Ruskin, so jealous of his son's public reputation, was not

dismayed by the Manchester lectures. Nor, when at length it came, was he put out by the generally negative reaction in the press. After publication, when *The Times* criticized Ruskin for speaking on matters that were not the province of an æsthete, his father was still cheerfully of the opinion that there was value in the address. *The Times* had associated Ruskin with Dr Thomas Guthrie, a famous Scottish preacher of the day, a philanthropist and pioneer of the ragged schools, whose *City: its Sins and Sorrows* had recently been published. John James wrote about the matter to Jane Simon:

> Mrs R. named to me your having heard that my Son's meddling with Political Economy might weaken his Influence in matters of Art. I feared this myself, but by his own confession his studies of Political Economy have not encroached much on his time — and on this weary subject a few new ideas will do no harm. The Times couples him with Dr Guthrie and says they are both in a state of helpless ignorance of the first principles of Political Philosophy. I might, perhaps, prefer the Simplicity of Dr Guthrie to the Philosophy of the Times; but, if my Son has so greatly committed himself in his last little book, I trust to the talk of Mr Simon, Mr Helps and Mr Carlyle bringing us an amended Second Edition . . .[21]

And to E. S. Dallas, who was a journalist on the newspaper, he repeated, 'As a City man I am half with *The Times* in believing my Son and Dr Guthrie innocent of Political Economy; but these Geniuses sometimes in their very simplicity hit upon the right thing, whilst your ponderous Economy discusser twaddles on in endless mazes lost.'[22] John James was not quite near the mark in believing that a combination of Simon, Helps and Carlyle would make Ruskin a sounder critic of society. Simon the administrator, Helps the experimental liberal reformer, were both people with whom Ruskin enjoyed an exchange of views. But he took little notice of what they said. It was towards Carlyle's message that his mind tended, towards a visionary conservatism that John James could not understand. For Ruskin as the Master of the Guild of St George, Dr Guthrie's philanthropy made 'all things smooth and smiling for the Devil's work'.[23]

This will plainly appear in *Munera Pulveris* of 1862, the best of Ruskin's middle-period political writings. The book is dedicated to Carlyle. In 1857, however, the relationship between the two men might have seemed rather distant. Carlyle had no interest in art: he even seemed to dislike it. Ruskin was too busy with art work to think of Carlyle. After the holiday in Scotland with his parents (and a brief visit to Oxford to see the Pre-Raphaelite frescoes) Ruskin had to settle

down to the long task of the arrangement of the Turner drawings. In some basement rooms in the National Gallery, which Ruskin scornfully called its 'cellar', he began to unpack the tin boxes in which the treasures had been crammed away. Because he had known the house in Queen Anne Street Ruskin was not surprised at the state of the drawings. But the description of their condition which he gave in the fifth and final volume of *Modern Painters* is filled with a sort of retrospective horror at what he now found:

> . . . some in chalk, which the touch of the finger would sweep away; others in ink, rotted into holes; others (some splendid coloured drawings among them) long eaten away by damp and mildew, and falling into dust at the edges, in capes and bays of fragile decay; others worm-eaten, some mouse-eaten, many torn, halfway through; numbers doubled (quadrupled, I should say,) up into four, being Turner's favourite mode of packing for travelling; nearly all rudely flattened out from the bundles in which Turner had finally rolled them up and squeezed them into his drawers in Queen Anne Street. Dust of thirty years' accumulation, black, dense, and sooty, lay in the rents of the crushed and crumpled edges of these flattened bundles, looking like a jagged black frame, and producing altogether unexpected effects in brilliant portions of skies, whence an accidental or experimental finger-mark of the first bundle-unfolder had swept it away.[24]

The first task was to ensure the safety of the drawings. In his cramped conditions, without enough natural light, sending up clouds of chalk and dust, and without the aid of any professional restoration techniques, Ruskin began his protection. He had to work with his sleeves rolled up, washing his hands every few minutes, spreading the drawings out on whatever surfaces were available, measuring and numbering them. Every evening, as George Allen recalled, 'after our day's work at the Gallery Mr Ruskin and I used to take the measurements of drawings to Denmark Hill, where I cut with my own hands about 800 thick passe-partout mounts — they were taken to the Gallery and the drawings inserted there'.[25] Many of them could not have been mounted before they were pressed. Since there were 19,000 separate drawings to deal with the variety of cleaning and cataloguing problems was enormous. At first, Ruskin seemed to be optimistic. Stacy Marks, the genial painter of birds who was to be a friend for many years, found him quite confident when he introduced himself in the 'cellar'. Marks wrote:

I found the eloquent exponent of Turner in rooms in the basement of the building, surrounded by piles of sketch-books and loose drawings by the master, which he was arranging, mounting and framing, — a congenial employment, a labour of love, to which he devoted months of time, with no recompense beyond the pleasure which the occupations afforded him. I can remember little of our conversation except that it was chiefly about Turner and his work. I had gone to the Gallery with an ill-defined feeling of awe of the great man I was about to see, but this was dissipated directly I had shaken hands with him. There was none of the posing of the genius; I found him perfectly simple, unaffected, kindly, and human.[26]

'Every day, and often far into the night,' Ruskin claimed, he worked on. By the end of December 1857 it seemed to him that there were 10,000 drawings which were 'far enough carried forward to give some question as to whether they should be exhibited or not'.[27] In effect, Ruskin was now re-learning Turner's entire career, and more intimately than he ever before had thought possible. He wrote to Ellen Heaton, a water-colourist and collector, of the 'excitement of discovering something precious or learning something new every half minute'.[28] This was almost painful. For as more and more was unfolded of Turner's art Ruskin had the gathering impression that what he had thought of him was only what a young man might think. The drawings recalled to him what he had known of the man. In truth Ruskin had revered him, until their quarrel: and in some measure had still revered him after he had decided that he could not forgive him. But he had never loved the man as he had loved the work, and he now looked sorrowfully on all that had been hidden in the artist's character. Perhaps he had only known Turner personally in his utter decline? Ruskin found that he could not talk of these troubles to his father. He did not even formulate his thoughts until the next summer. Then, far away in Bellinzona, he wrote to his father as follows:

You are quite right in your feeling about the later drawings in this respect, that the power of sight is in a considerable degree diminished, and that a certain impatience, leading sometimes to magnificence, sometimes to mistake, indicates the approach of disease; but at the same time, all the experience of the whole life's practice of art is brought to bear occasionally on them, with results for wonderment and instructiveness quite unapproached in the earlier drawings. There is, however, one fault about them which I have only ascertained since my examination of the Turner sketches. There is evidence in those sketches of a gradual moral decline in the

painter's mind from the beginning of life to its end — at first patient, tender, self-controlling, exquisitely perceptive, hopeful, and calm, he becomes gradually stern, wilful, more and more impetuous, then gradually more sensual, capricious — sometimes in mode of work even indolent and slovenly — the powers of art and know-ledge on nature increasing all the while, but not now employed with the same calm or great purpose — his kindness of heart never deserting him, but encumbered with sensuality, suspicion, pride, vain regrets, hopelessness, languor, and all kinds of darkness and oppression of heart. What I call the 'sunset drawings' — such as our Coblentz, Constance, Red Rigi, etc., — marks the effort of the soul to recover itself, a peculiar calm and return of the repose or youthful spirit, preceding the approach of death . . .[29]

One small group of drawings might have epitomized, for Ruskin, Turner's moral decline. Somewhere in the boxes he found work which he was later to describe as 'grossly obscene'. Ruskin had remarked in the Marlborough House catalogue, 'I never know whether most to venerate or lament the strange impartiality of Turner's mind, and the vast cadence of subjects in which he was able to take interest.'[30] At this point, Ruskin was remarking how great mythological subjects might alternate with views of the Isle of Dogs. Such a Thames-side scene might not be fully worthy of its painter, but it was still within the realm of art. These obscene drawings were not. This was also Wornum's view. For the good of Turner's reputation, and in the interests of the high view of the national culture that the bequest was intended to serve, it seemed best that these drawings should not form part of the collection. Ruskin already believed that there was no point in preserving 'valueless' scribbles or scraps. Wor-num was of the opinion that even to possess these drawings was illegal. The National Gallery authorities were in favour of burning them. Ruskin agreed, and watched as Wornum lit the fire. He hardly ever made explicit mention of this episode and it is not easy to estimate what effect it had on him. It was probably only a part of the experience of working with the Turner bequest. But it was around this time that he came to believe not merely that Turner's 'mind and sight partially gave way',[31] as the Marlborough House catalogue states, but that the painter went mad and 'died mad'. Such views were always privately expressed. Just as he never spoke of his quarrel with Turner, so he would not write publicly of his feeling that the artist's mind was diseased. Many years later, when Ruskin's own mind was in pitiful disarray, we occasionally find renewed warnings about a 'passionately

sensual character' that would lead to 'a kind of delirium tremens. Turner had it fatally in his last years';[32] and Ruskin's work with Wornum, otherwise forgotten, is suddenly mentioned in his diary's passages of insane free association that were written in the days before his own delirium.[33]

★ ★ ★ ★

> The manual labour would not have hurt me [wrote Ruskin of his work on the Turner catalogue] but the excitement involved in seeing unfolded the whole career of Turner's mind during his life, joined with much sorrow at the state in which nearly all his most precious work had been left, and with great anxiety, and heavy sense of responsibility besides, were very trying: and I have never in my life felt so much exhausted as when I locked the last box, and gave the keys to Mr Wornum, in May, 1858.[34]

The experience would be reflected in the graver tone of the fifth volume of *Modern Painters*: this spring, tired though he was, Ruskin proselytized for the future of art. In the first week of May he wrote *Academy Notes*, and published the pamphlet immediately. He noted with satisfaction that Pre-Raphaelitism had triumphed 'as I stated five years ago it would'.[35] If some of the initial impetus had left the movement, a social gain had become important. Art now had a democratic function. But this was not to be confused with mere popularity. *Academy Notes* dismissed Frith's *Derby Day* — 'It is a kind of a cross between John Leech and Wilkie, with a touch of daguerrotype here and there, and some pretty seasoning with Dickens's sentiment' — and reserved its most hopeful praise for John Brett's *Stonebreaker*.[36] With *Academy Notes* done, Ruskin felt ready for travel. After the traditional family feast on 10 May he set out, alone, for Italy: it is probable that he had arranged to meet Brett there.

In Paris Ruskin visited (a family obligation) the Comte and Comtesse Maison: the Comtesse was the eldest of the Domecq daughters. A week later he was in Basle, where he was joined by Couttet. There and at Rheinfelden he identified the sites of some of the Turner drawings he had recently catalogued. In the letters to Denmark Hill which now replace his diary we often find the themes of the last volume of *Modern Painters*. From Brunnen, in William Tell country, he wrote:

> I am surprised to find what a complete centre of the history of Europe, in politics and religion, this lake of Lucerne is, as Venice is a

centre of the history of art. First, the whole Swiss nation taking its name from the little town of Schwytz, just above this, because the Schwytzers were to the Austrian Emperors the first representatives of republican power, in their stand at Morgarten; then, the league of the three cantons to defend each other against all enemies, first signed and sealed in this little village of Brunnen; followed by the victories of Laupen, Sempach, Granson, Morat, and gradually gained power on the other side of the Alps in Italy until the Swiss literally gave away the Duchy of Milan, the competitors for it pleading their causes before the Swiss Council at Baden; and meantime, the great Reformation disputes in religion making these hills the place of their eternal struggle, till Zwingli was killed in the battle with these same three Catholic cantons, just beyond Zug on the road down from the Albis; whilst, on the other hand, the Republican party at Geneva was Protestant, and binding itself by oath in imitation of the oath of these three cantons, and calling itself Eidgenossen — 'bound by oath' — gets this word corrupted by the French into 'Huguenots', and so to stand generally for the Protestant party in France also.[37]

Some of Ruskin's admiration for the only modern republic he could approve of was worked up from, for instance, André Vieusseux's *History of Switzerland*, translated into English in 1840, but such prosaic sources were imaginatively paraphrased. Ruskin's views of the schisms of European history were romantic and partial, and he felt that art and legend are the heart of a nation's life. Thus, since history, art and nature are intertwined, the history of Switzerland was to be treated in the chapter of the fifth volume of *Modern Painters* entitled 'The Leaf Shadows'. Ruskin was in fact returning to an ambition he had felt since completing *The Stones of Venice*, a book on the culture of Swiss towns. It was never written, partly because it stirred in him disturbing social reflections. The peoples of Switzerland, he explained to his father, 'have sunk and remain sunk, merely by idleness and wantonness in the midst of all blessings and advantages . . . every man always acts for himself: they will never act together and do anything at common expense'.[38]

Ruskin's feelings for Switzerland were to reappear years later in his plans for the Guild of St George. Now, in 1858, they have a relevance to his collaboration with two English painters. This year he met at Fluelen J. W. Inchbold, a painter much commended in *Academy Notes*, and spent some time with John Brett. His praise of Brett's *Stonebreaker* in *Academy Notes* had concluded, 'If he can paint so lovely

a distance from the Surrey downs and railway-traversed vales, what would he not make of the chestnut groves of the Val d'Aosta!'[39] Another letter to his father tells us more of his attitude to these two members of the Pre-Raphaelite school:

> I sent for [Brett] at Villeneuve, Val d'Aosta because I didn't like what he said in his letter about his present work, and thought he wanted some more lecturing like Inchbold: besides that, he could give me some useful hints. He is much tougher and stronger than Inchbold, and takes more hammering; but I think he looks more miserable every day, and have good hopes of making him completely wretched in a day or two . . .[40]

There is in existence a notebook of Brett's which dates from this summer. It indicates that he and Ruskin were at one point working side by side, attended by Couttet. It contains portrait sketches of the old guide. Some pages are by Ruskin. They are marked 'JMWT': Turner's initials, for Ruskin, as before, was attempting to force his personal knowledge of Turner into the practice of a younger artist.[41]

★　　★　　★　　★

Towards the end of this summer, in Switzerland and Turin, we find signs that the forty-year-old Ruskin was developing a different interest in the opposite sex. Ruskin's sexual maladjustment is not an uncommon one. He was a pædophile. He is typical of the condition in a number of ways, for pædophilia generally emerges in his age-group, often follows a period of marital breakdown, and in old age is accompanied by (or is a palliative to) a sense of loneliness and isolation. An attraction to young girls was in Ruskin's sexual nature to the end of his life. In a letter to Denmark Hill from Italy, he now wrote, 'One of the finest things I saw in Turin was a group of neglected children at play on a heap of sand — one girl of about ten, with her black hair over her eyes and half-naked, bare-limbed to above the knees, and beautifully limbed, lying on the sand like a snake . . .'.[42] The image remained with him for a quarter of a century and more. The dark Italian girl appears in his diary in later years: she was even mentioned in the disastrous last lectures in Oxford in 1884. In 1865, in *The Cestus of Aglaia*, Ruskin describes her in a manner which is as close as he ever approaches to the sensual:

> She was lying with her arms thrown back over her head, all languid and lax, on an earth-heap by the river side (the softness of dust being

the only softness she had ever known), in the southern suburb of
Turin, one golden afternoon in August, years ago. She had been at
play, after her fashion, with other patient children, and had thrown
herself down to rest, full in the sun, like a lizard. The sand was
mixed with the draggled locks of her black hair, and some of it
sprinkled over her face and body, in an 'ashes to ashes' kind of way;
a few black rags about her loins, but her limbs nearly bare, and her
little breasts, scarce dimpled yet, — white, — marble-like . . .[43]

The sight of this girl was like a landmark for Ruskin, as he afterwards
looked over his life. But pædophilia became a part of his character only
gradually. The turning-points Ruskin identified were often over-
precise. So it was with the history of his religious convictions, which
at just this period underwent a change that Ruskin was later to exagg-
erate. The account in *Fors Clavigera* of April 1877 tells us:

> I was still in the bonds of my old Evangelical faith; and, in 1858, it
> was with me, Protestantism or nothing: the crisis of the whole turn
> of my thoughts being one Sunday morning, at Turin, when, from
> before Veronese's Queen of Sheba, and under quite overwhelmed
> sense of his God-given power, I went away to a Waldensian chapel,
> where a little squeaking idiot was preaching to an audience of
> seventeen old women and three louts, that they were the only
> children of God in Turin; and that all the people in the world out of
> sight of Monte Viso, would be damned. I came out of the chapel, in
> sum of twenty years of thought, a conclusively *un*-converted
> man.[44]

We must not believe that Ruskin changed his mind about religion as
abruptly as this. In *Fors*, and in another account of the experience in
Præterita, Ruskin abbreviated the way that he came to reject his
mother's Evangelical beliefs. 'That day,' he claimed, they 'were put
away, to be debated of no more.'[45] That was not true: he spent the next
thirty years debating them. Perhaps it was his hostility to conversion
that made Ruskin write in this way, as if his experience had been
directly opposed to that of so many other Christians. Conversion
experiences are common in Christian, and especially Protestant, cul-
tures: but an opposite experience of shedding a faith as though by
revelation is not known. Nonetheless, something happened to Rus-
kin's Christianity in these months. It had to do with a solitary life in an
unfamiliar, enlivening place. *Præterita* notes, 'I have registered the
year 1858 as the next, after 1845, in which I had complete guidance of
myself.'[46] In 1845, Ruskin had worked hard. This summer he was

determined to be lazy. He was glad that his father was not with him to urge the completion of *Modern Painters*. He relaxed in the social pleasures of Turin. Looking back at the Alps, and for once rather pleased to have left them, Ruskin diverted himself in what was still the capital of the old Sardinian kingdom, a town of colonnades, orange trees, soldiers, bands, theatres. He rose late, lingered over coffee and *Galignani* (the European English-language newspaper, as full of gossip as of information), sauntered to the picture gallery for an hour until 'I think it time to be idle' and 'see what is going on on the shady side of the piazzas'.[47] He dined well, drank half-pints of champagne and spent every evening at the Opéra Comique. On Sundays, the actors' *riposo*, he read French novels.

A few weeks earlier, on the second Sunday after parting from his parents, Ruskin had made a sketch of some orchises. It was the first time in his life that he had drawn on the sabbath day. There in his diary were the pen outlines of the flowers.[48] Could this be wrong? How could art and nature be ruled by Sabbatarianism? And once he had left Inchbold and Brett behind Ruskin's didacticism vanished. His appetite for art became fixed on one painting. In Turin's indifferent municipal gallery he took to copying a small detail from Veronese's *Solomon and the Queen of Sheba*, the painting mentioned in the account of the 'unconversion'. This he studied with a strange mixture of indolence and fanaticism. Augustus Hare, who passed through Turin that summer, reported of Ruskin's work:

> He was sitting all day upon a scaffold in the gallery, copying bits of the great painting by Paul Veronese . . . One day in the gallery I asked him to give me some advice. He said 'watch me'. He then looked at the flounce in the dress of a maid of honour of the Queen of Sheba for five minutes, and then he painted one thread: he looked for another five minutes, and then he painted another thread. At the rate at which he was working he might hope to paint the whole dress in ten years . . .[49]

It seems that this account was hardly exaggerated. The exercise occupied Ruskin for more than a month, and all that came of it were a few tiny scraps of overworked detail.

Ruskin's insistence that he was disillusioned with Evangelicalism in a Waldensian chapel has significance. It was his practice to read over the English service with his valet if in a foreign town without Protestant churches. In Turin, however, there were chapels of the Waldensian faith. They were newly and cheaply built: religious liberty had been granted to the sect in Turin only in 1848. The Waldensians, or

Vaudois, held a special place in the Protestant mythology of the
Ruskin family, as in English Protestantism as a whole. Milton's sonnet
'On the late massacre in Piedmont', with its prayer 'Avenge, O Lord,
thy slaughtered saints . . .', was inspired by the Waldensians' earlier
persecution. Confined to the Swiss, Piedmontese and northern Italian
valleys, they had there, some believed, preserved an uncorrupted
form of primitive Christianity. Appeals to the Vaudois character may
be found in the most entrenched of Ruskin's writings, in the *Pre-
Raphaelitism* pamphlet and in *Notes on the Construction of Sheepfolds*.
Now, however, he was exasperated by the narrowness of the faith.
How could one love Veronese and believe this preacher? A long letter
to his father now marks this turning point in Ruskin's views. Having
put the view that 'A good, stout, self-commanding, magnificent
Animality is the make for poets and artists, it seems to me', Ruskin
further explained,

> One day when I was working from the beautiful maid of honour in
> Veronese's picture, I was struck by the gorgeousness of life which
> the world seems to be constituted to develop, when it is made the
> best of. The band was playing some passages of brilliant music at
> the time, and this music blended so thoroughly with Veronese's
> splendour; the beautiful notes seeming to form one whole with the
> lovely forms and colours, and powerful human creatures. Can it be
> possible that all this power and beauty is adverse to the honour of
> the Maker of it? Has God made faces beautiful and limbs strong, and
> created these strange, fiery, fantastic energies, and created the
> splendour of substance and the love of it; created gold, and pearls,
> and crystal, and the sun that makes them gorgeous; and filled
> human fancy with all splendid thoughts; and given to the human
> touch its power of placing and brightening and perfecting, only that
> all these things may lead His creatures away from Him? And is this
> mighty Paul Veronese, in whose soul there is a strength as of the
> snowy mountains, and within whose brain all the pomp and
> majesty of humanity floats in a marshalled glory, capacious and
> serene like clouds at sunset — this man whose finger is as fire, and
> whose eye is like the morning — is he a servant of the devil; and is
> the poor little wretch in a tidy black tie, to whom I have been
> listening this Sunday morning expounding Nothing with a twang
> — is he a servant of God?[50]

John James could well have anticipated these sentiments, but Rus-
kin's mother was in high alarm. She sent him long instructions and
five pounds to donate to the Vaudois church. This Ruskin passed on,

dutifully, reflecting that he had given as much recently to a ballerina at the Opéra Comique. Deference to his mother sent him on an expedition to the Vaudois villages in the hills above Turin. 'I have seldom slept in a dirtier inn, seldom see peasants' cottages so ill built, and never yet in my life saw anywhere paths so full of nettles,' he complained.[51] He sought out an unidentified 'theological Professor' to talk with. But this person could convince him of nothing. Ruskin was conscious of the gap that was opening between him and his parents and found that he did not wish to make an effort to repair it. In one respect this was damaging to his work. He was only laxly engaged with the end of *Modern Painters*, the book that John James so wanted to be a great memorial to a father's belief in his son. There are, to be sure, certain passages in the fifth volume that derive from his summer in Turin. The conjunction of Wouverman and Fra Angelico in one chapter is due to the fact that both were represented in the Turin gallery. But *Modern Painters* would have been better served if Ruskin had spent more time in Venice, as his preface to the last volume admits. On his way back to England he had some intention of working in the Louvre. But he paused there only briefly. He arrived home in London with little done, and a mind greatly changed.

CHAPTER FOURTEEN

1857–1858

Ruskin was increasingly in demand as a lecturer. The success of *The Political Economy of Art* had persuaded him that the lecture was a natural form for his writing. Unofficial addresses at the Working Men's College (which were improvised) gave him a sense of the closeness of the lecturer's audience. From 1857 until his mental collapse in 1878 there was not a year when he did not speak publicly three or four times. Such addresses were usually published soon afterwards. The assumptions of the Working Men's College drawing class were repeated at the opening of the new Cambridge School of Art in 1858. Here again is the realist, democratic argument that 'We must set ourselves to teaching the operative, however employed — be he farmer's labourer, or manufacturer's; be he mechanic, artificer, sailor, or ploughman — teaching, I say, one and the same thing to all; namely, Sight.'[1] Other lectures given in 1858 were published the next year with the title *The Two Paths*. The first of them was organized by Ruskin for his own purposes. He had instituted a competition among the students of the Architectural Museum for the best piece of 'historical sculpture'. At the prize-giving this year the chairman was C. R. Cockerell. He was an opponent, since he was a classicist and Professor of Architecture at the Royal Academy. Ruskin was graceful to Cockerell in his introductory remarks but the rest of his address on 'The deteriorative power of conventional art over nations' was a call to arms. The 'two paths' of the book's title were the clear alternatives before art students, 'whether you will turn to the right or the left in this matter, whether you will be naturalists or formalists; whether you will pass your days in representing God's truth, or in repeating men's errors'.[2] Less tendentious, wider-ranging and more deliberately entertaining was another lecture collected in *The Two Paths*, that on 'The work of iron, in nature, art and policy', given in Tunbridge Wells in February of 1858, probably at the request of his cousin George Richardson.

At the beginning of the next year Ruskin went north to lecture at Manchester and Bradford. His appearances were organized by Gambart, whom he met for breakfast at the home of a local industrialist, Sir Elkanah Armitage. There they discussed the picture market, with enthusiastic schemes 'for buying all Venice from the Austrians —

pictures, palaces, and everything', and 'asked Sir Elkanah to set the project on foot, in Manchester'.[3] 'The Unity of Art', the lecture Ruskin now gave, was milder than his previous address in Manchester at the time of the International Exhibition. It seems to have been designed to point to controversial issues without itself arousing controversy. The whole expedition was friendly. Ruskin called on the novelist Elizabeth Gaskell, his admirer since the publication of *Modern Painters* III, when they had been introduced by Furnivall, and then set off towards Bradford. He told his father that he was studying Turnerian sites at Bolton Bridge and Knaresborough. But he seems to have been excited by a landscape that is Mrs Gaskell's rather than Turner's:

> The drive from Rochdale to Burnley is one of the grandest and most interesting things I ever did in my life . . . the cottages so old and various in form and position on the hills — the rocks so wild and dark — and the furnaces so wild and multitudinous, and foaming forth their black smoke like thunderclouds, mixed with the hill mist . . .[4]

Ruskin's dislike of the industrial north was not at the pitch it would reach a decade later. He could even propose a sensible co-operation between the demands of manufacture and the demands of art. His lecture at Bradford, 'Modern Manufacture and Design', was designed to be useful rather than hortatory. It does, however, contain the first of Ruskin's many direct questions to industrialists:

> If you will tell me what you ultimately intend Bradford to be, perhaps I can tell you what Bradford can ultimately produce. But you must have your minds clearly made up, and be distinct in telling me what you do want. At present I don't know what you are aiming at, and possibly on consideration you may feel some doubt whether you know yourselves. As matters stand, all over England, as soon as one mill is at work, occupying two hundred hands, we try, by means of it, to set another mill at work, occupying four hundred. That is all simple and comprehensible enough — but what is it to come to? How many mills do we want? or do we indeed want no end of mills? Let us entirely understand each other on this point before we go any farther. Last week, I drove from Rochdale to Bolton Abbey; quietly, in order to see the country, and certainly it was well worth while. I never went over a more interesting twenty miles than those between Rochdale and Burnley. Naturally, the valley has been one of the most beautiful in the Lancashire hills; one

of the far-away solitudes, full of old shepherd ways of life. At this time there are not, — I speak deliberately, and I believe quite literally, — there are not, I think, more than a thousand yards of road to be traversed anywhere, without passing furnace or mill.[5]

Ruskin's lecture ended with a direct comparison between Bradford and (in a magnificent description, a *tour de force* for lecture purposes) mediæval Pisa. He admitted, 'I do not bring this contrast before you as a ground of hopelessness in our task; neither do I look for any possible renovation of the Republic of Pisa, at Bradford, in the nineteenth century.'[6] And yet, although he did not realize it, all his instincts would soon lead him to propose just such a renovation. In five years' time he would address the burghers of Bradford with contempt: and in a decade he would come to the conclusion that the only way to save England was indeed to recreate there the conditions of the Gothic cities of the past.

<p align="center">★ ★ ★ ★</p>

Ruskin's description of the 'wretch' who had talked of the election of the Waldensian faithful was followed, that summer of 1858, by further attacks on Protestant services he attended on the Continent. To John James he wrote from Paris of a 'disgraceful' English evensong, the sermon 'utterly abominable and sickening in its badness'.[7] Such outbursts were not unusual. The Ruskins's church-going habits meant that they listened to a great number of sermons, a form of literature they rarely read, and both father and son were given to a violent connoisseurship of the preaching class.[8] As we might expect from these intelligent, curious and prejudiced men, they had some unusual preferences. For about five years, from 1857, their favourite preacher was an uncouth Evangelical Baptist for whom neither felt much doctrinal sympathy. This was Charles Haddon Spurgeon. When the Ruskins first went to listen to him and sought his acquaintance he was scarcely twenty-four years old, yet had become the most popular preacher in London. At the age of sixteen he had been converted by a Primitive Methodist. 'Baptism loosed my tongue,' he said, 'and from that day it has never been quiet.'[9] It was an uneducated tongue. Spurgeon was still an Essex country boy. His early practice in his vocation had been in extempore gatherings in Hackney Fields. He had progressed to the Exeter Hall and the Surrey Gardens Music Hall, working-class venues that could accommodate his audience of thousands. His oratory was interspersed with humorous anecdote and doggerel verse. It made the fastidious wince. Spurgeon was a preacher

to whom one sent the servants. 'He is likely to do really good service among the class to which he belongs,' one contemporary remarked, 'though he would be a scandal and a nuisance at St George's, Hanover Square, or in Westminster Abbey.'[10] Many intellectuals could not abide him. Matthew Arnold, for instance, was repelled. Yet Spurgeon's spirit shone beyond his vulgarity, as Lord Houghton — a fair reporter of nineteenth-century devotion — rightly saw: 'When he mounted the pulpit you might have thought of him as a hairdresser's assistant: when he left it, he was an inspired apostle.'[11]

Like Houghton, Ruskin defended Spurgeon to the sophisticated. 'His doctrine is simply Bunyan's, Baxter's, Calvin's, and John Knox's,' he wrote to the Brownings, '— in many respects not pleasant to *me*, but I dare not say that the offence is the doctrine's and not mine. It is the doctrine of Romish saints and of the Church of England. Why should we find fault with it especially in Spurgeon and not in St Francis or Jeremy Taylor?'[12] Between Ruskin and Spurgeon there developed an unlikely, warm friendship. They had next to nothing in common apart from their knowledge of the Bible and a love of its exegesis. Ruskin simply ignored all aspects of Spurgeon's views that would annoy him. The Baptist's fiery hatred of Carlyle he overlooked. He was not drawn by Spurgeon's insistence that all churches should be Greek rather than Gothic. Instead, nightly, at Spurgeon's tiny south London house, tasting wines from John James's own cellar, Spurgeon with a cigar, they would spar over their intimacy with Scripture and their utterly different natures, Ruskin provocative, Spurgeon laughing at him, each capping the other. Spurgeon recalled with amusement how 'Mr Ruskin came to see me one day, many years ago, and amongst other things he said that the Apostle Paul was a liar, and that I was a fool!'[13] But Ruskin had a real attachment to Spurgeon. The preacher's wife records:

> Towards the end of 1858 Spurgeon had a serious illness, and Ruskin called to see him during his convalescence. How well I remember the intense love and devotion displayed by Mr Ruskin, as he threw himself on his knees by the dear patient's side, and embraced him with tender affection and tears. 'My brother, my dear brother,' he said, 'how grieved I am to see you thus!' His sorrow and sympathy were most touching and comforting. He had brought with him two charming engravings . . . and some bottles of wine of a rare vintage . . . My husband was greatly moved by the love and consideration so graciously expressed, and he very often referred to it afterwards in grateful appreciation; especially when, in later years, there came a change of feeling on Mr Ruskin's part, and he strongly repudiated

some of the theological opinions to which Mr Spurgeon closely
clung to the end of his life.[14]

As one or two of their contemporaries recognized, there is some-
thing of Spurgeon's fundamentalism in Ruskin's *Unto This Last*. That
influence points to another difference, temperamental as well as intel-
lectual, between Ruskin and the Working Men's College. While his
politics alarmed all the Christian Socialists who gathered there, the
college's principal, F. D. Maurice, on the rare occasions when he met
his drawing master, was taken aback by the restless vehemence with
which Ruskin expressed views on religion. There was that about
Maurice which goaded Ruskin. He preferred to spend time with
Spurgeon, whom Maurice greatly distrusted. Ruskin's ties with the
Working Men's College were slackening. He saw Furnivall still but
was bored by others of the lecturers. The students who most
interested him he had taken away from the college and made his
assistants. Butterworth was still receiving money from Ruskin.
George Allen was taking lessons in line engraving from John Le Keux
and in mezzotint from Thomas Lupton, in preparation for the illustra-
tion of the fifth volume of *Modern Painters*. This was a more advanced
and significant teaching than was available at the college, for the
skilled Lupton had worked for Turner himself in years gone by.
Ruskin was pleased by this direct artisanal connection between Turner
and his own book: it had a deeper meaning in it than the elementary
drawing classes he used to give in Red Lion Square. Some of those
classes were now entrusted to Allen, but most of Ruskin's instruc-
tional drawing was carried out for him by William Ward, whom
Ruskin now referred to as both the college's and his own 'under
drawing-master'.[15]

When Ruskin was first asked by an Irish gentlewoman, a Mrs La
Touche, to give advice on her daughters' art education he sent William
Ward to see her, being too busy to call himself. Maria La Touche he
probably met through Lady Waterford, for she too was an
artistically minded woman not quite at home among the Irish aristo-
cracy. She was the daughter of Catherine, Countess of Desart. This
countess had been twice married, first to the Earl of Desart. Their son
was young Otway, Earl of Desart, whom Ruskin had known at Christ
Church. Catherine was widowed in 1820, when in her early thirties.
Four years later she married again. Her new husband was Rose Lam-
bert Price. He came of a baronetcy family in Cornwall which owned
large estates in Jamaica. Rose Lambert Price was much younger than
the still young dowager countess: he was still in his early twenties on

their wedding day. Maria Price, later Maria La Touche, was their daughter and only child, and thus the half-sister of Ruskin's Christ Church friend. She was not to remember her father, for he died two years after his marriage. Catherine, once more widowed, returned with her child to the Desert estates in County Kilkenny. There Maria spent her childhood.

With no memory of her Cornish father, with a background that was a trifle *déclassé*, Maria Price grew up to emphasize her Irishness. Intermittently educated near Brighton, in later life a traveller and the owner of a house in London, she yet had no wish to leave her native land. She was wed into another section of the Irish ascendancy. In 1843 she married John La Touche. The La Touche family had been in Ireland since the Edict of Nantes. They were Huguenot supporters of William of Orange: one of them had fought for him at the Battle of the Boyne. They had established a silk-weaving factory in the north and a bank in Dublin that later became the Royal Bank of Ireland. In the eighteenth century they purchased a country house at Harristown, County Kildare. Their fortunes became intermingled with the Anglo-Irish aristocracy. John La Touche's mother, for instance, was a daughter of the Earl of Clancarty. John La Touche was sent to England to be educated at Christ Church. He matriculated in 1833 and would have left Oxford just before the young Ruskin arrived there. He succeeded his father as head of the family in 1844, a year after his marriage to Maria Price. They then settled at Harristown, where their three children were born.

Maria La Touche, not in sympathy with the Anglo-Irish society she knew as the mistress of Harristown and the wife of the Sheriff of County Leitrim (as John La Touche became), disliked the hunting and horse racing, the gambling, drinking and crudity of manners of her acred neighbours. She was self-consciously devoted to the life of the soul. With a few other Irish ladies like Louisa, Marchioness of Waterford, Lady Drogheda and Lady Cloncurry, both married to County Kildare landowners, she formed a little society they called the Aletheme: they rechristened themselves with Greek names and discussed art. Lady Waterford was the most cultured of this group but Maria La Touche had more energy, more of a will to be artistic. She was more than merely amateur. She published two novels, *The Clintons* and *The Double Marriage*, both of them set in Ireland, both treating of romance across the divide that separated Catholic from Protestant. She wrote verse and was noted for the vivacity of her letters. She was quick to make friends, eager to travel, a little gushing. She thought a little wildness not a bad thing. She liked to visit London. John La

Touche had banking and government business there and so they kept a house in Mayfair, at first in Great Cumberland Street and later in Norfolk Street.[16]

Maria La Touche was in London in the new year of 1858, with her daughters Emily and Rose, when she first approached Ruskin. The momentous first meeting with Rose is described in the final pages of *Præterita*, an account which is practically the last thing Ruskin ever wrote: He called at Great Cumberland Street,

> . . . and found the mother — the sort of person I expected, but a good deal more than I expected, and in sorts of ways. Extremely pretty, still, herself, nor at all too old to learn many things; but mainly anxious for her children. Emily, the eldest daughter, wasn't in; but Rosie was, should she be sent for to the nursery? Yes, I said, if it wouldn't tease the child, she might be sent for. So presently the drawing room door opened, and Rosie came in, quietly taking stock of me with her blue eyes as she walked across the room; gave me her hand, as a good dog gives its paw, and then stood a little back. Nine years old, on 3rd January, 1858, thus now rising towards ten; neither tall nor short for her age; a little stiff in her way of standing. The eyes rather deep blue at that time, and fuller and softer than afterwards. Lips perfectly lovely in profile; — a little too wide, and hard in edge, seen in front; the rest of the features what a fair, well-bred Irish girl's usually are; the hair, perhaps, more graceful in short curl round the forehead, and softer than one sees often, in the close-bound tresses above the neck.[17]

Ruskin, now in his fortieth year, was taken with the La Touches. He liked the mother and felt that there was something exceptional about Rose. He had never taught a little girl before except by correspondence. There was no reason why he should do so now, except that he wanted to. He corresponded with Mrs La Touche while in Switzerland during the summer and on his return invited her, with Rose, to visit Denmark Hill. They were shown all the treasures: the Turners, the minerals, John Brett's painting of the Val d'Aosta, which Ruskin had just bought. Old Mrs Ruskin provided apples, peaches, a copy of *The King of the Golden River* for Rose. They visited the stables, where Ruskin chaffed Rose about Irish pigs. Soon they were on pet-name terms. Ruskin charmed the child, and she charmed him. Mrs La Touche evidently felt that an extraordinary privilege had been granted her: her letter of thanks was overwritten:

My Dear Mr Ruskin,
I have too long delayed thanking you, in my name and in Rose's, for

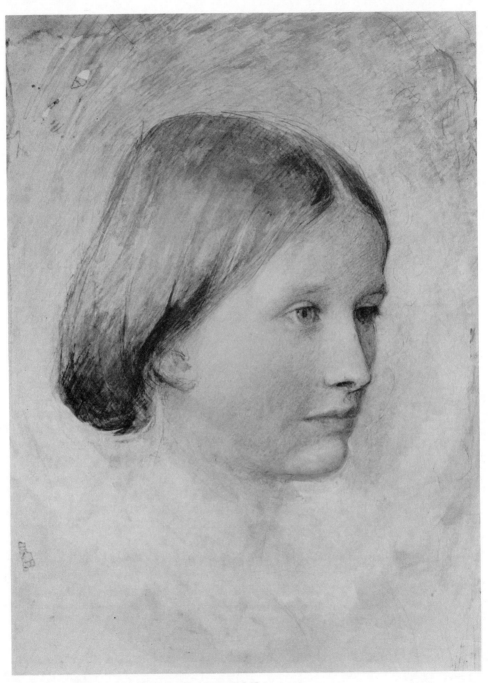

23. Rose La Touche, by John Ruskin, c.1860.

the pleasant hour we spent last Thursday — You, who live with and for Art, will not easily guess how much enjoyment you afforded to me, who am wholly unaccustomed to such an atmosphere out of dreamland. The 'Val d'Aosta' and the Rossettis and some of the Turners have been before me ever since — and Rose was very eloquent about them on the way home, she will not forget them, and will refer to them in memory hereafter, with better understanding of their meaning. Altogether we owe 'the immortal memory of one happy day' to Mrs Ruskin's kindness and yours: and more beautiful than all past sunsets was that which we saw on our way home — it was the interpretation, or rather it seemed to me the Apotheosis, of one or two of the Turners you had shown me — one of those skies no-one else ever attempted to paint — and under it, this evil London glorified into a shadowy semblance of the New Jerusalem, a city of sapphire and gold — It is a real consolation to me here, that my windows look towards the sunset: at home there would be a purple tracery of winter trees between me and the sky, and only a glow on the river's face to reveal what *it* saw. I have been wishing ever since, that you could see and tell the world about the Atlantic — I have never seen the Mediterranean — nor the subdued sea that sleeps around the 'Stones of Venice' except as you have shown them . . .[18]

There is much more of this letter, in the same manner. It closed with an invitation. Mrs La Touche wanted Ruskin and his mother to come to her new house in Norfolk Street, off Park Lane. When Ruskin went there he met other members of the family. Emily was grave and sensible, not very like the clever, inventive Rose. 'One never laughed at what she said,' *Præterita* records, 'but the room was brighter for it.'[19] But if the daughters were dissimilar it was their father who seemed almost out of place in the family. He was not the swaggering Irish sportsman that one would expect. He had been, but in a life that he had put behind him. Nor was he interested in the world of affairs and politics that, Ruskin presumed, had brought him to London. For, by fateful coincidence, he had been converted and baptized by Spurgeon. Ruskin knew of, but had not witnessed, Spurgeon's mass baptisms. Had he done so, he would no doubt have found them grotesque. He could not but find something peculiar, unnatural even, in John La Touche, who now professed a strict Calvinism far removed from the commonplace Church of Ireland Anglicanism of his wife. It was a Calvinism not only out of place in Mayfair but also extremist within its Irish context. One might compare (Ruskin was soon obliged to) the Evangelicalism of another branch of the La Touche

family planted at Delgany, fifteen miles from Harristown, visited a few years before by the historian J. A. Froude. Of these La Touches, Froude recorded:

> There was a quiet good sense, an intellectual breadth of feeling in this household, which to me, who had been bred up to despise Evangelicals as unreal and affected, was a startling surprise. I had looked down on dissenters especially, as being vulgar among their other enormities; here were persons whose creed differed little from that of the Calvinistic Methodists, yet they were easy, natural, and dignified. [20]

But this could not be said of John La Touche. His religion had not this naturalness. It seems that it could be satisfied only by the severities of the beleaguered Presbyterian church in Southern Ireland and its counterparts among Ulster Orangemen. The man himself was extraordinary. As is common in such converted sectarians, John La Touche believed himself to be — from the moment of his conversion, an experience to which he constantly returned — saved, redeemed, touched by God. He was at once dourly reserved and highly emotional. This was not a man with whom Ruskin could make light conversation about Christ Church. Ruskin's own association with Spurgeon was, for La Touche, no more than frivolous. His guest's standing as an art critic meant nothing to him, for he had no culture. Ruskin's own loss of conviction in the Evangelical faith further separated them. Neither now, nor at any later time, could the two men find anything in common.

Rose and Emily La Touche came out to Denmark Hill on further occasions, sometimes with their mother, never with their father, sometimes with a nurse or maid. Some attempt was made to start the girls drawing. Leaves and flowers were brought in from the garden. Ruskin was surprised at how much Maria La Touche knew of botany. Soon it was decided to transfer the classes to Norfolk Street, where there was a proper schoolroom. Ruskin went there more and more often. Maria La Touche was delighted: she could show him off to her friends. But Ruskin preferred to arrive an hour or two before the children's bedtime and then to take his leave, pleading that he had to work on his book. It was a friendship with the children. And soon enough there came an understanding that there was an especial love between Rose and Ruskin that was not shared by Emily. He was as kind to Emily as anyone, but the sisters were not equal in his affection. In this peculiar way Ruskin became established in the La Touche household, and Rose became established in his life. It was irreversible,

not to be ended until Rose died and Ruskin died: 'Rose, in heart, was with me always, and all I did was for her sake.'[21]

This was true, but for the five years after 1858 much of Ruskin's work was desultory. It was almost as though he were waiting for something to happen to him, something that would give a new direction to his life. By 1862 or 1863 he would have to identify his feelings for Rose as love. That did not occur to him now. And in these years he was lionized, even pursued, by a number of women. Ruskin was eligible. Both he and his father had the occasional idea that he might marry again. The pain of his marriage was behind him: so was the scandal. He was handsome, rich, distinguished. At forty, he was in the prime of life. All the same, his close friendships with the opposite sex were all with comfortably, happily married women. They were with people like Lady Trevelyan, with Mrs Simon, now with Mrs La Touche and soon with Mrs Cowper. These are women to whom he writes long, intimate, affectionate letters. He never writes as much to the husbands, sending a greeting only, although he is friendly with them. Within such settled relationships Ruskin could adopt a romantic attitude in which flirtation was not absent. With Jane Simon he had some secrets; to her he dropped heavy hints about women, especially Mrs La Touche, 'a lady who will perhaps be a friend in the course of time, and who is in the stage of friendship which would have been offended for ever unless it had received two notes . . .',[22] and of whom, a little later, he wrote, again to Mrs Simon, 'Yes, I think you are really very jealous. I wonder whether the "other" fault would be brought out if I were to show you what nice long letters I get now — every week or so — without being much troubled to answer them — from the other lady friend who I was fishing for . . .'[23]

Such ponderous flirting, which Ruskin too much enjoyed, had to be set aside on two occasions when women declared themselves in love with him. The first was an American, a Miss Blackwell, who knew the Simons and was a painter. We learn of her through letters to John James Ruskin, to whom Ruskin later revealed this admirer.

The whole affair was so ludicrous and pitiable that I did not want you to be troubled with it — and still more — did not want to be troubled with it myself more than was needful. It appears this young person came from America expressly to see if I should suit her for a husband — and had been trying to get more intimate with me by all sorts of low cunning, until at last in a fit of passion she betrayed herself to Mrs Simon — who had suspected her long: — then the question was how to cut her most decisively — with least offence . . .[24]

Of Miss Blackwell we hear no more. Anna Blunden was for longer
Ruskin's suitor. An artist, she began by sending him poetry, which he
advised her not to publish. His first letters to her were written under
the impression that he was addressing a man: not for some time did
Anna reveal her sex, and not before she had assured Ruskin of her high
regard for his conduct at the time of his marriage. Her importunate
tactlessness Ruskin suffered for years; his patience broke down when
she declared her love, and the letter he wrote then is revealing:

My dear Anna,
Upon my word I believe you are the profoundest and entirest little
goose that ever wore petticoats. You write to me four pink pages
full of nonsense about daisies and violets and 'being nothing but a
poor flower' and then you fly into a passion at the first bit of advice I
give you — declare that you do not want any — but that *I* do — and
set yourself up for my adviser — controller — and judge. You fancy
yourself in love with me — and send me the least excusable insult I
ever received from a human being — it was lucky for you I only
glanced at the end and a bit or two of your long angry letter and then
threw it into the fire — else if I had come upon the piece which you
refer to today — about my being false — I might have burnt this one
as well, without even opening it. You little idiot! fancying you
understand my books — and then accusing me of lying at the first
word that puzzles you about yourself — fancying you love me, and
writing me letters full of the most ridiculous egotisms and conceits
— and disobeying the very first order I give you — namely to keep
yourself quiet for a few days — and talking about suffering because
you have set your fancy on helping a man whom you can't help but
by being rational. Suffering! — indeed — suppose you had loved
somebody whom you had seen —, not for an hour and a half, — but
for six or seven years — who *could* have loved you — and who was
married at the end of those years to someone who didn't love them,
and was not worthy of them. Fancy *that*, — and then venture to talk
of suffering again. You modern girls are not worth your bread and
salt — one might bray a dozen of you in a mortar and not make a
stout right-hearted woman out of the whole set. I suppose you have
been reading some of the stuff of those American wretches — about
rights of women. One of them came over from America the other
day determined to marry me whether I would or no — and amused
herself by writing letter after letter to me to slander my best friends.
By the way, in the end of that long letter of yours — there was
something about 'silencing the *only* tongue that pleaded for me' —
or some such phrase (I wish I could silence it — by the bye, if you

write any more letters, let them be on white paper — or depend
upon it the servants will open them — by mistake!) but are you
really goose enough to think I have no friends? what do you think of
Mrs Browning by way of a beginning — whom I have not written
to for nine months — though she loves me truly — while you force
me to waste my time writing to you. There again — you are so
simply ridiculous in every point that I can't find words for you.

Write to a London Banker in large business and see if you can get
him to answer love letters — and do you suppose that because my
business concerns human souls, and not bags of money — that I am
the more willing to interrupt it?

However, here is one more serious word for you — and try to
make some proper use of it. There was some nonsense in your long
letter about Britomart and Una. Both of them were in love with the
man they were to marry, and who loved them. *Every* young
women who loves a man who has not asked for her love, or at least
if she may not naturally look forward to his marrying her — has lost
proper control over her feelings: — praying to God to know
whether you are to do it — is the same thing as praying to Him to
know whether you are to jump down a precipice. God will not
answer such a prayer — and the Devil will. [25]

There was as much pain as anger in this letter. The extremity of
Ruskin's exasperation laid bare a longing of his adolescence. The
reference to Adèle shows us something that normally was hidden in
Ruskin, the memory of an emotion keener than any he had felt for his
wife. Anna had uncovered what Ruskin wished to forget: the view
that women fall in love at the devil's command refers to the buried
subject of the end of his marriage. In conventional social circles, one
has the impression in these years of Ruskin as a man with a winning
urbanity, even when taken aback. That is the picture given by the
account in *Prœterita* of a new friendship with a woman he had first seen
many years before. It was the beautiful Georgiana Tollemache, whom
he admired from afar as a youth in Rome. They were at a party, sitting
on a sofa, when he burst out with what must have been a pleasing
declaration:

Having ascertained in one moment that she was too pretty to be
looked at, and yet keep one's wits about one, I followed, in what
talk she led me to, with my eyes on the ground. The conversation
led to Rome and, somehow, to the Christmas of 1840. I looked up
with a start; and saw that the face was oval, — fair, — the hair,
light-brown. After a pause, I was rude enough to repeat her words,

'Christmas in 1840! — were you in Rome *then*?' 'Yes,' she said, a
little surprised, and now meeting my eyes with hers, enquiringly.
Another tenth of a minute passed before I spoke again. 'Why, I lost
all that winter in Rome hunting you!'[26]

Georgiana Tollemache was now Mrs William Cowper. She and her
husband were to play an important part in Ruskin's future life. Their
names were to change twice in the coming years. They became the
Cowper-Temples in 1869 and Lord and Lady Mount-Temple in 1880.
That was because of William Cowper's noble birth and, it was said at
the time, because of its irregularity. The gossip was so generally
accepted that we can use the account of a friend of the family, Logan
Pearsall Smith. 'Cowper Temple', he explains,

> . . . was in law the son of Earl Cowper, but said to be the son of
> Lord Palmerston, who had long been Lady Cowper's friend, and
> who married her when Lord Cowper died. Their son had inherited
> Lord Palmerston's estates and great house at Broadlands; and the
> problem of this double paternity, if I may put it so . . . had been
> successfully regulated by the young William Cowper's adding Lord
> Palmerston's family name of Temple to that of Cowper in a double
> appelation. After acting as secretary to his unavowed father, he
> served in several posts in the governments of the time and was
> raised to the peerage as Lord Mount-Temple . . .[27]

Those 'several posts', no doubt easily available in the many Whig
governments of the mid-century, were as Junior Lord of the Treasury,
Junior Lord of the Admiralty, Under-Secretary for the Home
Department, President of the Board of Health, First Commissioner of
Works, and the like: not the appointments that would be given, one
after the other, to an exceptionally ambitious or talented man. People
remembered his wife more than him. Georgiana was now in her late
thirties. She was vague, sweet-natured, hospitable; a trifle theatrical in
her manner, yet not a seeker for attention; she was comforting, rather,
a helpful woman who found herself in sympathizing with other peo-
ple's problems. Later, Ruskin was to find her too bland, a person
without an edge. This was when he took many troubles to her about
his marriage and about Rose, the girl he wished to marry. Now, in the
late 1850s, he was simply pleased to know her and quite interested to
know her husband, and enjoyed the first of many visits to the family
home at Broadlands.

CHAPTER FIFTEEN

1858–1859

A proud entry in John James Ruskin's 1858 diary reads: 'March 10th Wednesday John began 5th Volume Modern Painters.'[1] Neither father nor son had much idea what the volume would contain, although they had realized that it ought to end the book. As soon became apparent, at least to its author, to approach a conclusion was to magnify the difficulties in making a new start with each volume while also relating new matter to old. To finish *Modern Painters*, now, was not merely to terminate a body of work, nor to finalize a scheme of art. The book represented twenty years of growth, revelation, reconsideration, and to conclude it was to conclude a part of Ruskin's life. It was that portion of his life that he owed to his father. John James was now seventy-five. Ruskin knew as his father knew that this fifth and last instalment would probably be the last thing he wrote for him. These matters were not spoken of.

It is possible to find many an intellectual influence in *Modern Painters* V, and more than one stylistic influence. Despite its grave tone and elevated subject-matter it is also one of Ruskin's books in which we find traces of his daily life in London. They are perhaps the more evident because there was so much in his life that was half decided. He was caught between new experiences and the doubting of old experiences. There was no certainty to drive forward the preparation of the fifth volume, and for this reason Ruskin felt little affection for his book. He looked widely for stimulus, even to James Russell Lowell in America. To Lowell he admitted being able

> . . . only to write a little now & then of old thoughts — to finish Modern Painters, which *must* be finished. Whenever I can write at all this winter I must take up that for it is tormenting me, always about my neck. — If no accident hinders it will be done this spring and then I will see if there is anything I can say clearly enough to be useful in my present state of mystification . . .[2]

Part of Ruskin's problem was that there was no one person with whom he might discuss the contents of his book. This was to be a volume that wandered far from John James's conception of the world. The last gift was the one in which the companionship between the two men was least evident. Instead, we have a book in which we hear the

echoes of conversations with schoolgirls, or with the painter John
Brett; that recapitulates talk with G. F. Watts, Tennyson, and the
Brownings; that at some points seems to bring Ruskin closer to the
Richmond family than he had been for years; and in the aftermath of
the Crimea is thoughtful of war. *Modern Painters* V is in this sense a
contemporary book. But in fact it retreats from the art of the day,
from modern painting. It closes Ruskin's writing on Turner as it bids
farewell to his committed response to the art of his contemporaries.

The first number of *Academy Notes* had taken up some observations
made in the second volume of *Modern Painters*. The last of the series
Ruskin published in 1859: the pamphlet is rather unlike his current
major work. Some sections of this *Academy Notes* are ordinary. One or
two entries have a private background: there is praise of a (probably)
unremarkable picture by 'A. Blunden'. As so many people did, every
year, one turns first to the verdict on Millais's contributions. In this
exhibition they were *The Vale of Rest* and *Apple Blossoms*. But those
few who followed Ruskin's thinking with care would have wished to
see what he made of the painting he had encouraged, in part super-
vised, and had now purchased, John Brett's *Val d'Aosta*. Evidently,
Ruskin now felt that there was more to Brett than to Millais, if only in
potential. The *Val d'Aosta*, he argued, was 'landscape painting with a
meaning and a use . . . for the first time in history we have, by help of
art, the power of visiting a place, reasoning about it, and knowing it,
just as if we were there . . .'. Ruskin then uses the picture to describe
the agronomy of the valley. But it is clear that art should have a higher
function. Although he does not use the word, Ruskin returned to his
theories of the imagination in finally criticizing the painting: 'It has a
strange fault, considering the school to which it belongs — it seems to
me wholly emotionless. I cannot find from it that the painter loved, or
feared, anything in all that wonderful piece of the world . . . I never
saw the mirror so held up to nature; but it is Mirror's work, not
Man's.'[3]

Thus was dismissed Brett's painting. Soon afterwards his friendship
with Ruskin, such as it was, came to an end. *Modern Painters* V, which
at one point acknowledges him, is full of longing for a kind of painting
that Brett could not provide. His Swiss landscape was the second high
point, as Millais's Glenfinlas portrait had been the first, of that natural-
ism in English painting which Ruskin had done so much to foster. But
Ruskin wanted more from naturalistic art. He wanted passion and he
increasingly wanted some kind of symbolism. It was not quite in
Pre-Raphaelitism, not even in Rossetti's, to provide the satisfaction
that comes from such art. But it was there in Turner. Ruskin now

found that he could gather more and more from the painter he had first admired, especially if he allowed Turner's thematic implications to settle and grow in his own imagination. Unconsciously or not, Ruskin looked into Turner for themes that were mythological rather than literary. This pleased a cast of his mind which sought a veracity grander and more mysterious than simple fidelity to nature. How thin and contrived, therefore, appeared Millais's invented symbolist painting, *The Vale of Rest*: what depth of meaning that picture feigned to possess already existed, ten times over, in Turner.[4]

Much of this cloudy conviction was found in Turner's Greek painting. The young Ruskin had felt it his Christian duty to attack Greek culture. But for years past he had been thinking more of the spirituality of the pagan world. His thoughts were occasionally expressed in public, in such places as the chapter 'Of Classical Landscape' in *Modern Painters* III, but more often they were kept to conversations with friends. Such friends were usually artists: they were not churchmen. Ruskin's sense of Greece did not move in strict measure with the fluctuations of his Christianity. But he allowed his instincts to find a relationship between the world of the ancient gods and the world that belonged to Christ. His study of myth was not scientific, nor archæological. He had no real feeling for the classical tradition. His Greek preoccupations — so marked in *Modern Painters* V — were more individual than they were akin to Turner's. His dark, emblematic books on Greek themes in the 1860s have no parallel in other literature of the day, though many Victorian intellectuals wrote on Greek culture. The great exponent of this kind of painting was G. F. Watts, and for him Ruskin now felt a sympathy that heretofore had been rather distant. However, Ruskin's appreciation of Watts's art hardly entered his public writings. The most telling comments are in private letters, from which we gather that Ruskin had benefited from discussions with an artist who knew as much about Titian as did the Richmonds and whose themes evoke, if they do not describe, the ancient world.

Ruskin's commendations of Titian are found at all stages of his career, but his feeling for the artist is not easily grasped. In the late 1850s there were people who heard Ruskin talk of Titian and believed his talk to be empty. One of these was probably the visually uneducated Tennyson, with whom Ruskin had a slight, wary friendship. There exists a vignette of Ruskin, by himself, in the company of this other great Victorian. In the spring of 1859 he wrote to a correspondent in the provincial north of England, a schoolmistress:

Any person interested in the art and literature of Young England would have been glad if they could have had a good sketch of one or two bits of scene yesterday.

You must have heard people speak of Watts — He's named with Rossetti sometimes in my things — the fresco painter — a man of great imagination & pathetic power: — he is painting Tennyson's portrait — both staying at the pleasant house of a lady to whose kind watching over him in his failing health, Watts certainly owes his life: — Mrs Prinsep — an old — (as far as a very beautiful lady of about eight-and-thirty can be so injuriously styled —) friend of mine also.

One of the scenes that perhaps you and one or two other people would have liked to have sketched, was this — Watts lying back in his arm chair — a little faint — (he is still unwell) with Tennyson's P.R.B. illustrated poems on his knee. Tennyson standing above him — explaining over his shoulder why said illustrations did not fit the poems, with a serious quiver on his face — alternating between indignation at not having been better understood, and dislike of self-enunciation: — I sitting on the other side of Watts — looking up deprecatingly to Tennyson — & feeling very cowardly in the good cause — yet maintaining it in a low voice — Behind me as backer Jones, the most wonderful of all the PreRaphaelites in redundance of delicate & pathetic fancy — inferior to Rossetti in depth — but beyond him in grace & sweetness — he, laughing sweetly at the faults of his own school as Tennyson declared them and glancing at me with half wet half sparkling eyes, as he saw me shrink — A little in front of us — standing in the light of the window Mrs Prinsep and her sister — two, certainly, of the most beautiful women in a grand sense — (Elgin marbles with dark eyes) — that you would find in modern life — and round the room — Watts' Greek-history frescoes. Tennyson's face is more agitated by the intenseness of sensibility than is almost bearable by the looker on — he seems to be almost in a state of nervous trembling like a jarred string of a harp. He was maintaining that painters ought to attend to at least what the writer *said* — if they couldn't, to what he meant — while Watts and I both maintained that no good painter could be subservient at all: but must conceive everything in his own way, — that no poems ought to be illustrated at all — but if they were — the poet *must* be content to have his painter in partnership — not a slave.[5]

The 'Jones' of this letter had not yet changed his name to Burne-Jones. Still now in his twenties, Jones already had a reputation in just the sort

of company Ruskin's letter describes. Indeed, he was hardly known elsewhere. He owed his convenient insulation from the difficulties of an early career to Rossetti and Ruskin. From Rossetti he derived his art, and it was Rossetti who had first introduced him, with his comrade William Morris, to the critic. As undergraduates, not many years before, Jones and Morris had read *The Stones of Venice* aloud to each other. To be taken up by Ruskin himself was wonderful good fortune. William Morris did not greatly interest Ruskin. But for 'Ned' he felt immediate and unshakeable affection. This was partly because they avoided the issues raised by Burne-Jones's art. Ruskin had a feeling that it might represent the next phase of Pre-Raphaelitism. Yet he made no attempt to mould Jones to the form of his own beliefs. He gave him no instruction whatever, only gifts. Nor did he mention him in print. It was to be fully eleven years before he gave public approval to his painting. This was in a lecture at the Royal Institution in 1867. The address he gave was quite important, and fully written out, but Ruskin never published it. Nearly another two decades passed before, in his last Oxford lectures, Ruskin again praised Burne-Jones before an audience. This was in 1883. The man had meant more to Ruskin than his art: and by then the art meant more to him in memory than in reality.

In 1859 Ruskin was not sure what new art he wanted. An appendix to that year's *Academy Notes*, the last of the sequence, gives a couple of pages to two exhibitions of water-colour societies. It is one of the first of the occasions, numerous later on, where we find an important statement in a comparatively minor or sequestered part of his works. He wrote here that English water-colour was 'in steady decline', that it was characterized by falseness and vulgarity, and that art itself, not merely water-colour, now suffered from 'the loss of belief in the spiritual world'. This sentiment was not totally new. But the prescription was startling. Ruskin argued, 'Art has never shown, in any corner of the earth, a condition of advancing strength but under this influence. I do not say, observe, influence of "religion" but merely of a belief in some invisible power — god or goddess, fury or fate, saint or demon.'[6] He was calling for an art of spiritual power which did not exist and could hardly be produced on demand. The difference was in his appeal to invisible powers which might not be Christian. In the context of his previous writings this was little less than impious. When he came to write out similar thoughts in the last volume of *Modern Painters* he rather clothed and obscured them. He wrote in such a fashion as, conceivably, to hide from his mother the loss of the Evangelical thrust with which the work began.

As *Academy Notes* went to press, Ruskin's parents were uppermost in his mind. The old people were as vigorous as ever in the way that they read and argued. Travelling, however, was difficult for them: Margaret Ruskin had scarcely been into London in the last few years. They wanted to spend one more summer on the Continent. It was to be a German expedition. Ruskin felt that he ought to study the Titians in German collections before writing any more about Venetian Renaissance art. Furthermore, at the National Gallery Site Commission in 1857 he had been embarrassed by questions put to him by two enemies, Effie's friend Dean Milman and the academic architect Charles Cockerell.[7] They had made him admit ignorance of German art galleries. And so the last family tour went from Brussels to Cologne, Berlin, Dresden and Munich. Ruskin found that contemporary art was no better in Protestant Germany than in France or Italy. To Clarkson Stanfield, whose abilities had been kindly surveyed in previous volumes of *Modern Painters*, he wrote condemnations of the Nazarene school. None of the party really felt at ease in Germany. Ruskin liked Nuremberg: but he was glad to find his old routes from Schaffhausen to Geneva. Leaving his parents there, he climbed to Chamonix in search of the original inspiration and the original material of *Modern Painters*. When the family reunited they travelled quickly to Paris and thence returned to London. It had not been a particularly exciting tour, and much sadness was mixed with the pleasures the Ruskins could always find for themselves. Nor was the expedition helpful to Ruskin's book. In the end his father had to insist on its completion. Ruskin did not confess how this came about until many years later, in an Oxford lecture. His address to undergraduates on *Modern Painters* was largely unscripted, but among the notes Ruskin wrote is this reminiscence:

Now the thing which I have especially to thank my father for is that he made me finish my book . . . He made me finish it with a very pathetic appeal. For fifteen years he had seen me collecting materials, and collecting and learning new truths, and still learning — every volume of the four pitched in a new key — and he was provoked enough, naturally, and weary of waiting. And in 1859 he took his last journey with me abroad; and when he came home, and found signs of infirmity creeping on him, and that it were too probable he might never travel far more, until very far, he said to me one day, 'John, if you don't finish that book now, I shall never see it.' So I said I would do it for him forthwith; and did it, as I could.[8]

* * * *

Immediately after this German tour Ruskin left his parents at
Denmark Hill while he went to stay for three weeks at a girls' school in
Cheshire. This was Winnington Hall, near Northwich. He had been
there once before, briefly, in the spring before leaving for Germany.
Ruskin had then found, to his surprise, that he enjoyed the company of
schoolchildren. He wanted to go there again. He was indulged at
Winnington; and after the strain of conducting his parents through
Europe it was a relaxation to talk to young girls. The school was a
retreat, and in some ways it became a second home. For the next ten
years it provided a background for some of the happiest moments of
his adult life.

Winnington Hall lay just outside the growing industrial area of
Manchester. The school had taken over an old manor house, set
among lawns and gardens. Its headmistress was Margaret Alexis Bell.
She had first met Ruskin when he gave his lectures in Manchester in
1857. Their friendship had developed slowly. Neither had met anyone
quite like the other. Ruskin felt that he had to explain himself to Miss
Bell: it was to her that he had addressed the long letter describing his
conversation with Watts and Tennyson. The world of metropolitan
Victorian culture was important to the determined Margaret Bell. In
some ways she wished to join it. She had been born into an unyielding
type of northern Methodism but she now held liberal religious opin-
ions, mostly derived from broad church Anglicanism. She followed
recent literature. She wished to appreciate art. Like many a headmis-
tress who owned her own school, she had a slightly uncertain social
status. But she was not much concerned with the usual appearances of
gentility. Her educational views were progressive, as Ruskin now
came to understand. He had some distant acquaintance with school
education, for he was in a position to give places at Christ's Hospital (a
privilege inherited from his father's City connections). But of girls'
schools he knew nothing. When he found that there were Turners on
the walls at Winnington, that drawing and water-colour were central
parts of the curriculum, that study was mingled with play and that
nothing was learnt by rote, Ruskin was made curious. To see his own
portrait hanging side by side with F. D. Maurice's only emphasized
the differences between this happy place and the Working Men's
College;[9] and Ruskin began to wonder what his influence in it might
be.

* * * *

A life half lived, with so much left to do; a growing sense of being
wiser; a feeling that he was witnessing the approach of his father's
death; a hardly sentient understanding of what Rose La Touche meant
to him: all these things and more were in Ruskin's mind as Christmas
of 1859 and the new year of 1860 approached. In February he would
be forty-one. He had found much success in the world but had also
learnt that public opinion is valueless. His troubles with the Royal
Academy, the National Gallery, and indeed the Working Men's Col-
lege, had all shown him that such institutions were too worldly for the
spirit of Turner he had tried to communicate. He had lost hope for
architecture when the Oxford Museum was built. He no longer felt
that he wanted to make comrades of artists. To one, J. J. Laing, who
had written enthusiastically of the spreading influence of Pre-
Raphaelitism, he replied bleakly, 'I entirely disclaim all parties, and all
causes of a sectarian or special character.'[10] One notices how drawn he
was at this time to people whose own concerns were inapposite,
nothing to do with his own: Spurgeon, whose vision of heaven was so
clear, or little Rose La Touche, or the girls at Winnington, or Ameri-
cans. Ruskin looked often to Carlyle. But he did not feel the need of
him that would come later on, and was not yet writing for Carlyle's
approval. He had to finish *Modern Painters* for his father: but he did not
know whether John James would like his last volume and he did not
know what he would write next, or who it would be for. He had no
obligation ever to write a book again. He told the Brownings that he
wanted 'to be able to take a few years of quiet copying, either nature or
Turner — or Titian or Veronese or Tintoret — engraving as I copy. It
seems to me the most useful thing I can do. I am tired of talking.'[11]
Ruskin's diaries are empty in these months, and his correspondence is
not vigorous. It would take a couple of years, and the realization that
he was in love, before he once again found a confident voice in which
to address the world.

A SHORT LIST OF THE CHIEF BOOKS CITED

Quotations from Ruskin's published works are taken from the Library Edition, *The Works of John Ruskin*, ed. E. T. Cook and Alexander Wedderburn, 39 vols., London, 1903-12. References are given by volume and page number thus: (XVI. 432). Place of publication of titles referred to in the Notes is London unless otherwise stated. Frequently cited books are abbreviated as follows:

Diaries. *The Diaries of John Ruskin*, ed. Joan Evans and John Howard Whitehouse, 3 vols., Oxford, 1956-9.

RFL. *The Ruskin Family Letters. The Correspondence of John James Ruskin, his Wife, and their Son John, 1801-1843,* ed. Van Akin Burd, Ithaca and London, 1973.

RSH. Helen Gill Viljoen, *Ruskin's Scottish Heritage*, Urbana, Illinois, 1956.

RI. *Ruskin in Italy. Letters to his Parents 1845*, ed. Harold I. Shapiro, Oxford, 1972.

RG. Mary Lutyens, *The Ruskins and the Grays,* 1972.

EV. Mary Lutyens, *Effie in Venice*, 1965.

MR. Mary Lutyens, *Millais and the Ruskins*, 1968.

NOTES

Chapter One

1. On all these matters see RSH and RFL. Both Professor Viljoen and Professor Burd provide information about Ruskin's ancestry. RSH has an appendix covering 'The Edinburgh Ruskins and their descendants and relatives of Croydon'. RFL contains a family tree.
2. XXXV, 62.
3. XXXV, 62.
4. XXXV, 18.
5. Ms Præterita Beinecke Library, Yale University.
6. From Sir Albert Gray's papers concerning his family and the Ruskins. Bodley Ms Eng Letts c 228.
7. JJR-Catherine Ruskin, 5 Oct 1812, RFL 54.
8. RSL, 116. See also RFL, 64n-65n.
9. JJR-George Gray, 31 Aug 1848, RG 150.
10. JJR-Catherine Ruskin, 13 Apr 1815, RFL 76.
11. JJR-Catherine Ruskin, 30 Jun 1815, RFL 79.
12. XXXV, 15-16.
13. XXXV, 34.
14. JJR-MR, 23 Jun 1819, RFL 95.
15. JJR-MR, 6 Dec 1829, RFL 211-12.
16. See RFL, 374-413 for this journey.
17. MR-JJR, 10 Apr 1820, RFL 98.
18. XXVIII, 345-6.
19. MR-JJR, 30 Jan 1822, RFL 109.
20. These favourite chapters are discussed by Viljoen in RSH 162.
21. The Bibles are described and illustrated in W. G. Collingwood, Ruskin Relics, 1903, 193-213.
22. XXXV, 40.
23. XXXV, 39-40.
24. JR-JJR, 15 Mar 1823, RFL 127-8.
25. XXXV, 88.
26. XXXV, 131.
27. Ms Bembridge 28.
28. JJR-JR, 6 Nov 1829, RFL 209-10.
29. JR-JJR, 10 May 1829, RFL 199-200.
30. To Jane Simon, for instance. Bembridge Ms L 12.
31. XXVI, 294n.
32. XXXV, 75.
33. XXXV, 63.

34. JJR-R. Gray, 17 Jan 1833, RFL 276.
35. XXXV, 16.
36. II, 286-97.
37. XXXV, 25.
38. Howels is identified in a letter from Ruskin to Joan Severn which includes both a letter from Howels and this contemporary comment; JR-JRS, 3 Jan 1876, Ms Bembridge L 41. The Præterita passage was taken from Fors, but Ruskin evidently did not correct the mistaken name when the autobiography was issued. For Howels see also Edward Morgan, A Memoir of the Life of William Howels, 1854.
39. XXVIII, 297-8.
40. For Andrews (and other clergy in the area) see E. G. Cleal, The Story of Congregationalism in Surrey, 1908, 105.
41. XXXV, 132.
42. MR-JJR, 10 Mar 1831, RFL 242.
43. MR-JJR, 10 Mar 1831, RFL 243.
44. JR-JJR, 19 Jan 1829, RFL 173.
45. See Van Akin Burd, The Winnington Letters, 1969, 60n.
46. XXXV, 25.
47. XXXV, 143.
48. XXXV, 73.
49. XXXV, 142.
50. XXXV, 143.
51. JJR-Mary Russell Mitford, 17 Dec 1853, Ms Bembridge L 11.
52. JR-JJR, 27 Feb 1832, RFL 267-8.
53. XXXV, 115.
54. Ms Bembridge 33.
55. II, 387. See also 359-68.
56. The description of the tour is at II, 340-87.
57. See XXXVIII, 3 et seqq. for Ruskin's publications. His first appearance in print was with 'On Skiddaw and Derwent Water', a poem in the Spiritual Times, Feb 1830, II, 265-6.
58. XXXIV, 365.
59. XXXV, 395.
60. XXXV, 83.
61. XXXV, 139-40.
62. See J. Garden, Memorials of the Ettrick Shepherd, 1894, 273-7.
63. I, xxviii.
64. XXXV, 102-3.
65. JJR-W. H. Harrison, 6 Jan 1839, Ms Bembridge L 5.

66. See George Croly, *Historical Sketches, Speeches and Characters*, 1842, 45 *seqq.*, and 310 *seqq.*

67. *Don Juan*, XI, Cantos 57-8.

68. XXXIV, 95.

69. The majority of Ruskin's diaries are preserved at Bembridge. References are given in this book to the published version (ed. Joan Evans and John Howard Whitehouse, Oxford, 1956-9), but also to the Bodleian Library transcripts, which contain the full text, and to the original volumes, in which there are diagrams and drawings.

70. VI, 476.

71. 3 Jun 1835, Diaries 2.

72. XXXV, 152.

73. XIV, 389-91.

74. XXXV, 179.

75. XXXV, 179.

76. XXXV, 180.

77. XXXV, 180.

78. JJR-George Gray, 28 Apr 1847, RG 27.

79. JR-JJR, 25 Mar 1836, RFL 350.

80. The *Iris*, 1834.

81. The essay is printed at I, 357-75.

82. XXXV, 217.

83. Extracts from Eagles's review are at III, xviii.

84. Ruskin's defence was found among his papers after his death. It is printed at III, 635-40.

85. XXXV, 218.

Chapter Two

1. XXXV, 191-2.

2. XXXV, 193.

3. XXXV, 610.

4. G. W. Kitchin, *Ruskin in Oxford and Other Papers*, 1904, 27-8.

5. JR-JJR, 12 Aug 1862, *The Winnington Letters*, ed. Van Akin Burd, 1969, 369-70.

6. XXXV, 196.

7. For Gordon see G. Marshall, *Osborne Gordon*, 1885.

8. XXXV, 252.

9. XXXV, 198.

10. H. L. Thompson, *Henry George Liddell*, 1899, 215n.

11. A. J. C. Hare, *The Story of my Life, 1896-1900*, V, 358.

12. Liddell-Acland (1854). Bodley Ms Acland d. 69.

13. XXXV, 205.

14. The manuscript of *Præterita* is preserved in the Beinecke Library, Yale University. Some plans, notes and passages are in Ruskin's diaries. For these extracts see S. E. Brown, 'The Unpublished Passages in the Manuscript of Ruskin's Autobiography', *Victorian Newsletter*, 16, Fall 1959, 10-18.

15. XXXV, 229.

16. JJR-MR, 13 Mar 1840, RFL 667.

17. 28 Dec 1839, Diaries 73.

18. 12 Mar 1841, Diaries 165.

19. I, xliii.

20. JJR-W. H. Harrison, 9 Jun 1839. Ms Bembridge L 5.

21. XXXV, 255-6.

22. XXXV, 259.

Chapter Three

1. 22 Jun 1840, Diaries 82.

2. XXXV, 305.

3. JJR-JR, 20 Apr 1842, RFL 734.

4. II, 343.

5. W. G. Collingwood, *The Life and Work of John Ruskin*, 1900, 75.

6. 31 Mar 1840, Diaries 74.

7. 15 Nov 1840, Diaries 110.

8. I, 380.

9. I, 381-2.

10. Mary Richardson's diary, 30 May 1840, Ms Bembridge T 49.

11. JJR-W. H. Harrison, n.d., Bodley Ms Eng Letts c 32 fol 55.

12. Mary Richardson's diary, 7 Feb 1840, Ms Bembridge T 49.

13. Mary Richardson's diary, 3 Apr 1840, Ms Bembridge T 49.

14. XXXV, 274-5.

15. XXXV, 275.

16. For George Richmond and his family, see A. M. W. Stirling, *The Richmond Papers*, 1926, and Raymond Lister, *George Richmond*, 1981.

17. JJR-W. H. Harrison, 25 Dec 1840, Bodley Ms Eng Letts c 32 fol 54.

18. For Ruskin's relations with Zorzi, see Jeanne Clegg, *Ruskin and Venice*, 1981, 183-7.

19. XXXV, 297.

Chapter Four

1. XXXV, 299.

2. XXXV, 304, *The King of the Golden River* was perhaps too long for *Friendship's Offering*, or Ruskin was perhaps unwilling to publish it there. John James wrote to W. H. Harrison that 'I expect in a week to receive manuscript of a Fairy Tale but which I must to follow orders dispatch to Scotland directly. I should like when it comes for you to cast your eye over it . . . if it would do for any monthly

. . .', 27 Sep 1841, Bodley Ms Eng Letts c 32 fol 78.

3. JJR-JR, 25 Aug 1841, RFL 680.

4. XXXV, 306.

5. See, for instance, the similarities between MPI and Harding's *The Principles and Practice of Art*, 1845. There are a number of stories of Harding's later opposition to *Modern Painters*. Ruskin claimed that Harding was jealous of the position given to Turner (XXXV, 401). Henry Holiday describes a Harding drawing class in 1858. Holiday had been drawing a large landscape from nature. '"What", [Harding] said, "are you a Pre-Raphaelite?" "I am." The diplomatic sky darkened and his face was itself a declaration of war. He at once attacked what he assumed to be my main body, viz., Mr Ruskin, and opened fire with two charges. 1st, that the writings of his renegade pupil were a mass of pernicious heresies; and 2nd, that they were merely a re-cook of his (Mr Harding's) own works on art . . .' Henry Holiday, *Reminiscences of my Life*, 1914, 49.

6. Ruskin thought Prout a little staid but always remembered him kindly, perhaps because the artist died after the party John James held for his son's birthday, while Ruskin was in Venice in 1852. W. H. Harrison recalled him 'at dinner at Mr Ruskin's . . . in wonderful spirits, and I remember his challenging me in a glass of champagne, and my rallying him on some circumstance . . . He was stepping into his carriage at the door at night, and shook hands very heartily, adding, "Why don't you come and see me?" This was eleven o'clock, and before twelve he was dead.' Harrison, 'Notes and Reminiscences', *University Magazine*, May 1878, 545.

7. 6 Jul 1841, Diaries 209.

8. XIII, 478.

9. XXXV, 309-10.

10. XXXV, 311.

11. XXXV, 314.

12. XXXV, 316.

13. Ruskin's correspondence with Clayton was published in 1894 as *Letters Addressed to a College Friend 1840-1845*. Some additional letters are at Bembridge. See I, 407-502.

14. Ruskin's degree has puzzled historians. The most reasonable explanation is Collingwood's. 'He could not now go in for honours, for the lost year had superannuated him. So in April he went up for a pass. In those times, when a pass-man showed unusual powers, they could give him an honorary class; not a high class, because the range of the examinations was less than in the honour-school. This candidate wrote a poor Latin prose, it seems;

but his divinity, philosophy, and mathematics were so good that they gave him the best they could — an honorary double fourth.' W. G. Collingwood, *Life*, revised ed., 1911, 69.

15. III, 665-6. The letter is dated 10 Mar 1844.

16. XXXV, 381.

17. A. M. W. Stirling, *The Richmond Papers*, 1926, 138.

18. 8 Feb 1843, Diaries 242.

19. 24 Feb 1843, Diaries 245.

20. 1 May 1843, Diaries 245.

21. The circumstances are explained at III, xxxii. A number of John James's letters to Harrison are concerned with the shortcomings of magazines and their publishers. It is the father of *Fors Clavigera* who writes 'I have *used my endeavours* to peruse Blackwood from old associations but in vain . . . you are right in a good monthly being wanted, but to start a new one would require a devotion to the Cause of more than one amateur of large fortune, for *publishers* are the smallest souled merchants in London — hard ignorant blockheads iron hearted pawnbrokers — receiving brains in pawn, doling out the merest pittance . . .' JJR-W. H. Harrison, 16 Dec 1843, Ms Bembridge L 5.

22. See William Knight's *Life of William Wordsworth*, 1889, II, 334, III, 243.

23. *Alfred, Lord Tennyson*, A Memoir by his Son, 1897, I, 223.

24. *The Letters of Elizabeth Barrett Browning*, ed. F. G. Kenyon, 1897, I, 384.

25. *Macmillan's Magazine*, Aug 1891, lxiv, 280.

26. J. W. Cross, *The Life of George Eliot*, 1885, II, 7.

27. John James Ruskin's press cuttings books are preserved in the library of the Ashmolean Museum, Oxford.

28. XXXV, 401.

29. III, 668. The letter is dated 12 Oct 1844.

30. 27 May 1843, Diaries 248.

31. 21 Nov 1843, Diaries 249.

32. 12 Dec 1843, Diaries 254.

33. III, 571-3.

34. 24 Nov 1843, Diaries 250.

35. III, 571-3.

36. *Macbeth*, II, 2, 64.

37. XXXVI, 81. The letter is dated 28 Sept 1847.

38. XXVI, 219-20.

39. XXXV, 329.

40. XXXV, 325.

41. XXVI, 222.

42. XXXVI, 38-9. The letter is dated 12 Aug 1844. The Hotel Meurice, in the rue de Rivoli, was used by Ruskin until his last visit to Paris

in 1881.
43. 20 Oct 1844, Diaries 318.

Chapter Five

1. XXXVI, 406.
2. XX, 25, and see also VII, 453 and XVIII, 148.
3. JR-Thomas Carlyle, 12 Jun 1867, in *The Correspondence of Thomas Carlyle and John Ruskin*, ed. G. A. Cate, Stanford, California, 1982, 136.
4. XXXV, 341-2.
5. JR-Acland, 27 Dec 1844, Bodley Ms Acland 4 b-c.
6. JR-JJR, 10 Apr 1845, RI 13.
7. XXXV, 346.
8. JR-JJR, 3 May 1845, RI 51.
9. IV, 347.
10. JR-JJR, 6 May 1845, RI 55.
11. XXXV, 346.
12. 8 Nov 1840, Diaries 106.
13. 18 Nov 1840, Diaries 108.
14. JR-JJR, 18 May 1845, RI 67.
15. JR-JJR, 18 May 1845, RI 68.
16. Ibid.
17. JR-JJR, postmarked 21 Jun 1845, RI 123.
18. JR-JJR, 22 Jun 1845, RI 124.
19. JR-JJR, 16 Jul 1845, RI 148. This was in Milan.
20. JR-JJR, 27 Jul 1845, RI 163. In fact Turner would never leave England again.
21. XXXV, 369.
22. JR-JJR, 6 Aug 1845, RI 168.
23. JR-JJR, 10 Aug 1845, RI 170.
24. JR-JJR, 15 Aug 1845, RI 172.
25. JR-JJR, 10 Sept 1845, RI 198.
26. JR-JJR, 11 Sept 1845, RI 200.
27. JR-JJR, 14 Sept 1845, RI 202.
28. JR-JJR, 4 Sept 1845, RI 211-12.
29. JR-JJR, 28 Sept 1845, RI 216.
30. 4 Jan 1846, Diaries 321-2.
31. 19 Jan 1847, Diaries 322. The entry is a long gloss on that of 4 Jan 1846.
32. IV, 60.
33. See the 'Epilogue' to the 1883 edition, IV, 343-57, which describes the 1845 tour and 'the temper in which, on my return to England, I wrote the second volume of *Modern Painters*'.
34. W. G. Collingwood, *The Art Teaching of John Ruskin*, 1891, 117.
35. XXXV, 413.
36. A. J. Finberg, *Life of J. M. W. Turner*, 1939, 418.
37. On the other hand, it is clear from his writings that Ruskin had amassed a great deal of Turner lore in the early years of his

involvement with the artist. No doubt this came from other artists, other collectors, and from Griffith. Some of these matters are dealt with in vol. XIII of the Library Edition, but there is no modern book on Ruskin's knowledge of Turner, except for the necessarily partial (but excellent) volume by Luke Herrmann, *Ruskin and Turner: A Study of Ruskin as a Collector of Turner, Based on his Gifts to the University of Oxford*, (1968).
38. XIII, 167.
39. JR-Griffith, 31 Nov 1854, Ms Bembridge T 73.
40. Famous for his *Horæ Subsecivæ* (1858-61 and 1882), which includes the celebrated dog story 'Rab and his Friends'. See *Letters of Dr John Brown*, ed. by his son and D. W. Forrest, with biographical introductions by Elizabeth T. M'Laren, 1907.

Chapter Six

1. *Church of England Quarterly Review*, July 1846, 205.
2. VIII, 95n.
3. XXXV, 418-19.
4. JJR-W. H. Harrison, Venice, 25 May 1846, Bodley Ms Eng Letts c 32 fol 243.
5. XXXVI, 64. The letter is dated 30 Aug (1846).
6. XXXV, 422.
7. XXXV, 249.
8. XXXV, 422.
9. XXXV, 249.
10. XXXV, 422.
11. JR-JJR, postmarked 21 Jun 1845, RI 123.
12. Ibid.
13. Quoted in RI, 123n.
14. XXXV, 422.
15. XXXV, 423.
16. XXXV, 249.
17. XXXV, 422.
18. VIII, xxv. The letter is dated 18 Mar 1847.
19. Ibid.
20. JJR-George Gray, 28 Apr 1847, RG 32-3.
21. ECG to her mother, 28 Apr 1847, RG 32-3.
22. ECG to her mother, 4 May 1847, RG 35.
23. ECG to her mother, 5 May 1847, RG 35.
24. ECG to her mother, 5 May 1847, RG 35-6.
25. XXXV, 423.
26. XXXVI, 71.
27. JJR to his parents, 27 Jun 1847, VIII, xxv-xxvi.
28. 30 Jul 1847, Diaries 351.
29. 21 Aug 1847, Diaries 362.
30. 25 Aug 1847, Diaries 364.

Chapter Seven

1. See XVII, 417-22, 'Of Improvidence in Marriage in the Middle Classes; and of the Advisable Restrictions of it', a letter from *Time and Tide*.

2. JR-ECG, 2 Nov (1847), Ms, Private Collection. This and other letters of the period are discussed in Mary Lutyens, 'From Ruskin to Effie Gray', *Times Literary Supplement*, 3 March 1978.

3. JR-ECG, 6 Mar (1847). Ms, Private Collection.

4. By a coincidence which must later have struck Margaret Ruskin as ominous, the Gray family had moved into Bowerswell in 1829.

5. JJR-George Gray, 23 Feb 1848, RG 90-1.

6. The evidence about Ruskin's wedding night has been collected by Mary Lutyens. See MR, 154-7.

7. MR 188-92.

8. ECG-George Gray, 25 Mar 1854, MR 156.

9. MR 188-92.

10. MR 219.

11. ECG-George Gray, 10 Jun 1848, RG 120.

12. ECG to her mother, 12 Nov 1848, RG 168.

13. He was Frederick Myers, a Cambridge Evangelical. Ruskin wrote to his brother-in-law, Dr Whewell, Master of Trinity College, Cambridge, of 'a day or two I am enjoying here — happy in the neighbourhood of St Johns church — and in the teaching of Mr Myers — an advantage which was indeed the chief motive of my choosing Keswick for our place of sojourn . . . I am especially gladdened by the return of the services and teaching of my own church — after some weeks experimentalising among the Scotch Free churchmen . . .' Keswick, 17 Apr 1848. Trinity Coll Cambridge Add Ms c 90/83.

14. JJR-George Gray, 28 Apr 1848, RG III.

15. ECG to her mother, 28 Apr 1848, RG III.

16. JJR-George Gray, 24 May 1848, RG 116.

17. Quoted and discussed at VIII, xxiii and 278.

18. See IV, 37-41.

19. JR-JJR, Florence, 30 May 1845, RV 89.

20. VIII, 3n.

21. J. G. Links, *The Ruskins in Normandy*, 1968, 14.

22. Ibid., 19.

23. XXXV, 156.

24. XII, 314-15.

25. Links, op. cit., 26-7.

26. Ibid., 41.

27. The letter was to W. H. Harrison. Links, op. cit., 83-4.

Chapter Eight

1. *Prospectus of the Arundel Society*, 1849, 8.

2. JJR-George Gray, 4 Mar 1849, RG 180.

3. JR-ECR, 24 Apr 1849, RG 185.

4. JR-ECR, 29 Apr 1849, RG 187.

5. 30 Apr 1849, Diaries 374.

6. 3 Jun 1849, Diaries 381.

7. Ruskin had a lifelong interest in this poem: he wished to know how far his own experience resembled Wordsworth's. See V, 364, 368, and XXXV, 233.

8. 3 June 1849, Diaries 381.

9. 3 Jun 1849, Diaries 382.

10. V, 289.

11. 4 May 1849, Diaries 375.

12. 22 Aug 1849, Diaries 431.

13. II Jul 1849, Diaries 408.

14. XXXV, 437.

15. JR-ECR, 3 May 1849, RG 195.

16. JJR-George Gray, Chamonix, 13 Jun 1849, RG 213.

17. George Gray-JJR, 22 Jun 1849, RG 218.

18. JR-George Gray, 5 Jul 1849, RG 231-2.

19. JR-ECR, Champagnole, 2 Sept 1849, RG 249.

20. ECR-George Gray, 9 Oct 1849, EV 45-6.

21. ECR-George Gray, 28 Oct 1849, EV 53.

22. ECR-George Gray, 28 Oct 1849, EV 53-4.

23. JR-W. L. Brown, 11 Dec 1849, XXXVI, 104.

24. ECR to her mother, 15 Dec 1849, EV 89.

25. ECR to her mother, 18 Jan 1849, EV 133.

26. ECR to her mother, 24 Dec 1849, EV 99.

27. ECR to her mother, 3 Feb 1849, EV 131.

28. ECR to her mother, 28 Dec 1849, EV 99.

29. See EV, 146.

30. Ruskin did not visit Venice between 1852 and 1869. On 10 May 1862 he told Rawdon Brown of his fear of sadness at returning there. See XXXVI, 408.

31. Effie told her mother that 'The gentlemen here are very goodnatured, I think, for when they come to see me they leave their cards for John and say all manner of Civil things too of him and he cuts them all on the street unless I am with him and make him, and he never calls on anybody.' 14 Dec 1851, EV 229.

32. ECG to her mother, 24 Feb 1850, EV 149.

33. See Robert Hewison, *Ruskin and Venice*, 1978, 54-5.

Chapter Nine

1. IX, xxxi. Queen Pomare of Otaheite (Society Islands) had appealed some years before for British protection.

2. See *Journals and Correspondence of Lady Eastlake*, 1895, 192.

3. ECG-Rawdon Brown, n.d., but written at Bowerswell, EV 170.

4. See IX, xlv. The Ruskins made little attempt to promote John Ruskin's books and were more eager that they should be widely read than that they should be well reviewed, though John James was nervous of his son's reputation. In his diary is an interesting list of the recipients of presentation copies of the first volume of *The Stones of Venice*. They practically all went to family friends and the engravers who had worked on the book. They were sent to 'Rogers, Acland, Brown W. L., Richmond, O. Gordon, Dale, Rev. D. Moore, Telford, Croly, Melvill, Harrison, Richardson, Inglis, Lockhart, Murray, Mitford, Edwardes (the soldier Herbert Edwardes, whose career Ruskin would examine in *A Knight's Faith*, 1885), Prof. Owen (probably the geologist Sir Richard Owen), Lady Trevelyan, Cheney, Eastlake, Mr George (a family friend who was possibly also a geologist), Runciman, Carlyle, Lady Davy, Dickens, Lupton, Armitage (the engraver J. C. Armytage), Boys (another engraver), R. Fall. Ms Bembridge 33.

5. Croly's alliance of political and religious prejudice, and his great interest in the press, were much remarked. See, for instance, James Grant, *The Newspaper Press*, 1871-3, vol. III, 24, on John James's favourite reading, the *Britannia*: 'Its principles were Conservative, but its chief feature was its thorough Protestantism. This will be readily believed when I mention that it was at first under the editorship of the late Rev. Dr Croly . . .' This was so of all the Ruskins's admired clergymen. Grant also reports, in *Travels in Town*, 1839, II, 103, that 'nearly all the clergy of the Church of England, in London, are decided Tories in their political views . . . The Rev. Mr Melville of Camden Chapel, Camberwell . . . is one of the most furious Tory partizans I ever knew, in the pulpit as well as out of it . . . the Rev. Mr Dale, of St Bride's Church, Fleet St; and the Rev. Dr Croly, of St Stephens, Walbrook, do severally now and then indicate their political views in their pulpit ministrations . . .' In *The Metropolitan Pulpit*, 1839, II, 15, Grant claimed of Melville that 'I have heard him deliver sermons in which there were passages of so ultra-political a character, that had a stranger been conducted blindfolded into the place in which he was preaching . . . he would have been in danger of mistaking the sermon of the reverend gentleman, for a speech of the

Earl of Winchilsea in the Lords, or of Sir Robert Inglis in the Commons . . .'.

6. For the 'Papal Aggression', see E. R. Norman, *Anti-Catholicism in Victorian England*, 1968. For the background of the Ruskins's political views see D. G. S. Simes's valuable *Ultra-Tories in British Politics, 1824-34*, Bodley Ms. D Phil c 1442.

7. See Thomas Carlyle, *Latter-Day Pamphlets*, No. VI, 'Parliaments', June 1850.

8. F. J. Furnivall, in his foreword to *Two Letters Concerning 'Notes on the Construction of Sheepfolds' by John Ruskin*, 1890, 8.

9. ECR-Rawdon Brown, 9 May 1854, MR 207.

10. William Holman Hunt, *Pre-Raphaelitism and the Pre-Raphaelite Brotherhood*, 1905, I, 50-1.

11. XXXVII, 427.

12. XIV, III.

13. XII, 319.

14. XII, 320.

15. XII, 322.

16. XII, 327.

17. Quoted at XII, 1n.

18. J. G. Millais, *Life and Letters of Sir John Everett Millais*, 1899, I, 116.

19. III, 624.

20. Hunt, op. cit.

21. 1 May 1851, Diaries 468.

22. ECG-George Gray, 24 Aug 1851, EV 183.

23. See also the letter to W. L. Brown given in Jeanne Clegg, *Ruskin and Venice*, 1981, 81-3. *Centesemi* were coins, the smallest part of the lira.

24. XVIII, 539.

25. ECG to her mother, 24 Feb 1852, EV 283.

26. JR-JJR, 16 Nov 1851, EV 184.

27. JR-JJR, 6 Mar 1852, J. L. Bradley ed., *Ruskin's Letters from Venice*, 1955, 212.

28. For these letters see XII, lxxviii-lxxxv. Some of the letters themselves are given at XII, 591-603.

29. See XI, 258-63.

30. See XII, lxxxiv.

31. See XII, l-lii.

32. JR-JJR, 28 Sept 1851, Bradley, op. cit., 23.

33. JR-JJR, 28 Dec 1851, Bradley, op. cit., 112. Ruskin recorded 'Turner buried' on 30 December 1851, and then abandoned diary entries until 20 July 1853, when he arrived at Glenfinlas.

34. Eastlake, op. cit., I, 273.

35. Collingwood, *Life*, 1900, 136.

36. XIII, xxvi-xxvii.

37. Eastlake, op. cit., I, 273.

38. ECR to her mother, 4 Jan 1852, RV 242.

39. JR-JJR, 1 Jan 1852, Bradley, op. cit., 119-20.
40. See XIII, xxx.
41. JR-JJR, 22 Feb 52, Bradley, op. cit., 191-20.
42. JR-JJR, 5 Feb 1852, Bradley, op. cit., 164.
43. JR-JJR, 8 Feb 1852, Bradley, op. cit., 171. Written on his birthday, this letter is a very extensive discussion of Ruskin's health in recent years.
44. 3 March 1874, Diaries 777.
45. See XVIII, 32 and XXV, 122.
46. XXXVI, 115.
47. JR-JJR, 25 Jan 1852, Bradley, op. cit., 149. This letter was written on a Sunday: Ruskin always gave more space to religious matters when he wrote on the sabbath.
48. JR-JJR, 22 Feb 1852, Bradley, op. cit., 192.
49. ECR to her mother, 8 Feb 1852, EV 263.
50. Ibid., 265.
51. Ibid., 265-6.
52. JR-JJR, 27 Dec 1851, EV 261.
53. ECR to her father, 19 Jan 1852, EV 249.
54. ECR to her mother, 20 Feb 1852, EV 271.

Chapter Ten

1. XXXVI, 142.
2. ECR to her mother, 3 Aug 1852, MR 17.
3. See MR, 15.
4. JR-Mrs Gray, 28 Aug 1852, MR 19-22.
5. Betty Miller, *Robert Browning*, 1952, 172.
6. Cate, op. cit., 1-2.
7. XXXV, 539-41.
8. See Cate, op. cit., 15. Jane Welsh Carlyle was never sympathetic to Effie. On 23 Feb 1856 she wrote to William Allingham '. . . what can be expected from a man who goes to sleep with, every night, a different Turner's picture on a chair opposite his bed "that he may have something beautiful to look at on first opening his eyes of a morning". (so his mother told me) . . . I never saw a man so improved by the loss of his wife! He is amiable and gay, and full of hope and faith in — one doesn't know exactly *what* — but of course *he* does . . .'. National Library of Scotland, Ms 3283 foll 123-4.
9. ECR to her mother, Feb 1853, MR 29.
10. Millais, op. cit., 92.
11. ECR to her mother, 27 Mar 1853, MR 39.
12. JR-W. L. Brown, 31 Mar 1853, Bodley Ms Eng Letts c 33 fol 110.
13. JJR-MR, 15 Dec 1854, Ms Bembridge L 2.
14. ECR to her mother, 15 Apr 1853, MR 42-3.

15. ECR to her mother, 3 May 1854, RG 45.
16. XI, 53.
17. XI, 53n.
18. ECR-Rawdon Brown, 20 Jun 1853, MR 50.
19. JR-W. L. Brown, Jun 1853, Bodley Ms Eng Letts c 33 fol 46.
20. A. J. C. Hare, *The Story of My Life, 1896-1900*, II, 348-51.
21. *Letters of Dr John Brown*, 88.
22. Pauline Trevelyan's review was to appear in *The Scotsman*. See Virginia Surtees ed., *Reflections of a Friendship: John Ruskin's Letters to Pauline Trevelyan 1848-1866*, 1979, for her connections with Ruskin and Millais.
23. XII, xix.
24. Millais-Holman Hunt, 28 Jun 1853, MR 55.
25. JR-JJR, 3 Jul 1853, MR 59-60.
26. XII, xxiv.
27. See RI, 166.
28. V, 122.
29. ECR to her mother, 10 Jul 53, MR 65-6.
30. XII, xxiii.
31. Acland to his wife, 27 Jul 1853, Bodley Ms Acland d 9 foll.134-5.
32. Acland to his wife, n.d., Bodley Ms Acland d 9 fol 136.
33. JR-JJR, 28 Jul 1853, MR 75.
34. Diaries 479.
35. Millais-C. A. Collins, n.d., MR 81.
36. Deposition by William Millais dated 9 March 1898, Bodley Ms Eng Letts c 228, fol 62.
37. JR-MR, 16 Oct 1853, MR 97.
38. JR-Hunt, 20 Oct 1853, MR 101.
39. JR-JJR, 6 Nov 1853, MR 107-8.
40. JJR-JR, 8 Dec 1853, Ms Bembridge L 4.
41. Millais-Mrs Gray, 19 Dec 1853, MR 114.
42. JJR-George Gray, 16 Feb 1854, MR 135.
43. ECR to her father, 7 Mar 1854, MR 154-7.

Chapter Eleven

1. For a description of this book, see Diaries 487.
2. XXXV, 415.
3. Bodley Ms Eng Letts c 33 fol 152.
4. A correspondence conducted through Griffith which Fawkes cut off. The two men were estranged for many years afterwards.
5. See MR 230.
6. 2 July 1854, Diaries 497.
7. 27 Sept 1854, Diaries 511.
8. Surtees, op. cit., 88.
9. Charles P. Lucas, 'Llewelyn Davies and the Working Men's College, *Cornhill*

Magazine, Oct 1916, 421 ff.

10. A successful painter at this period would decline to give lessons: this proved that he was more than a drawing master. Philip Gilbert Hamerton records Ruskin's opinion of drawing masters in the year before he began teaching at the Working Men's College. In 1853 Hamerton had asked him to recommend a master. Ruskin replied 'There is no artist in London capable of teaching you and at the same time willing to give lessons. All those who teach, teach mere tricks with the brush, not true art, far less true nature.' *An Autobiography, 1834-1858*, 1897, 128-30.

11. JR-Sarah Acland, 19 Oct 1854, Bodley Ms Acland d 72 fol 39.

12. XIII, 539.

13. V, xl.

14. Virginia Surtees ed., *The Diary of Ford Madox Brown*, 1981, 196, 16 March 1857.

15. See J. P. Emslie, 'Recollections of Ruskin', *Working Men's College Journal*, vol. 7, 180; and, generally, J. F. L. Harrison, *A History of the Working Men's College*, 1954, 16-85.

16. JJR-JR, 1 Dec 1853, MS Bembridge L 4.

17. Sarah Angelina Acland, 'Memories in my 81st Year', Ms notebook, Bodley Ms Eng Misc d 214.

18. *Letters of James Smetham*, 1891, 54-5.

19. XXXVI, 143-4.

20. XII, 55.

21. *Letters of Dante Gabriel Rossetti*, ed. Oswald Doughty and J. R. Wahl, Oxford, 1965-7, 134.

22. XXXVI, 32.

23. Rossetti was writing to his aunt, Charlotte Polidori. *Letters*, 250.

24. See V, 24-34.

25. See James S. Dearden, 'The Production and Distribution of Ruskin's *Poems*, 1850', *Book Collector*, Summer 1968.

26. Basil Champneys, *Memoirs and Correspondence of Coventry Patmore*, 1900, II, 277.

27. Ibid., II, 278-9.

28. *The Critic*, 27 Oct 1860.

29. Champneys, op. cit., I, 130n.

30. See David J. DeLaura, 'Ruskin and the Brownings: Twenty-Five Unpublished Letters', *Bulletin of the John Rylands Library*, 54, Spring 1972.

31. Ibid. Shenstone is commended for his love of nature at V, 360.

32. Ruskin's relations with Stillman are described in his *Autobiography of a Journalist*, 1901.

33. See R. B. Stein, *Ruskin and Aesthetic Thought in America, 1840-1900*, Cambridge, Mass., 1967.

34. VII, 451.

35. XXXV, 520.

36. *Letters of Matthew Arnold*, 1848-88, ed. G. W. E. Russell, 1895, I, 38-9.

37. J. B. Atlay, *Sir Henry Wentworth Acland*, 1903, 140-53.

38. Ruskin-Acland, n.d., Bodley Ms Acland d 72 fol. 37 a-b.

39. Ruskin-Sarah Acland, 19 Oct 1854, Bodley Ms Acland d 72 fol 39.

40. XVI, xliii.

41. XVI, xliv.

42. Ruskin-Acland, n.d., Bodley Ms Acland d 72 fol 43.

43. XVI, xlv.

44. XII, 430.

45. For whom, see Royston Lambert, *Sir John Simon 1816-1904 and English Social Administration*, 1963.

46. See Atlay, op. cit., 192-3.

47. XVI, 221.

48. Atlay, op. cit., 227.

49. Rossetti to his mother, 1 Jul 1855, *Letters*, 262.

50. Atlay, op. cit., 225-8.

51. Bodley Ms Acland d 72 fol 58.

52. Quoted in XVI, xlix.

53. See XVI, 207-40.

54. Ms Bembridge L 17.

55. JJR-Acland 25 Jun 1855, Bodley Ms Acland d 72 fol 54.

56. XVI, 436.

Chapter Twelve

1. Louisa, Marchioness of Waterford, was a rich amateur and patroness. She had mixed in Pre-Raphaelite circles since at least 1853. Ruskin's letters to her are collected in Virginia Surtees ed., *Sublime and Instructive*, 1972.

2. XVI, 213-14.

3. XIV, 152.

4. The letters are given at XII, 328-55.

5. Ibid.

6. IV, 333.

7. See XIII, xxi.

8. XIV, 5.

9. XIV, 9-10.

10. XIV, 13-14.

11. XIV, 18.

12. XIV, 19.

13. XIV, 20.

14. See A. M. W. Stirling, *The Richmond Papers*, 1926, 163 *seqq*.

15. Dante Gabriel Rossetti-William Allingham, 11 May 1855, *Letters*, 252.

16. XIV, 27.

17. XIV, 35.
18. Virginia Surtees ed., *The Diary of Ford Madox Brown*, 1981, 144, for 13 July 1855.
19. XIV, 43-6.
20. See XIII, 41 and 168.
21. *Athenæum*, July 26, 1856.
22. *Oxford and Cambridge Magazine*, June 1856.
23. XXXV, 519.
24. For Ruskin's early acquaintance with Norton, see *Letters of Charles Eliot Norton*, eds. Sara Norton and Mark A. DeWolfe Howe, Boston, 1913; and Kermit Vanderbilt, *Charles Eliot Norton, Apostle of Culture in a Democracy*, Cambridge, Mass., 1959.
25. 7 Sept 1856, Diaries 519.
26. See XXVIII, 517.
27. 21 Oct 1856, Diaries 524.
28. See XXXVI, liii.
29. 16 Oct 1856, Diaries 524.
30. 28 Nov 1856, Diaries 525.
31. See Dore Ashton, *Rosa Bonheur*, 1981, 111.
32. See William Bell Scott, *Autobiographical Notes*, 1892, II, 9-10.
33. A favourite phrase of Ruskin's. The first sentence of *Præterita* begins, 'I am, and my father was before me, a violent Tory of the old school.' XXXV, 13.

Chapter Thirteen

1. From George Butterworth's diary, Ms Bembridge 35.
2. Ibid.
3. XXXV, 488.
4. See XXXVI, 186-7 and 278-9.
5. Butterworth, op. cit.
6. See Brian Maidment, *John Ruskin and George Allen*, D. Phil. thesis, University of Leicester, 1973, 48.
7. See XXX, lv-vi and XXXVI, 186.
8. See XIV, 349-56.
9. Surtees, *Sublime and Instructive*, 8.
10. Ibid., 93.
11. V, 4.
12. See XIII, 161-2.
13. See XIII, 173-81.
14. See XIII, 186-226.
15. XIV, 106-11.
16. XIV, xxxvi and 464-70.
17. XXXVI, 263.
18. Ibid.
19. Ibid.
20. XXXVI, 273.
21. JJR-Jane Simon, 19 Feb 1858, Ms Bembridge L 12.
22. XXXVI, 319n.
23. XXIX, 593. John James's accounts show that he was a regular contributor to Guthrie's charities.
24. VII, 4.
25. XII, xxxvi-xxxvii.
26. H. Stacy Marks, *Pen and Pencil Sketches*, 1894, II, 165.
27. Surtees, *Sublime and Instructive*, 215.
28. Ibid.
29. JR-JJR, 20 Jun 1858, *Letters from the Continent 1858*, ed. John Hayman, Toronto, 1982, 51-2.
30. XIII, 119.
31. XII, 99.
32. This is a problem that underlay Ruskin's writing for the 1878 exhibition at the Fine Art Society. The catalogue was written at a time when his own mind failed. See XIII, 409-10 and 520-1.
33. See *The Brantwood Diary of John Ruskin*, ed. H. G. Viljoen, 1971, 98.
34. V, 5.
35. XIV, 151.
36. XIV, 161-2.
37. JR-JJR, 5 Jun 1858, Hayman, *Letters from the Continent*, 28-9.
38. See *Letters from the Continent*, 14-80, for Ruskin's letters home from Switzerland. Very many of them discuss Swiss character and institutions.
39. XIV, 172.
40. JR-JJR, 26 Aug 1858, *Letters from the Continent*, 147.
41. See Allen Staley, *The Pre-Raphaelite Landscape*, 1969.
42. JR-JJR, Sept 1858, *Letters from the Continent*, 171.
43. XIX, 83.
44. XXIX, 89.
45. XXXV, 496.
46. XXXV, 493.
47. JR-Lady Trevelyan, 27 Sept 1858, *Reflections of a Friendship*, 132.
48. 23 May 1858. Diaries 535. Ruskin wrote beneath the sketch, 'This drawing of orchises was the first I ever made on Sunday: and marks, henceforward, the beginning of total change in habits of mind. 24th Feb. 1868.'
49. A. J. C. Hare, *The Story of My Life, 1896-1900*, II, 107-9.
50. VII, xli. Although Ruskin sent these views to his father they were not exactly in a letter, but in one of the 'Notes on the Turin Gallery' he was composing with a view to *Modern Painters V*.
51. See *Letters from the Continent*, 141-4.

Chapter Fourteen

1. XVI, 171.
2. See XVI, 259-92n. The whole lecture is a fine statement of Ruskin's views in the latter days of his Pre-Raphaelitism.
3. XVI, lxv.
4. XVI, 336n.
5. XVI, 336-7.
6. XVI, 340.
7. JR-JJR, 12 Sep 1858, *Letters from the Continent*, 170.
8. In 1880 Ruskin looked back on his experience of sermons. 'I am now sixty years old, and for forty-five of them was in church at least once on the Sunday, — say once a month also in afternoons, — and you have about three thousand church services. When I am abroad I am often in half-a-dozen churches in the course of a single day, and never lose a chance of listening . . . add the conversations pursued, not unearnestly, with every sort of reverend person . . .' XXXIV, 217n.
9. W. J. Fullerton, *C. H. Spurgeon*, 1920, 39.
10. Joseph Johnson, *Popular Preachers of our Time*, 1864, I, 613.
11. Quoted in Fullerton, op. cit., 39.
12. XXXVI, 275.
13. XXXIV, 659-61.
14. Ibid.
15. See XV, 189.
16. For this background, see Van Akin Burd, *John Ruskin and Rose La Touche*, 1979, 23-49.
17. XXXV, 525. Ruskin mistook her age in this passage: she was ten years old. But factual mistakes in *Præterita* were seldom corrected.

18. Bodley Ms Eng Letts c 34 fol 3.
19. XXXV, 526.
20. See Waldo Hilary Dunn, *James Anthony Froude*, 1961-3, I, 64-7.
21. XXXV, 533.
22. JR-Jane Simon, 20 Jun 1858, *Letters from the Continent*, 187.
23. JR-Jane Simon, 9 Nov 1858, Bodley Ms Eng Letts c 34 fol 88.
24. JR-JJR, 26 Jun 1858, *Letters from the Continent*, 59.
25. JR-Anna Blunden, 20 Oct 1858, *Sublime and Instructive*, 98-100.
26. XXXV, 503.
27. Logan Pearsall Smith, *Unforgotten Years*, 1938, 39-40.

Chapter Fifteen

1. Ms Bembridge 33.
2. XXXVI, 338-9.
3. XIV, 234-8.
4. Ruskin would have been the more displeased in noticing that the painting depicts the back garden at Bowerswell.
5. JR-Margaret Bell, 3-4 Apr 1859, *Winnington Letters*, 149-50.
6. XIV, 240-3.
7. XIII, 539.
8. XXII, 511-12.
9. For this background, see Van Akin Burd, *The Winnington Letters*, 1969, 19-54.
10. XXXVI, 324.
11. XXXVI, 331.

INDEX

The following brief index refers only to proper names. A full index will be found at the end of the second volume.